T0069197

CONDITION
THE AGEING OF ART

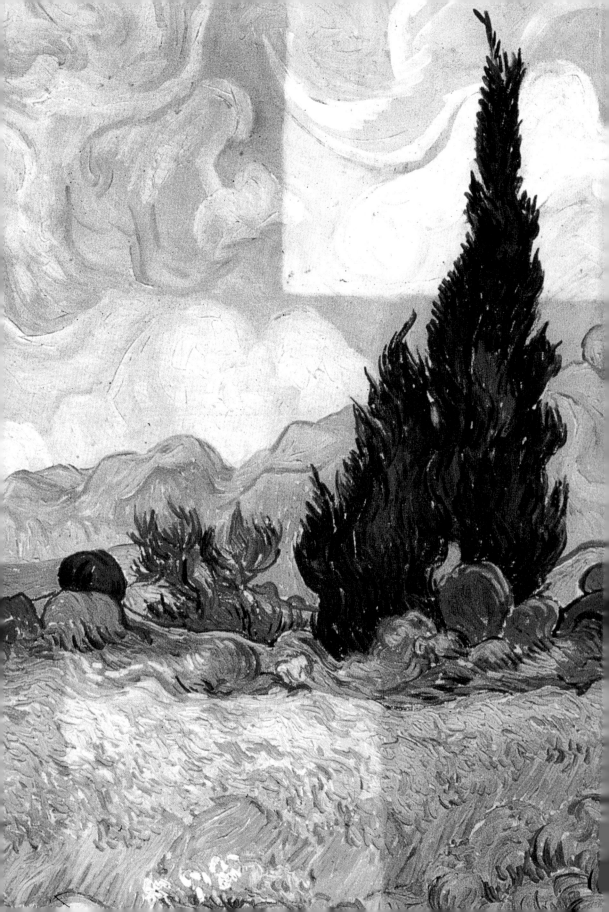

Paul Taylor

CONDITION
THE AGEING OF ART

Paul Holberton publishing

For Sara and Sima

Copyright © 2015
Texts copyright © the author

All rights reserved. No part of this publication may be transmitted in any form or by any means, electronic or mechanical, including photocopy, recording or any storage or retrieval system, without the prior permission in writing from the copyright holder and publisher.

ISBN 978 1 907372 79 7

British Library Cataloguing in Publication Data

A catalogue record for this book is available from the British Library

Produced by Paul Holberton publishing
89 Borough High Street, London se1 1nl
www.paul-holberton.net

Designed by Laura Parker
www.parkerinc.co.uk

Origination and printing by
Grafiche Damiani - Faenza Group, Italy

FRONT COVER Jean-Auguste-Dominique Ingres, *The Composer Luigi Cherubini with the Muse of Lyric Poetry*, 1842 (fig. 68), detail
BACK COVER William Hogarth, *Time smoking a picture*, 1761 (fig. 131)
FRONTISPIECE Vincent van Gogh, *A wheatfield with cypresses*, 1889 (fig. 105), detail

CONTENTS

PREFACE

1
Nicola Lochoff's attempted reconstruction of the original appearance of Sandro Botticelli's *Birth of Venus*, 1930s, tempera on canvas, 170 × 272 cm, Henry Clay Frick Fine Arts Building, University of Pittsburgh, © The Estate of Nicola Lochoff

2
Sandro Botticelli, *The Birth of Venus*, 1483–85, tempera on canvas, 172.5 × 278.5 cm, Galleria degli Uffizi, Florence

This book began as a study of something else: I was meaning to write a book about the concept of 'technique' in art theory. While reading up on that topic I came across a slim volume written over seventy years ago, but still very informative and also extremely readable – Daniel Thompson's *The Materials and Techniques of Medieval Painting*. Thompson's remarks about the Russian picture restorer Nicola Lochoff, who had attempted to repaint the faded art of the past in its original bright colours, made me want to see what these reconstructions looked like. Once I had found an image of Lochoff's gleaming version of Botticelli's *Birth of Venus* (figs. 1 and 2), I began to wonder if the Renaissance art that has come down to us might not be a drab travesty of its original, colourful appearance. I started looking for a book which would tell me more about condition – how paintings change in appearance over time.

To my surprise, I was unable to find one. There are many shelves of books on conservation and restoration, but nothing which focuses on condition. It occurred to me that I might be able to fill this gap in the art historical literature. After I had tried out the idea on a few friends and received some enthusiastic encouragement, I abandoned my plan to write a book about technique, and set to work on the new project that had caught my imagination.

This is meant to be a simple, informative and practical book. It would be possible to write an interesting philosophical study on the concept and/or culture of condition, but this work has no such aim. The plan here is to provide a hands-on introductory text, which can be used as a first orientation in the study of condition, and can remain as a basic reference work when the reader has taken the subject further.

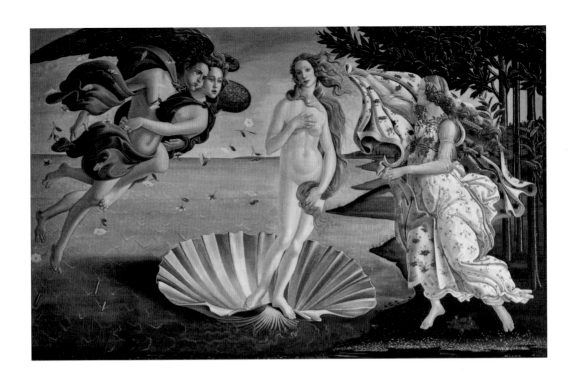

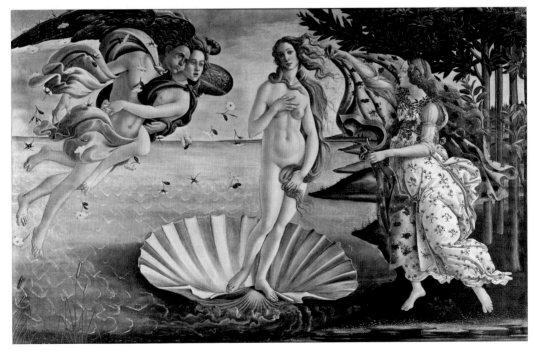

Most of the works discussed in this book are in London collections, in particular the National Gallery. There are two main reasons for this. The first is that I wanted to be able to see the paintings I was discussing; photographs, even high resolution photographs, are often misleading. The other is that the works in the National Gallery are among the most thoroughly studied paintings in the world, with detailed analyses of their technique published every year in the *National Gallery Technical Bulletin*, and summaries of the condition of each picture provided in the superb new series of National Gallery Catalogues. It is very difficult to make accurate remarks about condition in the absence of scientific information, and I have gratefully made use of the research of the Gallery's scientific, conservation and curatorial departments.

Many people have been generous and helpful while I have been working on this book. Isabelle Chartier of the University of Pittsburgh was exceptionally kind in answering my enquiries and sending me photographs of Nicola Lochoff's paintings, together with copies of his letters and other archival material. Margriet van Eikema Hommes spent a day with me looking at pictures in the National Gallery and the Wallace Collection, and has answered many questions over e-mail since. Marco Cardinali and Marjolijn Bol taught me a great deal over a technical evening meal in a trattoria in Rome. Alexis Ashot introduced me to many aspects of condition while we examined paintings at Christie's. Helen Glanville and Spike Bucklow let me spend a day watching restoration in action at the Hamilton Kerr Institute, and reined in some of my more wayward theories. And it has again been a pleasure to work with Paul Holberton and Laura Parker while making this book.

I also thank Jonathan Allen, Jaynie Anderson, Jean-Luc Baroni, Xavier Bray, Bodo Brinkmann, Lorne Campbell, Emilie Carreón, Nicola Christie, Lucy Davis, Rembrandt Duits, Laura Fenelli, Chiara Franceschini, Ivan Gaskell, Karin Hellwig, Charles Hope, Paul Joannides, Ian Jones, Joan Kendall, Katrien Keune, Berthold Kress, Helen Langdon, Peter Mack, Anna Marcone, Ann Massing, Anthony Meyer, Rachel Morrison, Martin Percy, Ashok Roy, Paola Sannucci, Jennifer Sliwka, Marika Spring, Joan Stanley-Baker, Peter Struycken, Anna Tummers, Joshua Waterman and Barnaby Wright. Elizabeth Savage gathered the photographs with marvellous efficiency.

For reading some or all of the book in draft and giving me suggestions and criticism, particular thanks must go to Richard Beresford, Alison Clarke, Michel Favre-Félix, Erma Hermens, David Jaffe, Ulrike Kern, Suzanne Laemers, Gregory Martin, Jane Martineau, Lizzie Marx, Elizabeth McGrath, Sally Salvesen and Sara Trevisan.

INTRODUCTION

One of the most influential books in twentieth-century art history
was Erwin Panofsky's *Studies in Iconology*. In this seminal work, the
very latest German approaches and methods were presented to
an Anglo-Saxon audience for the first time. One of the dazzlingly
learned chapters was devoted to the figure of Cupid wearing a
blindfold, and Panofsky showed how this theme could be traced
back to the writings of medieval moralists. For thinkers of this
Christian stamp, lovers were metaphorically blind, since they were
"without judgment or discrimination and guided by mere passion".
But later, in the Renaissance, "moralists and humanists with
Platonizing leanings" contrasted the figure of the blindfold Cupid
with another kind of Cupid – one who had perfect sight, since he
possessed vision of an exalted, divine nature. Panofsky observed
that in an emblem book of the late sixteenth century Earthly Love
was shown as a blindfold Cupid, being chased by a blindfoldless
Platonic, or Divine Cupid (fig. 3).

Panofsky admitted that he could not find very many Platonic
Cupids in the art of the period, but he did have one telling example,
an "ingenious allegory", with which he ended his chapter on a
high note. A painting by Lucas Cranach the Elder, preserved in the
Philadelphia Museum of Art (fig. 4), showed, as he put it, "a little
Cupid removing the bandage from his eyes with his own hand and
thus transforming himself into a personification of 'seeing' love. To
do this he bases himself most literally on Plato, for he stands on an
imposing volume inscribed *Platonis opera* from which he seems to
be 'taking off' for more elevated spheres."[1]

Panofsky did not live to see the picture cleaned in 1973, but, if
he had, he might have been disappointed by the results. It turned

HOW ART
HISTORIANS
CAN BE FOOLED
BY CONDITION

3
Giulio Bonasone, 'Platonico
Cupidini', from Achille
Bocchi, *Symbolicarum
Quaestiones*, Bologna: Apud
Societatem Typographiæ
Bononiensis, 1574, 44,
emblem XX

4
Lucas Cranach the Elder,
Cupid removing his blindfold
(fig. 6), c. 1530, as overpainted
between c. 1600 and 1973,
oil on panel, 79.1 × 38.1 cm,
John G. Johnson Collection,
Philadelphia Museum
of Art

out that the *Works of Plato* were never part of Cranach's original intention. The panel in Philadelphia is a cut-down fragment (fig. 6) of what was almost certainly a larger painting of Venus and Cupid (compare fig. 5), and the volume of Plato was later overpaint which came away in the restorer's solvent.[2]

In his enthusiasm, Panofsky had forgotten a fundamental axiom of art history. The way paintings look today is usually not the way they looked in their own time. Pictures are overpainted and overcleaned, they darken and discolour, they split and flake and undergo traumas from fire to the restorer's iron and vacuum table. Anyone writing about a work of art needs to establish at the outset how much it has changed since it was first made. Theories of art history have been built on works whose appearance is made up of little more than repaint and decay, and the beginner needs to be warned about the many pitfalls dug by time for the unwary.

This book is meant for that beginner. Experienced restorers and curators will learn little from what follows; this is an introduction to the problems of condition. I have imagined a reader who is studying the subject at university, but hope that much of what I write will appeal to anyone with an interest in art. Perhaps, too, some lecturers and professors may learn more from it than they might like to admit. I certainly wish that a book like this had been

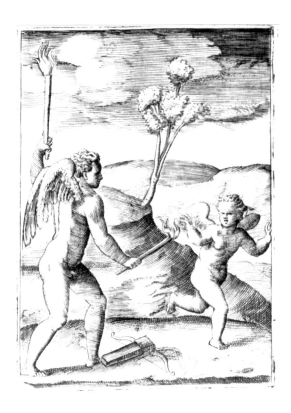

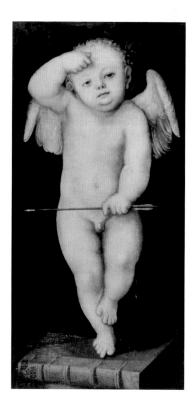

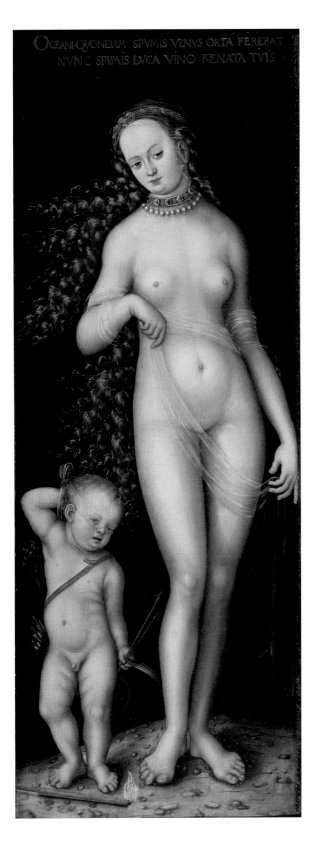

OCEANI QVONDAM SPVMIS VENVS ORTA FEREBAT
NVNC SPVMIS LVCA VINO RENATA TVIS

5
Lucas Cranach the Elder, *Venus and Cupid*, c. 1518–20, oil on panel, 101.5 × 37.5 cm, Art Museum, Princeton University

6
Lucas Cranach the Elder, *Cupid removing his blindfold*, c. 1530, fragment of a painting of *Venus and Cupid*, oil on panel, 79.1 × 38.1 cm, John G. Johnson Collection, Philadelphia Museum of Art

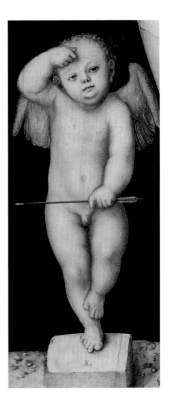

7
Follower of Leonardo da
Vinci, *St John the Baptist*,
c. 1508–12, as overpainted
between 1915 and 1989 to
resemble the Angel of the
Annunciation, oil on poplar,
71 × 52 cm, Kunstmuseum,
Basle

on my reading list when I began my studies in art history; it might
have saved me from a number of mistakes which were just as bad
as Panofsky's.

In fact, only a month before I sat down to write this introduction,
I made a mistake of exactly the same kind. I was writing an article
about Leonardo da Vinci, and wanted to mention a painting in
the Kunstmuseum in Basle (fig. 7). I had seen this illustrated in a
number of books on Leonardo, where it was attributed to the studio
of the artist, and was said to depict an angel. There is a passage in
Giorgio Vasari's *Lives of the Artists* which describes a painting by
Leonardo of "the head of an angel, who raises one arm, and appears
from the shoulder to the elbow in foreshortening; the other hand
touches the breast".[3] It has often been suggested that the painting
in Basle may be a copy of the (now lost) original.

So I wrote to the Kunstmuseum, asking for an image of the
painting to use in my article. They replied that they would be
happy to provide me with a photograph of their painting of John
the Baptist. This was, I thought, a rather odd remark, but since I
knew the picture was based on other paintings of John the Baptist

8
Follower of Leonardo da Vinci, *St John the Baptist*, c. 1508–12, oil on poplar, 71 × 52 cm, Kunstmuseum, Basle

by Leonardo I assumed they were making some reference to this fact, and thought no more about it. But when the photograph arrived through the post I saw that they were being perfectly precise: the painting I had ordered did indeed depict John the Baptist (fig. 8).

What had happened? The curator of Italian paintings at the Kunstmuseum, Bodo Brinkmann, kindly sent me a long e-mail describing the painting's history. In 1917 a man called Paul Sarasin, cousin of the then owner Felix Sarasin, published a seemingly scholarly volume called *The Angel of the Annunciation by Leonardo da Vinci*.[4] In this book he announced that a painting, previously considered a picture of John the Baptist from the studio of Leonardo, had, two years earlier, changed its identity during cleaning. The cross and animal skin of St John were revealed to be later overpaint, which the restorer had easily removed. Underneath was a painting of an angel, dressed in a light chiton. Since this corresponded so closely to the description of the painting of the angel by Vasari, it must, he argued, be the same picture. It was not studio work at all, but a genuine original by Leonardo.

9
Raphael, *The Transfiguration
of Christ*, 1518–20, 'tempera
grassa' on wood, 410 ×
279 cm, Pinacoteca,
Musei Vaticani, Rome

Sarasin did not make many converts to his idea that the painting
was really by Leonardo, but his account of what the restorer
had found was universally accepted. Leonardo scholars began to
describe the picture as the Angel of the Annunciation, even though
this was Sarasin's own identification, and not Vasari's. They are in
fact still doing so today,[5] despite the fact that when, in 1989, the
painting was restored, it became clear that Sarasin's description of
the 1915 cleaning was entirely inaccurate.

At this point the story becomes murky. Sarasin claimed that
the attributes of John the Baptist were removed by the restorer,
revealing the angel's chiton underneath. But this was not so: the
saint's cross and pelt were still there – they had been painted
over by the restorer. Whether in doing this he was following or
subverting the instructions of the Sarasins we will probably never
know. It is possible that he was asked to remove the Baptist's
attributes and balked at the request. Whatever: it is hard to think
up many scenarios which do not suggest conscious and deliberate
deceit on the part of the two cousins. Not that they ever cashed in
on their story; Felix Sarasin left the painting in his will to the art
museum of his home town.[6]

The two cases of overpainting we have considered so far are
admittedly extreme, but it can be a surprise to learn how much of
a painting's surface has been added in the centuries since it was
made. We will investigate this phenomenon further in Chapter Two.
Overpaint is, however, not the only way in which a painting can
deceive the art historian. Another common alteration is brought
about by chemical changes in the paint surface. A particularly
telling example of this phenomenon was discussed recently in a
fascinating analysis of Raphael's *Transfiguration* (fig. 9) by Margriet
van Eikema Hommes.[7]

Raphael's painting is split into two halves, with the actual event
of Christ's transfiguration above, while below is a scene where his
disciples try, in his absence, to cure a boy possessed by the devil.
The scene of exorcism is lit in a very dramatic way, with strong
lights set against pitch black shadows, and it has been suggested
in a number of books and articles on Raphael that this striking
chiaroscuro was deliberately chosen by the artist to heighten the
drama of the scene. Indeed, it has been argued that the sharp clash
of light and shade in the *Transfiguration* influenced artists of the late
sixteenth century, like Caravaggio, and that Raphael's painting thus
initiates a new 'mode of chiaroscuro' in European art.

Van Eikema Hommes, however, will have none of this. She is an
expert on pigment discolouration, and she argues, through careful
comparisons with early copies of the work, that the *Transfiguration*'s
current appearance has more to do with paint chemistry than

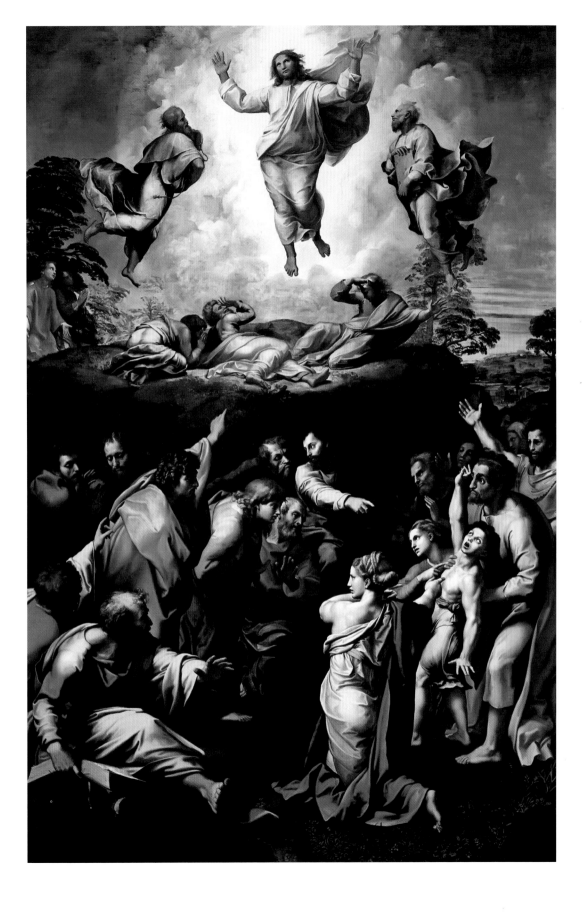

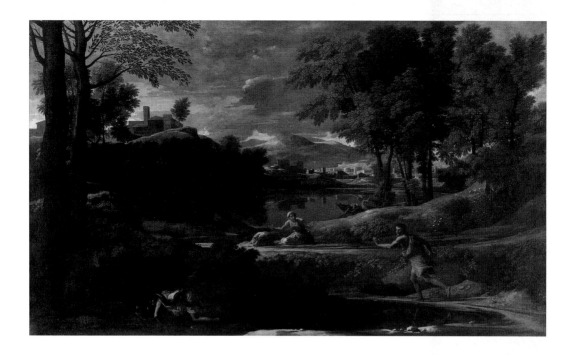

10

Nicolas Poussin, *Landscape with a man killed by a snake*, 1648?, oil on canvas, 118.2 × 197.8 cm, National Gallery, London

Raphael's intentions. She also calls attention to a passage from Vasari which gives support to her view:

> And if in this work he had not, as if by some caprice, adopted the lamp black of the printers – which, as has often been remarked, by its nature becomes ever darker with time and harms the other colours with which it is mixed – that work would, I think, look as fresh as when he painted it, whereas today it looks more stained than anything else.[8]

We will have more to say about darkening in Chapter Five; it is a complex issue on which research is still in progress, and we will see that there are various different theories about its causes. But, whatever the reasons may be, it can be shown that most paintings do alter in tone, and sometimes these mutations can be severe, radically changing the appearance of a work. We can misconstrue the original intentions of a painter badly if we fail to appreciate this.

As an example of the phenomenon, take a landscape by Nicolas Poussin in the National Gallery in London (fig. 10). The gallery's own catalogue hardly gives it a clean bill of health: "The painting is worn throughout, but particularly in the area of the woman's left arm, part of which is illegible, the tree trunk at lower left and in the foreground. Much of the red-brown ground is showing through. The foreground rocks have lost definition. The ultramarine in one of the

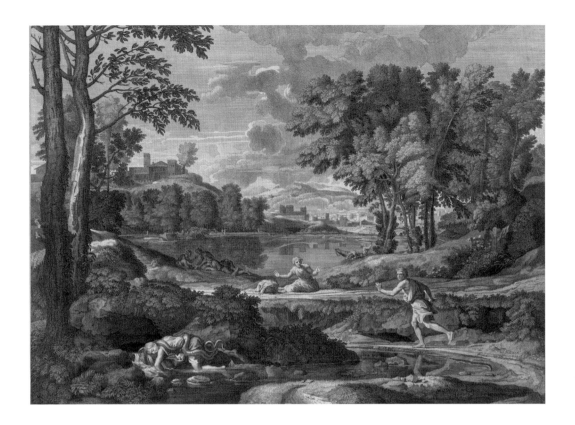

middleground figures has discoloured, and some of the foliage paint is similarly affected."[9]

Sombre as it sounds, this is something of an understatement. The painting has been heavily 'lined' (more on lining in Chapter Three) and the weave of the canvas has pushed up to the surface in certain areas. But worse than that is the overall darkening of tone, which has left parts of the painting almost invisible in shadow.

Is this what Poussin intended? Some critics have thought that it was. In a recent book in which the painting is discussed in absorbingly minute detail, T.J. Clark argues that what Poussin depicted is the dark light just before dawn: "So the darkness is simply the gloom still cast by the hill with the farmstead on top – its diffuse early morning shadow. The sun is climbing; in a matter of minutes the remains of nighttime will have dispersed."[10]

I am not sure that we are supposed to be looking at dawn – it is hard to work out any consistent lighting for this painting, since objects seem to be lit from a number of different directions – but in any case I doubt that Poussin meant the work to look this gloomy. A print after the painting, made in 1701 (fig. 11), shows that parts of the picture which to us are almost illegibly dark seem to have been clearly visible then. It is not a question of nighttime: it is a question of condition.

11
Étienne Baudet after Nicolas Poussin, *Landscape with a man killed by a snake*, 1701, etching and engraving on paper, 57.5 × 75.9 cm, Rijksprentenkabinet, Amsterdam

The deep darkening of tone we see in the Poussin is not uncommon in European painting from the sixteenth to the eighteenth centuries. One of Poussin's French contemporaries, Claude Lorrain, suffers from the same affliction, so that many of his landscapes, which were originally fresh and verdant, have now settled down into a gloom which makes parts of his paintings difficult to discern. What did they look like when they left Claude's studio? This question occurred to David Hockney, an artist who takes an active interest in art history, and he decided to try to recreate on computer the original appearance of a Claude in the Frick Collection, which, as well as darkening in the usual ways, may also have suffered some damage in an eighteenth-century fire (fig. 12).[11]

In Hockney's reconstruction of Claude's intentions (fig. 13), the space fades back gradually into the distance, and the trees take on the colours of spring. One can argue about whether or not Hockney has caught Claude's exact balance of colour. In order to reconstruct the original colours precisely one would need to carry out a very extensive pigment analysis. Even if one did this, it would be hard to know exactly how the pigment mixtures would have looked in Claude's day, especially as there would be uncertainty about the make-up of the paint and any final glazes and varnishes (more on these in Chapter Six). Hockney's own approach was based partly on comparisons with better-preserved Claudes, and partly on intuition. He may or may not have come close to the colour of the original; but he must have caught much of its spaciousness. In Hockney's digital restoration, each object seems to stand clearly in front of the one behind it, creating room in which the viewer can imagine him or herself walking.

Seventeenth-century art theoretical texts discuss visual roominess as an ideal attribute of a painting,[12] and we are told by one of Claude's artist friends, Joachim von Sandrart, that this was a particularly striking feature of his art:

> he gave me an early morning landscape in which it can actually be seen how the sun, risen for some two hours over the horizon, drives away the misty air, and how, with a most wonderful truthfulness, the floating dew sinks into the water; the sun plays over the ground in proportion so that it is truly just like life, lighting grass, bushes and trees, with everything in natural light and shadow, including the reflections shown perfectly, so that the distance of each object can be, as it were, measured in proportion and found correct, as in life itself[13]

We also have good visual evidence that Claude meant his *Sermon on the Mount* to have this virtue. In a book he called the *Liber Veritatis*, the Book of Truth, the artist kept a visual record of

12
Claude Lorrain, *The Sermon on the Mount*, 1656, oil on canvas, 171.5 × 259.7 cm, The Frick Collection, New York

13
David Hockney, Digital reconstruction of the original appearance of Claude Lorrain, *The Sermon on the Mount*

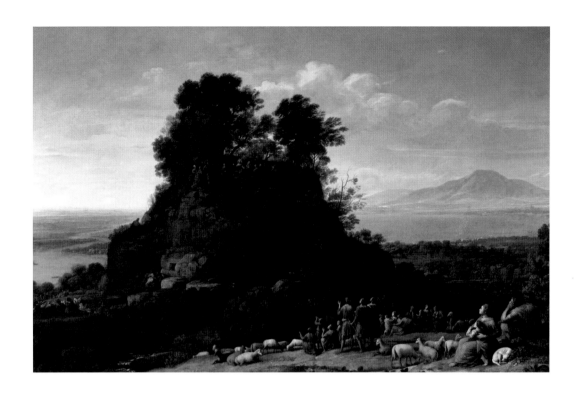

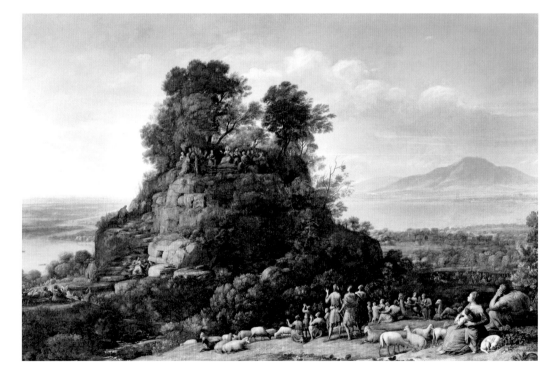

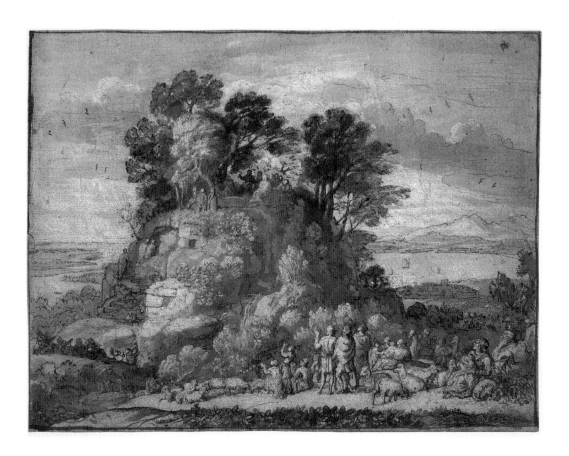

14
Claude Lorrain, *The Sermon on the Mount*, 1656, pen and ink and wash, heightened with white, on blue paper, 20.1 × 26.2 cm, British Museum, London, Department of Prints and Drawings

the paintings he had sold, and his drawing of the Frick painting (fig. 14) shows that it had the spatial clarity of Hockney's version. The original has some passages which are fairly legible – in the foreground, in particular – but in its darker sections it is hard to work out what is where. The Mount in Claude's drawing curves round in space and we can imagine every part of what we see, while in the painting it is a forbiddingly uniform mass of darkness.[14]

Hockney's interest in virtual reconstruction was anticipated, a century ago, by a Russian artist who tried to rejuvenate the imagery of the past by the more laborious method of painting pictures all over again, employing the colours which, he believed, they had once enjoyed (fig. 1). Nicola Lochoff (1872–1948) was well known among historians, curators and collectors of Italian Renaissance art in Europe and America during the interwar years.[15] When he made a replica of Simone Martini's *Dream of St Martin* (figs. 15 and 16) he did not just reproduce what he saw; he returned it to what he took to be its original appearance. In a letter to his American patron Helen Clay Frick, he wrote: "I have restored the 'Dream' … really as it was 600 years ago. And, without modesty, I may proudly say that my reproduction is now nearer S. Martini's vision than

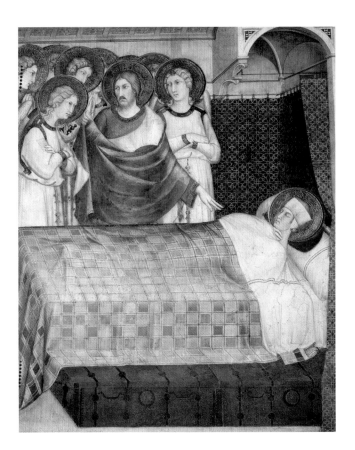

15
Simone Martini, *The Dream of St Martin*, 1317–19, fresco, 265 × 200 cm, Chapel of St Martin, Lower Church, San Francesco, Assisi

16
Nicola Lochoff, Reconstruction of the original appearance of Simone Martini's *Dream of St Martin*, 1929–30, fresco on plaster panels, 334 × 258 cm, Henry Clay Frick Fine Arts Building, University of Pittsburgh. Collection of the University Art Gallery, University of Pittsburgh, © The Estate of Nicola Lochoff

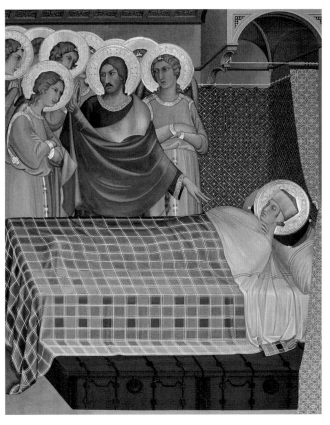

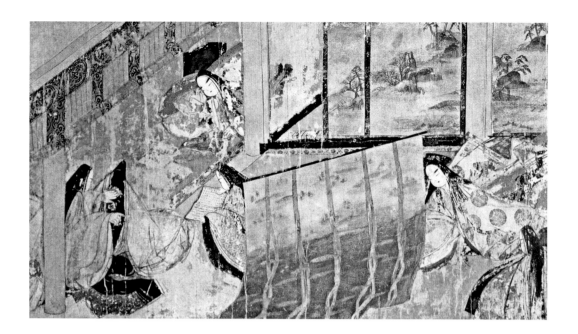

Japanese, Heian period, *The daughters of the Shuzaku emperor*, from *The Tale of Genji*, 12th century, painted handscroll, 21.5 × 39.2 cm, Tokugawa Art Museum, Nagoya

the tarnished and dim original, and that I can show it and prove it scientifically."[16]

Lochoff trained as a chemist at St Petersburg University, and he had an extensive knowledge of Renaissance pictorial technique; but all the same I doubt if he could "prove it scientifically", since he would not have been able to make a proper pigment analysis with the technology available to him. Still, he knew that paints discolour with the passing centuries, and with this knowledge he was able to make informed guesses about how the fresco might have looked in Simone Martini's day. He was aware that blues of all sorts are susceptible to darkening, blanching and other kinds of deterioration, and so he judged that the greyish-black of the curtain behind the saint's bed had degraded from its original blue. He may have been right about this; but whether he managed to pick exactly the right blue from which it had degraded is harder to say.

With careful pigment analysis it is possible to produce reconstructions of discoloured old paintings which can make more claim to "prove it scientifically".[17] Figure 17 shows a painting from the oldest surviving non-Buddhist painted scroll in Japan, the twelfth-century *Tale of Genji* scroll. It is immediately obvious that the painting is very cracked and worn, but what is less obvious is that many of the colours have changed not only in intensity but also in hue (more on hue change in Chapter Four). After careful analysis of the paint, scientists at the Tokugawa Museum in Nagoya managed to ascertain which pigments were originally used, and have therefore been able to suggest what the paint originally looked

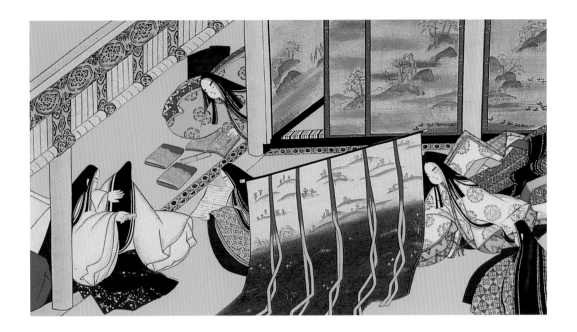

like (fig. 18). This image presents the colours in a schematic, flat way, and the original paints, being laid down in brushstrokes on paper, must have been more varied in texture and less uniform and intense in colour. Nevertheless, it is clear from the reconstruction that much of the original pigmentation is faded or transformed.[18]

Whatever we think of these attempted reconstructions – and perhaps they all seem a bit bright – they do make the issues at stake very clear. Pictures darken, pigments discolour and fade, and the paintings we see today in museums, galleries, churches and temples are often much altered by the centuries.

The subtitle of this book is 'The Ageing of Art', not 'The Ageing of Paintings', but up till now we have only looked at paintings. And if you look through the rest of the book, you will see that most of the illustrations that follow are also of paintings – in fact, of European paintings, from the fifteenth to the nineteenth centuries.

That is not, of course, because European paintings are alone in suffering from the effects of time. Other forms of art in other parts of the world deteriorate too. Nevertheless, there has been much more research into the ageing of European paintings than into the ageing of, for example, New Caledonian wooden sculptures (fig. 19). That is not only due to the Eurocentrism of our academic institutions, although it is partly due to that. It is also because the number of things that typically go wrong with a piece of wooden

TROUBLESOME
TECHNIQUES

19
New Caledonia, Ancestral
doorjamb, 18th or 19th
century, wood, 115 × 70 cm,
Linden-Museum, Stuttgart

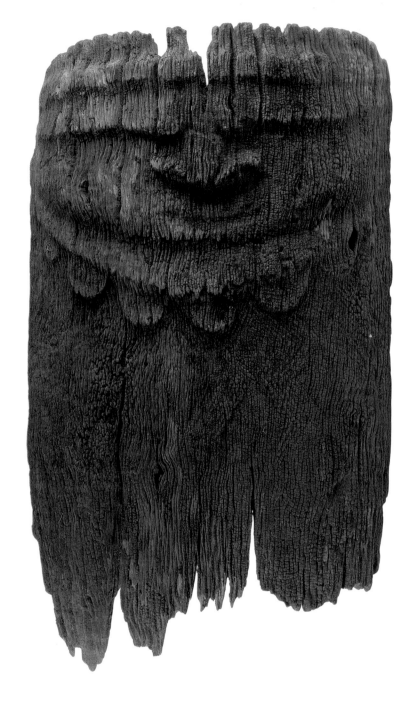

sculpture are rather smaller than the number of things that typically go wrong with an 'Old Master' painting. A wooden sculpture can split and rot and be eaten by woodworm; but a European painting on wood can split, rot, be eaten by woodworm, warp, blister, crack, cup, flake, darken, blanch, discolour, become too translucent and disappear under a centuries-old varnish; and it can also suffer from the efforts of its owners to rectify these situations: it might be transferred, relined, ironed, abraded or repainted. There are many paintings that have suffered from all of these misfortunes, so that the New Caledonian doorjamb depicted here (fig. 19), although it is so clearly ravaged by time, seems to be facing its wrinkled old age with a greater element of integrity and dignity.[19] At least it is clear what has happened to this sculpture. So much money and effort has been spent on using the cosmetic arts of the restorer to conceal the old age of European paintings that, when face to face with a picture, it is often unclear what we are looking at. Is this the touch of the 'Old Master' in question, or is it some fakery, an outcome of x centuries' efforts to shore up its fading appearance? Part of the problem of condition – in Europe at least – is that condition has been considered a problem, which needs to be solved by various procedures that cure some kinds of ailment but create others.

However, it is not all the fault of perfectionist owners and ingenious restorers. These restorers would have had much less work if European paintings had been made differently. 'Old Master' pictures are far too complex for their own good. They rely for their delicate effects on layers of fragile materials, all of which are subject to change and decay. Too many things can go wrong, and sooner or later, they always will.

European paintings, then, will take up most of our attention in this book, and we will only touch in passing on many art forms which are of equal interest, but of less destructive technical complexity. The sorts of problems faced by works of other kinds, from the discoloration of contemporary art to the cracking of early twentieth-century painting and the microbial destruction of non-European sculpture, are also encountered on European works made between the fifteenth and the nineteenth centuries. These paintings provide, then, a convenient laboratory for the study of many species of artistic deterioration.

That study will begin in Chapter Two; in the first chapter, we will prepare the ground for the later discussion by introducing some basic technical concepts, and we will say something about the technologies used in the study of art works.

NOTES

1 Panofsky, *Studies in Iconology*, 95-128, pl. LVII, fig. 106; see, too, the opening of the following chapter, 'The Neoplatonic movement in Renaissance and North Italy' (129): "That a provincial German painter like Lucas Cranach should have represented a Cupid 'de-blinding' himself is eloquent proof of the popularity which the 'Platonic' theory of love had during the first quarter of the sixteenth century".

2 Theodor Siegl, the conservator who removed the overpaint, thought the book could have been added in the late 16th or early 17th century. I thank Joshua Waterman for finding this information in the curatorial files of the Philadelphia Museum.

3 Vasari, *Vite*, II, 5: "... una testa d'uno Angelo che alza un braccio in aria, che scorta dalla spalla al gomito venendo inanzi, e l'altro ne va al petto con una mano"; Taylor, 'Leonardo', 36-37. Throughout this book I write as if Vasari were the author of all the words in *Le Vite*, but this has recently been questioned: see Hope, 'Vasari's *Vite* as a Collaborative Project'.

4 Sarasin, *Verkündigungsengel*.

5 Zöllner, *Leonardo*, 166; Kemp, *Leonardo*, 337-38.

6 For a colour reproduction of the painting since cleaning and a brief account of the Sarasin affair, see Delieuvin (ed.), *Leonardo's Saint Anne*, 246-47.

7 Van Eikema Hommes, *Changing Pictures*, 171-213.

8 Vasari, *Vite*, II, 86: "E se non avesse in questa opera, quasi per capriccio, adoperato il nero di fumo da stampatori, il quale, come più volte si è detto, di sua natura diventa sempre col tempo più scuro et offende gl'altri colori coi quali è mescolato, credo che quell'opera sarebbe ancor fresca come quando egli la fece, dove oggi pare più tosto tinta che altrimenti". Vasari's advice is repeated in Van Mander, *Schilder-boeck*, 49v.

9 Wine, *French Paintings*, 324-33.

10 Clark, *Sight of Death*, 80. There are interesting remarks on the painting's condition, courtesy of Mark Leonard, chief conservator at the J. Paul Getty Museum, on 186-88 of Clark's book.

11 Gayford, *Conversations with Hockney*, 146-53. For a description of the painting's condition, see Davidson, *Frick Collection*, 50-52.

12 Taylor, 'Houding', esp. 224-26.

13 Sandrart, *Teutsche Akademie*, II, 3 (Dutch and German artists), 332: "... unter andern hat er mir überlaßen eine Morgenstund, darinnen eigentlich zu erkennen, wie die Sonne etwan zwey Stund über dem Horizont aufsteigend, die neblichte Luft vertreibet, und der Thau über dem Waßer schwebend, in der Warheit sich verwunderlich hinein verlieret, die Sonne spielet nach Proportion über die Gründe herein, daß sie fast warhaft dem Leben gleich, Graß, Gesträuß und Bäume beleuchtet, und alles in natürlichen Licht und Schatten, samt der reflexion perfect zeiget, also gleichsam die distanz eines jeden nach proportion abzumessen, und correct wie in dem Leben selbst zu finden ist": http://ta.sandrart.net/-facs-559. I thank Paul Holberton for bringing this passage to my attention.

14 See Van de Wetering, 'Original appearance', for similar comparisons, between works by Rembrandt and drawings after his work by students. It would appear that Rembrandt's famously sombre backgrounds were once more spacious and detailed than they appear to be today.

15 Thompson, *Materials of Medieval Painting*, 47-48, 73 and 228. A study of Lochoff's work and thought has yet to be written.

16 Letter sent to Helen Clay Frick on 20 May 1930, preserved in the Helen Clay Frick Art Files in the Frick Art Reference Library Archives in New York. I thank Isabelle Chartier of the University Art Gallery in Pittsburgh for making this material available to me.

17 Van Loon et al., 'Ageing and Deterioration', 215.

18 I thank Joan Stanley-Baker for bringing this reconstruction to my attention.

19 Meyer, *Oceanic Art*, 436-37, fig. 494. The masks, known as *jovo* or *tale*, are discussed in Boulay, *Maison Kanak*, 108-12.

1.

TERMS AND
TECHNOLOGIES

It is easy to think that a painting must be made with paint. However some paintings, for example in batik, are made with dyes (fig. 20).[1] What is the difference between a dye and a paint? The distinction may seem a slender one, but many of the problems of condition – and many of the subtle effects of painting – come from the fact that artists generally use paints, rather than dyes.[2]

A dye is a soluble pigment, while paint contains insoluble pigments.[3] Dyes colour textiles by leaving the solution in which they are mixed, and forming a close chemical bond with the fibres to which they are applied. Paints do not form a chemical bond like this; instead they stick to things. A paint contains two principal ingredients – a coloured powder and an adhesive which will fix that powder to a surface. The powder does not become part of the surface, it just adheres to it. If the adhesive, for whatever reason, becomes unfixed, then the powder will fall away, leaving no trace of its colour.

In dyeing, the pigments form a much less fragile bond with the fibres to which they are applied. It might seem sensible, therefore, to make pictures from dyes rather than from paints. And in fact, in the Middle Ages and the Renaissance the most prestigious and expensive pictures in Europe *were* made with dyes, or at least with dyed thread – they were tapestries and embroideries (fig. 21).

Although dyes are bound chemically to their fibrous support, their colours are not always fixed firmly to the dyes. Many dyes bleach in sunlight, and the natural yellow dyes used in traditional tapestries and embroideries were particularly prone to fading. In the tapestry shown here we can see that the blues, probably based on indigo, have held up well, as have the reds, though they are a

20
Alice M. Pashley, Portrait
of the artist's Trinidadian
servant, 1926, batik-dyed silk,
68.6 × 48.3 cm, Victoria and
Albert Museum, London,
given by the British Institute
of Industrial Art

21
Southern Netherlands,
The Devonshire Tapestries:
Boar and Bear Hunt, 1425–30,
dyed woollen tapestry (detail),
380 × 1020 cm (approx.),
Victoria and Albert Museum,
London

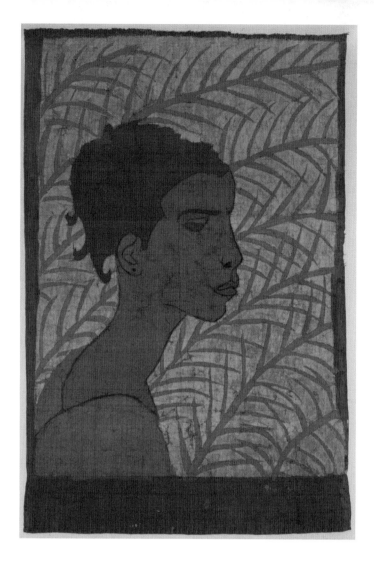

little wan; but the yellows have largely disappeared. Since greens were made by double-dyeing thread, once in indigo and once in some natural yellow such as weld, the green grass and leaves have turned bluish. And where yellow has been used to make the colour of skin or dried grass, the thread has reverted to the off-white of the original wool.[4]

Paints fade too, but fifteenth-century Netherlandish tapestries have suffered much more than fifteenth-century Netherlandish paintings (fig. 22). And paints have other advantages. If the weaver wants to modulate a colour, to find a slightly finer shade for the flesh, for example, then a new batch of thread must be carefully dyed and woven into the whole. The painter, on the other hand, can mix new colours on the palette, as soon as they are needed. It is hardly

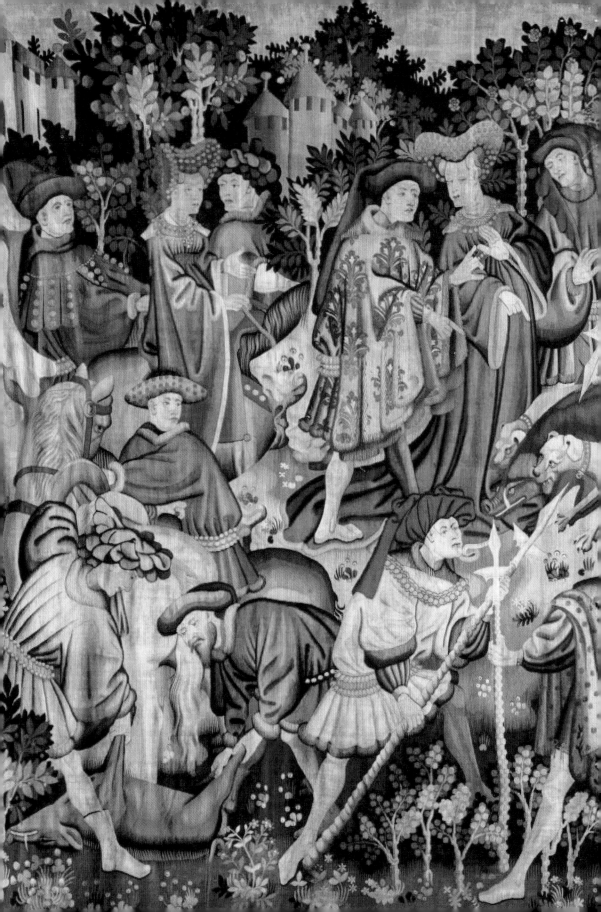

Rogier van der Weyden, *Mary Magdalene reading* (fragment), before 1438, oil on mahogany, transferred from another panel, 62.2 × 54.4 cm, National Gallery, London

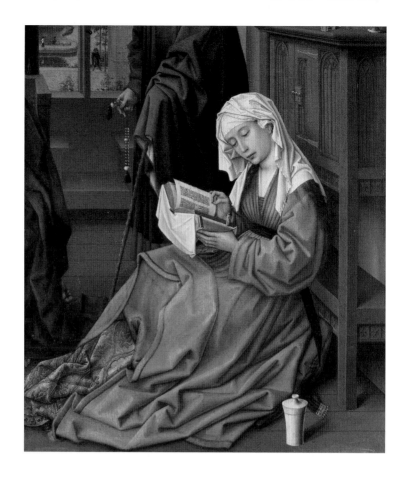

surprising that painters managed to achieve a much more delicate and smooth effect when depicting the fall of light (figs. 23 and 24).

The painter has another advantage, of translucency. Dyed thread is opaque, but paints, depending on their thickness, consistency and pigment type, allow light to pass through. As a result, the painter can use underlayers in order to create colour effects. In the painting in fig. 24, for example, the rich colour of the woman's dress was achieved by laying transparent blue layers ('glazes') over mixtures of blue and red on top of red underpaint.[5] For anyone working in tapestry it would have been impossible to achieve the same translucent complexity of hue.

BINDERS

As we said above, in order to attach coloured powder to a support, you need adhesive. The adhesives in paint are known as binders – or media, or binding media, or vehicles; all these terms are used, and we will be using all of them in what follows. There are many kinds of binder, but the kinds most often encountered in the

23
Southern Netherlands, *The Three Fates* (detail), early 16th century, tapestry woven in wool and silk, 272 × 234 cm, Victoria and Albert Museum, London

24
Robert Campin, Portrait of a woman, c. 1435, oil with egg tempera on oak, 40.6 × 28.1 cm, National Gallery, London

conservator's laboratory fall into four main categories, those based on egg, on oil, on lime and on glue.[6]

In art history today, binders based on egg are invariably referred to as 'tempera', but in the past the word had a broader sense. In the seventeenth century, Italian writers on art used to refer to egg or glue binders as 'tempera',[7] and Cennino Cennini, in his *Libro dell'Arte* of around 1400, used the word to mean egg, glue, oil or lime binders.[8] 'Tempera' derives from the Latin *'temperare'*, to mix or combine correctly: a tempera was a liquid with which pigments were combined in order to make paint.

Egg paint can be based on the yolk, the white, or both together. In order to make an egg white binder, egg whites are beaten to the stage where the bowl can be turned upside down and the froth stays where it is – meringue-makers also know this 'whipping point'. Then the foam is put into a sieve and drained overnight. The liquid that drips into the bowl is called 'glair'. It can be combined with water, and makes an excellent binder for pigments; it was also regularly used as a varnish. Glair was the standard binding medium for European manuscript illumination until the fourteenth century (when it began to be replaced with gum arabic, of which more in a moment), and it was also used as a mordant (a fixative, an adhesive) for gold and silver leaf. It is surprisingly tough, and thus well suited to the handling that pictures in books have to undergo, but it does not give quite the same richness of colour that egg yolk can impart.[9] A little egg yolk was sometimes added to the glair used to bind red pigments, to lend them extra lustre; but yolk was not used on its own as a binder in manuscripts, since it makes too fragile a paint. Yolk tempera will crack if it is put on a page that is constantly being turned and bent by readers. Even a stretched canvas is not optimal, and the vast majority of surviving paintings with a yolk binder are on wood.[10]

Yolk binders – or rather yolk and water binders, since the two are mixed together to make the medium – were the standard vehicle for Italian panel painters. Although they were replaced by oil binders (and panel by canvas) in the course of the sixteenth century, it has been argued that this was not a case of the fittest surviving. In the nineteenth and early twentieth centuries there was an enthusiastic advocacy of tempera painting by a group of artists, scientists and historians, who argued that oil binders aged far less well than egg yolk binders. Oil binders, it was said, yellowed and, at the same time, made the paint of which they were part become translucent. Yolk tempera did neither, and as a result, according to one authority, "paintings in egg tempera have generally changed less in five hundred years than oil paintings do in thirty".[11]

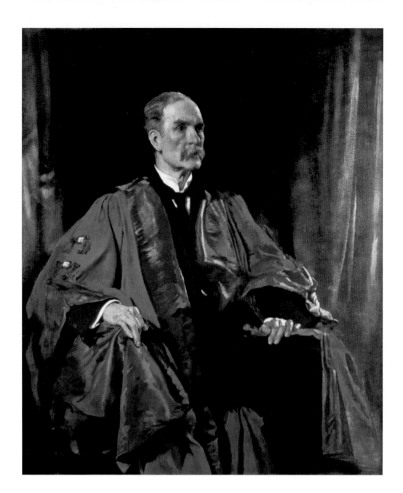

25
Charles Sims, *Professor Matthew Hay*, 1924–25, egg tempera and oil on canvas, 144 × 120 cm, University of Aberdeen

Not that oil needed to be banned entirely from the artist's studio. The advocates of yolk media observed that some of the most technically perfect of the early Netherlandish painters had used a mixed technique, with yolk underlayers and oil upper layers. After careful study of these mixed media, a much respected materials scientist of the first half of the twentieth century, Professor A.P. Laurie, laid out a technical programme which, he claimed, would make the paintings of his time last as well as those of the Van Eycks. And he was willing to let his theories stand up to be tested. He used a black-and-white illustration of the painting in fig. 25 as the frontispiece of one of his books, and beneath it he wrote:

> This picture is of peculiar interest as it is a modern example of the 15th-century oil tempera technique, the picture having been painted in egg and finished in oil. If the theory developed in the text is justified, this picture should keep up to its present colour-key quite as perfectly as the Van Eycks and other oil tempera pictures of the 15th century.[12]

Given that this painting is only one sixth the age of Jan van Eyck's *Arnolfini Portrait* (fig. 64), it is too soon to judge Laurie's theory. It is in any case hard to assess the extent to which the portrait has kept up to its colour-key, when we only have black and white photographs as a record of its original appearance. But whether or not Laurie managed to develop a method of painting that will survive the effects of time as well as Van Eyck's, he was wrong to think that Netherlandish paintings from the fifteenth century were usually painted in a layered technique of oil over egg. Some of them were, but, even when they were, not all areas of the picture were painted that way. In the portrait in fig. 24, the woman's draperies are painted as Laurie thought, but her face was painted purely in oil. And there are many other early Netherlandish paintings, for example the Arnolfini Portrait, which were painted in linseed oil only. The media in paintings by Van Eyck in the National Gallery in London have recently been tested, and no evidence for any egg content has been found.[13]

Given that Van Eyck was able to use oil paint in such a way that his works have survived in excellent condition for nearly 600 years, it is hard to claim that oil paint as such is the cause of pictorial deterioration. It may be true that paintings in egg tempera in museums today are on average in better condition than their fellow paintings in oil. But paintings in egg tempera are usually on wood rather than on canvas, and, as we shall see in Chapter Three, paintings on canvas undergo particular traumas. Then, too, paintings from before 1500 – the great era of tempera – were deeply unfashionable for 400 years. Because they were not being bought by art-lovers or sold by dealers they could slumber quietly in churches and storerooms, and did not have to undergo the often harsh restoration methods of the seventeenth and eighteenth centuries. And a certain aesthetic selection may also have been at work: given that they were not much valued, tempera paintings in poor condition are more likely to have ended life on a bonfire. We cannot conclude, then, that tempera paintings owe their relatively good condition to the fact they were painted in tempera.

Why was it that oil painting swept away tempera so effectively? Because artists could do more with it. Egg tempera makes for beautifully crisp, clear paintings in a rather high key. It is hard to paint darker passages without their ending up looking obscure and muddy.[14] When Leonardo da Vinci introduced a new darker tone into Italian art as a way of creating greater relief (fig. 26), he preferred to use oil as his medium. Furthermore, in oil it is possible to layer paint using transparent glazes; tempera is opaque, and does not adapt to glazing.[15] These veils of colour in oil helped Leonardo to create his famously smooth '*sfumato*' modelling. And when,

26
Leonardo da Vinci, Portrait of a woman, '*La belle Ferronnière*', c. 1490, oil on wood, 62 × 44 cm, Musée du Louvre, Paris

in the following century, Titian began to explore the effects of painting thickly, with brushstrokes that stood proud of the canvas ('*impasto*'), then it was again oil that allowed him to do so. Egg tempera is hard to work when it is thick, and is normally applied thinly, in delicate flurries of small parallel brushstrokes (fig. 27).[16] Another great advantage of oil paint is that it can be endlessly mixed, blended and reworked on the canvas, whereas egg tempera does not lend itself to such treatment. The painter in tempera places each stroke neatly in accordance with a preconceived plan, and avoids improvisation.[17] There is a sense in which painting on tempera is a little like weaving a tapestry: everything must be carefully prepared beforehand.[18]

The same is true, to an even greater extent, of another medium – painting in lime, that is, mural painting. There are two methods of painting in lime. In the first, wet lime is mixed with the pigments, and applied to a dry wall. The second method is more secure and makes the paints look fresher, and has therefore always been preferred. A plaster, made with fresh lime, is spread on a wall. While the plaster is wet, the painter applies his pigments, mixed with water, to the damp surface. Since he can only work for nine or ten hours before it sets, he lays down as much wet plaster as he thinks he can paint in a day. The plaster dries, and in drying, it fixes the pigments in place.

This second procedure is known as *buon fresco*, good fresh painting. It differs from all the other binding systems in that the fixative is not mixed with the pigments and then applied to the support; rather, the fixative is applied to the support, and the pigments are added after. Complete pictures can be made in this way, and from the mid sixteenth century some artists vied with one another to finish everything while the plaster was wet, since it suggested decision and despatch on the part of the painter, and the colours of fresco were thought less likely to darken than paints made with glue or egg.[19] There are, however, disadvantages to the process. Some colours are ruined by the alkali in lime, so cannot be used in *buon fresco*. According to Vasari, only earth colours were suitable for pure fresco painting, and Cennini banned orpiment, vermilion, azurite, red lead, white lead, verdigris and all the lakes; other authors also mistrusted ultramarine, malachite, bone black and indigo.[20] Artists who were not so committed to the purity of *buon fresco*, therefore, would try to get round this problem by adding more colours after the plaster had set; they would be painted *a secco*, on the dry wall, using a binder of tempera or, more usually, glue.[21] And *secco* had an advantage, in that it allowed the artist time for "those last refinements and perfections which the artists who came before us gave to their paintings with delight and love", as

27
Carlo Crivelli, *Dead Christ supported by angels* (detail of fig. 35), c. 1470–75, tempera on poplar, 72.4 × 55.2 cm, National Gallery, London

28
Andrea del Castagno,
Pippo Spano, c. 1448,
fresco transferred to canvas,
250 × 140 cm, Galleria degli
Uffizi, Florence

the sixteenth-century author Armenini put it: the fresco could be brought to a higher degree of finish.[22]

These dry "touches and refinements" must have looked pleasing when they had just been painted, but they were much more vulnerable than the pigments locked into the plaster. Andrea del Castagno in his portrait of Pippo Spano (fig. 28) decided to paint the shadows of the mercenary's tunic in dark blue *a secco*. The effect was probably very successful; but in 1850 the fresco was in such a perilous state that it had to be peeled off its wall and glued to a canvas, and either before or during this process the blue retouchings fell away, leaving the plaster bare.[23] Many other frescoes have lost their *secco* layers, owing to damp, or microbial attack, or on occasion because restorers have erroneously assumed that a

DOMINVS PHILIPPVS HISPANVS DESCOLARIS RELATOR VICTORIE THEVCRO3

29
Dirk Bouts, *The Entombment
of Christ*, probably 1450s,
size on linen, 87.5 × 73.6 cm,
National Gallery, London

work was painted in *buon fresco* and have cleaned it all the way down
to the plaster. As we will see in Chapter Six, the recent cleaning of
the Sistine Chapel ceiling seems to be a case in point.[24]

The last of the traditional media we will discuss here, glue,
is represented by two rather different substances, size and gum.
Size is an animal glue, usually produced by boiling scraps of animal
skin – or parchment, since parchment is processed animal skin –
in water.[25] The result is an adhesive jelly, which can be dried into
cakes and reliquefied when needed. Some of the uses of size as a
medium were secondary ones; it was used, as we have said, for *secco*
layers, and for the painting of certain colours (especially blues) in
manuscripts. It was also used to paint whole pictures, rarely in Italy,
but very frequently in the Low Countries (fig. 29), where the town
of Mechelen (Malines) was well known for mass-producing cheap
pictures in size on bare canvas.[26] Although hundreds of studios were
producing these pictures in Mechelen in the fifteenth and sixteenth
centuries, very few glue paintings survive today, and those that do

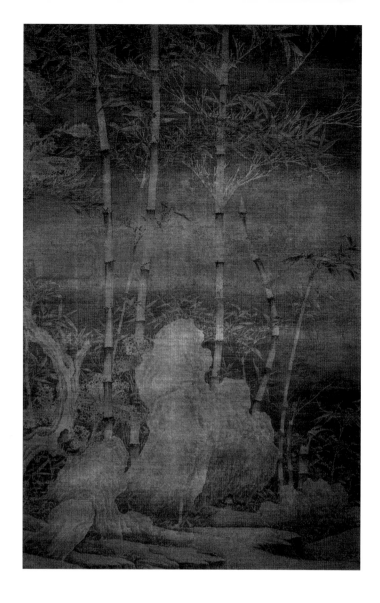

30
Xu Xi, *Snowy bamboo*,
10th century, ink on silk,
151.1 × 99.2 cm, Shanghai
Museum

are extremely fragile. Size canvases are hard to protect; if they are varnished or waxed, the glue darkens. If they are washed with any of the cleaning fluids most commonly used on paintings over the centuries – water, soap, washing soda, urine, alcohol – they will flake away from their grounds. Sometimes pictures of this kind died in the attempt to clean them, and others, being black with filth and cheap in the first place, were probably thrown away.

Although size was a popular medium in Mechelen, its main use as a binder in the visual arts was not in Flanders, but in China, where a size made with either cow or fish skin was used as the binder for carbon black ink. A mixture of size and carbon was dried

and moulded into sticks or cakes, which were sold to scholars and artists. As much of the stick or cake as was needed would be ground with water just before use, and it formed the principal paint (because ink is hard to distinguish from paint by anything other than its function) of Chinese art (fig. 30). Although size as a binder for paintings can cause problems, Chinese ink has always been famous for its exceptional colourfastness and durability. Western black inks, based on iron gall, turn brown; Chinese black inks stay black, and they do not flake or powder, either.[27]

Gum arabic is the hard, sticky sap of a tree, the *Acacia senegal*, which grows in and around the Sudan. Or at least, that is what it is in theory; but any gum that fulfils the same purpose – cherry, plum, peach, almond – has probably been sold as gum arabic in the past. In art, it has had two main functions. As noted above on p. 32, during the fourteenth century it began to replace glair as the principal binder in manuscript illuminations. After the death of the manuscript tradition in the sixteenth century, gums found a new life in the seventeenth as the principal medium of watercolour. [28]

It is easy to suppose that watercolour uses water as a medium, but water is not an adhesive. If pigments were used with water and nothing else, then the coloured powders would fall off the paper. Modern blocks of watercolour are not blocks of pure pigment; they are blocks (not unlike cakes of Chinese ink) in which pigments are set into an adhesive gum. When the artist wipes a wet brush across the cake, a paint, with gum as a binder, is transferred to the bristles. The water is doing no more adhesive work than it does in tempera or fresco painting.[29]

Gum arabic watercolour is not the only kind of watercolour. Water was used as a solvent for size painting, and glue colours of varying consistencies could be made by adding more or less water. Vasari used the word '*guazzo*' – from which the modern term 'gouache' is derived – to refer to the glue medium of paintings made for temporary decorations. In fact the original meaning of *guazzo* in Italian was 'a water hole', a place where one could '*guazzare*', 'splash about'. Vasari's terminology is picking up on the fact that glue is water soluble.[30]

As we noted above, egg tempera is also soluble in water, and so size and tempera today are often referred to as 'aqueous media'. This categorization has roots in the sixteenth century. Karel van Mander, the early historian of painting in the Low Countries, used the term 'water-colour' ('*water-verwe*') to refer to paints with media of egg or glue, which were soluble in water. For him, paints were either oil or water-based; he did not always distinguish between tempera and size.[31] A similar ambiguity exists in the English word 'distemper', which was used to refer to both glue and egg tempera.[32]

31
Michelangelo, 'The
Manchester Madonna',
c. 1497, tempera on wood,
104.5 × 77 cm, National
Gallery, London

Lime is soluble in water, but there is a certain amount of disagreement as to whether or not fresco should be counted as an aqueous medium. It probably should be, but in the literature on conservation it is generally referred to as if it were in a binder class of its own.

SUPPORTS
AND GROUNDS

Before the massive expansion in commercial imagery in the twentieth century, a rather small number of substances were used as supports for painting – plaster, wood, copper, canvas, parchment, paper and silk being the most common. Some of these surfaces need preparation before paint can be applied to them. Wood, canvas and silk are porous, and paint tends to sink in; their absorbency is lessened if a layer of size is applied first. After its sizing the canvas, or panel or silk, can receive paint straight away. In China, fine paintings were often made directly on sized silk (fig. 30); and the size painters of the Netherlands covered their canvas with a layer of glue before they settled down to work (fig. 29).

The dangers of painting on to cloth treated with no more than size are clear from the two examples. As the sized cloth ages, it browns; and the image browns with it. When the painting by Xu Xi was first made, its silk was creamy in colour, and it must have looked very white and wintery (the original effect can be partly recaptured by making a greyscale copy of this image). Now, however, the whole picture's principal colour is not a snowy white but a slushy brown. This is a common property of old Chinese paintings, one so widespread that aficionados of Chinese art rarely bother to remark on it.[33]

In the painting by Dirk Bouts (fig. 29), the browning of the support can be seen in areas where the paint is very damaged and has flaked away – it is particularly visible in the sky. And even in areas where the paint is relatively complete, such as the red and green mantles of the mourners, the underlying brown of the linen gives an overall sombre tone – although it should be added that the picture is also very dirty (and uncleanable).[34]

In order to avoid the problem of the colour of the support taking over the picture, and in order to give a finer, smoother surface on which to paint, artists in ancient Egyptian times learned to cover their sized support with a white layer of chalk or gypsum, mixed with size. When this had hardened it was smoothed and polished, and gave a firm base for the pigments above it. This layer, known in Italian as 'gesso' and in Dutch simply as 'the white' (het wit), was still being used four thousand years later.[35] An example is clearly visible in an unfinished painting by Michelangelo (fig. 31). Here the white

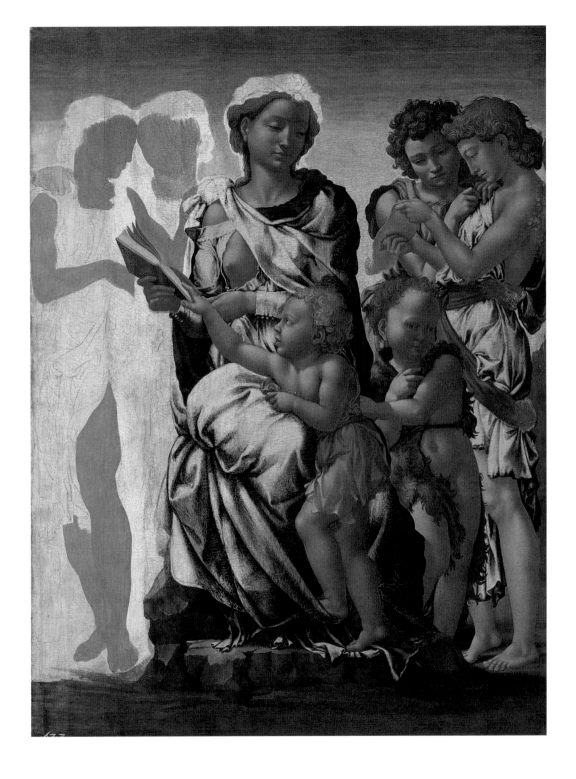

32

Jonathan Janson, *Girl at a window*, reconstruction of the paint build-up used by Johannes Vermeer, 2008, oil on canvas, 55 × 50 cm

areas are the gesso ground, on which underdrawing is seen at left. Areas of flesh have been given an underlayer of green earth. On late medieval Italian paintings the flesh often looks greenish (e.g. fig. 38), and in this painting the Virgin too looks rather sickly; but, as the youths on the right (especially the one with the darker hair) make clear, the green is not meant to be seen, but rather to make itself felt as a faint luminous glow beneath the pinks, whites and browns of the flesh tones.[36] A painting on which the underlying green hue is plainly visible is either unfinished or in poor condition.[37]

These white chalk/gypsum grounds form an excellent protection for a painting, but they have one great failing; they tend to crack when bent. If they are applied to a rigid support such as a panel this does not greatly matter, but when they are attached to a more flexible backing, such as a canvas, it does.[38] With the rise of canvas as the support of choice in European painting, the thick white ground became unsuited to the new times,[39] and painters replaced it with grounds consisting of layers of size, often mixed with whiteners such as gypsum, flour or lead white, followed by a pigmented oil 'primer', sometimes made with the addition of resins.[40] A glue and oil primer is more flexible than gesso, and for the first decades of its life, before it sets completely hard, it can even be rolled up with the canvas.[41] However, when it does finally set, rolling of this kind causes a distinctive kind of cracking in the paint (see p. 103 and fig. 71).

The use of pigmented primers encouraged artists to colour the ground in order to produce subtle effects in the surface layers.[42] As time passes and these upper layers become either thinner through abrasion or more translucent through chemical changes in the oil medium, the tinted primers begin to show through more than originally intended. The results can be seen in, for example, Poussin's *Landscape with a man killed by a snake* (fig. 10), where a red-brown primer is clearly visible at numerous places in the darkened foreground. The excessive darkening of that painting has in fact been blamed on the underlayers becoming visible, but we will present alternative suggestions in Chapter Five.

On top of the ground and primer, a representational layer known as the 'dead-colouring' or 'laying-in', which blocked out the overall tonal arrangement of the painting, was often added.[43] How this worked in practice can be seen if we examine the sequence in fig. 32.[44]

In (A) we see the sized canvas, which receives a ground layer (B) and a primer (C). On to this primer the artist sketches his preparatory drawing (D). The drawing is filled in with brown paint, to provide the dead-colouring (E). The background is then worked

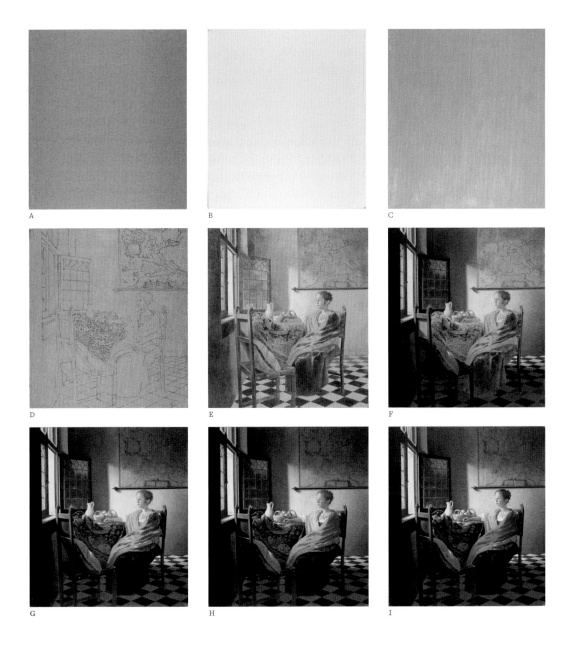

up, and the underlying tones show through to give as many shades of grey as there are browns in the dead-colouring (F). The same dead-colour affects the final layers of red and blue (G, H, I). Note that the blue of the shawl is painted twice; by the end of the whole process there are five layers of paint at the girl's left shoulder. And this is not the last layer, since on top of all of this goes the varnish.

45

Varnish is not a substance, so much as a loosely related family of substances. There are hundreds of different recipes from the Middle Ages onwards for liquids which can be used to varnish a painting. Most of them have this much in common: they are meant to protect the paint layers from dirt, moisture and abrasion, and to give gloss and depth to the colours. Sometimes varnishes have been tinted, in order to give a particular colour to the picture, or to parts of it; and they have also frequently been used as paint media, since they are easy to work, make colours shine with greater brilliancy, and provide a firm layer for further glazes painted on top of them.[45]

There is no one ingredient which turns up in every varnish. Glue has often been used for coating pictures, especially fish glue, isinglass. In old recipe books one sometimes reads of 'water varnishes'; these were mixtures of gum arabic and water – watercolour without the colour, in effect.[46] Another substance frequently used for making varnishes, as we have already noted in passing (p. 32), was egg white.[47]

These aqueous substances were recommended as temporary coatings, to be added shortly after pictures had been painted. The theory was that paintings had to be completely dry before the final resinous varnish was applied, or the varnish would sink into the paints and be impossible to remove. The temporary varnishes were meant to protect the picture and give it a pleasing gloss during the year or years before its final varnishing. But in practice, this final varnishing did not always take place, or at least not for many centuries, and many owners preferred to refresh the 'temporary' varnish rather than add a resinous varnish.[48] According to François-Xavier de Burtin, author of a very informative treatise on art collecting published in 1808, many of the old paintings that he encountered had not been varnished at all, or at least only with glue, gum or egg white. These varnishes were usually discoloured and had proved the wisdom of postponing the final varnish, since they had been added to the surface of the painting before it had fully dried, had partly coalesced with the paint, and were extremely difficult to remove. A final varnish was often painted on top of these temporary varnishes, making cleaning doubly difficult.[49]

De Burtin found all of the temporary varnishes very tiresome, but he disliked even more the old practice (which Rubens apparently endorsed) of covering the surface of a picture with oil.[50] The oils used as binding media were often processed in various ways to make them dry more quickly: they might be left in the sun for a long time, or boiled with certain substances, known as 'siccatives', such as litharge (lead oxide).[51] Once they had undergone modifications of this kind they would make swift-drying paint, but they could also be spread over the picture in their pure state and allowed to set

hard. Unfortunately the oil yellowed and browned with time, and needed eventually to be removed. Which was almost impossible, since any method used to dissolve or abrade the varnish oil must also dissolve or abrade the oil binding the pigments – they were the same substance.[52]

The most widely applied varnishes, since at least the fifteenth century, have been those made with resins, the scented liquids that ooze from certain trees and plants, and then set firm. Because they harden from a liquid state, and because to begin with they are transparent or translucent, they can be brushed out flat and left to form a resilient protective layer over a painting. Some resins are relatively soft – mastic, colophony (from various conifers), sandarac, benzoin and dammar. Others are very hard, especially the fossil and semi-fossil resins, amber and copal.[53] These hard resins are extremely difficult to remove without damaging the painting, and have therefore been less often used as surface coatings;[54] but they have sometimes been used as additions to binding media.[55]

When making a resin varnish, the aim is to get the resin to melt, to stay liquid when cooled and bottled, and to dry hard when brushed out in a thin layer. There are four main ways of achieving this:

1. melt the resin in a solvent;
2. melt it in a solvent and mix it with linseed or walnut oil;
3. melt it in hot linseed or walnut oil;
4. melt it over a fire and mix it with linseed or walnut oil.

The solvent was normally 'oil of turpentine' ('turps', the volatile spirit made by distilling balsams – soft, oily resins – tapped from conifers), but it might also be oil of lavender ('spike-oil'), alcohol, or naphtha, a form of petrol. All but the hard fossil resins melt below simmering point in these liquids. Solvents like these, however, do not turn up in varnish recipes before the end of the fifteenth century, and before that time resins had to be reduced to liquid using large amounts of heat.[56]

To melt resins in linseed or walnut oil is something of a labour. The oils have to be boiled like jam, and, if the resins are of the harder kinds, this can take hours. What is more, because they are subjected to such heat, they are likely to turn dark brown or red. The same is true when they are melted over a fire, which is the only way to reduce amber or the hardest kinds of copal, both of which can take several days to dissolve. Then again, resins treated by methods 3 and 4 are less brittle than resins melted in solvent. As a result, they are less likely to be damaged – but they are also much harder to remove. Every varnish has its own vices and virtues.

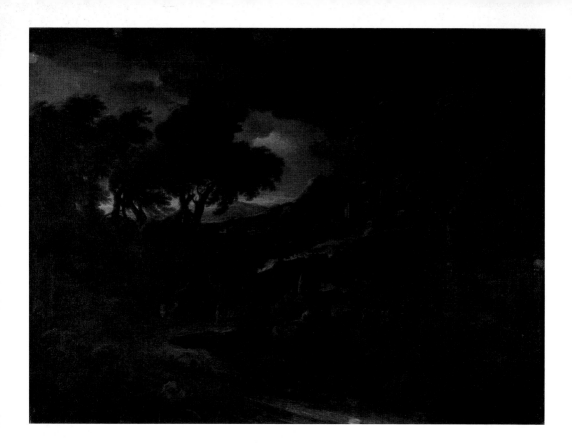

33
Gaspard Dughet, *Landscape with a storm*, c. 1660, oil on canvas, 137.5 × 195.2 cm, National Gallery, London

34
William Turner, *The Fighting Temeraire tugged to her last berth to be broken up* (detail), 1839, oil on canvas, 90.7 × 121.6 cm, National Gallery, London

Some varnishes (methods 2, 3 and 4) contain or are combined with oil; these are known as 'oil varnishes'. Other varnishes (method 1) contain no more than the resin melted in the solvent; these are known as 'spirit varnishes'. Spirit varnishes are much easier to remove from a painting than oil varnishes, and so with time they have become increasingly popular as surface coatings. They seem to have been used as paint media, too, but the results of this have been less fortunate – a point to which we will return in Chapter Six.

Varnishes need to be easily removable, since, like drying oil, they often change colour over time. The landscape by Gaspard Dughet in fig. 33 is covered in a varnish which is well over two hundred years old, and makes the painting almost invisible.[57] However, varnishes do not always darken to this extent. Turner's *Fighting Temeraire* has not had its varnish removed since it entered the National Gallery in 1856 (fig. 34).[58] An even more striking example is a painting by Carlo Crivelli (fig. 35) which is still coated with a pine-resin varnish dating from the fifteenth century. It has yellowed, but not to a disturbing extent; and the varnish has protected some passages of paint so well that they are in a perfect state of preservation (fig. 27).[59]

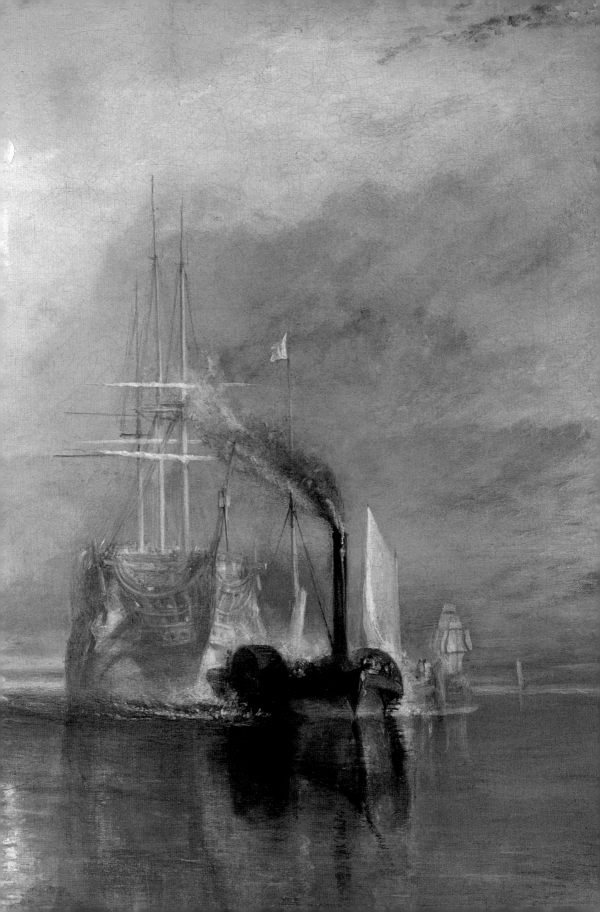

It must be admitted that the Turner and the Crivelli are rather unusual cases, and most varnishes over a century old are normally removed and replaced. A painting by a leading artist from the sixteenth century may have had its varnish changed several times. This repeated cleaning carries risks: there have been many complaints over the centuries that paintings have been seriously abraded during the removal of the varnish layer. We will return to this issue in Chapter Six; but we should note that for these and other reasons there has been a sense, ever since the sixteenth century, that the advantages of varnish might not outweigh the risks. Vasari writes of one Giovan Francesco Caroto that he "held an opinion, in which he was not far from the truth, that varnishing pictures spoiled them, and made them become old sooner than they otherwise would".[60]

Despite these doubts of Caroto, which Vasari seems partly to have shared, varnish continued to be employed as a coating for oil paintings until the Impressionists, in another of their radical breaks with the past, chose not to use it.[61] Unfortunately their preference, and the similar preference of the Post-Impressionists (figs. 111 and 115)[62] and Cubists who followed them, has not always been observed by restorers. Surfaces which were meant to be delicate and matt, like fresco, have often been glossed with varnish.[63]

In order to overcome the yellowing, browning and darkening of traditional resin varnishes, modern conservation science has devoted much effort to developing a synthetic varnish that will remain permanently clear. Whether a clear varnish should be used in the restoration of old paintings, given that artists knew their pictures would yellow and may have compensated for the effect, is a controversial matter, to which we will return in Chapter Six. But synthetic varnishes are in any case still some way from perfection; to date, they have shown an unpleasant tendency to turn grey.[64] The Poussin in fig. 10 provides a sombre example: the synthetic varnish on this painting is only sixty years old, and has already darkened.[65]

ULTRAVIOLET

The original varnish on Crivelli's *Dead Christ* (fig. 35) was first picked up by an ultraviolet lamp (fig. 36). Without the information gained from this now essential instrument, the varnish might not have been recognized for what it was.

Ultraviolet photographs like fig. 36 do not really recapture the rather eerie experience of looking at a painting with the help of an ultraviolet lamp. When aiming one of these devices at a picture, the paint surface fluoresces in different shades of blue, and then certain areas suddenly glow red or yellow instead. At first all this

enigmatic visual data seems meaningless, but with some small practice and instruction much useful knowledge can be gained. In particular, varnishes are revealed very clearly. In fig. 36, all the areas in a spectral light blue are under a varnish. Those in dark blue are areas where the varnish is absent. The dark patches on Christ's body are places where the varnish has been chipped or abraded; but the background is dark blue because no varnish was put there in the first place.

The fact that this varnish only covers the painted parts of the picture, and does not extend over the gold background, is significant. Cennino Cennini recommended that gold backgrounds should not be varnished. It would appear that whoever varnished the painting (not necessarily Crivelli himself) was aware of that workshop tradition. Restorers in later centuries invariably varnished gold backgrounds; that this one is varnish-free suggests a contemporary hand.

Then there is another revealing sign. The areas of damage to the varnish correspond exactly to areas where paint is missing. If varnish covers an area that has been chipped or abraded, then it must be younger than those chips and abrasions; but on this Crivelli, that never happens. We can conclude that the varnish was applied before the painting suffered any damage, hence close to the start of its life.

Of all the technological devices in the conservation department, the ultraviolet lamp is probably the one which is most useful for the student of condition, since it reveals repaint so effectively. Look at the back of Christ's head in fig. 36: the dark blue shows that the original varnish has been removed. There is a large area of damage here, which extends down to the face of the right-hand angel (fig. 35). This was very skilfully restored in the nineteenth century, so that the parts of Christ's hair which are original and the parts which are repainted are not easy to distinguish by eye; but the ultraviolet lamp sees through the deception immediately.[66]

Besides unmasking repaint, the ultraviolet lamp can also show up *secco* retouchings on fresco. It is often thought that ultraviolet will only reveal fairly recent retouchings, but that depends, as in the case of the Crivelli, on how many layers of varnish have been removed beforehand. And in fresco paintings, ultraviolet will often fluoresce very strongly over *secco* additions that seem to have been made soon after the plaster had dried.[67]

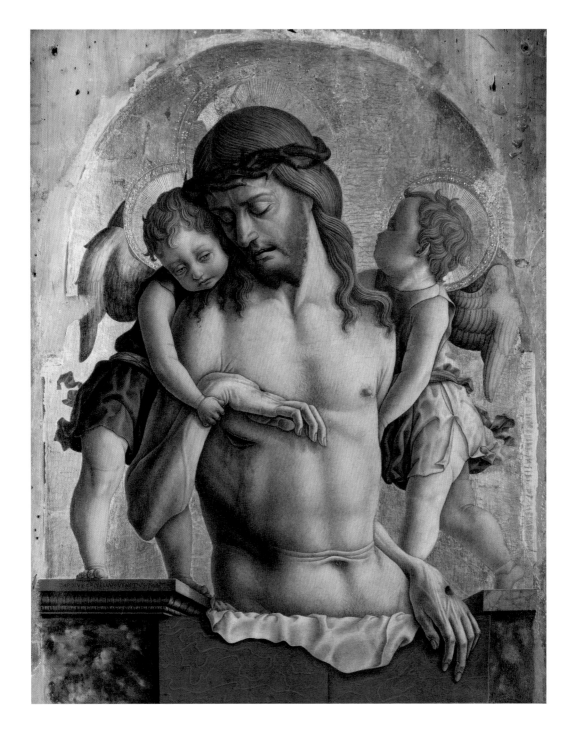

35
Carlo Crivelli, *The Dead Christ*
supported by angels, c. 1470–75,
tempera on poplar,
72.4 × 55.2 cm, National
Gallery, London

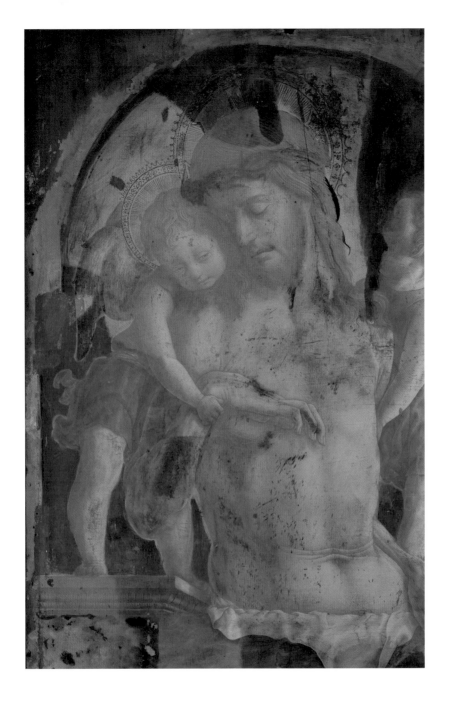

36
Ultraviolet photograph of
detail from Carlo Crivelli,
*The Dead Christ supported by
angels* (fig. 35)

Ultraviolet is hyper-sensitive to surfaces; infrared sees through surfaces to underlayers. Infrared rays do not, however, pass all the way through a painting and out the other side, as X-rays do; rather they register materials which are just beneath the surface. In particular, they are very sensitive to underdrawings.

You can study a painting with an ultraviolet lamp in your hand, but not with an infrared lamp; infrared rays have to be viewed with a special camera. This camera can only take photographs of small areas of a painting, and the photographs are then patched together. In the past, an infrared photograph looked rather like a quilt; but now, with the help of computer image processing, the photographs can be blended together into very appealing images.[68] The underdrawings revealed in infrared reflectograms sometimes seem more attractive than the paintings above them. The reason for that in certain cases, including perhaps the one shown here (figs. 37 and 38), is that the underdrawing was made by the master, while the painting was executed by an assistant.[69]

Different substances used in underdrawings – carbon-black, sepia, iron-gall ink – become visible or invisible at different wavelengths of infrared. In the early days of infrared, photographs were taken within a rather small range of wavelengths. By introducing some variety, traces of underdrawing have been found in the work of artists – such as Caravaggio – who were thought not to have used underdrawing at all.[70]

Photographs of underdrawing tell us a great deal about the stages of design through which a painting has passed, but they do not often shed light on problems of condition. Infrareds and X-rays tell us more about condition when a work is covered with a great deal of overpaint. In fig. 39, an X-ray photograph of fig. 40, we can see that the face of the saint has been prettified. Her nose has been made more elegant, her eyelids have been lowered, her squint straightened and her lips made fuller.[71]

Extracting information like this from an X-ray is not straightforward, and will normally go hand in hand with a close

37
Infrared reflectogram of Duccio, *The Annunciation* (fig. 38)

38
Duccio, *The Annunciation* (detail), 1311, egg tempera on poplar, 43 × 44 cm, National Gallery, London

39
X-radiograph of Workshop of
the Master of the Magdalene
Legend, *St Mary Magdalene*
(fig. 40)

surface inspection. It is easy to suppose that in an X-ray the
painting's underlayers are revealed. That is not the case; on their
way through objects, X-rays pick up a miscellany of information.

X-rays are absorbed by lead white, lead tin yellow and vermilion,
and so these pigments show up white on X-radiographs. In fig. 40
the saint's sleeves and headdress, which despite appearances are
pale blue (they are concealed by a thick and very discoloured
varnish),[72] presumably contain lead white, since they show up
lighter on the X-ray.

X-rays are also very sensitive to the relative thickness of layers.
The white blobs by the mouth and on the forehead in fig. 39 are
retouchings, which may have come out white because they are
thicker, or possibly because they contain some lead white.

As can be seen from this brief comparison, X-radiographs are by
no means unambiguous, and have to be interpreted together with
information of other kinds. They can sometimes alert us to the
possibility that a painting is a fake – for example, if the paint surface

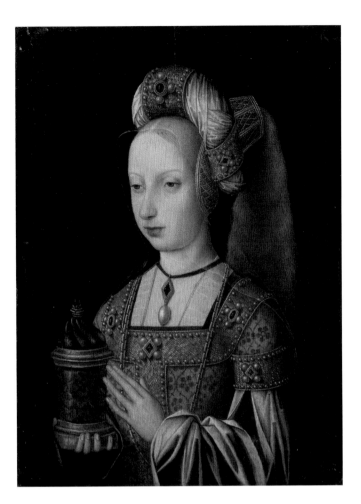

40

Workshop of the Master of
the Magdalene Legend,
St Mary Magdalene, c. 1510,
oil on oak, 37.5 × 27 cm,
National Gallery, London

is thinner or thicker than is usual for the artist. And they can be
particularly useful when examining supports.

If a panel has had holes filled, either nail holes (visible in fig. 39)
or worm holes, then these infills will show up in an X-ray. They can
suggest, as here, the existence of overpaint, and sometimes they
can suggest more than that. Artists in the past normally worked on
fresh panels, which were not worm-eaten; if many plugged worm-
holes are revealed in an X-ray, that may suggest either that a forger
is reusing an old panel to give a plausibly aged effect, or that the
paint has been transferred from another panel (more on transfer
in Chapter Three).[73]

When applied to paintings on canvas, X-rays can reveal the
number, thickness and curvature of the threads of the original
linen. I write 'original', because most old paintings on canvas
have one or two lining canvasses glued to the back (again, more
in Chapter Three), which means that the original canvas is
sandwiched between the lining canvas(ses) and the paint surface

and is therefore often invisible to the naked eye. Knowledge of the thread count and the width of the threads can be revealing, since it sometimes allows us to establish that painting x was made on a canvas from the same bolt of cloth as painting y, and if painting y is by (say) Rembrandt, that may be welcome news.[74] And knowledge of the curvature of the threads is important when we are on the lookout for 'cusping' – a concept we will discuss in Chapter Two.[75]

One of the simplest technical methods of examining a picture is with a magnifying glass, and a high-resolution digital photograph is the modern and more effective equivalent. In fig. 41 we see a detail of Mary Magdalene's sleeve (fig. 40), and it is immediately apparent that the crackle pattern in the paint stops a few centimetres short of the edge of the painting. This confirms what was suggested by the X-ray (fig. 39)– that the border of the picture in fig. 40 was painted by a later hand. We will have more to say about crackle patterns (craquelure) in Chapter Three; but this one example should make it clear that the high-resolution photographs which are now freely viewable at a number of sites on the web are very powerful tools for anyone interested in condition.[76] High-resolution photographs are also extremely useful in identifying abrasion on a painting's surface, a subject to which we will return in Chapter Six. And 'photomacrographs', as they are called, take us to an even higher degree of magnification, revealing the handling of paint in almost intrusive detail; fig. 42 shows 'an ultramarine glaze blotted with a fabric pad'.[77]

Another form of magnification, microscopy, is used to help identify pigments, either on the surface of a painting or as part of a cross-section sample. In the latter method a tiny sliver of paint is taken – usually with a hypodermic syringe – from the painting, and can reveal both the strata and contents of the paint layers.[78] Art historians sometimes complain about having unintelligible slices of paint (fig. 43) inflicted on them in lectures, but for the student of condition they provide essential information. If one comes across a passage of a painting which looks as if it might be discoloured – for example the unusual pale orange mantle worn by the saint in Sebastiano del Piombo's *Raising of Lazarus* (figs. 44 and 82) – one cannot know what the original colour was meant to be without establishing which pigments the artist used. Perhaps Sebastiano meant the cloak to be this colour. As it happens he didn't; the paint sample in fig. 43, which is taken from the area in question, shows us that the cloak was painted in red lead. This has now whitened, but originally it would have given this part of the

41
Detail from Workshop of
the Master of the Magdalene
Legend, *St Mary Magdalene*
(fig. 40)

42
Photomacrograph of detail
from Garofalo, *The Vision of
St Augustine*, c. 1518–25, oil on
poplar, 65 × 81.8 cm, National
Gallery, London

43
Cross-section of light
orange paint from detail in
Sebastiano del Piombo, *The
Raising of Lazarus*

44
Detail from Sebastiano
del Piombo, *The Raising of
Lazarus* (fig. 44), c. 1517–19,
oil on canvas, transferred
from panel, 381 × 289.6 cm,
National Gallery, London

painting a bright orange hue.[79] Cross-section analysis can answer many questions of this kind, and ideally we would be able to use the technique for every detail of every painting; but then our paintings would be disfigured by numerous syringe holes. Cross-section samples are taken either from edges concealed by the frame or from areas of damaged paint, and the number that are taken from any picture is strictly limited and not necessarily representative. Our most revealing technique of investigation is therefore less useful than we would like. We can only hope that with recent advances in scanning technology we will soon be able to answer questions about paint layers with a method that does not involve picking pictures to pieces.[80]

An experienced researcher who has seen many cross-section samples, and who is familiar with the rather small number of pigments generally used in traditional painting, will be able to identify most of those pigments with nothing more than an optical microscope. Identifying the media within which the pigments are bound, however, is impossible with the naked eye; and there are as well a few cases where natural and synthetic varieties of a pigment are visually indistinguishable. When the eye is no longer able to answer our questions, other methods have to be brought into play. There are a number of chemical and physical techniques which are used by conservation scientists. Commonly used methods at present include gas chromatography, mass spectrometry, Raman spectrometry, Fourier transform infrared spectrometry, scanning electron microscopy, X-ray fluorescence, energy dispersive X-ray spectroscopy and infrared microscopy. Conservation scientists like to use acronyms for these techniques, and so one will often see GC, MS, FTIR, SEM, XRF or EDX in the literature; some of the techniques are used in tandem, and so are referred to by double-barrelled acronyms, like GC-MS or SEM-EDX.

Anyone interested in finding out more about these and other techniques will find further reading in the notes;[81] but for present purposes all we really need to know is that they are all ways of identifying pigments and media. Conservation scientists can therefore reconstruct most of the original constituents of the paints used, even when the visual appearance of those paints may have changed quite dramatically. For questions of condition, this is very important. An area of drapery in a painting may look blue, and a cross-section analysis may show no trace of any other pigment; but 'SEM-EDX' may reveal the presence of aluminium or calcium compounds in the sample, which would suggest the former

presence of a red or yellow lake pigment. The drapery, then, was once purple, or green.[82]

It should be noted, however, that, despite the great advances in conservation science in recent decades, some elements of the original paint are still hard to identify. It is very difficult at present to prove through scientific means that asphalt, or bitumen, was used in a painting,[83] even though we know from written sources that it was a popular pigment, especially in the early nineteenth century.[84] Solvents continue to resist analysis, since they evaporated centuries ago. And although 'GC-MS' has been a very successful tool for tracing resins in binding media, there are occasions when it will fail to identify a resin. It has been suggested that when amber, the hardest of the resins, is subjected to the great deal of heat it needs to reach its melting point, its characteristic chemical structure can be so altered that it may prove impossible to identify.[85] Certainly to date very little amber has been identified in varnishes,[86] and yet there are many recipes for amber varnish in early modern texts.[87]

We need to be aware of these limitations, because art historians tend to suppose that, if a scientific technique has failed to find an ingredient in a painting, then it cannot be present in the painting. For example, analyses of media hardly ever find traces of resin in Rembrandt's binders, and it has been argued on the basis of this that he preferred a simple vehicle of pure oil.[88] However, given that amber varnish was sometimes added a drop at a time and can be very hard to identify, it may be premature to assert that he never added any to his medium.[89] And it has been claimed in recent years that, although Reynolds has long been thought to have made liberal use of bitumen in his paintings, he cannot have done so,[90] since scientific methods have not discovered it.[91] And yet from the latest research on this elusive substance it would seem that it is difficult to trace by the methods currently available to science.[92]

1 Dyrenforth, *Batik*.

2 Fundamental works on dyes and paints are Hofenk de Graaff, *The Colourful Past*; Feller (vol. 1), Roy (vol. 2), FitzHugh (vol. 3), Berrie (vol. 4), (eds.), *Artists' Pigments*.

3 In the technical literature dyes are called soluble coloured substances rather than soluble pigments, since pigments are defined as insoluble: Wicks et al., *Organic Coatings*, 417. Some pigments, the lakes, are made by fusing soluble dyes with insoluble chemicals: the resulting pigment is insoluble.

4 Van Beek and Heertjes, 'Fading of Organic Dyes'; Crews, 'Fading Rates'; Mills and White, *Organic Chemistry*, 155–56.

5 Campbell, *Fifteenth Century Netherlandish Paintings*, 77.

6 Doerner, *Materials of the Artist*, 96-314; Thompson, *Materials of Medieval Painting*, 42-73; Gettens and Stout, *Painting Materials*, 3-81; Mayer, *Artist's Handbook*, 167-400; Mills and White, 'Paint Media'; White and Pilc, 'Analyses of Paint Media'; Mills and White, 'Mediums used by Stubbs'; White, 'Van Dyck's Paint Medium'; Carlyle, *Artist's Assistant*, 101-33; Fuga, *Artists' Techniques and Materials*, 92-135. For other binding materials, such as enamel, encaustic, acrylic and casein, Ward (ed.), *Grove Encyclopedia*, provides clear introductory articles. For the uses of wax in mixed media and encaustic see Carlyle, *Artist's Assistant*, 111-18.

7 Baldinucci, *Vocabolario*, 162: "*Tempera f. Termine della Professione de'Pittori, e vale, ogni liquore, o sia colla, o chiara d'uovo, con che si liquefanno i colori. Donde ne viene, la denominazione, di pittura a tempera, del dipignere a tempera.*" See too Vasari, *Vite*, I, 51; Vasari, *On Technique*, 223-25.

8 Cennini, *Libro dell'Arte*, chapter 60: "*Soffera tempera di rossume d'uovo, e di colla, e di ciò che vuoi*"; chapter 67: " *... il lavorare in fresco, cioè di quel dì, è la più forte tempera e migliore, e 'l più dilettevole lavorare che si faccia*"; chapter 91: "*Come tu dèi fare l'olio buono per tempera*"; chapter 134: "*quella tempera di quella chiara dell'uovo*". However, Cennini does not always seem sure that fresco should be called *a tempera*; in chapter 58 he writes: "*È buono da lavorare in fresco, cioè in muro, senza tempera*".

9 Thompson, *Materials of Medieval Painting*, 50-52.

10 Thompson, *Practice of Tempera Painting*; Bomford, Dunkerton, Gordon and Roy, *Art in the Making: Italian Painting before 1400*, 28-29; Ward (ed.), *Grove Encyclopedia*, 668-71.

11 Thompson, *Materials of Medieval Painting*, 63; see too Thompson, *Practice of Tempera Painting*, 120.

12 Laurie, *Painter's Methods and Materials*. The good condition of work by fifteenth-century artists was often noted by those who wanted to reform the poor technical practices of nineteenth-century painting. See Mérimée, *Peinture à l'huile*, ix; Eastlake, *Methods and Materials*, v-vi; Keim, *Ueber Mal-Technik*, 13-14.

13 Billinge et al., 'Northern European Painting', 40-43, 53-54.

14 Thompson, *Practice of Tempera Painting*, 4.

15 This point is discussed further below, in Chapter Six, note 13 (p. 228).

16 Thompson, *Practice of Tempera Painting*, 99-100; cf. Vasari, *On Technique*, 293, where the editor, G. Baldwin Brown, observes that tempera impasto is possible if no water is mixed with the yolk. Thompson's directions are based on practical experience rather than theory: "It is very important that the color should be thin enough for the brush to move perfectly freely over the gesso Thick color dries slowly, and if it is touched again with the brush while it is still wet, makes unsightly spots, uneven in color and surface".

17 Thompson, *Practice of Tempera Painting*, 4-5.

18 On oil painting in general see Cennini, *Craftsman's Handbook*, 57-59; Vasari, *Vite*, I, 51-52; Vasari, *On Technique*, 227-30; Doerner, *Materials of the Artist*, 96-114; Laurie, *Painter's Methods and Materials*, 128-63; Mayer, *Artist's Handbook*, 167-256; Ward (ed.), *Grove Encyclopedia*, 421-25; Bol, *Oil and the Translucent*.

19 Vasari, *Vite*, I, 50; Vasari, *On Technique*, 221-22: "But beware of having to retouch it with colours that contain size prepared from parchment, or the yolk of egg, or gum

or tragacanth, as many painters do, for besides preventing the wall from showing up the work in all clearness, the colours become clouded by that retouching and in a short time turn black. Therefore let those who desire to work on the wall work boldly in fresco and not retouch in the dry, because, besides being a very poor thing in itself, it renders the life of the pictures short." From the state of preservation of the *secco* in fig. 135 it is clear that Vasari overstated his case here. And Vasari himself made use of tempera when painting the walls of his own house: Vasari, *Vite*, II, 998; Secco-Suardo, *Restauratore*, 480. Other 16th-century painters recommended the use of *secco*; see Armenini, *Veri precetti*, 130-34, and cf. the quotation from Karel van Mander, note 21 below.

20 Cennini, *Craftsman's Handbook*, 42-57; Vasari, *Vite*, I, 50; Vasari, *On Technique*, 221-22; Armenini, *Veri precetti*, 105. There is still disagreement among authors about which pigments suit fresco and which do not: Ward (ed.), *Grove Encyclopedia*, 224, writes that malachite is 'not suitable for fresco', while Gettens and FitzHugh, 'Malachite', 184, say that malachite "is quite suitable for the technique of pure fresco". On the 'lakes', see pp. 134 and 139.

21 Karel van Mander, who spent four years in Italy in the 1570s and painted some frescoes while he was there, wrote in his life of Federico Zuccaro that "Federico enlivened and gave the final touches to this same work with egg tempera not many years since, as is the manner in Italy, painting things wet, and after they dry glazing with lake the reds made from what they call *terra rossa*, the green earth with azure green, and so forth"; Van Mander, *Schilder-boeck*, 186r.

22 Armenini, *Veri precetti*, 130.

23 Conti, *History of Restoration*, 283. On the vulnerability of blue *secco* additions to fresco, see Secco-Suardo, *Restauratore*, 480.

24 On fresco in general, see Armenini, *Veri precetti*, 105-21, 130-34; Mérimée, *Peinture à l'huile*, 299-305; Merrifield, *Fresco Painting*; Doerner, *Materials of the Artist*, 264-314; Laurie, *Painter's*

Methods and Materials, 191-9; Mayer, *Artist's Handbook*, 360-400.

25 Armenini, *Veri precetti*, 119-21; van Eikema Hommes and Froment, 'Een doek van geene beteekenis'; Ward (ed.), *Grove Encyclopedia*, 604-5.

26 Wolfthal, *Beginnings of Netherlandish Canvas Painting*. One Italian painter who often worked in glue was Andrea Mantegna: Rothe, 'Mantegna's Paintings in Distemper'; Higgitt and White, 'Paint Media', 92-93. On the darkening of his *Triumph of Caesar* cycle at Hampton Court, which was long thought to be painted in tempera but is now thought to be in size, and which was given a wax impregnation in the early 1930s, see Percival-Prescott, 'Lining Cycle', 11. I thank Nicola Christie for information on the cycle's history.

27 Winter, *East Asian Paintings*, 49-50, 81-85.

28 Norgate, *Miniatura*; Mayer, *Artist's Handbook*, 327-43.

29 Thompson, *Materials of Medieval Painting*, 57-58. It should, however, be said that it is common to refer to water as a medium; even the chemist George Field spoke in these terms: Field, *Chromatography*, 200.

30 Vasari, *Vite*, I, 54: "*Del dipignere nelle mura di chiaro e scuro di varie terrette, e come si contrafanno le cose di bronzo; e delle storie di terretta per archi o per feste a colla, che è chiamato a guazzo, et a tempera*"; Vasari, *On Technique*, 240. On the etymology of '*guazzo*', see the online *Dizionario etimologico*, http://www.etimo.it/. '*Guazzare*' is now obsolete; the modern Italian word is '*sguazzare*'. Vasari also used the word '*acquerello*', referring to an ink wash. Baldinucci, *Vocabolario*, 3: "*Acquerello. Una sorta di colore che serve per colorir disegni; e si fa mettendo due gocciole d'inchiostro in tant'acqua quanta starebbe in un guscio di noce, e più a proporzione. Fannosi anche altri acquerelli neri e coloriti, nel modo detto.*"

31 See his paraphrase of Vaernewyck in Chapter Six, note 8 (p. 227). Van Mander also thought of 'water-verwe' as a style of painting, loosely applied 'without a maul-stick', as he put it: *Schilder-boeck*, 256v.

32 Pilkington, *Dictionary*, xvii: "DISTEMPER, is a preparation of colours, without oil, only mixed

with size, whites of eggs, or any such proper, glutinous, or unctuous substance; with which kind of colour, all the antient pictures, before the year 1410, were painted, as also are the celebrated cartons of Raphael". See too OED, s.v. 'distemper n. 2': "A method of painting, in which the colours are mixed with some glutinous substance soluble in water, as yolk of egg mixed with water, etc., executed usually upon a ground of chalk or plaster mixed with gum". As the entries in the OED show, the word has often also been used to refer to size painting, and still is: Digney-Peer et al., 'Imitative retouching', 621.

33 I thank Joan Stanley-Baker for bringing this painting to my attention and discussing it with me.

34 Bomford, Roy and Smith, 'Techniques of Dieric Bouts'; Campbell, *Fifteenth Century Netherlandish Paintings*, 38-45.

35 Cennini, *Craftsman's Handbook*, 69-74; van Mander, *Schilder-boeck*, 47v; Thompson, *Materials of Medieval Painting*, 30-37; Bomford, Dunkerton, Gordon and Roy, *Art in the Making: Italian Painting before 1400*, 17-19. In Italy gypsum was the main ingredient of grounds, while north of the Alps chalk was used: van de Graaf, 'Old Painting Recipes', 271-72; Stols-Witlox, 'Grounds', 162-63.

36 Thompson, *Practice of Tempera Painting*, 113-4.

37 Ruhemann, *Cleaning of Paintings*, 53, suggests as causes for this phenomenon of greening flesh in early Italian painting "wearing or increased transparency of the flesh paint on top". See pp. 184-90 below for a discussion of increased transparency; it should be noted that tempera paints do not become transparent in the same way that oil paints sometimes can, since the refractive index of egg is too low.

38 Mayer, *Artist's Handbook*, 295-96; Van Hout, 'Ground Layer', 212-13.

39 However, thick white layers continued to be used by some artists well into the seventeenth century: Van Hout, 'Ground Layer', 212.

40 Armenini, *Veri precetti*, 124-25; Doerner, *Materials of the Artist*, 8-9; Mayer, *Artist's Handbook*, 290-93; Stols-Witlox, 'Grounds',

164-66. Instead of 'primer', English art historical texts often use the Italian '*imprimatura*'. This is the sixteenth-century spelling; since the seventeenth century it has been spelled '*imprimitura*' in Italian. The terminology surrounding grounds and primers is very vague: for a discussion of the difficulties, see Van Hout, 'Ground Layer'.

41 Vasari, *Vite*, I, 53; Vasari, *On Technique*, 236-37.

42 Van Hout, 'Ground Layer', 216-17; Kirsh and Levenson, *Seeing Through Paintings*, 74-78.

43 Lairesse, *Groot Schilderboek*, I, 12-13, 277, 329-30; de Piles, *Cours de peinture*, 229-30; Watelet and Lévesque (eds.), *Encyclopédie Méthodique* I, 206-07; Merrifield, *Original Treatises*, ccxciii-ccxcvii.

44 The images in fig. 32 are kindly provided by the artist and Vermeer scholar Jonathan Janson, for whose research see www.essentialvermeer.com, and Janson, *Your Own Vermeer*; for his own paintings, see www.jonathanjanson.com.

45 Two clear short introductions to the varieties of varnish are Stout, *Care of Paintings*, 10-11 and 14-16, and Gettens and Stout, *Painting Materials*, esp. 51-59 and 72-73. On the history of varnish, see Tingry, *Traité ... vernis*; Field, *Chromatography*, 208-11; Merrifield, *Original Treatises*, cclxi-cclxxxi, 114, 162-63, 606, 628-37, 670-75, 688-91, 694-99, 742-43, 763-64, 838-41; Eastlake, *Methods and Materials*, I, 219-319; Lehmann, 'Öl-, Harzöl- und Harzfirnisse'; White and Kirby, 'A Survey of Nineteenth- and Early Twentieth-century Varnish'; Carlyle, *Artist's Assistant*, 57-93; Bol, *Oil and the Translucent*; Phenix and Townsend, 'Historical varnishes'. On the nature of varnish, see Church, *Chemistry of Paints*, 55-68, 90-107, 112-22; Doerner, *Materials of the Artist*, 114-42; Laurie, *Pigments and Mediums*, 144-51; Laurie, *Painter's Methods and Materials*, 164-76; Mills and White, 'Natural Resins'; White, 'Brown and Black Glazes'; de la Rie, 'Influence of Varnishes'; Mills and White, *Organic Chemistry*, 95-128, 179-89; Mayer, 'Traditional Varnishes'; Ward (ed.), *Grove Encyclopedia*, 729-32.

46 De Mayerne, *Pictoria Sculptoria*, 15r; Sanderson, *Graphice*, 86; Anon.,

Excellency of the Pen and Pencil, 106; de Burtin, *Traité*, I, 401-02; Carlyle, *Artist's Assistant*, 236-37.

47 De Mayerne, *Pictoria Sculptoria*, 15r; de Piles, *Élémens*, 167-68; Anon., *Excellency of the pen and pencil*, 106; Hundertpfund, *Painting Restored*, 111; R. and P. Woudhuysen-Keller, 'Eggwhite varnishes'; Carlyle, *Artist's Assistant*, 233-36; Massing, *Picture Restoration*, 216.

48 De Mayerne, *Pictoria Sculptoria*, 15r; Anon., *Excellency of the pen and pencil*, 106; Dossie, *Handmaid*, I, 222; de Burtin, *Traité*, I, 401-02, 406; Mérimée, *Peinture à l'huile*, 265; Bedotti, *Restauration*, 40; Kurz, 'Time the Painter', 96.

49 De Burtin, *Traité*, I, 401-02; see too Déon, *Conservation*, 87; Bedotti, *Restauration*, 40; Secco-Suardo, *Restauratore*, 400-01.

50 De Mayerne, *Pictoria Sculptoria*, 7v, with the claim that Rubens endorsed the practice; Eastlake, *Materials and Methods*, I, 520-27.

51 Carlyle, *Artist's Assistant*, 41-54.

52 De Burtin, *Traité*, I, 395-99.

53 On the difference between amber and copal, see Leonard et al., 'Amber varnish', 9-10.

54 De Burtin, *Traité*, I, 399; though copal varnishes became more popular after de Burtin published his treatise. Mérimée, *Peinture à l'huile*, 101; Phenix and Townsend, 'Historical varnishes', 258-59.

55 Eastlake, *Methods and Materials*, I, 303; Secco-Suardo, *Restauratore*, 293-37; Carlyle, *Artist's Assistant*, 244-45. See too the discussion on p. 62 below.

56 Laurie, *Pigments and Mediums*, 158. The first recipes for spirit varnishes known to me are in Borghini, *Riposo*, 175-76. There are also a number of recipes in Anon., *Ricette*, 670-75. The date of this latter text ('The Paduan Manuscript') is still unsettled; Lehmann, 'Öl-, Harzöl- und Harzfirnisse', 70, suggests it is before 1580; Merrifield, *Original Treatises*, 643, acknowledges the argument for the earlier date, but believes that it was composed "during the middle, or latter part, of the seventeenth century". As Eastlake, *Materials*, I, 475, observes, Karel van Mander describes Joos van Cleve in a fit of madness painting his clothes

with "*Terbentijn vernis*", turpentine varnish, which may suggest that spirit varnishes were known before 1600 in the Netherlands.

57 Wine, *French Paintings*, 147; for its state when it entered the National Gallery in the 1820s, see Crookham, 'Turner Bequest', 59, fig. 41.

58 Egerton, *British Paintings*, 306.

59 Dunkerton and White, 'Discovery … Crivelli'.

60 Vasari, *Vite*, II, 254: "*Costui era d'openione, né in ciò si discostava dal vero, che il vernicare le tavole le guastasse e le facesse più tosto che non farieno divenir vecchie; e perciò adoperava lavorando la vernice negli scuri e certi olii purgati*". See too Vasari, *Vite*, I, 53; Vasari, *On Technique*, 232.

61 Their opinion was not uniform, however; Renoir preferred to use varnish at different stages of his career: see Phenix and Townsend, 'Historical varnishes', 257-60.

62 Van Gogh appears to have returned to the use of varnish in the last months of his life, while Gauguin preferred to wax his paintings: Phenix and Townsend, 'Historical varnishes', 260; on wax varnishes, see Carlyle, *Artist's Assistant*, 247.

63 Richardson, 'Crimes against Cubists'; Keck et al., '"Crimes against Cubists": Exchange'; von der Goltz, Proctor et al., 'Varnishing', 654-56.

64 Nicolaus, *Restoration*, 312-13, 318-20; Rothe, 'Croce e Delizia', 17; Roy, 'Comments'.

65 Mark Leonard, quoted by Clark, *Sight of Death*, 186.

66 Dunkerton and White, 'Discovery … Crivelli'.

67 Stout, *Care of Pictures*, 112-13; Marijnissen, *Dégradation*, I, 271-74; Taft and Mayer, *Science of Paintings*, 75; Cardinali et al., *Diagnostica artistica*, 112-19; MacBeth, 'Technical examination', 300-04.

68 MacBeth, 'Technical examination', 296.

69 On infrared in general, see Marijnissen, *Dégradation*, I, 267-70; Burmester and Bayerer, 'Towards Improved Infrared'; Saunders and Cupitt, 'Elucidating reflectograms'; Taft and Mayer, *Science of Paintings*, 125-27; Cardinali et al., *Diagnostica artistica*, 120-35; MacBeth, 'Technical examination', 296-300.

70 Bellucci et al., 'Caravaggio's Underdrawing'.

71 Campbell, *Fifteenth Century Netherlandish Paintings*, 335.

72 Campbell, *Fifteenth Century Netherlandish Paintings*, 336.

73 Roy and Mancini, 'Virgin and Child ... History of Error'.

74 However, it could have been used by one of his pupils, or by the next person to visit his canvas dealer.

75 On X-rays and their uses, see Ruhemann, *Cleaning of Paintings*, 127-30; Cardinali et al., *Diagnostica artistica*, 136-51; Padfield et al., 'Improvements ... X-rays'; MacBeth, 'Technical examination', 300-04; Marijnissen, *Masters' and Forgers' Secrets*.

76 See in particular the Google Art Project; the Collection Viewer at the National Gallery, London; the Rijksmuseum, Amsterdam; and the Metropolitan Museum, New York.

77 Dunkerton et al., 'Technique of Garofalo', 32, pl. 14.

78 Plesters, 'Preparation ... Paint Cross-Sections'; Cardinali et al., *Diagnostica artistica*, 96-111, 162-67; Wolbers et al., 'Cross-section microscopy'.

79 Dunkerton and Howard, 'Sebastiano', 42.

80 One promising development is tomography: Liang et al., 'Optical Coherence Tomography', Targowski et al., 'Optical coherence tomography', and Pinna et al. (eds.), *Scientific Examination*, 147-49.

81 Pinna et al. (eds.), *Scientific Examination*; Mills and White, *Organic Chemistry*, 14-30, 169-95; Ward (ed.), *Grove Encyclopedia*, 650-68; Townsend and Boon, 'Research and Instrumental Analysis'.

82 Van Eikema Hommes, *Changing Pictures*, 82, n. 25.

83 Bothe, 'Asphalt', 137-38. It is very difficult but not impossible: see White and Kirby, 'Rembrandt and his Circle', 71, for asphalt in a painting by Ferdinand Bol.

84 Borghini, *Riposo*, 207; Bosse, *Le peintre converty*, 47; Baldinucci, *Vocabolario*, 106; Lairesse, *Groot Schilderboek*, I, 14, 314; Watin, *Art du peintre*, 217; Tingry, *Traité ... vernis*, 1-3; Vergnaud, *Manuel du peintre*, 41; Bouvier, *Manuel*, 57-59; Mérimée, *Peinture à l'huile*, 200-03; Paillot de Montabert, *Traité*, IX, 365-68; Ruskin,
Elements of Drawing, 142; Harley, *Artists' Pigments*, 150-52; Carlyle, *Artist's Assistant*, 403-07, 479-83; Bothe, 'Asphalt', 142-43.

85 Mills and White, *Organic Chemistry*, 112.

86 Leonard et al., 'Amber varnish', identify amber varnish in a painting by Orazio Gentileschi; White and Kirby, 'Rembrandt and his Circle', 73-74, argue that amber is detectable in the medium of a shaded area in a painting by Ferdinand Bol.

87 De Mayerne, *Pictoria Sculptoria*, 43r, 44r-44v, 48v-49r, 52r-52r, 72v-73r, 150v-51r, 161r-v; Berger, *Maltechnik*, 13, 65; Merrifield, *Original Treatises*, cclxvii-lxxii, 628-29, 644-45, 688-89, 698-99, 723-24, 742-43. Eastlake, *Materials of Painting*, I, 230-35, argued that 'amber' was sometimes confused with other substances, such as sandarac and juniper resin. It is also possible that amber was sometimes confused or adulterated with the harder kinds of copal: Mérimée, *Peinture à l'huile*, 48-49; Gettens and Stout, *Painting Materials*, 4. It has also been observed that the precise distinction between amber and copal was probably not made in past centuries: Leonard et al., 'Amber varnish', 9-10. On the advantages claimed for amber varnish as an ingredient of the painting medium see Secco-Suardo, *Restauratore*, 293-97; Merrifield, *Original Treatises*, cclxxii-lxxiv; White and Kirby, 'Rembrandt and his Circle', 71-74; Leonard et al., 'Amber varnish', 10.

88 Van de Wetering, *Painter at Work*, 224-43; White and Higgitt, 'Rembrandt', 50; Hermens and Townsend, 'Binding Media', 210-211.

89 White and Kirby, 'Rembrandt and his Circle', 74, state with due caution that in Rembrandt's paintings "there is no evidence so far to suggest the addition of substantial quantities of resin to the oil medium".

90 Redgrave and Redgrave, *English School*, 53, 450-451.

91 Morrison, 'Mastic and Megilp'; Hermens and Townsend, 'Binding Media', 212.

92 Bothe, 'Asphalt', 137-43.

2.

LOSSES

TOTAL LOSS A recent study of the survival rate of seventeenth- and eighteenth-
century Dutch paintings concluded that, by the end of the twentieth
century, over 99% of those paintings had been destroyed.[1] This
statistic, like any statistic, can of course be questioned; but it is
hard to argue that fewer than 95% of Dutch paintings of the period
have been destroyed.

The eighteenth century is not long ago, and works of art from
earlier times have suffered much more. Artists in the Renaissance
were trained to revere the names of the great Greek painters of
antiquity, Protogenes, Zeuxis and Apelles; one of the most common
clichés of poetry praising artists was to say that Artist X was the
new Apelles, or Zeuxis or Protogenes.[2] And yet no work by any
of these artists has survived; in fact no more than a few faded
remnants and possible mosaic copies have come down to us from
the whole period of painting of which Apelles and his colleagues
were the chief figures.[3]

How have so many pictures come to be destroyed? When
paintings have spectacular, violent ends we sometimes hear about
their fate. Thousands of works which were burnt or blown up
during World War Two have been carefully documented. Over four
hundred paintings from the Gemäldegalerie in Berlin – including
works by Bellini, Botticelli, Caravaggio, Cranach, Van Dyck,
Ghirlandaio, Goya, Hals, Murillo, Rubens, Tiepolo, Tintoretto,
Titian, Veronese and Zurbarán – were destroyed in one place, the
flak tower at Friedrichshain on the outskirts of Berlin, in a fire
which broke out soon after the end of hostilities in 1945.[4] This was
certainly not the first time that fire had destroyed large numbers of
paintings in one place at one time. Other celebrated art fires of the

past swept through the Doge's Palace in Venice in 1577, Whitehall Palace in London in 1698, the Jesuit Church at Antwerp in 1718, the Coudenberg Palace in Brussels in 1731, the Alcazar Palace in Madrid in 1734, the Boijmans Museum in Rotterdam in 1864, the church of Santi Giovanni e Paolo in Venice in 1867, and the Hôtel de Ville in Paris in 1871. And there is no reason to think that fires like this will stop breaking out in future; only a few years ago, in 2004, around 100 contemporary works were destroyed in a fire at the Momart warehouse in London.[5]

Canvas and wood are very flammable, bronze and marble less so; but thousands of works made of these harder materials have also been consumed by fire. Most of our knowledge of ancient Greek sculpture comes from marble copies of lost bronze originals. It is not easy to 'lose' bronze statues; if left in the open air, or underground or underwater, they will continue to exist for millennia, with no more damage than a surface crust of turquoise patina. The reason for the almost complete destruction of ancient bronze statues is that they have been melted down for their metal.[6]

Marble sculpture too can be melted down. When put into a furnace, marble is reduced to lime, an important ingredient for the construction industry. It has been suggested that medieval viewers may have seen more ancient statues around them than their Renaissance descendants, in part because so many met their end in the lime furnaces.[7] Ancient statues were still being turned into lime during the early sixteenth century, as a letter of complaint from Raphael to Pope Leo X attests.[8] In fact it is possible that some of Raphael's own frescoes were painted on lime which had been made from ancient marbles.

Flammability has also spelled the destruction of countless wooden sculptures, even though no commercially valuable product is produced by burning them. During the Reformation there were instances of Catholic statues being burned by iconoclastic Protestants, but these activities were dwarfed by the fiery eradication of non-European sculpture by Christians trying to root out paganism. Very few Mesoamerican and Peruvian cult figures have come down to us, and much African and Oceanic sculpture seems to have met the same end.[9]

Humans can destroy works of art for commercial and ideological motives, but many other works meet their end for aesthetic reasons. When tastes change, art in the old manner is often discarded. Pope Julius II ordered frescoes by Piero della Francesca and Perugino to be chiselled off the walls and ceilings of the Vatican when he decided that Raphael could do a better job.[10] And hundreds of thousands of obscurer *objets d'art* have been thrown away when owners die and heirs do not share their tastes.

Choosing whether or not to keep a work of art is not, of course, simply a matter of taste. It can also be a matter of condition. A picture which is blackened or flaking or white with fungus is more likely to find its way to the rubbish heap than a freshly painted work. And this is probably the main reason why entire schools of art have been erased from history.[11] If a painting is not kept at just the right level of humidity in a temperature-controlled environment, then either organisms – worms, beetles, mould, fungi, bacteria – will devour it, or it will expand and contract and pull its own paint layers apart. The works of Apelles and his contemporaries did not need iconoclasts, fires or warfare to destroy them; the environment could erase them without human help.

FRAGMENTS

Short of total destruction, the worst fate a work of art can suffer is partial destruction, when some portion of the whole goes missing. Few ancient marbles have come down to us without the loss of a hand or a foot or a head. Extremities can fall off owing to sharp knocks, caused by a blow or a fall, but marbles can also be destroyed by the weather. Sudden expansion in hot sun will crack a sculpture; so too will a very cold day. If moisture has found its way into the stone, then when the water freezes and expands in a hard frost the stone can split and fracture. It is hardly surprising that sculptures which have endured two thousand winters are usually in fragmentary form.[12]

The statue in fig. 45 is, by the standards of ancient marbles, reasonably well preserved. The surface is not unduly weathered, and substantial portions of the original stone have survived intact. It is in fact about as well preserved as the statue in fig. 46. The latter only looks in better condition because its many losses have been restored. There are a number of different versions of this sculpture of Silenus and Bacchus, and although all are damaged it is possible, from comparison between the various fragments, to form a fairly complete picture of their original appearance. There is not much doubt that the sculpture in fig. 45 looked much like the restored sculpture in fig. 46 when it was first carved.

Some might feel, then, that the sculpture in fig. 45 should be restored, in the same way that the statue in fig. 46 has been restored. Given that we know what the artist was trying to achieve, why not achieve it for him? Why leave the original as a fragment, when there is no need?[13]

In fact the statue in fig. 45 was, like many antiquities, restored in the eighteenth century; but the museum in which it appears, the Glyptothek in Munich, has de-restored it. The right leg and left knee

and hands of Silenus were removed in the 1960s, when the curators at the museum made the decision to exhibit only original antique marble: all post-Renaissance accretions were removed from the galleries.[14]

The Glyptothek's curators wanted to display authentic remnants of ancient sculpture, and to banish inauthentic additions. But what is authenticity? The fragment in fig. 45 preserves the authentic stone, but it fails to preserve the authentic concept, or the authentic appearance, or the authentic context of presentation. Is it authentic to prop up this shattered piece of marble on a stainless steel post? Given that it has no legs, should it not be lying on its back? And where are the authentic effects of ageing? The surface has been carefully cleaned, polished and waxed to give it the stylish sheen one expects in a leading museum, but which it almost certainly did not enjoy when it was in some Roman garden, home or temple.[15]

45
Roman copy after a Greek original, possibly by Lysippus, 1st–2nd century AD, *Silenus with the infant Bacchus*, 187 cm high, Glyptothek, Munich

46
Roman copy after a Greek original, possibly by Lysippus, 1st–2nd century AD, *Silenus with the infant Bacchus*, 187 cm high, Musei Vaticani, Rome

47
Archaic Greek, *Athena and Warriors*, c. 490–480 BC, marble, life-size, Glyptothek, Munich

Ancient sculptors tried to make marble look like living flesh.[16] This strange alchemy is hard enough to achieve when a statue has not lost its arms and legs; but when the beholder is distracted by missing limbs, and surfaces of broken stone, the illusion of life becomes very hard to maintain. We are forcefully reminded that this is a lump of dead, broken marble. The statue in fig. 46, on the other hand, almost seems to pulse with life, just as the artist intended. One could argue that the shattered sculpture in fig. 45 is not two thirds of an ancient work of art: by losing the semblance of humanity, it is no longer an ancient work of art at all.

The curators who removed the limbs from this sculpture may have been sympathetic to some of these arguments, but they could have pointed out that this particular sculpture is not a typical case. Since there are numerous other versions of the statue of Silenus and Bacchus we can, in this instance, reconstruct its original appearance. But the Glyptothek's policy was introduced in order to deal with unique fragments, such as the pediments of the Sanctuary of Aphaia at Aegina (fig. 47), which are impossible to reconstruct with complete certainty; and which had been restored in an anachronistic and inaccurate way by the nineteenth-century sculptor Berthel Thorvaldsen (fig. 48). It may be regrettable to present the shattered remains of artworks, but is that not preferable to misleading the public with false restorations and arbitrary reconstructions? And if we can agree that a whole sculpture is more than an assemblage of fragments, is a fragment not more true to

48
Archaic Greek with additions by Berthel Thorvaldsen, *Athena and Warriors*, c. 490–480 BC and AD 1816–20, marble, life-size, Glyptothek, Munich

the statue of which it formed part when it is shown as it is, rather than smothered in stucco which follows the ideas of someone who lived two thousand years later? It would of course be better if ancient sculptures were not broken in pieces, but given that they are, perhaps we need to accept the fact, and not pretend to ourselves and others that we can reconstruct more of their original appearance than we actually can.

Between these two opposing views there are of course many possibilities for compromise. Indeed the Glyptothek has recently been reconstructing Thorvaldsen's figures, to display alongside the original sculptures. Thorvaldsen was one of the most important and influential sculptors of his time, and his conceptions of Greek statuary are worth preserving in themselves.

Clearly, reconstruction is easier in some cases than others. For the Silenus, replacing the missing parts is relatively straightforward. For the broken-off feet from Aegina (fig. 47), any attempt to replace the figure that owned those feet must be highly speculative.

We face a similar set of questions and disagreements when it comes to paintings that have been cut down. We have already encountered one extreme example (fig. 5) of this phenomenon. Restoring the missing Venus from Lucas Cranach's painting would not be impossible – one could copy the goddess from a similar painting (fig. 6). However the Venuses in Cranach's paintings of Venus and Cupid all differ from one another, and so the reconstruction would need to be imaginative.

49
Rembrandt van Rijn, *The Night Watch*, 1642, canvas, 363 × 437 cm, Amsterdam, Rijksmuseum

50
Rembrandt's *Night Watch* (fig. 49) as it appeared before it was cut down in the 18th century, c. 408 × 508 cm, reconstruction by the author from photographs of the original in the Rijksmuseum and the copy by Gerrit Lundens (after 1642, oak, 66.8 × 85.4 cm, London, National Gallery)

Sometimes, however, we have enough evidence to replace a missing fragment with fair accuracy, although in these cases there is little consensus on how we should proceed. Despite the appeals of a number of art historians, the conservators at the Rijksmuseum are opposed to the idea of restoring Rembrandt's *Night Watch* (fig. 49), which was cut down in the eighteenth century, to its original appearance, even though the survival of a good early copy would make such a restoration relatively easy. In fig. 50 the original is blended with the copy to give an idea of what a restored *Night Watch* might look like; the result, it seems to me, is a more effective, legible and elegant composition.[17]

Conservators are not always so purist in their attitude. When, in 1934, a panel of Hubert and Jan van Eyck's Ghent altarpiece was stolen, it was decided to replace the panel with an exact replica, made using photographs and old painted copies. The replica was painted by the Belgian picture restorer Joseph Van der Veken, who did his work so well that anyone seeing the altarpiece who has not been told of the theft might well assume that the modern panel was by Hubert or Jan. In fig. 51, one of the panels is original, the other by Van der Veken; it is not immediately clear which is which.[18] Once

our eyes have been alerted, the Van der Veken addition is easy to recognise, but most visitors to St Bavo's Cathedral in Ghent would probably agree that the altarpiece is preferable without the gap made by the theft.

Our museums contain many paintings that we either know, or suspect, to have been cut down. But how, in fact, can we tell? The answer is that, while we can sometimes tell that a canvas or panel has not been cut down, it is harder to know when it has been.

CUTTING DOWN

 If a canvas is tacked down neatly over its wooden stretcher and the edges of the canvas are bare of paint, then of course we can be sure that it has not been cut down. However, very few canvasses from the period before 1800 present themselves in such straightforward entirety. Almost all canvasses have been 'lined', that is, they have been glued to another support, most often a canvas (we will discuss this process further below: see pp. 108–17). In the course of this process the original tacking margin – the strip of canvas used to nail the painting to its stretcher – was in the past

51
Detail from Hubert van Eyck,
Jan van Eyck, and Joseph
van der Veken, The Ghent
Altarpiece, 1424–35 and
1939–45, oil on panel, 350 ×
457 cm, St Bavo, Ghent

normally cut off. We can see this in Titian's *Bacchus and Ariadne* (fig. 59), which has been lined and relined several times. The borders of the image are slightly uneven: this is where the tacking margin has been sliced away. All around the image is a brown strip, which is the support – in this case a piece of artificial board – to which the old canvas has been adhered.[19] When a painting has been cut away from its tacking margins there is always the suspicion that areas of the original paint may have come with it. It is nevertheless sometimes possible to establish that a painting has not been much cut down. This is thanks to the phenomenon of 'cusping'.[20]

In fig. 52 we can see how cusping comes about. The canvas on the easel at right has not been nailed on to a stretcher; rather it has been tied with string to a wooden frame. The artist will only tack it down to the stretcher when he has finished painting. But in its current position the canvas is being distorted at the edges by the string, which is looped through the material. The outer edge of the canvas is stretched out in a wave pattern. If the canvas is primed while stretched like this, then the waviness will be fixed into the cloth. If the original canvas is concealed beneath a lining canvas then these waves will not be visible, but an X-ray can reveal them.

A canvas which has an intact set of wavy 'cuspings' on all four

52
Jan Miense Molenaer, *A painter's studio*, 1631, oil on canvas, 86 × 127 cm, Gemäldegalerie, Staatliche Museen, Berlin

sides has not been cut down. Needless to say, paintings like this are not as common as we would like. What is more common is to see cusping down one or two sides, but not on the others; and often the cusping is only partial – the tops of the waves are cut off – suggesting that the canvas has been slightly trimmed.

However, we cannot know who did the trimming. It may have been the artist, and formed part of his intention. And, in any case, not all canvasses were strung out on a frame like this. Sometimes artists painted straight on to a canvas which had already been nailed to its stretcher. Sometimes, too, a long strip of canvas was tied out and primed all at once, then cut into segments, so that cusping only took place on two sides. Absence of cusping, then, cannot be taken as evidence that the canvas is a fragment. The presence of complete cusping is proof that the canvas is not a fragment.

The same can be said for a feature encountered on the backs of wooden panels. In order to fit these into the frame, the wood was often planed down, 'bevelled', on all four sides. If on examining a painting it becomes clear that there are bevelled edges which have been cut down, then that suggests that the picture may be a fragment. If the paint extends right up to the edge of the panel on all four sides, rather than petering out as the edge is approached, then that would suggest the same. But again, we cannot be sure that the sawing down of the panel was not carried out by, or with the approval of, the artist. Complete bevelling is proof that the panel is not a fragment, but incomplete bevelling is not always conclusive proof that the panel is a fragment. What can tip the balance of evidence is when we see two kinds of bevelling: one kind is aged, of the same dark colour as the rest of the wood, while the other bevelling is lighter in tone, and clearly done centuries later.[21]

PAINT LOSS

Of all the forms of loss encountered in paintings, the most common is paint loss. We will discuss some of the reasons for, and treatments of, the flaking away of paint in the next chapter; here we will discuss the different strategies which have been adopted to conceal it.

When faced with a picture which has lost a great deal of its paint, there are three things one can do.

1. Nothing.
2. Repaint in such a way that the loss is still visible, but less disturbing.
3. Repaint so convincingly that the loss is no longer visible.

'Visible' here is ambiguous, since there are restorations which are visible close to, but not at a distance. And 'close' and 'distant' are also variable terms. Some restorations can be seen from a few metres, some from a few centimetres, and some only after prolonged scientific study.

From a theoretical point of view, strategy 1 is impossible. One cannot do nothing, because to do nothing is already to make a decision about what the work of art is going to look like – so one has done something. And in actual practice, complete inaction is rare. What is more common is for some limited variety of method 2 to be applied. So for example a large area of paint loss will be painted in a cool colour such as bluish-grey, which will tend to recede from the view and not distract the eye from the remains of the image; or alternatively a colour as near as possible to the surrounding hue and tonality will be used.

In Italy, which contains more old, hence damaged paintings than any other country, the problem of what to do with lacunae has received a great deal of theoretical discussion. Two leading philosophers of restoration, Cesare Brandi and Umberto Baldini, former Directors of the Central Institute for Restoration in Rome, have both devoted attention to the principles and practice of painting infill. As a result of their work, Italian restorers have developed a number of related techniques by which they try to ensure that interventions are always recognisable, at the same time as attempting to preserve the unity of the work of art.

Common to most techniques is the principle that the brushwork of the original must not be mimicked. So restorers often paint with short, parallel brushstrokes which all tend vertically or horizontally, and are easy to distinguish from their original neighbours; or sometimes in points or curls of paint to produce the same effect. These strokes will be more or less variegated in colour, so that they do not simply blend in with the surrounding hue. Strokes painted in this way have a certain resemblance to hatching, the lines used to indicate shade in drawing and engraving, and the Italian for hatching is *tratteggio*. That Italian word is also used both within and beyond Italy to refer to this style of restoration brushwork.[22]

The main differences between the styles of *tratteggio* come in the degrees to which the brushstrokes correspond to what is lost. Some varieties deliberately create large areas of void in the painting, while at the opposite extreme are kinds which one might term 'semi-deceptive'. Fig. 53 shows examples of the latter. The retouches in the sky and on the hat of a figure by Piero della Francesca are conspicuous enough from close to, but are invisible from the normal viewing distance (this figure is around ten metres above the ground, on a church wall).

In between these styles of *tratteggio* come types which attempt to fill in medium-sized lacunae, where the original loss is so large that it cannot be filled in without some imaginative reconstruction, but where some attempt is made to disguise the infill by making it blend with its surroundings. Much thought has gone into these *tratteggio* techniques, known as 'chromatic abstraction', and 'chromatic selection', which base themselves on Baldini's studies of colour theory.[23] The two methods are closely related; in both, the lacunae are filled with a medley of red, blue and yellow or green dots or strokes, and the restorer is allowed to add local colour where necessary. Chromatic abstraction makes less attempt to blend in with its surroundings than chromatic selection, but in practice the two are hard for anyone who is not a restorer to tell apart. An example of the general approach can be seen in fig. 54.

Whether this polychrome shape is found to be a satisfactory

53
Detail from Piero della Francesca, *The Exaltation of the Cross* (fig. 83)

54
Detail from Andrea Mantegna, *The Adoration of the Magi* (fig. 55), showing present *tratteggio*

55
Detail of Andrea Mantegna,
The Adoration of the Magi,
c. 1463, tempera on panel,
76 × 76.5 cm, Uffizi, Florence
before recent conservation

solution to the problem of paint loss will probably depend on taste. To some it may seem distracting; the way it toys with the colours it is supposed to replace creates visual interest. It is meant to be a neutral way to fill a gap, but it persistently attracts the attention. A plain piece of the underlying panel, or at least a flat expanse of a cool colour, might be less disturbing. However, it should be noted that this photograph, as a close-up, is misleading; *tratteggio* is made to be viewed from actual viewing distances, in churches, museums or other collections, and what stands out as glaring in the art historian's photograph can be impossible to discern in real environments.

Nevertheless, it might be argued, the lacuna could be filled with a deceptive retouch that completes the painting (and indeed old photographs show that, early last century, it was; fig. 55). However this approach did not find favour with post-war Italian picture restorers. A central tenet of the Brandi-Baldini theory of restoration was that the restorer must never deceive; and some deceptive retouches were just too deceitful. Before the addition of the *tratteggio* infill to this Mantegna, the landscape, the camels and the top half of the head of an attendant had been repainted in a deceptive style, and were convincing enough. However, the restorer had not known how to reconstruct two figures who were in very fragmentary form; so he just painted them out. To Brandi and his followers, dubious sleights of hand like this were unacceptable, but some may still find the result here preferable to an intrusive area of *tratteggio*. And, while the restoration was dishonest, it could have been openly admitted. For there are, one might argue, various ways to be honest. One could repaint the camels and the attendants with all the care to duplicate the original style shown by Joseph Van der Veken (fig. 51), and then put a photograph on the wall showing what the painting looked like before it was restored. Or, if that was considered too disturbing, one could add a sentence to the information given, such as 'an area of paint ten centimetres long and two centimetres wide above the head of the black Magus has been lost, and has been filled in by the gallery's conservation department'.

This might be considered 'inauthentic', but, as we saw above (pp. 71–75), there are competing kinds of authenticity. Mantegna's painting did not contain a polychrome shape like this. It contained camels and attendants, and a camel or attendant painted by a top restorer in the style of Mantegna is going to look more like Mantegna's camels and attendants than this multi-coloured interpolation.

Chromatic abstraction has been more generally applied to medieval than to later works of art, in part because earlier paint is

56
Hans Holbein the Younger,
'*The Ambassadors*', 1533, oil on
oak, 207 × 209.5 cm, National
Gallery, London

more likely to have suffered extensive damage, and in part because
the unity of space and the developed chiaroscuro of later painting
would suffer more from polychrome infill of this kind. And in some
countries the chromatic approaches have never been very popular,
with the preference being given instead to deceptive retouching.

As an example of the latter approach, take the National Gallery's
restoration of Hans Holbein's *Ambassadors* (fig. 56). The painting
has suffered a fair amount of damage over the years (fig. 57), in part
due to the writhing and warping of its precarious support made
of ten separate planks, and it has been extensively repainted in a
deceptive style. All of this repainting was recently removed and
redone, since the older infills were discolouring, and some were
in any case incorrect. The most recent retouches try to mimic the
style of Holbein, and, as can be seen from the detail in fig. 58, they

are very successful. By comparing figs. 57 and 58 it is possible to tell where the new paint has been applied; but it is almost impossible to locate the retouches without consulting the photograph of the painting before restoration.

57
Hans Holbein the Younger, 'The Ambassadors' (fig. 56) after cleaning, before restoration

To a restorer raised in the school of Brandi this is deceitful practice, but the deception has been revealed and described in detail in a well-illustrated article in the *National Gallery Technical Bulletin*, a journal which is freely available on the web.[24] And it can be argued that Holbein's painting is now in a state of completeness similar to that it enjoyed when the artist and his patrons last saw it. The parts of the painting which are in better condition can be enjoyed without the distraction of assertive lacunae.

Whatever our preferences in this respect, those who are interested in condition need to know that many paintings in art

58
Hans Holbein the Younger,
'The Ambassadors' (fig. 56)

59
Titian, Bacchus and Ariadne,
1520–23, oil on canvas,
176.5 × 191 cm, National
Gallery, London

60
Titian, Bacchus and Ariadne
(fig. 59), state after cleaning,
before restoration

galleries and in auction houses around the globe are in a worse
state of preservation than *The Ambassadors*, but that the extent
of their damage is very skilfully concealed. A striking example of
this is Titian's *Bacchus and Ariadne*, the famous blue sky of which
contains a great deal of infill (figs. 59 and 60). Other paintings
have been largely reconstructed: Pisanello's *Virgin and Child with
Saints Anthony Abbot and George* (fig. 61) was almost completely
repainted in the middle of the nineteenth century by a celebrated
Milanese restorer called Giuseppe Molteni. Molteni seems to have
reconstructed the painting, which was very badly worn, as well as
he could, and the result is certainly pleasing; but little of the paint
surface that survives is by Pisanello.

One might think that, when retouching, it is hard to find exactly
the right pigment to fill a particular lacuna. This is of course
difficult, but it is not normally the pigment that is the real problem
– it is the binder. It might seem logical to use oil as a binding
medium when retouching an oil painting, but this is not advisable.
Oil darkens with age, and most of this darkening occurs in the
first decades of its application. So when a retouch is applied it may
match its surroundings perfectly at the time, but half a century later
it will be darker than the region around it.

Seasoned restorers in oil have long been aware of this problem,
and tried to circumvent it by inserting their additions slightly
lighter than their surroundings, so that they would darken to the
right tint.[25] But this is an approximate art, and one that does not

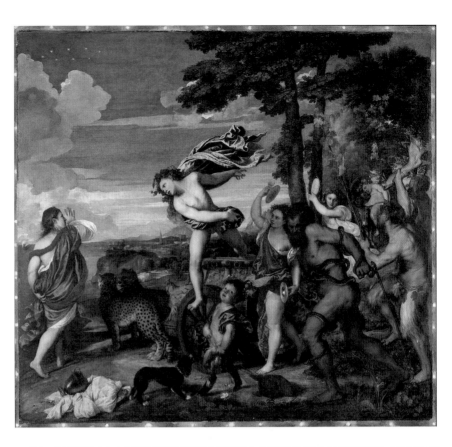

61

Antonio Pisano, called
Pisanello, *The Virgin and
Child with Saints Anthony
Abbot and George*, c. 1435–41,
egg tempera on poplar,
48 × 31 cm, National Gallery,
London

always succeed. Less experienced restorers have not always been
aware of the need for the technique, and the results have shown in
their work. One can see the outcome of an incompetent attempt
to retouch in oil in the painting by Piazzetta in fig. 62, which was
restored by a former owner, the painter and art critic Roger Fry. His
additions are now clearly visible, and old photographs show that
they already stood out clearly from the rest of the painting within
thirty years of being added.[26]

In order to avoid the darkening of oil retouches, picture restorers
try to use binding media which will hold their tone for decades,
or preferably for centuries. One relatively stable medium is egg

62
Giovanni Battista Piazzetta,
The Sacrifice of Isaac, probably
after 1735, oil on canvas, 201.2
× 133.4 cm, National Gallery,
London

tempera, which was widely used by conservators in the middle
of the last century, and still has its advocates today.[27] Tempera,
however, also has problems. One is that, as we have already
observed (p. 37), it does not lend itself well to impasto. If using
tempera on a thickly painted oil surface, the restorer has to build
up a filling of putty, silicone or some similar material to mimic the
brushwork, and then cover it with a thin layer of paint. Another
problem is that, although it keeps its tone well for decades, it is
more erratic at the time of application; it can become lighter as it
dries, and darker when the varnish is applied. Modern restorers
who use tempera therefore often apply their final layer of pigments

using a specially prepared wax-resin retouching medium. We are back here with acronyms: restorers favour PVA, or B-72, or MS2A, or A-81, and so on – again, interested readers can find out more about modern retouching media through the literature cited in the footnotes below.[28] These wax-resin preparations, since they hold their tone with exceptional fidelity, are now increasingly used instead of tempera for the entire retouch; and the companies which market them have also introduced special retouching gels, which allow the restorer to mimic the texture of the paint that she or he is trying to match.

The more artificial the binding medium, the better, since it clearly signals to later restorers where the retouchings have been laid. And these wax-resin media have another advantage: although they are stable they are easy to remove with solvents. This is the most fundamental principle of honest retouching, whether one favours deceptive or visible brushstrokes. Retouchings must be reversible. If in the future the restorer's brushwork should discolour, or if the theory of restoration which underlay it should come to seem wrong-headed, then it must be possible to unpick the stitching, and start again.

1 Van der Woude, 'Volume and Value', 309; cf. Bok, 'Pricing the Unpriced', 101.

2 Frangenberg (ed.), *Poetry on Art*.

3 Pollitt, *Art in the Hellenistic Age*, 185-229; Andronicos, *Vergina*, esp. 31-37, 83-119.

4 Norris, 'Flakturm Friedrichshain'.

5 Bernhard, *Verlorene Werke*; Flick, *Missing Masterpieces*.

6 Greenhalgh, *Survival*, 6-7.

7 Greenhalgh, *Survival*, 8, 183, 206-07.

8 Weiss, *Classical Antiquity*, 98-104.

9 Tavárez, *Invisible War*, 31, 55; MacCormack, *Religion in the Andes*, 406-15; Brain, *Art and Society in Africa*, 111; Hackett, *Art and Religion in Africa*, 139, 159, 161.

10 Vasari, *Vite*, I, 354; II, 70. Raphael spared one work by Perugino, his master, the ceiling of the Stanza dell'Incendio.

11 Delacroix, *Journal*, II, 400 (29 July 1854).

12 Hempel, 'Note on Conservation of Sculpture'; Wihr, *Restaurierung von Steindenkmälern*, 39-60.

13 Vasari, *Vite*, II, 134; Thayer, '"Restoration"', 488; Conti, *History of Restoration*, 114-20, 221-34; Ramage, 'Restorer and Collector'.

14 Knell and Kruft, 'Munich Glyptothek'; Diebold, 'Politics of Derestoration'; Fendt, 'Restoration or De-Restoration?'

15 Hermens and Fiske, *Authenticities*, foreword.

16 Pliny, *Natural History*, 36: 4: 24.

17 I argue this on the basis of a close reading of a contemporary description of the painting in Taylor, '*Zwierich van sprong*'.

18 Van der Veken painted the *Just Judges* (left-hand panel). On the career of Joseph 'Jef' Van der Veken, see Verougstraete et al., *Restaurateurs ou Faussaires*, 108-59. On the attribution of different sections of the altarpiece, see Van der Velden, 'Quatrain', who argues that Hubert and Jan painted the lower section, while Jan on his own painted the upper section.

19 Lucas and Plesters, 'Titian's *Bacchus and Ariadne*', 34-35.

20 Bomford, Brown and Roy, *Art in the Making: Rembrandt*, 19-20.

21 Bomford, Brown and Roy., *Art in the Making: Rembrandt*, 19-20.

22 Brandi, *Theory of Restoration*; Baldini, *Teoria del restauro*; Marijnissen, *Dégradation*, I, 376-89; Émile-Mâle, *Restauration des Peintures*, 90-100; Giannini (ed.), *Dizionario del restauro*; Ciatti, 'Laboratorio'; Nicolaus, *Restoration*, 291-4; Schädler-Saub, 'Italia und Germania'; Rothe, 'Croce e Delizia', 16-17; Nadolny, 'History of visual compensation'. For appreciative criticism of the Italian retouching method see Ruhemann, *Cleaning of Paintings*, 258-65; for sharp criticism of the *tratteggio* restoration of Cimabue's Crucifix, see Wilmot, 'Examining "authenticity"', 98-99.

23 Baldini, *Teoria del restauro*.

24 Wyld, 'Holbein's Ambassadors'. I have given the painting its traditional title of 'The Ambassadors', but Hudson, 'Vanity', has put forward good reasons for thinking that the two men are not ambassadors but brothers, and that the figure on the right is François de Dinteville.

25 Watelet and Lévesque (eds.), *Encyclopédie Méthodique*, II, 758-59; Mogford, *Hand-Book*, 59-64.

26 Ackroyd, 'Retouching Media', 53-54. On Fry's disastrous attempts to restore Mantegna's *Triumph of Caesar* see Blunt, 'Mantegna's "Triumph"'; Blunt, 'A Project'; Spalding, *Roger Fry*, 213-15.

27 Lank, 'Egg Tempera as a Retouching Medium'; Digney-Peer et al., 'Imitative retouching', 627.

28 Doerner, *Materials of the Artist*, 406-12; Ruhemann, *Cleaning of Paintings*, 181-89, 240-68; Ruhemann, 'Criteria for Distinguishing'; Stanley-Baker, 'Problem of Retouching'; Berger, 'Inpainting using PVA'; Nicolaus, *Restoration*, 257-303; Ellison et al. (eds.), *Mixing and Matching*; Digney-Peer et al., 'Imitative retouching'.

3.
CRACKING
AND FLAKING

Most old paintings are marked by a visible network of cracks across their paint surface – the crackle pattern, or craquelure. It is perhaps surprising that these cracks receive little attention from art critics and historians, and that viewers also appear unconcerned about them. If a friend or relative were to develop a fine mesh of cracks over her or his face their appearance would be very distressing, and yet we can look at a portrait of a woman whose head is disfigured by deep black fissures without being perturbed (fig. 26). When paintings are even slightly abraded some art-lovers will complain that they have been ruined by overcleaning, but an assertive and disfiguring crackle like this is hardly ever taken as a serious objection to a picture's condition. The converse is also true; no one praises a painting for being free of craquelure. Some artists of the mid-sixteenth century in Flanders, such as Pieter Pourbus (fig. 63), managed to overcome the problem of crackling entirely; there are many paintings made fifty years ago which have more cracks than this picture, made 450 years ago. And yet Pourbus gets little credit for this technical feat, and no one seems to enjoy his paintings the more for being free from craquelure.[2]

Although crackling is rarely discussed, and although we seem to have a remarkable capacity for ignoring it, it certainly can be very obtrusive. One painting in which it has a particularly disturbing effect is Jan van Eyck's Arnolfini Portrait (fig. 64). Much of the picture surface in this work is in good condition, but the front of Giovanni Arnolfini's garment is in a poor state. Part of the problem is that, in an attempt to produce the rich purple effect we saw in fig. 24, Van Eyck spread an ultramarine blue glaze over the surface, and this glaze has discoloured with 'ultramarine sickness' (of which

63
Pieter Pourbus, *An Allegory of Love*, c. 1547, oil on oak, 132.8 × 205.7 cm, Wallace Collection, London

more in the next chapter). But an even more distracting problem is the craquelure, which proliferates across the surface and, being raised in ridges along the cracks, scatters white light, so that it is hard to see the form of the garment through the reflected glare.[3]

It is often in the darker parts of a painting that the crackle pattern is most distracting.[4] We can see a clear example of this if we turn again to the portrait by Campin in fig. 24. The painting has a marked pattern of crackles all across its surface, and yet it is most noticeable in the areas where it matters least – the background and the dark purple garment. There are probably two main reasons for this intrusiveness of the craquelure in the darks. The first is that lighter areas of a picture will normally contain lead white, which is an exceptionally tough paint, and so less likely to buckle up and scatter distracting reflections.[5] The other reason is simply that reflected white light will stand out much more against a dark background. But that neither rule invariably applies can be seen in Leonardo's *Belle Ferronnière* (fig. 26), where the most unpleasant crackling is reserved for the lightest areas of the portrait.

Why does craquelure develop? There are two main kinds of crackle pattern, 'ageing cracks' and 'drying cracks'. Ageing cracks can come about due to physical movement between the paint layers and the support. Once the paint has dried and hardened it becomes brittle, and any bending, warping, or expansion and contraction in the support can cause the paint above it to crack. Supports expand

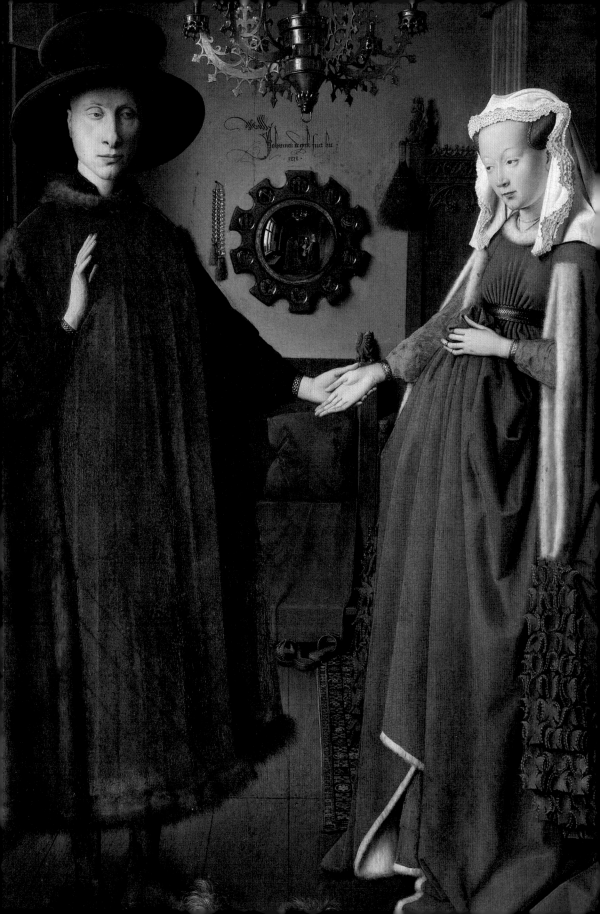

or contract to some extent as temperatures change, but they expand much more if they are 'hygroscopic', that is, if they readily take up moisture from the atmosphere. Wood and linen are hygroscopic, metal and stone are not, and so craquelure appears more often on panel and canvas pictures than on those made on copper or slate.[6]

However, it is not only the support which leads to crackling. The paint layer itself is hygroscopic. So too is varnish, which will often develop its own craquelure, independent of the paint beneath it.[7] And the glue in the ground, besides expanding and contracting, can also attract fungi and microbes, whose activities induce swelling and cracking.[8]

Ageing cracks on wood show distinct national characteristics. The cracks in figs. 64 and 24 are typical of works painted in the Netherlands, in that they are tightly massed and run parallel to the grain of the wood, which in the north was usually oak. The cracks in figs. 26 and 38, on the other hand, are less tightly packed and have a predominant direction at right angles to the grain. This perpendicular orientation is typical of Italian paintings on poplar. To what extent these differences are caused by the characteristics of the wood, or the nature of the ground on top of it, is still being researched.

When it comes to ageing cracks on canvas, there are again differences between schools of painting. The differences here seem to be caused not by the type of canvas, but by the type of ground. In seventeenth-century Holland, the ground tended to be thinner than was normal in eighteenth-century France and England, and this difference in thickness has its effect on the craquelure. In the painting by Jan Steen in fig. 65, the cracks run in a fine mesh pattern, following the threads of canvas. Their direction is more vertical than horizontal, since the paint has been broken along the weft threads, which weave in and out of, and envelop, the warp threads. In the areas of flesh in William Hogarth's *The Graham Children* (fig. 66), however, we can see a much looser, curvier and less directed form of craquelure, common in eighteenth-century paintings. Here the thickness of the ground means that the weave of the canvas does not crack the paint; rather, the craquelure forms as the thick brittle paint layer bends and splits.[9]

Ageing cracks usually split all the paint layers, and have their base in the ground, often right next to the support.[10] Drying cracks, on the other hand, are caused by splits and tears within individual paint layers which form during the process of painting. Typically, this occurs when a fast-drying paint layer is laid on top of a slow-drying paint layer. As paint dries, it tries to shrink. If the layer beneath it is dry and hard, then the upper layer will have something to grip on to, and the paint will hold together, and dry flat in an

65
Detail from Jan Steen, *Two men and a young woman making music on a terrace*, c. 1670–75, oil on canvas, 43.8 × 60.7 cm, National Gallery London

even film. But if the underlayer is not fully dry, then the upper layer will drag at the soft substance beneath it and split open, leaving gaps through which the lower layer can be seen.[11]

Drying cracks are relatively rare before the eighteenth century, but then they proliferate. Perhaps the decline of the master-apprentice system led to a rise in technical bad habits. The detail of Hogarth's painting (fig. 66) shows ageing cracks on the flesh parts, but drying cracks in the background.[12] These drying cracks are, however, very mild and unobtrusive when compared to the large surface wounds found elsewhere in late eighteenth- and nineteenth-century painting (fig. 68).[13] The more spectacular of these tears have long been attributed to the contemporary addiction to bitumen, although recent research into the properties of this much-maligned pigment suggests that it is not the pigment itself, so much as the amount of oil mixed with it, that causes the problem.[14]

Bitumen was certainly not necessary for the production of

drying cracks, as Édouard Manet's *In the Conservatory* shows (fig. 67). Manet clearly made a sudden decision to shrink the size of the sitter's hat, and painted it over before its yellow paint had fully dried. Shrinkage in the upper layers has pulled open the paint surface, revealing the remnants of the old hat underneath.[15]

In the Conservatory, besides this detail, contains a most varied and interesting crackle pattern. Some of it, however, is not so much crackle as crack. The straight black lines that cross the face of the sitter are particularly noticeable. These are not drying cracks, since they penetrate through to the ground. At the same time they do not have the irregular appearance of ageing cracks. It is possible that the painting has received a blow, although it is hard to think what kind of blow would have caused so straight a deformation. What probably we see here is another kind of craquelure, one that falls half way between ageing and drying. Paintings can crack or split owing to too much glue, or too powerful a glue, in the priming. Glue is strongly

66
Detail from William Hogarth, *The Graham Children*, 1742, oil on canvas, 160.5 × 181 cm, National Gallery, London

hygroscopic, and its expansions and contractions can put enormous pressure on a paint surface. Too gluey a priming will wrench the upper layers apart.[16] Manet, who bought his canvasses ready primed from the art supplier, may have been unaware of the danger.

In the great compendium of technical recipes compiled in the seventeenth century by the physician Theodore Turquet de Mayerne, a number of different methods are given for curing cracks of this kind. One is rather alarming: he recommends pulling the whole canvas firmly over the edge of a table.[17] This is better advice than it sounds. By performing this operation the entire paint surface is broken into small islands of craquelure, and the stresses and strains which were fracturing the paint surface are alleviated. Of course, the painting now has much more craquelure than before,

67
Detail from Édouard Manet, *Dans la serre* (*In the conservatory*), 1878–79, oil on canvas, 115 × 150 cm, Alte Nationalgalerie, Berlin

68
Jean-Auguste-Dominique Ingres, *The Composer Luigi Cherubini with the Muse of Lyric Poetry*, 1842, oil on canvas, 105 × 94 cm, Musée du Louvre, Paris

but that is preferable to large areas of paint peeling away from the canvas.

The conservators at the Alte Nationalgalerie in Berlin would probably be reluctant to perform this table method on their famous Manet, but the violent technique may be less harmful to the painting than de Mayerne's other suggestions. They all involve impregnating the back of the canvas with oil or glue, so that it will soak through and, once dry, hold down the cracked paint surface. In the short term this will solve the problem, but in the long term the painting has to cope with even more adhesive than before, when the problem from the start was an excess of adhesion.[18] And soaking a whole painting in animal glue provides food for bacteria, microbes and fungi, who can break out and damage the paint surface.[19]

FAKE CRACKLING

Restorers in public museums which promote 'deceptive' retouching tend to leave one faint trace of their activity behind them. They normally do not mimic the crackle pattern on the surface, so that gallery-goers with persistence and good eyesight can see where the new paint has been applied. As we saw in fig. 41, the sudden termination of the craquelure allows us to distinguish the original artist from a later hand. However, not all restorers are so kind. Sometimes craquelure is introduced into a painting either fictively, with a pencil or paint brush, or by employing special techniques to make the paint surface crack.[20] The former is relatively easy to detect, although one does need to be very close to the paint surface before it becomes visible. fig. 69 shows an example in a fifteenth-century Netherlandish panel. The crackle pattern over the angel's face is genuine, but on the drapery at right craquelure has been painted in black in an attempt to disguise an extensive area of overpaint.[21]

This much deception can be unmasked quite easily, but when a top restorer is trying to deceive us it becomes far harder to detect the fraud. Take the detail of the Christ Child from a painting known as the Renders Madonna (fig. 70). Some of this panel is fifteenth-century, and is attributed to Rogier van der Weyden; but most of it was painted in the early 1920s by the restorer we have already encountered, Joseph Van der Veken. In this detail the upper lip, left cheek, nose, eyes and forehead of the Child are genuine; the rest is by Van der Veken.[22]

At first sight, Van der Veken's craquelure looks entirely convincing. Since he did not publicize his restoration work, some distinguished contemporaries were taken in, and the panel was assigned to Rogier van der Weyden by the leading historian of early

69
Detail from Follower of
the Master of the St Ursula
Legend, *The Virgin and Child
with two angels*, c. 1490, oil on
oak, 47 × 34.5 cm, National
Gallery, London

Netherlandish painting at that time, Max Friedländer.[23] It was only
in 1999, when it was subjected to a close scientific examination,
that the full extent of Van der Veken's work was revealed: about
three quarters of the picture is in the restorer's hand. Nevertheless,
although Van der Veken clearly faked this crackling with enormous
skill, a number of art historians sensed that something was wrong.
When he first saw the Renders Madonna at an exhibition at the
Royal Academy in London in 1927, the famous collector Frits
Lugt wrote in his catalogue "extremely suspicious" and "strange
craquelure".[24]

What was it that Lugt found strange about the craquelure?
Van der Veken's biggest problem was that he was trying to mimic
ageing cracks by creating drying cracks. The precise details of
his method are still being researched, and he employed slight
variations depending on the tonality of the surrounding paint,

but when painting light areas, as here, he appears to have placed a layer of dark varnish beneath his upper layer – which may in its turn have contained glue or a strong drying agent. The upper layer then contracted and pulled itself apart, revealing the dark varnish beneath. Since this varnish was dark, it mimicked to some extent the appearance of shadow in ageing cracks.

There were, however, a number of limitations to the method. The first was that ageing cracks, as we have seen, tend to run parallel to the grain of the wood, while drying cracks split according to different principles. The fake crackling in fig. 70 spreads aimlessly, and does not have the tight, rectangular pattern one associates with Netherlandish paintings on oak. Ageing cracks also have a tendency to respect certain contours in the image. Compare the way the genuine ageing cracks, around the eyes of the child, split along the lids, the iris and the edge of the eyeball, while the fake drying cracks cross over the ear as if it was not there. Another problem with Van der Veken's method was that the drying did not always take place in the right way. Sometimes the fissures in the upper layer were too broad, pulling the dark layer of varnish apart to reveal lighter layers of ground below. Sometimes too they were insufficiently straight, cracking in a trembling line. Since both faults would have given the game away, Van der Veken was forced to strengthen the cracks with a pen or brush, and at close range these later manipulations are visible.

Lugt could have noticed any of these anomalies. But another method Van der Veken employed might have fooled him. On some panels the hyper-restorer would produce fake ageing cracks by forcing the wood to expand, probably by soaking the support in water. The wood would therefore pull the ground and paint layers apart in the same way that it would on an old painting.

In paintings on canvas, craquelure is easier to forge. One method is to tap the paint lightly with a hammer. Another is to roll the canvas up, a way of forging craquelure which has been known and employed since the seventeenth century.[25] The works of Willem van de Velde the Younger often show a very marked crackle pattern, which suggests that they have been rolled – or possibly pulled over the edge of a table (fig. 71). However, since his reputation in the eighteenth century was very high ("William Vandevelde, the son, was the greatest man that has appeared in this branch of painting; the palm is not less disputed with Raphael for history, than with Vandevelde for sea-pieces"), and since we know that his works were extensively copied, it is possible that some paintings with marked craquelure currently assigned to Van de Velde are copies which have been rolled in an attempt to make them look like originals.[26]

70

Detail from Joseph Van der Veken and Rogier van der Weyden (attr.), The Renders Madonna, 1450s and 1920s, oil on oak, 36 × 27 cm, Musée des Beaux-Arts, Tournai

71
Willem van de Velde the
Younger, *Dutch vessels aground
at low water,* c. 1660, oil
on canvas, 32.9 × 36.9 cm,
National Gallery, London

It used to be claimed that forged craquelure had one other
limitation, in that it could mimic only a flat crackle pattern, and
could not capture the way that islands of paint bordered by cracks
often curl up at the edges.[27] In fact the claim is untrue: Van der
Veken produced fake craquelure of this kind, and the art historian
Roger-Henri Marijnissen has published a method which produces
a similar effect.[28] However, the results of Marijnissen's process are
extreme, and hardly the same as the delicately ribbed appearance of
a paint surface which is just beginning to rise away from its canvas.
We can see an example of this more subtle kind of crackling in a
painting by Tiepolo (fig. 72). Ridges of raised craquelure can be
seen catching the light in the background, and their presence is
also detectable on the bare shoulder and chest of the woman. The
network of broad white lines on her flesh shows where someone
has begun and abandoned an attempt to clean off the varnish. Since
the surface is raised in ridges, passing a swab over the surface will

72
Giambattista Tiepolo, *Flora*,
1750s, oil on canvas, 88.3 ×
69.9 cm, private collection,
as sold at Christie's, London,
2 December 2008, before
restoration

73
Philip Tideman, *Venus and Adonis*, 1703–04, oil on canvas, 91.4 × 86.4 cm, Hopetoun House

catch at the upturned edges, and will abrade them more than the surrounding area. The result is that more varnish was taken off the rims of the craquelure, causing these white lines. The restorer, possibly an amateur, seems to have noticed what was happening and decided to leave the job to someone else.[29]

In this particular case, only varnish has been removed; but it often happens that paint along the edges of crackles will be more abraded than the area around them. The phenomenon is not always as easily visible with the naked eye as it is in the Tiepolo, but becomes clear through the magnifying glass. There is an example of the phenomenon in fig. 42, where the dark ageing cracks all run through a thin channel of abraded white paint.

Slightly raised craquelure is a problem when it comes to cleaning the surface, but if it remains stable it does not endanger the painting. The condition only turns into an alarming one as the islands of craquelure curl into isolated cups, and start to detach themselves from the support. We can see on the Tiepolo that this

process has already begun, and that a few flakes of paint have come away, revealing the canvas. The situation in this case is still rectifiable, but serious cupping, if it is not dealt with quickly, can be the ruin of a painting. In the branches at the top of this picture (fig. 73) there is a light strip which looks like a sprig of autumn leaves, but is instead bare canvas where the paint has flaked and fallen.[30]

A painting can go from relative health to a state of cupping and flaking fairly quickly if the canvas starts to shrink. Sometimes, if a canvas is wetted, either with water or with some aqueous substance such as glue, it can shrink by up to 5 cm in an instant, buckling the paint on the surface. This kind of mishap will only happen to an unlucky picture restorer, but an owner who hangs a painting on a damp wall can expect a slow-motion version of the same experience.[31]

Cupping can be an effect of the canvas shrinking; it can also come about due to the paint surface shrinking, and this will be made worse if there is a lack of cohesion between paint and support – if, for example, the latter is made of stone. It is also sometimes said that a deteriorating varnish can contract and cause paint to buckle. To date this seems to be less a proven phenomenon than a not implausible assumption, but it has nevertheless been used as a justification for removing varnish from paintings.[32]

Up to now we have spoken of flaking as an effect of cupping, which in turn is an extreme form of craquelure. Most flaking does happen in this way, but it can also occur in paintings which have no craquelure. We have already noted (p. 92) that the paintings of Pieter Pourbus are free of crackling, but they are not immune to flaking. The painting in fig. 63 has been given a number of retouches in order to fill small areas of paint loss, caused in this case by an unstable support. Like Holbein's *Ambassadors* (figs. 56, 57), Pourbus's *Allegory of Love* is painted on a panel composed of planks, and the movement of and between these planks has led to flaking.[33]

Another cause of flaking is blistering; the paint surface remains whole on the surface but becomes detached from its support. Blisters of this kind can remain unobtrusive for many years, but if the picture is subjected to any kind of stress then there is a good chance the blister will crack open and fall away. Blisters on paintings can be caused by microbes feeding on the glue in the ground,[34] but they can also be an effect of extreme heat. The Claude in fig. 12 has received treatment for blistering, which was probably caused by the fire it went through in the eighteenth century.[35] However, fire is not the only source of heat, and some paintings show the marks of blisters which seem to have been brought about by other means. Fig. 74 shows a detail from a famous painting by

74
Detail from Titian, *The
Vendramin Family*, begun
about 1540–44, completed
about 1550–60, oil on canvas,
206.1 × 288.5 cm, National
Gallery, London

Titian in the National Gallery in London. Above the head of this boy
there is a patch of dark brown blisters which, according to the most
recent catalogue of the Venetian paintings in the gallery, "may be a
result of poor drying but also suggests singeing from an iron during
lining".[36]

LINING

When art historians criticize the restoration of paintings, they
normally complain about overcleaning. And yet some restorers have
claimed that the main cause of damage to paintings is lining.[37] If
they are right, then this is very unfortunate, since from c. 1670 to
c. 1970 lining was considered a routine, essential restoration job,
which was carried out on almost all paintings on canvas as a matter

of course.[38] Cleaning controversies – in which art historians and critics lambast the cleaning policies of major museums – come and go, but no art historian has ever started a lining controversy. The principal opponents of lining have been restorers: historians of art do not seem to have developed an interest in the problem.

Lining is intended to save paintings like those in figs. 72 and 73. Both paintings are flaking, and in both the canvas is sagging. A canvas can sag for more than one reason. Oxidation, pollution, microbes and humidity can all cause canvasses to swell, decay and lose their tension.[39] Since it is no longer held flat and taut by the stretcher the paint layer can contract on the canvas, causing cupping and flaking. The canvas must therefore be restretched. However, to restretch an old, fragile canvas, without causing further damage, is not easy. The old canvas has to be strengthened first, and the traditional method of achieving this aim is by fixing a new canvas on to the back of the old.

Since a sagging canvas will often be one from which the paint is beginning to work itself free, the process of lining attempts to treat both sagging and flaking at the same time. Both canvasses are soaked in enough adhesive to fasten the peeling paint.

Lining varies from restorer to restorer, but most of the following processes form part of most lining practices:[40]

1. One or more sheets of specially prepared smooth, soft paper are pasted on to the surface of the painting to protect it during the lining process. In the past, muslin was sometimes used for this purpose.
2. The painting is removed from its stretcher, and its old, probably worn and possibly ripped tacking edges are either given temporary repairs and ironed flat, or cut away.
3. The canvas is attached face down to a frame or smooth surface, and possibly stretched.
4. The back of the canvas is cleared of any protrusions, such as knots or labels.
5. An adhesive is spread over the back of the canvas.
6. A fresh canvas is stretched on a frame. It too is cleared of protrusions, and covered in adhesive.
7. The old and the new canvasses are brought together.
8. In order to make the adhesive melt, and thus infuse not only the two canvasses but also the ground layer, warm irons are passed lightly over the back of the new canvas.
9. The conjoined canvasses are removed from their frames and attached to a new stretcher.
10. The protective layers of paper or muslin (and possibly varnish) are removed.

75
Detail from Giovanni Battista Moroni, *Leonardo Salvagno* (?), c. 1570–75, oil on canvas, 100.6 × 74.9 cm, National Gallery, London

The most alarming of these processes is number 8, the ironing of the canvas. Every restorer would agree that this is not entirely free of risk. If the iron is too hot – and in the days before electric irons with temperature dials, gauging an iron's temperature was not so easy – the paint can leave bubbles, as in fig. 74; and a cooler iron than this can singe the paint, turning white skin the colour of milky coffee.[41]

Too much heat is one worry; too much weight is another. Instructions for lining always stress that the iron should glide across the surface, and that no downward pressure should be exerted. The flat, drumskin appearance of many lined paintings reveals that this advice is hard to follow in practice. Unlined canvasses are always striking for the delicacy of their impasto. The process of lining tends to flatten the texture of the paint, especially as many paintings have been not merely lined but also relined, and sometimes more than once.[42]

We can get some idea of the differences between lining badly, lining well and lining not at all if we look at three portraits by

Giovanni Battista Moroni in the National Gallery in London (figs. 75–77).[43] The recent catalogue of Bergamasque painting in the Gallery by Nicholas Penny is very candid about the poor condition of the first of these paintings. "The painting was crushed in the process of lining. This accounts for the extensive crackle in the blacks …. The flesh now looks blotchy and the shadows do not read convincingly".[44] All of this is true, and more can be said. When compared with the unlined painting – fig. 77 – we can see that much detail has gone missing from the eyebrows, eyes and beard, and that the delicate elasticity of the surface of the skin seems to have been rubbed away. Indeed the whole tone has changed, turning the skin from flesh to leather. Some of this is due to old varnish, but, as we can see from the whiteness of the ruff, the varnish is not exceptionally yellow.

Too much heat was applied, and this has browned the paint; at the same time the heat may have caused the protective paper or muslin to adhere too strongly to the surface, leading to damage

76
Detail from Giovanni Battista Moroni, *A man with discarded armour*, c. 1554–58, oil on canvas, 202.3 × 106.5 cm, National Gallery, London

when it was detached. The damage to the area to the right of the ear was perhaps caused by an accident of this kind, especially if muslin, which is harder to remove, was used.[45]

Damage like this is far from being the worst problem an overhot iron can cause. The heat can dry out the paint, turning it to crumbly powder. The nineteenth-century restorer Henry Mogford, who was working around the time this painting by Moroni was last restored, and who had experience of contemporary lining practice, described the following kind of disaster: "Pictures have been so burnt, that either a total and irremediable discoloration has ensued, or they have become so dried and perished, that the particles have only been kept together by being abundantly imbued with stiff varnish. In the latter case the picture can never again be cleaned; in attempting to do so, the whole would come away from the canvas."[46]

Besides too much heat, too much pressure has been applied, as Penny observes. It is possible that the liner did not keep the iron perfectly flat, but allowed one edge to dig into the canvas – an error warned against in instructions for lining. But even an iron held flat, if pressed too hard, could have caused the extensive, disfiguring crackle. As we observed above (p. 95), paintings before the eighteenth century are often painted on thin grounds, and the crackle on a canvas will follow the weave of the cloth beneath it. In our discussion of craquelure we treated this as if it were an effect of nature, but sometimes it is not. Pressure applied to a canvas during lining can push the weave of the canvas into the paint, so cracking it. And heat, by softening the paint, will make the problem worse: which is why a painting which has been scorched will often have a very obtrusive craquelure, and vice versa.[47] Fig. 75 provides us with one example of this dual phenomenon, and fig. 65 with another.

A closer look at fig. 65 reveals another effect of too much pressure. The surface is not only extensively cracked: the thread of the canvas has been pushed down so hard that it has buckled and pitted the paint. The lining seems to have occurred while the painting was varnished, because spots of varnish were caught in little depressions of the pitted surface when the picture was subsequently cleaned, and these have now turned brown. A number of these spots can be seen in the sky above the left shoulder of the man in this detail. This particular pattern of varnish, crushed into the thread pattern of the canvas, is common in paintings which have been too heavily lined.[48]

Note in the portrait in fig. 75 that the craquelure is more obtrusive in the blacks. As we have already said (p. 93), lead white is an exceptionally tough paint, and will provide some resistance to crackling; any area of the painting which has no or little lead white will be more likely to undergo extensive damage. At the same time,

77
Detail from Giovanni Battista Moroni, *Canon Ludovico di Terzi*, c. 1559–60, oil on canvas, 101.5 × 82.7 cm, National Gallery, London

blacks are often very fragile. The reasons for this will be discussed later, in Chapter Five.

It should be emphasized that the painting in fig. 75 was not scorched and crushed by the National Gallery's restoration department. It has not been lined, cleaned or restored in any other way since it entered the Gallery in 1865, and what we see here is archaeological evidence of nineteenth-century, or possibly eighteenth- or even seventeenth-century, lining practice. Not that all linings of paintings before the twentieth century resulted in damage of this kind. The painting in fig. 76 was also first lined over a century ago; it entered the National Gallery in 1876 in a lined state. When the first lining began to deteriorate it was relined in late 1969. Nevertheless, the painting is, in Nicholas Penny's view, "in exceptionally good condition".

Compared to the portrait in fig. 75, of course, it is. But when compared to fig. 77, its condition seems slightly wanting. To be sure, the flesh does not have the smoky colour we see in fig. 75. The skin still has the pinky creamy tones of real skin. At the same time, it has a certain blotchiness to it. There are greyish patches all across the face, as if the topmost layer has partially flaked off, revealing a cooler underpaint. This may be due to an over vigorous cleaning at some time in the past, but it also seems possible, especially given the peculiar nature of the scars – which are reminiscent of a similar patchiness on the skin in fig. 75 – that the paint in fig. 76 suffered damage when protective paper or muslin was peeled off at the end of the lining process.[49]

Restorers have long been aware of the dangers of ironing, and over the past 60 years devices have been invented in order to line pictures using less heat and pressure. There are still conservators who line with irons, since in their opinion if the job is done with skill and care it will not damage the painting, but many restorers today prefer to carry out this operation on a 'low-pressure cold table'. This has evolved from an invention introduced into conservation in the 1950s, the 'vacuum hot table', which had in its turn evolved from the 'hot table'.

The hot table was just that: a table the surface of which could be heated. Most important, the heat could be adjusted and regulated, so that it was impossible to apply too much heat to a painting placed on top of it. The canvas and the lining canvas were put on the table and brushed with adhesive, and the heat of the table provided the right amount of heat to melt the adhesive. Then they were put together, laid on the hot table, and brushed to free any air bubbles trapped between the two.[50]

This was an improvement, but it was soon found that mere brushing was not enough. More pressure was needed in order to

fix and impregnate the canvasses, especially when the paint was badly cupped and needed to be reflattened. In order to achieve these goals, the hot table was fitted with a sheet of rubber or PVC, and a suction pump was attached so that all the air could be sucked out from beneath the sheet. Atmospheric pressure flattened the sheet on to the canvas, providing a more evenly distributed form of pressure than had been possible with irons.[51]

This device was taken up with great enthusiasm. As one conservator wrote, "the thrill of receiving one's first hot table is an unforgettable experience to most restorers".[52] However within a decade it became clear that the vacuum hot table also had its drawbacks. It provided a very safe overall pressure, but too much of it, and a problem encountered in traditional lining – of the weave of the canvas leaving an imprint on the paint surface (fig. 65) – was made worse by the vacuum method. In fact it was not merely a case of the original canvas being pressed into the paint; often the lining canvas came through as well, and sometimes the different weaves of the original canvas and the lining canvas set up 'moiré patterns', interference effects which produced wavy arabesques or criss-cross markings on the surface of the picture.[53] The dotted lines on the face of the dying Leonardo in Ingres's history piece (fig. 78) are similar to those one sees on printed photographs that are copies of other printed photographs, but in this case they are on the painting itself.[54]

78
Detail from Jean-Auguste-Dominique Ingres, *The Death of Leonardo da Vinci in the Arms of François I*, 1818, oil on canvas, 40 × 50.5 cm, Petit Palais, Paris

These problems with the vacuum hot table led to the development of the low-pressure cold table.[55] If too much heat and too much pressure were the problems, then clearly a way had to be found to use less of both. But in order to achieve these aims, the adhesives used up till then needed to be replaced.

As noted in passing above, the purpose of most lining interventions is not simply to glue a new canvas on to the back of the old. The aim is also to re-attach any cupping or flaking paint. To this end, the canvas, the ground and any chinks and fissures in the paint are impregnated with adhesive, which soak through in a molten state and so attach cupping and flaking paint from the back.[56] Unfortunately these adhesives can cause a number of side effects as they do so.

In the early days of lining the adhesive used was normally some kind of size, often mixed with flour paste. Some restorers still use a similar mixture today. Sturgeon glue (isinglass) is much used by conservators in Russia, while in Italy 'pasta-lining' with wheat starch paste is a traditional adhesive.[57] As we have already noted, a disadvantage of any glue is that it provides food for fungi, microbes and bacteria.[58] Modern glue lining adhesives contain anti-fungoid agents to counter this problem, while in the nineteenth century creosote was used to the same end, but neither preventative is particularly effective.[59] And the other disadvantages of glue, its tendencies to swell and contract and cause cracking, have always stood against it.[60]

In the eighteenth century restorers who were looking for an alternative to glue began instead to use wax. This solved the problem of cracking, but in the twentieth century it was discovered that wax darkens the canvas and ground, and also makes the paint surface more brittle and easier to abrade. To overcome these failings, resin was added to the wax, but after some decades it was found that wax-resin has all the same drawbacks, and in addition swells the paint layer so it cracks.[61]

In any case, glue, wax and wax-resin need heat and pressure if they are to melt and saturate the canvas, ground and paint layers. Since the 1930s, restorers have been looking for an adhesive which would avoid subjecting paintings to these forms of stress. Numerous synthetic adhesives of various kinds have been introduced, all of which have their champions, but none of which, so far, has triumphed over its competitors. It is hoped that these adhesives will behave better than their predecessors over the long term. Some of them can be used on the low-pressure cold table, which uses a movement of air to create suction, rather than a full vacuum, and which can be used either cold or at low temperature. Too much heat and too much pressure can now be avoided.[62]

Although methods of lining which appear to be safer and more effective have been developed, the greatest change in lining practice over the past forty years has been a new attitude – a reluctance to line at all. Whereas, in the past, lining was a routine, now it is an exception. No previously unlined painting has been lined at the National Gallery in London since 1976.[63] Instead, an unlined canvas will have its tacking edges strengthened, or will be 'strip-lined', where thin strips of canvas or other material are glued on to all four sides. If the paint surface is flaking, its individual flakes may be treated one by one. Instead of heating whole paintings with hot tables and lining irons, small heated spatulas are used precisely where they are needed. [64] If the flaking has gone too far to make this practicable, then treatments have been developed on the vacuum hot table which allow the paint to be softened in solvents and gently pressed flat.[65] The doctrine today is one of minimal intervention, and the lining factories of the past have been shut down.

This new attitude is welcome, but so far as sixteenth-, seventeenth- and eighteenth-century paintings are concerned, it has come too late. A recent survey of unlined paintings from the period before 1800 in museums around the world managed to find just 43.[66] Nevertheless, unlined paintings from the period after 1800, which are more common – figs. 111 and 115 are examples – may be spared lining in future.

Unlined canvasses are often in excellent condition, but so too are some lined canvasses. When carried out well, lining can be undetectable without careful examination of the back of the painting. At the same time, many paintings which were in a dangerous condition have now been consolidated and made sound for centuries to come. If some paintings were ruined by poor lining in the past, most were not. It is easy to exaggerate the dangers of lining. But between good linings and disastrous linings there are many more which, while they have not ruined a picture, have made alterations to its tone and colour which subtly undermine the artist's intention. We will return to these issues in Chapter Five.

Lining is a treatment for paintings on canvas, but many of the processes involved in lining have also been applied to panels. Like canvasses, panels have undergone impregnation with glue or wax-resin, they have been ironed, and they have been sucked on to vacuum hot tables. They have also been put through treatments which canvasses rarely or never undergo, such as transfer and flattening. If it is true to say that panels today are in marginally better condition than canvasses, that is only because they have not

TREATING WOOD

received as much routine conservation of this kind. The restorer David Bomford recounts how a colleague at another museum once told him that a painting on canvas in perfect condition had been wax-lined in order to 'preserve' its perfection. In the post-lining era, anecdotes like this are recounted with a sigh; as Bomford writes, "our definition of perfection has undergone a sea change since then".[67] Before that sea change, however, lining was considered by many to be a positive boon. Canvasses were lined whether they needed it or not.

Panels have not had to face this blanket attitude: when they are in good condition they have usually been left alone. But when they have been discovered cupping, flaking or warping, they have had to undergo conservation techniques just as severe as those applied to canvasses.

Cupping or flaking on panel has in the past been dealt with using methods like those de Mayerne recommended for cracked paint. The front of the panel was brushed with glue, wax or wax-resin, and ironed flat with a lining iron (in the post-ironing era, pressure has been applied instead by the spatula or the vacuum pump). All the dangers and disadvantages of canvas lining – heat, pressure, adhesives – were also present in these methods of treating wood.[68]

Ironing a flat surface is easy enough, but ironing a bent surface is difficult. At the same time, until quite recently, a warped panel was considered aesthetically inferior to a flat panel. Ever since the eighteenth century, therefore, panels have been forcibly flattened, by planing them down and attaching a wooden cradle to the back.[69] Sometimes the planing is very severe; Holbein's 'Ambassadors' (fig. 56) is just 5 mm thick. The panel – which, as we have already noted, is formed of ten separate planks (p. 84) – was made this thin so that it could be forced flat by a cradle. Cradles consist of fixed struts, glued to the panel parallel to the grain, in which slots are cut so that moveable struts, arranged perpendicular to the grain, can slide freely. A cradle of this kind will certainly hold a 5 mm thick piece of wood flat, but unfortunately the thinner the wood, the more it will try to warp; and if it is unable to do so, it will split, crack, blister or flake instead.[70] 'The Ambassadors' has done all of these things numerous times (fig. 57), and has only settled down now because for the past sixty years it has been exhibited in air-conditioned galleries, where constant humidity and temperature levels keep the oak stable.[71]

The Ambassadors has to be held in some kind of restraint due to its multi-plank construction, but simpler paintings on single panels can be allowed to warp, and in the current attitude of minimal intervention that is what they often do. For the most part a bowed painting is perfectly enjoyable as it is, and it is hard to see

why so much effort was devoted to flattening panels in the past.

Warping aside, wood has a more serious failing as a support: it provides food for fungi, and for the larvae of a number of common beetles. Everyone knows how rot and woodboring larvae can reduce healthy wood to a powdery, spongy mass of flakes, and the supports of many paintings have been reduced to a similar state.[72] Today, badly deteriorated wooden panels are usually treated by soaking them in synthetic resins (whole sculptures can be consolidated in the same way). These fill up the holes and make the panel hard enough to saw.[73] But from the middle of the eighteenth century until well into the twentieth, the normal treatment for a rotten panel was simply to replace it.

This replacement, or 'transfer', is probably the most impressive of all the techniques of restoration, and also the most obviously

79
Raphael, The Mackintosh
Madonna, c. 1509–11, oil on
canvas, transferred from
wood, 78.8 × 64.2 cm, National
Gallery, London

80

Rembrandt van Rijn, Self-
portrait, 1640, oil on canvas,
102 × 80 cm, National Gallery,
London

dangerous. The paint layers were entirely removed from their
rotten support. There were two main ways of doing this. In one,
the panel was destroyed; in the other it was preserved. If the panel
was to be destroyed, it was planed and chiselled away, or eaten with
nitric acid. If the panel was to be preserved, the ground was eroded,
either by steaming it, or by subjecting it to acidic vapours, and the
panel was lifted away. In both methods, the aim was to remove not
merely the panel but also the ground, so that the back of the paint
itself could be seen. Another support, either a panel or (more often)
a canvas, was given a preparatory ground, and the paint surface was
glued and ironed down on to it.[74]

The restorers who invented this method in eighteenth-century
Italy clearly had strong nerves, and it is surprising that the procedure
has not completely destroyed more paintings. One panel that seems
to have suffered badly from the operation is Raphael's Mackintosh
Madonna (fig. 79). This was treated with nitric acid, probably in
gaseous form, and it seems that something went wrong: the image
we see now is almost entirely repainted.[75] But it would be misleading
to give the impression that this is a typical outcome of the transfer

81
Rembrandt van Rijn, Self-
portrait, 1639, etching on
paper, 20.5 × 16.4 cm, British
Museum, London

technique. Rogier van der Weyden's *Magdalen Reading* has also been
transferred (fig. 22) – the wood of the painting's panel is mahogany,
a tropical timber unknown in Europe in Rogier's day – and yet the
surface of the painting is for the most part in excellent condition.[76]

In between this disaster and this success story there are many
paintings which are in a fit state to exhibit to the public, but which
have nevertheless been altered by the transfer process. Rembrandt's
Self-portrait of 1640 (fig. 80) has been transferred from canvas to
canvas, and while at first sight it seems to have survived the ordeal
quite well, the more one compares it with the artist's etched self-
portrait of the year before (fig. 81), the more it becomes clear that
half-tones and shadows have been flattened and details of texture
gone missing. Sebastiano del Piombo's *Raising of Lazarus* (fig. 82)
has been transferred twice, once from panel to canvas, and once
from canvas to synthetic panel. The effects of the first of these
transfers was described as follows by Henry Mogford:

> This important specimen at once elucidates all the advantages and
> disadvantages of the procedure. The picture is so far preserved,

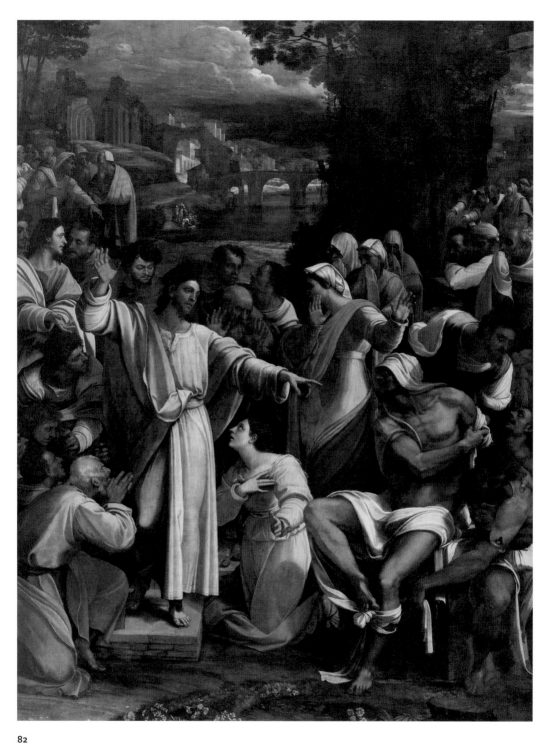

82
Sebastiano del Piombo, *The Raising of Lazarus*, c. 1517–19, oil on canvas, transferred from panel, 381 × 289.6 cm, National Gallery, London

that the paint lays smoothly enough on a canvas base, and will probably (that is the canvas) last for a great number of years. The evil has become apparent, for the picture is irremediably dyed throughout with a dark tone, arising from the penetration into the colours of the great mass of paste and glue which was consumed in attaching it to the new canvas. Another evil ensued: this thick mass of farinaceous and glutinous matter called into existence myriads of worms, which for a time threatened to devour the entire picture, until they were poisoned by the application of the corrosive sublimate of mercury.[77]

The attack of the worms – probably flour or biscuit beetles, in the opinion of more recent researchers – did indeed take place, and is noted in the National Gallery's records for the year 1837;[78] but Mogford's claim that the painting has been darkened by an excess of glue is more controversial. The painting does seem oddly fragmented, with light, highly coloured areas standing out in islands from the brown and black areas that envelop them. It is very easy to suppose that something has gone badly wrong with the overall tone of the painting. But is this an effect of glue? Many paint samples have been taken from this painting, and it is hard to see evidence of glue darkening the paint (fig. 43). In most of the samples glue is clearly visible, but it lies in a smooth, placid layer just beneath Sebastiano's primer. And while it has discoloured to a dark greenish-brown, it is so deep in the paint structure that it is almost certainly invisible from the surface.[79] But if glue has not caused the darkening, what has? This is a question to which we will return in Chapter Five.

As we have already noted in passing, the transfer technique could also be applied to fresco (p. 38 and fig. 28), and sometimes it needed to be.[80] Fresco has a reputation for great permanence: Vasari held it to be the most durable of painting techniques.[81] It is nevertheless the case that wall paintings are often in very poor condition. Unlike easel paintings, which enjoy domestic temperatures, mural paintings are typically to be found in churches and other buildings which, even if heated, are likely to be cool or cold in winter. With chilly temperatures come condensation and humidity, and with humidity can come various kinds of micro-organism.

Wall paintings can be attacked from two directions. Should the wall become damp, either through leaks in the structure of the building or capillary action from the ground, then salts and fungi are likely to grow in the wall. Besides causing efflorescence on the

83
Piero della Francesca, *The Exaltation of the Cross*, 1452–66, fresco, 747 × 390 cm, Basilica di San Francesco, Arezzo

surface of the painting, these intrusive elements can also weaken the plaster so that it powders and falls away. Anyone who has faced a damp problem in a cellar will be familiar with these symptoms.

In fig. 83 we see a mural painting by Piero della Francesca which appears to have suffered from a leaking roof, and has lost a large strip of plaster as a result.[82] This kind of damage to mural paintings is far from unusual, and many frescoes, in Italy and elsewhere, are defaced with areas of blank plaster.

However, the loss of plaster is not the only form of attack a wall painting can suffer. Besides attacking frescoes from behind, erupting out of the wall to which they are fixed, bacteria and fungi can also inhabit the front of the painting. All they need to live and breed happily on the surface are some nutrients, and these are provided by the egg or glue binders used in painting *a secco*. Vasari's preference for *buon fresco* had a conservational rationale. Microbes can feed off the binder in an area of *secco*, and when they have devoured it, the pigments it enclosed will fall to the ground.[83]

In Piero della Francesca's painting, there are numerous passages where we can see that the *secco* has been destroyed. Most immediately noticeable is the blank patch in the centre of the composition, where there are fragmentary remains of green paint,

which once perhaps depicted foliage. Then there is the large hat being lifted by the figure at right; it seems unlikely that this was originally white, and the same can be said of the white peaked hat held in the hand of a kneeling figure before him. The blue cape of the clean-shaven man kneeling in the same line of figures may look as if it is an ornate brocade, but closer inspection reveals that it is threadbare, much of the blue having been eaten away.

When we look at a detail of the fresco (fig. 53) we can see that, as well as consuming binders, bacteria and fungi also stain and discolour the surface. The yellowish blotches on this young man's hat and on the sky were surely not laid down by Piero's brush; they are more likely marks left by fungi and bacteria. The restorer adding *tratteggio* infills has echoed colours produced not only by the artist, but also by microbes devouring his work.[84]

Besides feeding off the *secco* and leaving unsightly stains, microbes can also destroy *buon fresco*; the acidic secretions of micro-organisms can dissolve the plaster into which pigments are locked. Bacterial and fungal secretions can even change the colours of certain pigments, such as azurite, malachite, umber, lead white, red lead and yellow massicot.[85]

An interesting example of azurite turning green can be seen in a detail of a fresco from the fourteenth century, a fresco which, at

84
Attributed to Pietro Nelli, *The Death of Saint Anthony*, 1370s, fresco, Cappella di Sant'Antonio Abate, ex Chiesa di Santa Maria a Le Campora, Florence

the time that this photograph was taken, had never been restored (fig. 84). Here the sky appears in three colours – red, blue and green. The red is the underpaint, laid down in *buon fresco* – a typical feature of Florentine mural painting at this time, when red often formed the underlayer for blue. The blue is the final colour, painted *a secco*, which originally covered the entire sky. The red and the blue were painted by the artist, but the green was not; this is an effect of microbial attack. Micro-organisms feeding on the binder in the blue paint have secreted acetic acid, and this has turned blue azurite into green copper acetate. This green region of the *secco*, then, is in the course of being devoured; the red is the area from which the binder has already been eaten: the blue is the area which will be eaten next – although, at the time of writing, conservators are preparing to restore the frescoes, which will put an end to the microbes' meal.[86]

Microbial attack is one cause of colour change, but there are also other causes, not all of which are well understood. We will discuss a number of these in the chapter that follows.

NOTES

1 Déon, *Conservation*, 91-92; Stout, *Care of Pictures*, 26-42, 50-51; Marijnissen, *Dégradation*, I, 130-38, and for further literature see II, 464; Ruhemann, 'Criteria for Distinguishing Additions', 150; Keck, 'Mechanical Alteration'; Bomford and Roy, 'Hogarth's *Marriage*', 47-49; Bucklow, 'Description of Craquelure'; Bucklow, 'Description and Classification', Bucklow, 'Classification of Craquelure'; Kirsh and Levenson, *Seeing Through Paintings*, 152-59.

2 Friedländer, *Art and Connoisseurship*, 193.

3 For a discussion of the condition of this painting see Campbell, *Fifteenth Century Netherlandish Paintings*, 174-211 (although he is not troubled by the craquelure).

4 Margriet van Eikema Hommes, *Changing Pictures*, 205-06, suggests that the crackle pattern in dark areas may be drying cracks, caused by an excessive use of siccative. Nicholas Penny (see p. 111) argues that the phenomenon can be caused by heavy, hot ironing during the lining process. See too Nicolaus, *Restoration*, 122, 202, where he points

out that black painted areas become hotter than white areas during ironing.

5 De Burtin, *Traité*, I, 416-17; Church, *Chemistry of Paints*, 131; GettensKühn and Chase, 'Lead White', 69-70.

6 However, examples of paintings on copper with pronounced craquelure are not very hard to come by: see, for example, Frans van Mieris the Elder, *A woman in red feeding a parrot*, c. 1663, 22.5 x 17.3 cm, National Gallery, London, NG840.

7 Berger and Russell, 'Interaction between Canvas and Paint'; Dunkerton and Howard, 'Sebastiano', 29; Berovič, 'Biodeterioration'.

8 Mogford, *Hand-Book*, 37, 40-41 (Bomford and Leonard [eds.], *Readings II*, 240); Marijnissen, *Dégradation*, I, 326, 341-43; Ruhemann, *Cleaning of Paintings*, 153; Émile-Mâle, *Restauration des Peintures*, 84; Kelly, *Art Restoration*, 145-46; Berovič, 'Biodeterioration', 55-58; Seves et al., 'Microbial Degradation', 124-25; Nicolaus, *Restoration*, 192, 204-07; Dunkerton and Howard, 'Sebastiano', 29; Petersen and Klocke, 'Micro-

organisms and insects', 695-99.

9 Bucklow, 'Description of Craquelure'; Bucklow, 'Description and Classification'; Bucklow, 'Classification of Craquelure'.

10 Ibbetson, *Accidence or Gamut*, 1-2; Bucklow, 'Description of Craquelure'.

11 Mérimée, *Peinture à l'huile*, 101-02. Needless to say this simple account does not cover all cases: Bucklow, 'Classification of Craquelure', 287-88.

12 Bomford and Roy, 'Hogarth', 47-49.

13 Vigne, 'Ingres and Co.', 534, writes that the face of the muse in this portrait of Cherubini by Ingres was executed by Henri Lehmann, adding that "the bitumen used by Lehmann to add sheen to the Muse's skin revealed all too well the quality of his participation. The entire figure is eroded, whereas that of the musician still demonstrates the excellence of the materials chosen by Ingres, who always maintained a prudent distrust of the seductive product that destroyed so many Romantic paintings."

14 Bothe, 'Asphalt', 124.

15 *In the Conservatory* can be studied in high resolution online at googleartproject.com.

16 Stout, *Care of Pictures*, 40; Percival-Prescott, 'Lining Cycle', 4-5; Karpowicz, 'Cracks'.

17 De Mayerne, *Pictoria Sculptoria*, 102-04, 312-14.

18 Von der Goltz et al., 'Consolidation', 373.

19 Petersen and Klocke, 'Microorganisms and insects', 695.

20 Marijnissen, *Dégradation*, I, 136-38, II, 374-75; Nicolaus, *Restoration*, 185-87.

21 Campbell, *Fifteenth Century Netherlandish Paintings*, 342-45.

22 Verougstraete et al., *Restaurateurs ou Faussaires*, esp. 28-29, 46-47, 72-75.

23 Friedländer, *Altniederländische Malerei*, p. 34. He may, however, have possessed a photograph of the panel in its damaged state, so would have known that it had been heavily restored: Laemers, 'A Matter of Character', 160. Friedländer's complex relations with Renders are analysed in detail by Laemers.

24 Laemers, 'A Matter of Character', 157. Lugt was not the first to question the paintings in the Renders collection, and was aware of the public accusations originally levelled in a review by Friedrich Winkler: Laemers, 'A Matter of Character', 150-57. See Fry, 'Renders Collection', for a description of the widespread suspicion surrounding the Renders paintings: although Fry himself concluded that "the general result of my examination was astonishment at the powerful effect of suggestion even on the minds of learned and competent students of art history; for I found no evidence in the pictures themselves which could bring them under suspicion of being forged", Lugt noted on a piece of paper inserted into his copy of the Royal Academy exhibition catalogue: "see the naive article by Roger Fry in the Burlington Magazine": Laemers, 'A Matter of Character', 158. I am grateful to Suzanne Laemers for discussing these issues with me.

25 Sanderson, *Graphice*, 16: "It is said that *Laniere* in *Paris*, by a cunning way of tempering his Colours with Chimney Soote, the Painting becoms duskish, and seems ancient; which done, he roules up and thereby it crackls, and so mistaken for an old Principall, it being well copied from a good hand". Nicolaus, *Restoration*, 187, describes forging craquelure by pulling the canvas over the edge of a table.

26 Walpole, *Anecdotes of Painting*, 250. Robert Woodcock, the composer and painter, is said by Walpole to have "copied above forty pictures by Vandevelde", 336. I am not claiming that the painting in fig. 71 is by Woodcock, but then again I am not sure it is by Van de Velde.

27 Stout, *Care of Pictures*, 53-60; Marijnissen, *Dégradation*, I, 138-40; Keck, 'Mechanical Alteration', 21-23; Kelly, *Art Restoration*, 140-42; Nicolaus, *Restoration*, 189-207.

28 Verougstraete et al., *Restaurateurs ou Faussaires*, 72-75; Marijnissen, *Dégradation*, II, 374-75.

29 The painting has been restored since this photograph was taken. I thank Jean-Luc Baroni for letting me see the work in its cleaned state.

30 Skinner, 'Tideman'.

31 Doerner, *Materials of the Artist*, 382; Marconi, 'Unusual Examples', 78-79; Berger, 'Effects of Adhesives', 131; Berger, 'Use of Water', 66-68;

Bomford with Dunkerton and Wyld, *Conservation*, 40; Young, 'History of Fabric', 119.

32 Stout and Pease, 'Paint cleavage'; Thornton et al., 'Deterioration', 333-34; Horovitz and Reifsnyder, 'Slate or stone'. Thornton et al. are writing of lacquer on furniture and the others are describing paintings on stone, but the argument is still used to justify the cleaning of pictures on canvas and panel: for a recent instance see Curie and Pasquali, *Restoration*, 383. I thank Michel Favre-Félix for discussing this matter with me.

33 Ingamells, *Wallace Collection*, IV, 271.

34 Cifferi, 'Microbial Degradation', 880.

35 Davidson, *Frick Collection*, 50-52; Levenson, 'Emergency preparedness', 722.

36 Penny, *Venice 1540–1600*, 210; von der Goltz, Birkenbeul et al., 'Consolidation', 369.

37 Bedotti, *Restauration*, 23; Ruhemann, *Cleaning of Paintings*, 53; Bomford with Dunkerton and Wyld, *Conservation*, 40. See too Bomford, 'Conservator as Narrator'.

38 On the early history of lining, see Marijnissen, *Dégradation*, I, 33-35; Nicolaus, *Restoration*, 117-18, 123, 136; Massing, *Painting Restoration*, 23, 98-102.

39 Nicolaus, *Restoration*, 80-84.

40 Watelet and Lévesque (eds.), *Encyclopédie Méthodique*, II, 776-77; Ibbetson, *Accidence or Gamut*, 17-18; Mérimée, *Peinture à l'huile*, 257-58; Paillot de Montabert, *Traité*, IX, 700-01; Déon, *Conservation*, 1-4; Mogford, *Hand-Book*, 39-48 (reprinted in Bomford and Leonard [eds.], *Readings II*, 239-44); Dover, 'Restoration', 184-87; Doerner, *Materials of the Artist*, 382-85; Stout, *Care of Pictures*, 67-68; Laurie, *Painter's Methods and Materials*, 235-36; Marijnissen, *Dégradation*, I, 324-26; Kelly, *Art Restoration*, 145-50; Messens, 'Hand Lining'; Lucas, 'Lining and Relining Methods'; Wehlte, *Materials and Techniques*, 579-81; Émile-Mâle, *Restauration*, 34-39; Bergeon, *"Science et Patience"*, 43-73; Nicolaus, *Restoration*, 117-30; Baroni, *Restauro*, 50-69; Massing, *Painting Restoration*, 98-102; Hackney et al., 'Lining'.

41 Mogford, *Hand-Book*, 42 (Bomford and Leonard [eds.], *Readings II*, 240-41); Penny, *Venice 1540–1600*, 210.

42 Goya, *Life in Letters*, 264; de Burtin, *Traité*, I, 90, 409, 421-43; Marijnissen, *Dégradation*, I, 326-27; Kelly, *Art Restoration*, 146; Percival-Prestcott, 'Lining Cycle'; Hackney, 'Texture and Application', 24; Bomford, 'Moroni's "Canon Ludovico di Terzi"', 37; Townsend, 'Turner's Oil Paintings', 58; Kirsh and Levenson, *Seeing Through Paintings*, 174-77; Massing, *Painting Restoration*, 121, 278-81. Cf. van de Wetering, 'Autonomy of Restoration', 194-95, for remarks which show that Van Gogh was blasé about the crushing of his impasto.

43 Penny, *Bergamo, Brescia and Cremona*, 200-05 (fig. 76), 224-27 (fig. 77), and 247-49 (fig. 75). Although the portrait of Lodovico di Terzi has not been lined, it has been treated in other ways; it has been cleaned, strip-lined, and had paint buckling and cracking flattened, using solvent vapour on the vacuum hot table: see Bomford, 'Moroni's "Canon Ludovico di Terzi"'.

44 Penny, *Bergamo, Brescia and Cremona*, 247.

45 De Burtin, *Traité*, I, 412, 421, 425; Mérimée, *Peinture à l'huile*, 258; Mogford, *Hand-Book*, 43 (Bomford and Leonard [eds.], *Readings II*, 241); Percival-Prestcott, 'Lining Cycle', 13. Dossie, *Handmaid*, II, 381-87, suggests that the protective muslin be removed with acid.

46 Mogford, *Hand-Book*, 46-7 (Bomford and Leonard [eds.], *Readings II*, 243). Cf. Laurie, *Painter's Methods and Materials*, 236.

47 Kelly, *Art Restoration*, 150; Penny, *Bergamo, Brescia and Cremona*, 247, as quoted on p. 111. Spike Bucklow has suggested to me (personal communication) that heat would be likely to melt paint, making it hard to crack. Compare the discussion of the effects of heat (and solvent) on paint films in Erhardt et al., 'Long-Term Processes'.

48 For other examples of this phenomenon see Penny, *Bergamo, Brescia and Cremona*, 45 (Giovanni Cariani [?], NG 1203); Penny, *Venice 1540–1600*, 186 (Follower of Jacopo Tintoretto, NG 3647), 192 (Domenico Tintoretto [?], NG 173) and 269 (Titian, NG 3948). See

too Émile-Mâle, *Restauration des Peintures*, ills. 28 and 29.

49 This was not caused by the *re*lining of the canvas; on photographs of the painting taken before 1969, the blotches are already there.

50 Ruhemann, 'Impregnation and Lining'; Nicolaus, *Restoration*, 136.

51 Straub and Rees-Jones, 'Marouflage'; Ruhemann et al., 'Some Notes on Vacuum Hot Tables'; Slabczynski, 'Vacuum Hot Table'; Marijnissen, *Dégradation*, I, 328-30; Ruhemann, *Cleaning of Paintings*, 153-55; Kelly, *Art Restoration*, 150-52; Nicolaus, *Restoration*, 124-27, 136.

52 Percival-Prestcott, 'Lining Cycle', 12.

53 Newman, 'Method for Lining Canvas', 31; Berger, 'Weave Interference'; Percival-Prestcott, 'Lining Cycle'; Cummings and Hedley, 'Surface Texture Changes'.

54 I thank Pauline Chapelain of Agence Roger-Viollet for information concerning this painting.

55 Mehra, 'Low-Pressure Cold-Relining Table'; Mehra, 'Cold Lining'; Reeve et al., 'Low-Pressure Table'; Walden, *Ravished Image*, 149; Mehra, *Foderatura a freddo*; Nicolaus, *Restoration*, 124, 128-30, 138.

56 Marijnissen, *Dégradation*, I, 201-03, 332-41; Ruhemann, *Cleaning of Paintings*, 150; Émile-Mâle, *Restauration des Peintures*, 83-86.

57 Mogford, *Hand-Book*, 40-41 (Bomford and Leonard [eds.], *Readings II*, 240); Ruhemann, *Cleaning of Paintings*, 150-53; Percival-Prestcott, 'Lining Cycle'; Newman, 'Method for Lining Canvas'; Yashkina, 'Sturgeon Glue'; Baldini and Taiti, 'Italian Lining Techniques'; Keck, 'Lining Adhesives'; Émile-Mâle, *Restauration des Peintures*, 34-36; Young and Ackroyd, 'Mechanical Behaviour', 85-86; Nicolaus, *Restoration*, 140-41; von der Goltz, Birkenbeul et al., 'Consolidation', 370-71; Hackney et al., 'Lining', 416-23.

58 Mogford, *Hand-Book*, 37, 40-41 (Bomford and Leonard [eds.], *Readings II*, 240); Marijnissen, *Dégradation*, I, 326, 341-43; Ruhemann, *Cleaning of Paintings*, 153; Émile-Mâle, *Restauration des Peintures*, 84; Kelly, *Art Restoration*, 145-46; Berovič, 'Biodeterioration', 55-58; Seves et al., 'Microbial Degradation', 124-25; Nicolaus,

Restoration, 192, 204-07; Dunkerton and Howard, 'Sebastiano', 29; Petersen and Klocke, 'Micro-organisms and insects', 695-99.

59 Seves et al., 'Microbial Degradation', 124-25.

60 Stout, *Care of Pictures*, 40; Percival-Prescott, 'Lining Cycle', 4-5; Karpowicz, 'Cracks'.

61 Kelly, *Art Restoration*, 146; Berger and Zeliger, 'Wax Impregnation of Cellulose'; Berger, 'Some Impregnating Effects', 131-32; Émile-Mâle, *Restauration des Peintures*, 84; Walden, *Ravished Image*, 150; Bomford and Staniforth, 'Wax-Resin Lining'; Bomford with Dunkerton and Wyld, *Conservation*, 40; Hackney et al., 'Lining', 424-33.

62 Berger, 'Lining of a Torn Painting'; Berger, 'Lining and Mounting with BEVA'; Émile-Mâle, *Restauration des Peintures*, 36-38; Fieux, 'Lining Adhesives Compared'; Nicolaus, *Restoration*, 127, 141-43; Bria, 'Synthetic Consolidants and Lining Adhesives'; Tomkiewicz et al., 'Instead of lining', 396-400; Hackney et al., 'Lining', 438-52.

63 Bomford, 'Conservator as Narrator', 5.

64 Ackroyd, 'Structural Conservation'; Villers, 'Introduction'; Nicolaus, *Restoration*, 105-16; Tomkiewicz et al., 'Tear mending'.

65 Bomford, 'Moroni's "Canon Ludovico di Terzi"'. Cf. Berger, 'Use of Water'.

66 Kirsh and Levenson, *Seeing Through Paintings*, 262. Twelve of the 43 are by Velázquez. The authors do not claim that their list is complete, and there are of course many unlined paintings in other museums and private hands. The paintings listed by Kirsh and Levenson have never been lined; paintings today are sometimes 'delined': Hackney et al., 'Lining', 437.

67 Bomford, 'Conservator as Narrator', 6-7. See similar comments in Young and Ackroyd, 'Mechanical Behaviour', 85-6.

68 Koester, *Ueber Restauration*, I, 16; Doerner, *Materials of the Artist*, 385; Rosen, 'Preservation of Wood Sculpture', 45-51; Stout, *Care of Pictures*, 98-99; Marijnissen, *Dégradation*, I, 201-03, 334-35, 364; Ruhemann, *Cleaning of Paintings*,

149; Berger, 'Vacuum Envelope for Panel'; Émile-Mâle, *Restauration des Peintures*, 83-84 and ills. 51-56; Nicolaus, *Restoration*, 212-20; McClure, 'History of Structural Conservation', 239; Reeve, 'Structural Conservation of Panel Paintings', 404; von der Goltz, Birkenbeul et al., 'Consolidation', 370. De Burtin, *Traité*, I, 412 and Paillot de Montabert, *Traité*, IX, 698-99, give accounts of similar treatment for canvasses with blisters.

69 Émile-Mâle, *Restauration des Peintures*, 28-30; Nicolaus, *Restoration*, 53-65; Rosen, 'Preservation of Panel Pictures'; Schiessl, 'History of Structural Panel Painting Conservation'; McClure, 'Conservation of Panel Paintings'; Ackroyd, 'Structural conservation'.

70 Buck, 'Is Cradling the Answer?'; Wyld and Plesters, 'Sassetta', 7; Bomford, 'Introduction', xx; Rothe and Marussich, 'Florentine Stabilization Techniques', 312; Glatigny, 'Backings', 364; Nicolaus, *Restoration*, 62-65; Reeve, 'Structural Conservation of Panel Paintings', 411; Brewer, 'Practical Aspects', 455.

71 Wyld, 'Restoration History of Holbein's Ambassadors', 11-14.

72 Émile-Mâle, *Restauration des Peintures*, 21-23; Nicolaus, *Restoration*, 25-39.

73 Schniewind, 'Consolidation of Wooden Panels'; Nicolaus, *Restoration*, 45. Before the introduction of synthetic resins many other ingredients were used, some with unhappy results: Rosen, 'Preservation of Wooden Sculptures'; Schiessl, 'Panel Painting Conservation', 212-13; Nicolaus, *Restoration*, 41-44.

74 Watelet and Lévesque (eds.), *Encyclopédie Méthodique*, II, 777, 779; de Burtin, *Traité*, I, 423-24; Paillot de Montabert, *Traité*, IX, 703-07; Déon, *Conservation*, 13-17; Mogford, *Hand-book*, 35-39 (reprinted in Bomford and Leonard [eds.], *Readings II*, 237-9); Forni, 'Transfer'; Doerner, *Materials of the Artist*, 380-81; Marijnissen, *Dégradation*, I, 35-37, 46-49; Ruhemann, *Cleaning of Paintings*, 156-61; Émile-Mâle, 'First Transfer'; Émile-Mâle, *Restauration*, 39-40; Bergeon, *"Science et Patience"*, 75-95; Nicolaus, *Restoration*, 65-70; Émile-

Mâle, *Histoire de la restauration*, 258-87; Conti, *History of Restoration*, 142-57; Massing, 'Restoration Policy'; Massing, *Painting Restoration*, 34-49.

75 Nicolaus, *Restoration*, 69. When the transfer of this painting was first carried out by Robert Picault it was considered a great success, but his transfers usually needed restoration shortly after: Massing, *Painting Restoration*, 36-39.

76 Campbell, *Fifteenth Century Netherlandish Paintings*, 394-95.

77 Mogford, *Hand-Book*, 37 (Bomford and Leonard [eds.], *Readings II*, 238).

78 Dunkerton and Howard, 'Sebastiano', 29.

79 On this, see the discussion of Sebastiano's *Holy Family* on p. 169.

80 Watelet and Lévesque (eds.), *Encyclopédie Méthodique*, II, 779; Paillot de Montabert, *Traité*, IX, 707-09; Secco-Suardo, *Restauratore*, 208-46; Conti, *History of Restoration*, 254-62; Reille-Taillefert, *Peintures murales*, 71-76.

81 Vasari, *Vite*, I, 50; Vasari, *On Technique*, 222. See too the enthusiastic defence of the same view in Claude Robin's article on fresco in Watelet and Lévesque (eds.), *Encyclopédie Méthodique*, I, 318-21. Mosaic, encaustic and enamel may perhaps boast similar degrees of permanence.

82 Since this photograph was taken, the gap has been filled in with 'deceptive' *tratteggio*, some of which can also in be seen in the detail of this fresco in fig. 53.

83 Ciferri, 'Microbial Degradation'; Laiz et al., 'Microbial Communities'; Karbowska-Berent, 'Microbiodeterioration'; Reille-Taillefert, *Peintures murales*, 46-50.

84 This analysis is speculative, and my own.

85 Karbowska-Berent, 'Microbiodeterioration', 294.

86 Bracci et al., *Cappella di S. Antonio*. On red as an underlayer for blue in frescoes, see Forni, *Manuale*, 42; Thompson, *Materials of Medieval Painting*, 72. On azurite turned into copper acetate by microorganisms secreting acetic acid, see Karbowska-Berent, 'Microbiodeterioration', 294. I thank Laura Fenelli for her advice and assistance in my discussion of this fresco.

4.
IMPERMANENT PIGMENTS

If Apelles's paintings had not all been lost, they might still be in good condition. We are told by Pliny that he and his contemporaries used just four pigments – a white from Melos, a yellow ochre from Attica, a red earth from Pontus, and black made from burnt ivory.[1] It is clear that he was not a very colourful artist, but what he put down on to the panel was unlikely to change in hue, since yellow ochres, red earths and bone blacks are among the most stable of pigments.

Apelles was using a palette which had proved itself over a very long period of time: three of his pigments had been in use since the Palaeolithic. Yellow ochre and red earth, both varieties of iron oxide, provide the colours of animal hides at Altamira and Lascaux.[2] Ivory black may have been used in cave painting – there must have been a fair amount of tusk to hand – but since ivory black is identical to black made by burning any other kind of animal bone, it is impossible to be sure. Bone black certainly was used in prehistoric times, together with charcoal. Apelles is credited by Pliny with the invention of ivory black, but, if he really did this, he had no reason to be proud: he had just made bone black for a much higher price.[3] Over the centuries many artists have thought that ivory makes a better black than ordinary animal bone, but this is probably because, in the words of a recent article on the subject, 'ivory being less commonly available, ivory black was more carefully made'.[4]

As for the white from Melos: this has puzzled historians, since there is no obvious source of white on the island, no calcite or chalk or lime or lead, the usual ingredients of white in Apelles's day. However it has recently been suggested that Apelles was not using any of these traditional substances for his white, but that the

pigment in his paintings may have contained an ingredient which, it used to be thought, was not found in paint before the twentieth century – titanium dioxide. There is a seam of kaolin on the island of Melos which contains titanium dioxide as an impurity, and some of this titanium-rich kaolin has been found in pigments on artefacts scattered around the former Roman empire. It may be, then, that the white from Melos used by Apelles was mined from the same source.[5]

This possible oddity aside, Apelles's palette was prehistoric, and if he had painted on cave walls rather than panels we might be able to enjoy his art today: the subdued colours he used could have lasted for tens of thousands of years. Whether Apelles knew this, and was guided by the conscious aim to paint in a durable fashion, we do not know, since there is so little literary evidence from antiquity about attitudes towards pigments. We know that authors from Cennini onwards were very aware of the problem of discoloration,[6] but our ancient sources, Theophrastus, Pliny and Vitruvius, have less to say, though there is one passing remark which shows that the ancient world was aware of at least one aspect of the problem. Vitruvius tells us that vermilion sometimes blackens, and in this he was perfectly right.[7]

VERMILION

Vermilion is normally a bright red pigment, with a hint of orange. It is found in nature as cinnabar, mercuric sulphide, but by the eighth century AD chemists across Eurasia had learned how to make it artificially, and so most of the vermilion that appears in post-antique art, both in Europe and the Far East, was manufactured rather than mined.[8] Not that it is easy to tell the difference. Even when looking down an electron microscope, artificial vermilion can be hard to distinguish from cinnabar.[9]

Vermilion is a capricious pigment. It can keep its hue for millennia – well-preserved vermilion has come down to us from Roman times – but will sometimes turn black or grey.[10] In fig. 85 we can see some examples of this darkening, on the robes of St Mary Magdalene at left, and on the garment of the priest with the raised arm. Note that the darkening is not entirely random, but seems to have some pictorial logic: there is more discoloration in the shadows than on the lights. Although the reasons for vermilion's darkening are still being researched, it has been found that the pigment is much more likely to change hue if it is used in a pure form, on the surface of a painting. In fig. 85, the pigment blackens where it is laid down pure in the shadows, but when it is used to paint the highlights it is mixed with red lead, which prevents its discoloration.

Vermilion darkening occurs most frequently on tempera paintings. That is not because the pigment reacts with the egg binder – there are examples of this darkening on paintings bound with oil, too. It seems rather that artists became increasingly aware of the problem of vermilion darkening, and learned how to avoid it. By the time tempera gave way to oil as the most common binder, the pigment's vagaries were widely known. [11]

Fifteenth-century Netherlandish painters seem to have been the first to understand vermilion's character and to treat it with the appropriate caution. For the reds in Rogier van der Weyden's *Magdalen reading* (fig. 22), vermilion was used in the underlayer, while the upper surfaces were glazed with a red lake. [12] The brightness of vermilion shines through the red lake glaze to give a forceful hue, but it is kept beneath the surface and so prevented from darkening. [13]

85
Detail from Jacopo di Cione,
The Crucifixion, c. 1369–70,
egg tempera on wood,
154 × 138.5 cm, National
Gallery, London

Red lake is not a single pigment, but a group of pigments. The most common in painting are madder lake, brasilwood lake, lac lake, kermes lake and cochineal lake. They are all produced by a similar chemical process. The lakes are soluble vegetable or animal dyes which are turned into pigments by making them react with insoluble powders. Madder and brasilwood are plant dyes; lac, kermes and cochineal (the latter two are known together as carmine) are dyes produced from powdered insects. When these dyes are put into a retort with an alkali and some alum, a red precipitate is formed. This precipitate can be mixed with a binder to make red lake paint.[14]

Madder and brasilwood often have a scarlet hue, while lac and carmine tend towards crimson, with a faint flush of blue. Like the dyes on which they are based, the lakes have a tendency to fade. We can see clear examples of lake fading on the robe of the fainting Virgin Mary in fig. 85, and on the robe of Christ in fig. 96. The paint in both cases is carmine, which has turned from a rich crimson to a patchy light pink. For an idea of what a well-preserved carmine looks like, see the robe of Christ in fig. 89.[15]

The red lakes were often combined with white to make pink, and as a result it is hard to tell by eye if a red has faded to pink or if it was meant to be pink from the outset. It is only by means of technical examination that this kind of question can be answered. A sample from the robe of Christ in Sebastiano del Piombo's *Raising of Lazarus* (fig. 82) has been examined through the microscope, and it shows that a layer of red lake has whitened at its surface. As a result, we can say for sure that the highlights of Christ's robe are lighter than Sebastiano intended.[16] On the other hand, the robe of Saint John the Evangelist in fig. 85 was thought to be faded red lake, until the analysis of paint samples showed that its colour was a pale pink from the start.[17] There may well be faded lakes on the garments of the Virgin and the boy at the right of Michelangelo's *Manchester Madonna* (fig. 31), and on the garment of the woman kneeling at the front of Raphael's *Transfiguration* (fig. 9), but, without looking beneath the surface of the paint, it is impossible to be certain.[18]

In appearance, the lakes are very translucent in oil, although they are relatively opaque in other binders. In oil, then, they tend to be glazed over more opaque pigments such as vermilion, as in the painting by Rogier van der Weyden (fig. 22). When a lake is used to cover vermilion, its fading will be practically invisible, since the red below the surface takes the place of the red that has vanished. The two pigments support one another's frailties: the vermilion counteracts the fading of the lake, and the lake protects the vermilion from darkening.[19]

Although the vegetable and insect red lakes are little used in

painting today, synthetic dyes precipitated on to inorganic materials were still occasionally used as red paints in the twentieth century. One of the most famous, or rather notorious, of these was 'lithol red', a bright colour which much appealed to Mark Rothko. A series of paintings he made for Harvard University, which combined lithol red and artificial ultramarine, were placed in a very sunny position which quickly faded the reds. Crimsons and pinks turned violet and blue in the space of twenty-five years.[20]

Red lead is close in hue, intensity and opacity to vermilion, though rather more orange. Their similarity of appearance has led to a similarity of name in various languages. Pliny called vermilion *minium*, and red lead *minium secundarium* (though, with time, red lead has taken over the name *minium* as its own). In Chinese, vermilion is called *zhu*, while red lead is called *zhufen* – vermilion powder.[21]

There is a naturally occurring mineral called minium – lead tetroxide – and it is chemically identical with red lead. However it is not common, and the pigment has been made artificially since at least the fifth century BC, by heating lead white.[22]

Red lead has long had a bad reputation as a pigment, not only because it is poisonous, but also because it is said to discolour. This accusation is well-founded, but it depends on the medium in which the pigment appears. In tempera and oil, it holds its colour well. On wall paintings, in watercolours and in manuscripts, however, it can turn chocolate brown or black.[23] This phenomenon is particularly common in Chinese and Japanese art. In a print by Hiroshige (fig. 86), what was meant to be the bright red foliage of autumn has turned a brown so dark that in places it is nearly black. An idea of what it was supposed to look like can be seen in a better preserved version of the same print (fig. 87).

The precise cause of this discoloration has not yet been established. It is known that exposure to the air makes darkening more likely. The fact that wall paintings and works on paper and parchment are particularly prone to this shift in colour may also suggest a microbiological cause. As we saw above (p. 126), acetic acid can turn azurite into green copper acetate; it can also turn red lead tetroxide into black lead dioxide. Perhaps this is another case of microbial acid secretion changing a colour – it is clear from the foxing of the paper that fungi have visited this copy of the print. But this is not the only possible cause. Hydrogen sulphide, a gas that can be found widely even in air-conditioned museums, tarnishes metals and also darkens red lead.[24]

86
Utagawa Hiroshige, *Red Maple Trees at the Tsûtenkyô Bridge*, from the series *Famous Views of Kyoto*, c. 1834, woodblock print, ink and colour on paper, 23.5 × 36.8 cm, Department of Asia, British Museum, London

87
Utagawa Hiroshige, *Red Maple Trees at the Tsûtenkyô Bridge*, from the series *Famous Views of Kyoto*, c. 1834, woodblock print, ink and colour on paper, 23.5 × 36.8 cm, Museum of Fine Arts, Boston

Besides turning black, red lead can also turn white, and there are two different kinds of whitening. In the first, a chalky surface is caused by an unexplained chemical reversion to lead white. In the second, the red lead 'saponifies', that is, it reacts with linseed oil to form fatty acid soaps. These soaps coagulate over time within lead-containing paints, and when seen through the microscope they rather resemble fat or gristle (fig. 43). Sometimes they are so large and prominent that they are visible as small white bumps on the surface of the paint, making for a gritty appearance. And sometimes so many are formed that the original colour is extinguished in a thin layer of semi-translucent white soap (in the uppermost layer in fig. 43 no red lead particles remain).[25]

We will encounter these lead soaps again in the following chapter; it has recently been argued that they are a leading cause of darkening in paintings. 'Saponification' is currently a key word in conservation circles. It is the saponification not of red lead that has attracted most of the attention, however, but rather of white lead. The theory, as we shall see, is that lead soaps make white lead more translucent, allowing the dark of grounds and supports to be seen through paint layers containing the pigment; and since very many layers contain white lead, that leads to a darkening of the image.

For now we will observe only that saponification does not always turn red lead translucent, or dark: it can make it whiter. We see a good example of this in Sebastiano del Piombo's *Raising of Lazarus*

(fig. 82). The peculiar tint of the cloak of St John the Evangelist (fig. 44), light like orange mousse, was not intended by Sebastiano. What has happened here, as the cross-section in fig. 43 shows, is that a layer of red lead, lying on top of a layer of red lead and red lake, has saponified, almost entirely turning into white soaps. Originally the cloak was a rich tangerine colour, but now it is a great deal paler.[26]

REALGAR AND ORPIMENT

Like vermilion and red lead, realgar and orpiment are closely related, although their affinity goes deeper than mere appearance. They are both varieties of arsenic sulphide, and indeed, when exposed to strong light or heat, realgar can turn into orpiment and vice versa. Both occur in nature, and both can also be manufactured artificially. They are poisonous, foul-smelling, hard to work and slow-drying, and artists used them as little as they could; but they provided very beautiful colours, orpiment a bright golden yellow, and realgar a rich ruddy orange.[27]

Unfortunately these colours do not normally survive well in paintings. According to Cennini, orpiment could not be used either in *buon fresco* or *al secco*, since it blackened when exposed to the air.[28] Both orpiment and realgar can also whiten in air, and orpiment has a tendency to fade. In easel paintings the pigments could be put to some use, and were often combined, with the yellow

88
Detail from Marco Marziale, *The Virgin and Child with saints*, 1507, oil on wood, 221.5 × 143 cm, National Gallery, London

89
Ugolino di Nerio, *The Betrayal of Christ*, c. 1324–25, tempera on poplar, 40.5 × 58.5 cm, National Gallery, London

of the orpiment as the highlight and the orange of the realgar as the shadow. The effect may have been pleasant at the time, but it has often deteriorated since. The orpiment fades and the realgar lightens and the result is an odd, blotchy effect (fig. 88).

The fading of orpiment can have some strange effects when it is mixed with blues in order to make green. In fig. 89 the trees were painted using a standard technique for all kinds of foliage at the time; first the shadows were painted as a black shape, and then leaves were painted on top in green, a mixture of orpiment and azurite and black. The black has survived, but the azurite has darkened and the orpiment has largely disappeared. This fading of the orpiment has had an even odder effect in the foreground, where green plants have almost entirely vanished, leaving no more than faint grey ghosts on the earth.[29]

The poisonous nature of realgar and orpiment can affect their relations with other parts of the painting. Besides being incompatible with all lead- and copper-based paints, areas of a picture covered in orpiment and/or realgar can be prone to flaking and blistering. The retouches painted in to cover the gaps add to the general effect of patchiness.[30]

Orpiment and realgar more or less disappeared from the palettes of European painters once chrome yellow and cadmium yellow and orange became available in the nineteenth century.[31]

The yellow lakes were made in a similar way to the red lakes, by forming a precipitate from yellow dyes and insoluble powders such as alum. There were, however, no yellow-dye-producing insects to grind down; yellow lakes are all based on vegetable dyes. Plants widely harvested for yellow dye in European painting before 1700 included weld, buckthorn and broom. Of the three, the most often used was weld (*Reseda luteola*), a plant which grows wild on waste spaces (but was also cultivated) and has various names in English, including Dyer's Rocket, Dyer's Weed and Yellow Weed.[32]

Another difference between the yellow lakes and the red lakes is that artists discovered, apparently around the beginning of the seventeenth century, that they could improve the colour of the dye by adding chalk. Weld went from being a sombre brownish yellow to being a bright greenish yellow, which was very useful for combining with blues to make leaves and grass. In the short term, this must have been a great improvement, but in the medium and long terms the results have often been ruinous, since lakes based on chalk are even more prone to fading than lakes based on alum.[33]

Yellow lakes are not used in their pure form very often in art; they are normally mixed with blues to form green. Most of the damage done by their fading comes therefore in the depiction of landscape and plants, where their departure leaves the foliage looking blue – we saw the same effect earlier in tapestry (fig. 21). Claude Lorrain's *Jacob with Laban* (fig. 90) is a good example of

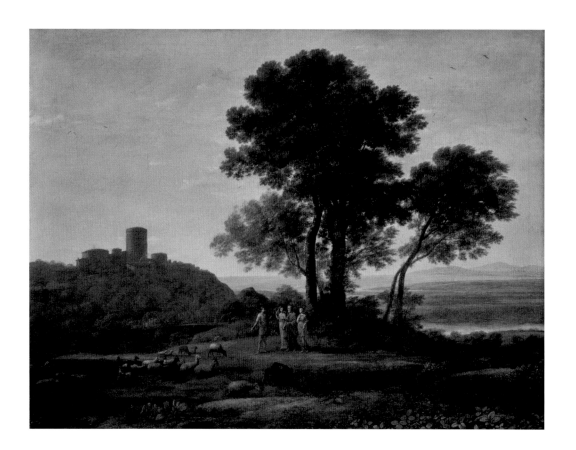

90
Claude Lorrain, *Jacob with Laban and his Daughters*, 1676, oil on canvas, 94.5 × 72 cm, Dulwich Picture Gallery, London

what can happen in painting. Some may find the blueness of this landscape appealing; by giving even the plants in the foreground the colour of the distance it lends a certain drowsy dreaminess to the scene. But it was not what Claude intended. Hockney's reconstruction of the Claude in the Frick Collection (fig. 13) may not capture the exact greens of the original, but certainly the grass from which his sheep are eating seems more realistic and appetizing than the patchy blue herbage under Laban's flock.[34]

Seventeenth-century yellow lakes were particularly unstable, but in earlier times, when the lakes were made using alum rather than chalk, they sometimes held their colour well. The green draperies in fig. 89 are made from a mixture of azurite and weld lake, with lead tin yellow in the highlights, and while they may be a touch bluer than originally intended, they are still decidedly green.[35]

Since orpiment and the yellow lakes were unstable, it might be asked why they were mixed with blues to make greens. One answer is that the principal green pigment was hard to use, had a tendency to turn brown, and had an aggressive nature not dissimilar to that of orpiment. When used on paper or silk, especially in hot countries, it could devour and destroy the support.

Verdigris is formed artificially by making copper react with vinegar. The immediate result of this reaction is a blue crust of copper acetate, which is broken off and sold in lumps. This can then be ground down into a turquoise powder, to form a turquoise paint.[36]

Turquoise, but not for long. One of the peculiarities of verdigris is that, although at first it is turquoise, within a month it has turned green.[37] Artists who use it must paint in the knowledge of how it will appear, rather than how it does appear. This chameleon effect is much stronger in oil than in tempera or watercolour; the change in colour comes about due to the reaction of the pigment with its binder. One can already see that artists without a strong visual memory might prefer to mix yellow lake with blue, and have a green that would at least look green while they were using it. And besides, verdigris had a reputation for discoloration, one which it deserved.[38] This reputation may have been worsened by a practice which was common in Europe in the fifteenth and sixteenth centuries (and seems to have originated in Carolingian times) of dissolving verdigris in balsam or turpentine to form a resinous green glaze, copper resinate.[39] It has recently been shown that oleoresinous media can contribute to the discoloration of verdigris.[40]

That this is not a universal law is shown by one of the best-preserved greens in fifteenth-century art, on the dress in the Arnolfini Portrait (fig. 64). This was painted with a copper resinate glaze, drawn over a verdigris, yellow and white underlayer.[41] Verdigris can discolour and corrode, but it can also hold its colour well. The variability of its behaviour could be the result of variations in its mode of production. Impure copper and odd kinds of vinegar may have produced slightly different substances. Manufacturers of verdigris were perhaps unable to distinguish good and bad batches of verdigris, and so were forced to sell goods of differing quality.[42] Even technicians as accomplished as Rogier van der Weyden (fig. 22) and Hans Holbein (fig. 56) did not always obtain perfect results with the pigment. The bright greens in the *Magdalene Reading* and the '*Ambassadors*' look slightly soiled – the verdigris is beginning to turn. The garment of the angel in Marco Marziale's altarpiece is frankly filthy (fig. 88), and much of the landscape in Titian's *Sacred and Profane Love* has entirely blackened (fig. 91).[43] It is only by comparing this last to the same artist's *Bacchus and Ariadne* (fig. 59), where the verdigris has for the most part survived

Titian, '*Sacred and Profane
Love*', c. 1514, oil on canvas,
118 × 279 cm, Galleria
Borghese, Rome

well, that one can get some sense of the effect he was trying to
achieve.[44]

Titian is not the only artist whose greens have turned dark
brown. There are many black and brown trees in medieval and
Renaissance art, and while some of them were brown to begin with
(e.g. in fig. 82, and the tree at top right in fig. 59), many were not.
Originally Antonio del Pollaiuolo's *Apollo and Daphne* (fig. 92) was
set in a lush green landscape.[45]

In both the Borghese Titian and the Pollaiuolo, the verdigris has
done more than brown. It is also beginning to seep out and stain the
area around it.[46] Verdigris attacks its surroundings, and its corrosive
tendency can even devour its support.[47] It has proven particularly
destructive in Asian art, where many manuscript illuminations and
devotional images have been destroyed by verdigris dissolving their
paper or silk.[48] An example of the harm it can do is visible in the
coloured drawing by Muḥammadí in fig. 93. Here the two trees by
the stream were once bright green, and have browned; but besides
discolouring, they are also visibly eating away at the paper on which
they were painted.[49]

In Far Eastern art, and especially in Japan, the green of choice
was not verdigris but malachite. This pigment is blue when ground
fine and a slightly bluish green when ground coarsely. The gritty
texture of the green paint makes it hard to use as a glaze like copper
resinate, and it is not so pure a green as verdigris. It is, however,
much more stable: the green in fig. 17 is very worn and somewhat
faded, but after 900 years it is still recognizably the same hue as the
green in figs. 86 and 87.[50] Malachite was less often used in Europe,
although in the fifteenth century it went through a period of
popularity with Italian tempera painters. Unfortunately they tended
to finish it with a copper glaze, and this has usually discoloured.[51]

92
Antonio del Pollaiuolo,
Apollo and Daphne, c. 1470–80,
oil on wood, 29.5 × 20 cm,
National Gallery, London

Like realgar and orpiment, malachite and azurite are close relations
at the chemical level. Malachite is green copper carbonate, and
azurite is blue copper carbonate.[52] Azurite has a tendency to turn
green (fig. 84 and pp. 125–26), and it has long been thought that in
doing this it is turning into malachite.[53] However, recent research
suggests that the change may be due to azurite becoming copper
chloride, or copper acetate.[54] As we have already seen (pp. 125–26),
it seems that this is sometimes caused by microbiological activity.[55]

Malachite was already being made artificially in the fifteenth
century, but azurite was generally used in its mined form. Since
it often appears intermixed with malachite particles in nature,

AZURITE

93
Muḥammadí, *'Fête champêtre'*, late 16th century, ink, gouache and gold on paper, 22.5 × 14.7 cm, Department of the Middle East, British Museum, London, 1920,0917,0.302

it can take on some of this pigment's greenish hue even without discoloration. In fig. 89, the robe of Saint Peter, cutting off the ear of Malchas at the left, is an example of naturally turquoise azurite.[56]

Besides turning green, azurite can also turn black. The Virgin Mary sometimes has a black mantle, and this is usually discoloured azurite (fig. 94).[57] The phenomenon may be caused by the discoloration of the medium,[58] or possibly by varnish or dirt soaking into the texture of the paint, which tends to be coarse;[59] it has also been suggested that this darkening occurs as a consequence of the use of alkalis as cleaning agents.[60] It seems that in some cases the pigment is transforming itself at the surface into copper oxide, for reasons which are still not well understood.[61] Azurite was sometimes used as an underlayer, with ultramarine blue glazed over it, possibly as a way of saving the expense of

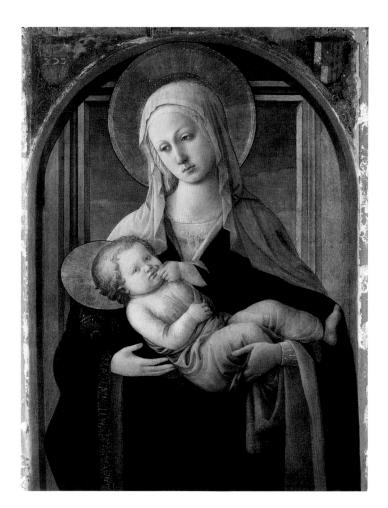

94
Fra Filippo Lippi and
Workshop, *The Virgin and
Child*, c. 1450-60, egg tempera
on wood, 76.6 × 61 cm,
National Gallery, London

ultramarine.[62] Sometimes, however, the ultramarine deteriorates
– more on ultramarine sickness in a moment – and the azurite
darkens, and the result is a rather unpleasant effect (see the cloak
of Christ in fig. 89, and the dress of Daphne in fig. 92).[63]

Deciding when azurite has and has not discoloured is not always
easy, since even when it is very well preserved (as in fig. 22) it is
a slightly wan pigment, which cannot really hold its own against
vermilion, red lead or verdigris. Only one blue before the eighteenth
century could stand up to this visual competition, and that was
ultramarine, ground from a stone quarried at Badakshan, in what
is now Afghanistan.

Ultramarine blue is probably the most famous of pigments, and yet few people can recognize it. Scholars have argued that viewers in the past were better able to identify its particular hue, and that they were sensitive to its appearance in paintings. Michael Baxandall, in a famous passage of his *Painting and Experience in Fifteenth-Century Italy*, wrote of the great cost of the pigment, "made from powdered lapis lazuli expensively imported from the Levant", and added that "painters and their public were alert to all this and the exotic and dangerous character of ultramarine was a means of accent that we, for whom dark blue is probably no more striking than scarlet or vermilion, are liable to miss. We can follow well enough when it is used simply to pick out the principal figure of Christ or Mary in a biblical scene, but the interesting uses are more subtle than this. In Sassetta's panel of *St Francis Renouncing his Heritage* in the National Gallery [fig. 95] the gown St Francis discards is an ultramarine gown."[64]

In fact it is not; it is a black gown. All the blues in this painting are indeed ultramarine, but the gown is not blue.[65] The blues are mostly light, not dark, because they have been mixed with white; only one, the gown of Francis's father, is dark, although originally it was less so. Here pure ultramarine has been glazed over silver, but the silver underneath has tarnished, darkening the blue.[66]

The true colour of unadulterated ultramarine is not often encountered, since it is usually either mixed with lead white or laid as a glaze over silver or other colours such as azurite (fig. 89) or grey (fig. 85), and, since it is very translucent, it picks up some of the hue of whatever is beneath it.[67] Only rarely is it applied thick and pure, so that the viewer can see its particular tint: one example is the deep shadow of the blue draperies in Titian's *Bacchus and Ariadne* (fig. 59).[68] Of course, not everyone could afford to lavish ultramarine so profusely. For those who were not as well funded as Titian, less pure grades of ultramarine were available, but Cennini warns us that the lowest grades, which were more grey than blue, "are worse than ashes".[69]

The claim that ultramarine had a special significance for contemporary viewers can easily be overstated. The visual difference between azurite (fig. 22) and ultramarine painted over azurite (fig. 89) is a small one. Even conservators can confuse the two; for some years the National Gallery's Conservation Department believed, incorrectly, that ultramarine had not been used in fig. 89.[70] Given that it is difficult to tell the two pigments apart, people in fifteenth-century Italy who were not professional painters must have found it hard to be alert to ultramarine accents. Nor is there much evidence that painters, who were better equipped to distinguish azurite from ultramarine, tried to use the latter in a

95
Sassetta, *Saint Francis renounces his Earthly Father*, c. 1437–44, egg tempera on poplar, 87.5 × 52.4 cm, National Gallery, London

consistently meaningful way. In the Sassetta, the pigment has been used randomly, to paint ceilings, clothes and the marbling on steps. In a picture by Pedro Campaña (fig. 96), ultramarine is used for draperies throughout the painting, but for the blue of Christ's cloak the artist chose to use the much cheaper smalt – which has since discoloured to brown.[71]

Ultramarine was often mixed with lead white, for a number of reasons. The first is an obvious one: few objects are very dark blue, and so by lightening the pigment's tone it could be used in more contexts. Then too ultramarine is a fairly slow drier, whereas lead white is a fast one, and could speed up the process of painting.[72] Another reason is that, when laid on pure, as already noted, ultramarine tends to be translucent, and if it is not applied thickly it will allow whatever is beneath it to determine its colour. Lead white, which is more opaque, improves its hiding power.[73] And ultramarine on its own tends to produce a rather granular paint which is hard to work; mixing it with white, or other pigments, makes it easier to handle.[74]

Ultramarine often survives well, as can be seen clearly enough in Titian's *Bacchus and Ariadne* (fig. 59)– albeit that much of the sky, as we saw in Chapter Two, is modern retouching. But for reasons which are still not understood, areas of ultramarine paint – even high-grade ultramarine – can sometimes turn blotchy and pallid. A striking example is provided by the undergarment of Signora Arnolfini (fig. 64), and we have already noted that the tabbard of her husband has an ultramarine glaze drawn over it which has deteriorated. The same disrupted, patchy effect can be seen in figs. 89 and 92, as well as in fig. 96, especially in the cape of Martha, the woman stretching her arm towards Christ.

Two main theories have been put forward to explain this 'ultramarine sickness'. One suggests that the pigment itself has lost its colour. Lapis lazuli turns grey when it comes into contact with acid, and various suggestions have been made as to how acids may have found their way into the paint, from sulphur dioxide in the atmosphere to alum in the ground. A different theory argues that the main cause of the sickness is not the discoloration of the pigment, but rather the deterioration of the medium around the pigment.[75]

There is no doubt that lapis lazuli can discolour in acid, but nevertheless it seems, from recent studies of paintings in which ultramarine sickness has occurred, that the particles of the pigment themselves are well preserved; the problem is that the medium around them has shattered into microcracks, which produce an effect of misty greyness. Quite why this should happen to some patches of ultramarine and not to others is under investigation.[76]

The misty greyness is known as 'blanching', and it is not

confined to ultramarine.[77] Other pigments are also connected with the phenomenon, including smalt, of which more in a moment, and green earth. These non-ultramarine forms of blanching are generally quite rare, but for some reason they are common in the work of some seventeenth-century artists, especially Poussin, Dughet, Claude and Cuyp. Claude's *Jacob with Laban* (fig. 90) is a typical example. Besides the bluing of the landscape due to yellow lakes fading, the painting also has large hazy areas which are hard to read. These are examples of blanched paint, caused by tiny cracks in the medium.

Blanching can also appear in varnish, where it looks like a white haze. The normal solution for this problem today is to remove the varnish, but in the 1860s a distinguished chemist, Max von Pettenkofer, invented a different system. Having realised that blanching was due to microfissures, he reckoned that if he could induce the varnish to swell, the fissures might close up again. To achieve this, he put paintings in boxes with alcohol, so that the vapours could melt the varnish and make it recoalesce. The results were promising but slow, and so to speed things up he rubbed the surface with a natural balsam called copaiba. This produced the desired effect, and for a time the Pettenkofer method was advocated as a scientific restoration practice.[78]

Unfortunately its benefits were short lived: within a few years the blanching returned. Moreover the effect of this treatment on the underlying paint layers was called into question. Recent studies have shown that paint treated in this way could become molten, with layers intermingling or disintegrating. The Pettenkofer

96
Pedro Campaña (after Federico Zuccaro), *The Conversion of Mary Magdalene*, about 1562, oil on panel, 29.8 × 58.6 cm, National Gallery, London

method is now widely condemned, but it is believed that much of the damage was caused by the copaiba balsam.[79] Experiments with the use of solvent vapours as a way of curing blanching have continued.[80] Thirty years ago the Claude in fig. 90 was treated with vapours of alcohol and dimethylformamide, with, apparently, "good results" – although, from the appearance of the painting today, the results seem not to have lasted very long.[81]

A more traditional treatment of blanching, which restorers sometimes still apply today, is to rub oil into the blanched areas. This works very well, in the short term, but as the oil yellows over time the areas end up darkened rather than blanched.[82]

Most of the pigments we have been discussing up till now are simple compounds, but ultramarine is not; the chemical formula of lapis lazuli is given variously and *inter alia* as $(Na,Ca)_8(AlSiO_4)_6(SO_4,S,Cl)_2$, $3Na_2O.3Al_2O_3.6SiO_2.2Na_2S$, and $Na_3Ca(Al_3Si_3O_{12})S$.[83] Unsurprisingly, medieval alchemy was unable to provide a synthetic alternative, and it was only in 1828, as the result of a prize competition, that artificial ultramarine was put on to the market.[84] This was chemically very similar to natural ultramarine, visually almost indistinguishable, and around a tenth of the price. Yet it has never put natural ultramarine entirely out of business; lapis lazuli has kept its mystique, and not followed poisonous pigments like orpiment, realgar and verdigris into history.

SMALT

Since both ultramarine and azurite were ground down from minerals rather than made artificially, their supply was conditional on reserves of ore. For a time in the sixteenth and seventeenth centuries known seams of azurite were mined out, leading to a general shortage of the pigment. This pushed up the price of ultramarine still further, leaving painters in need of an affordable blue.[85] Smalt, a form of glass manufactured from cobalt ore, quartz and potash, which had been used to make paint since medieval times, was pushed into production, even though everyone knew that it was far from satisfactory as a pigment for painting.[86]

Smalt is widely used in ceramics, and provides the blue in both Ming vases and Delftware. In fired glazes it is perfectly colourfast, but when used in paints it has a strong tendency to fade.[87] We have already seen one example of this in the cloak of Christ in fig. 96, but the faded appearance of smalt turns up in numerous other contexts. Sixteenth- and seventeenth-century art is full of grey-brown skies, where one might have expected to see a sunny blue expanse. One example is the sky in Pieter Pourbus's *Allegory of Love* (fig. 63); another is Pieter Bruegel's *Adoration of the Magi*

97
Pieter Bruegel the Elder, *The Adoration of the Magi*, 1564, oil on oak, 111.1 × 83.2 cm, National Gallery, London

(fig. 97). The discoloration of the smalt in Bruegel's painting is rather remarkable, since the pigment was also used for the cloak of the Virgin Mary, where it has held up fairly well in the highlights, although it has turned a dull greyish brown in the shadows.[88]

Besides having a tendency to fade, smalt is not easy to work. As a kind of glass, it is very translucent, and if it is ground fine it becomes colourless. It must therefore be left coarse – but then it does not mix well with oil. The paint is spread over the painting, but the oil separates out and trickles down the surface, like a badly made sauce. Painters tried to combat this problem in various ways. They kept the support flat when they were using smalt paint; and/or they set the oil down first, with a trace of white or black as needed, and then, when it had dried enough to be tacky to the touch, sprinkled the smalt on top. Indeed in Saxony, one of the main centres for smalt production, coarsely ground smalt was known as *Streublau*, 'strew-blue'.[89] Other methods to deal with smalt,

according to Karel van Mander, were to pucker the surface with the point of a nail before applying the paint, or to try to soak up the abundant oil with coarse paper; and some preferred to use a special oil, such as poppy oil.[90]

Without precautions of these kinds, smalt could sink into the oil while it was drying; but this was not the reason for its discoloration. It appears that the pigment reacts with its medium, leading to damage to both. The glass loses its potassium colourant and absorbs water, and the medium can either shiver into microcracks or turn an unappealing brown.[91]

INDIGO

Indigo, a blue bordering on black, was already used as a colourant in ancient Egypt. Besides being one of the oldest of dyes, it is also one of the most widespread, being known in Asia, Europe and pre-Columbian America. Like madder, brasilwood and weld, it is a vegetable dye, but unlike those three it is derived from a wide variety of plants. The most famous in Europe is *Isatis tinctoria*, woad, but there are many others in different parts of the world. About half of these are related members of the genus *Indigofera*.[92]

Indigo does not operate in the same way as the red and yellow lakes. The indigo material extracted from plants, once processed and dried, takes the form of hard, insoluble, blue-black lumps, looking much like a mineral (in the past they have often been mistaken for such). It can only be used as a dye once it has been reduced in a fermenting vat of alkaline substances. However, since it is solid and insoluble it can function straight away as a pigment, by being ground down and mixed with a binding medium.[93]

When dyeing wool, indigo is exceptionally permanent, as we have already seen (fig. 21). As a pigment it is much less so, being prone to fade in light.[94] A comparison of two different impressions of a Japanese woodblock print shows what could happen to the paint when it faded: it changed from a cool slate blue (fig. 98) to an insipid yellowy-brown (fig. 99).[95] At the other end of Eurasia, indigo caused the same problem (fig. 100). The background of this portrait by Cornelius Johnson was once grey-blue rather than grey-green. Some of the original colour is visible in the little patches of retouched paint, which were meant to match the hue of the indigo which has now vanished. This suggests that indigo may fade over long periods of time. A great deal of colour loss has occurred since the painting was last restored, and this restoration may have taken place centuries after the portrait was made. Perhaps the painting was moved into a lighter position after its restoration, bringing about a bleaching of the dye.[96]

98
Torii Kiyonaga, *A Pilgrimage to Enoshima*, c. 1789, woodblock print, ink and colour on paper, 39.1 × 78.2 cm, Museum of Fine Arts, Boston

99
Torii Kiyonaga, *A Pilgrimage to Enoshima*, c. 1789, woodblock print, ink and colour on paper, 39.1 × 78.2 cm, British Museum, London

PRUSSIAN BLUE

Prussian blue stands out from all the other pigments discussed in
this chapter by its youth. It was invented – or rather discovered by
accident, since its Prussian inventor was trying to make a red lake
– in 1704,[97] and its presence in paintings that were supposed to be
earlier has long stood as proof either of forgery or of intervention
by restorers.[98] It is chemically complex, if not as elaborate as
ultramarine: its principal components are iron and cyanide.[99] Until
the last quarter of the nineteenth century its production involved
the addition of blood or other animal remains.[100]

Like ultramarine it is very translucent, but at the same time it
has great tinting power. One drop of Prussian blue combined with
640 drops of lead white looks recognisably blue.[101] Within twenty
years of its discovery it had found its way on to the palettes of
leading artists, and long remained there – Picasso used a great deal
of it.[102] In the 1970s, however, it began to lose ground to a rival,
phthalocyanine blue.

Prussian blue is permanent when used pure, but starts to fade
when mixed with white.[103] Since, like indigo, it is a dark blue,

101
Thomas Gainsborough,
Mr and Mrs Andrews, c. 1750,
oil on canvas, 69.8 × 119.4 cm,
National Gallery, London

and there are only so many dark blue things in nature, this is a serious failing. However, the fading of Prussian blue, so far, is less noticeable than the fading of smalt or indigo. Few people can have noticed that the light blues in Gainsborough's *Mr and Mrs Andrews* (fig. 101) have discoloured; this is something which emerged from research by the National Gallery's Conservation Department. The blue patches in the sky are tending towards a yellowish grey, and in a few more centuries may be as subdued as the faded smalt in Bruegel's *Adoration of the Magi* (fig. 97). There are also dull, yellowy-brown patches on Mrs Andrews' skirt. The only pigments used by Gainsborough in these browned areas of the painting were (tarnished) Prussian blue and white.[104]

The yellowing of Prussian blue is thought to be caused by the oxidation of the paint, and is irreversible.[105] Its tendency to lose its hue was already noticed in the eighteenth century, and surprised no one: paints made from animal dyes – lac and carmine – had long had a poor reputation for permanence.[106]

Anyone who has been to a gallery of old European art knows that gold leaf was applied liberally to medieval paintings. What is less well known, because it is barely visible, is that silver was used too. Gold can flake away from its background, and it can darken with dirt, but it always remains gold – it does not tarnish. Silver, on the other hand, can and does turn grey or black.[107]

In Sassetta's painting of St Francis renouncing his earthly father (fig. 95), the gold on the background is still recognisable, even though it is flaking away from its red base. Gold was also used on the cope surrounding the naked St Francis, although it is now hard to read since the cope has turned brown – originally it was a bright, copper resinate green. Some silver can still be seen on the robe held by the saint's father, but the silver used to depict the two windows in the white wall above that robe has now turned black.[108] In Jacopo di Cione's *Crucifixion* (fig. 85), the helmets and armour of the soldiers in the background look like they were painted in a very dark grey, but again they are made from silver leaf; and the same is true of the helmets in Ugolino di Nerio's *Betrayal* (fig. 89). It would be impossible to be sure that any of these passages were made of silver if technical examinations had not been carried out.[109]

The tarnishing of silver can be caused by hydrogen sulphide, which, as we have already noted, is found even within a museum environment.[110] This poisonous gas has become more common with industrialization, but tarnishing is not a new phenomenon: Cennini wrote that "you are to work with silver as little as you can, because it does not last; and it turns black, both on wall and on wood, but it fails sooner on a wall".[111]

1 Pliny, *Natural History*, 35: xxxii. I am grateful to Peter Struycken for discussing this complex issue with me, and correcting a number of mistakes.

2 Helwig, 'Iron Oxide'.

3 Pliny, *Natural History*, 35: xxv.

4 Winter and FitzHugh, 'Carbon', 21.

5 Katsaros et al., 'Melian Earth'.

6 Van Eikema Hommes, *Changing Pictures*, esp. 17-50.

7 Vitruvius, *On Architecture*, 7: ix: 2.

8 Merrifield, *Fresco Painting*, xxiv-vii; Church, *Chemistry of Painting*, 166-67; Thompson, 'Artificial Vermilion'; Thompson, *Materials of Medieval Painting*, 106; Harley, *Artists' Pigments*, 125-28.

9 Gettens, Feller and Chase, 'Vermilion and Cinnabar', 171-72.

10 Cennini, *Craftsman's Handbook*, 24; Doerner, *Materials of the Artist*, 72; Church, *Chemistry of Painting*, 169-70; Thompson, *Materials of Medieval Painting*, 107; Gettens and Stout, *Painting Materials*, 170-73; Wehlte, *Materials and Techniques*, 105-06; Spring and Grout, 'Blackening of Vermilion'; van Eikema Hommes, *Changing Pictures*, 27-30; Keune, *Metal Soaps*, 93-112; van Loon, *Color Changes*, 65-8, 83-4; van Loon et al., 'Ageing and Deterioration', 237.

11 Bomford, Dunkerton, Gordon and Roy, *Art in the Making: Italian Painting before 1400*, 31-32, 147-52; Gordon, *Italian Paintings Before 1400*, 44-47.

12 Billinge et al., 'Materials ... Van der Weyden'.

13 Van Loon et al., 'Ageing and Deterioration', 238.

14 Church, *Chemistry of Painting*, 170-8, 183-7; Doerner, *Materials of the Artist*, 76-7; Thompson, *Materials of Medieval Painting*, 108-24; Gettens and Stout, *Painting Materials*, 110, 123-24, 126-27; Wehlte, *Materials and Techniques*, 110-13; Harley, *Artists' Pigments*, 131-47; Schweppe and Roosen-Runge, 'Carmine'; Schweppe and Winter, 'Madder and Alizarin'; Mills and White, *Organic Chemistry*, 142-45; Kirby and White, 'Identification of Red Lake'; Kirby, Spring and Higgitt, 'Technology of Red Lake Pigment'; van Eikema Hommes, *Changing Pictures*, 26-35; Van Loon et al., 'Ageing and Deterioration', 220.

15 Saunders and Kirby, 'Light-Induced Changes'; Spring, Penny, White and Wyld, 'Colour Change ... Pedro Campaña'.

16 Dunkerton and Howard, 'Sebastiano', 42.

17 Bomford, Dunkerton, Gordon and Roy, *Art in the Making: Italian Painting before 1400*, 33-34.

18 Plesters in Ruhemann and Plesters, 'Technique of Painting in a "Michelangelo Madonna"', on the basis of a paint sample identified as "a crimson lake dyestuff similar in reactions to madder lake" on the Virgin's dress in the Manchester Madonna.

19 Van Loon et al., 'Ageing and Deterioration', 238.

20 Cohn (ed.), *Rothko's Harvard Murals*; Standeven, 'Lithol Red'; Druzik and Michalski, 'Lighting', 687. For similar effects brought about in Van Gogh's paintings due to his fondness for 'geranium lake', see Vellekoop et al., *Van Gogh at Work*, 264.

21 FitzHugh, 'Red Lead and Minium'.

22 Thompson, *Materials of Medieval Painting*, 100-02; Gettens and Stout, *Painting Materials*, 152-54; Wehlte, *Materials and Techniques*, 103-05; Harley, *Artists' Pigments*, 123-25.

23 Higgitt et al., 'Pigment-Medium Interactions'; van Eikema Hommes, *Changing Pictures*, 12, 27-31.

24 Cassar et al., 'Air Pollution'. The effects of hydrogen sulphide were also discussed in the nineteenth century: Carlyle, 'Artist's anticipation of change', 63.

25 Van Loon, *Color Changes*, 65-68; Van Loon et al., 'Ageing and Deterioration', 220.

26 Dunkerton and Howard, 'Sebastiano', 41-43.

27 Thompson, *Materials of Medieval Painting*, 176-77; Gettens and Stout, *Painting Materials*, 135, 152; Wehlte, *Materials and Techniques*, 82, 93-94; FitzHugh, 'Orpiment and Realgar'; Dik, 'Jan van Huysum', 71; van Eikema Hommes, *Changing Pictures*, 28-31, 35-37, 62, 64; van Loon, *Color Changes*, 86-87; van Loon et al., 'Ageing and Deterioration', 221.

28 Cennini, *Craftsman's Handbook*, 26-7.

29 Gordon, *Italian Paintings Before 1400*, 433. For examples of similar

orpiment effects in Dutch art, see Dik, 'Jan van Huysum'.

30 Penny, *Bergamo, Brescia and Cremona*, 122-24.

31 Harley, *Artists' Pigments*, 93-94.

32 Church, *Chemistry of Painting*, 160-61; Doerner, *Materials of the Artist*, 66-67; Thompson, *Materials of Medieval Painting*, 163-69; Gettens and Stout, *Painting Materials*, 136, 151-52, 174; Wehlte, *Materials and Techniques*, 95-96; Harley, *Artists' Pigments*, 107-15.

33 Bergeon, *"Science et Patience"*, 159; Bomford, Brown and Roy, *Art in the Making: Rembrandt*, 24; Hermens and Wallert, 'Pekstok Papers'; Bomford, Dunkerton, Gordon and Roy, *Art in the Making: Italian Painting before 1400*, 37-39; Saunders and Kirby, 'Light-Induced Changes'; van Eikema Hommes, *Changing Pictures*, 25-32, 141-42, 147; van Loon, *Color Changes*, 72-73; Spring and Keith, 'Aelbert Cuyp'; van Loon et al., 'Ageing and Deterioration', 221.

34 Brachert, *Patina*, 62; Kirby and Saunders, 'Sixteenth- to eighteenth-century green deterioration', 157; Wine, *French Paintings*, 46.

35 Gordon, *Italian Paintings Before 1400*, 432-34.

36 Thompson, *Materials of Medieval Painting*, 163-69; Gettens and Stout, *Painting Materials*, 169-70; Harley, *Artists' Pigments*, 80-83; Kühn, 'Verdigris'.

37 Kühn, 'Verdigris', 135.

38 Cennini, *Craftsman's Handbook*, 33; Secco-Suardo, *Restauratore*, 384-86; Church, *Chemistry of Painting*, 200-01; Thompson, *Materials of Medieval Painting*, 165-67; Plesters, 'Cross-Sections and Chemical Analysis', 115, 125; Wehlte, *Materials and Techniques*, 124; Kockaert, 'Green and Brown Glazes'; R. and P. Woudhuysen-Keller, 'Thoughts', 133-34; Bergeon, *"Science et Patience"*, 157-58; Van Loon, *Color Changes*, 10, 68-71; Van Loon et al., 'Ageing and Deterioration', 219, 233-34.

39 Laurie, *Pigments and Mediums*, 35-38, 159, 165-66; R. and P. Woudhuysen-Keller, 'Thoughts'. Cf. Kühn, 'Verdigris', 148; van Eikema Hommes, *Changing Pictures*, 52. Copper resinate is greener than basic verdigris, which may account for some of its appeal: Kühn, 'Verdigris', 135.

40 Gunn et al., 'Copper Pigments and Oleoresinous Media'; cf. Gettens and Stout, *Painting Materials*, 170.

41 Campbell, *Fifteenth Century Netherlandish Paintings*, 182.

42 Van Eikema Hommes, *Changing Pictures*, 52-59.

43 Erwin Panofsky, *Studies in Iconology*, 150-51, suggested that the lighting in this landscape was symbolical of sacred and profane love: "the background of Titian's painting ... is divided into two halves, a dimly lighted scenery with a fortified town and two hares or rabbits (symbols of animal love and fertility), and a more rustic and less luxurious, but brighter landscape with a flock of sheep and a country church".

44 Lucas and Plesters, 'Titian's *Bacchus and Ariadne*', 40-41.

45 Thompson, *Materials of Medieval Painting*, 166; Plesters, 'Cross-Sections and Chemical Analysis', 125.

46 Bergeon, *"Science et Patience"*, 158.

47 Thompson, *Materials of Medieval Painting*, 164-65; Kühn, 'Verdigris', 137.

48 Bhowmik, 'Verdigris in Indian Painting'.

49 Canby, *Persian Painting*, 92.

50 Gettens and Stout, *Painting Materials*, 127-28; Gettens and FitzHugh, 'Malachite'.

51 Cennini, *Craftsman's Handbook*, 31-32; Thompson, *Materials of Medieval Painting*, 160-62; Wehlte, *Materials and Techniques*, 122-23; Lucas and Plesters, 'Titian's *Bacchus and Ariadne*', 40-41; Harley, *Artists' Pigments*, 79; Gettens and FitzHugh, 'Malachite'; Dunkerton and Roy, 'Materials ... Fifteenth-Century Panel Paintings', 24; Bomford, Dunkerton, Gordon and Roy, *Art in the Making: Italian Painting before 1400*, 41.

52 Gettens and Stout, *Painting Materials*, 95-96; Gettens and FitzHugh, 'Azurite', 23.

53 Wehlte, *Materials and Techniques*, 142; Harley, *Artists' Pigments*, 48; Gettens and FitzHugh, 'Azurite', 27.

54 Dei et al., 'Green Degradation'. Van Loon et al., 'Ageing and Deterioration', 218, suggest that darkening of the oil medium may also play a part, though this of course will not explain azurite discoloration in fresco.

55 Karbowska-Berent, 'Microbiodeterioration', 294.

56 Gordon, *Italian Paintings Before 1400*, 433. The cloak, however, is painted with a mixture of azurite and green earth.

57 Bergeon, *"Science et Patience"*, 155. Gordon, *Fifteenth Century Italian Paintings*, 156-61, does not say that the pigment used in the robe of Filippo Lippi's Virgin is azurite; but from its colour, and since it shows up dark in the infrared reflectograms she publishes, I assume that it is azurite. For the light appearance of ultramarine and the dark appearance of other blues in infrared reflectograms see Plesters, 'Ultramarine', 50-52. However this infrared test is not infallible; when the layer of ultramarine is very thin it can fail to appear as white. Bomford, Dunkerton, Gordon and Roy, *Art in the Making: Italian Painting before 1400*, 114, used the infrared argument to claim that Ugolino di Nerio's *Betrayal of Christ* (fig. 89) did not contain ultramarine. It appears that this was incorrect (Gordon, *Italian Paintings Before 1400*, 432-34).

58 Gettens and FitzHugh, 'Azurite', 27.

59 Thompson, *Materials of Medieval Painting*, 133-34; Gettens and Stout, *Painting Materials*, 95.

60 Thompson, *Materials of Medieval Painting*, 134-35; Bomford, Roy and Smith, 'Techniques of Dieric Bouts', 50; cf. Dei et al., 'Green Degradation', 83.

61 Gutscher et al., 'Azurite into Tenorite'; Gettens and FitzHugh, 'Azurite', 27; van Loon et al., 'Ageing and Deterioration', 220.

62 Cennini, *Craftsman's Handbook*, 55; Gettens and FitzHugh, 'Azurite', 25; Bomford, Dunkerton, Gordon and Roy, *Art in the Making: Italian Painting before 1400*, 36; van Eikema Hommes, *Changing Pictures*, 32-33.

63 Gordon, *Italian Paintings Before 1400*, 432.

64 Baxandall, *Painting and Experience*, 11.

65 Baxandall's mistake was made only in the first edition of his book; as he wrote in the preface to the second edition, he was made aware that the gown was black by the philosopher Richard Wollheim. He selected a different painting, Sassetta's *St Francis and the Poor Knight* (NG4757), to make the same point in subsequent editions. I do not know of any technical analysis of the gown, but from a visual inspection it seems to me likely that Baxandall was right to agree with Wollheim.

66 Wyld and Plesters, 'Some Panels from Sassetta', 12; Gordon, *Fifteenth Century Italian Paintings*, 330.

67 Plesters, 'Ultramarine', 44.

68 Lucas and Plesters, 'Titian's *Bacchus and Ariadne*', 40-41.

69 Cennini, *Craftsman's Handbook*, 38. In Dutch art treatises mention is made of *asblaauw*, 'blue ashes', but this was not low-grade ultramarine; it may have been vivianite. Cf. Lairesse, *Groot Schilderboek*, I, 209, 219; Spring and Keith, 'Aelbert Cuyp', 77-78. For the greying of a low-grade ultramarine glaze, see Penny, *Venice 1540–1600*, 102.

70 Bomford, Dunkerton, Gordon and Roy, *Art in the Making: Italian Painting before 1400*, 114; Gordon, *Italian Paintings Before 1400*, 432-34.

71 Spring, Penny, White and Wyld, 'Colour Change ... Pedro Campaña', 57.

72 Mayer, *Artist's Handbook*, 71; cf. the same procedure for indigo, in van Eikema Hommes, *Changing Pictures*, 143.

73 Plesters, 'Ultramarine', 44.

74 Church, *Chemistry of Painting*, 204.

75 Nicolaus, *Restoration*, 184-85; Klaas, *"Ultramarinkrankheit"*, 9; van Loon et al., 'Ageing and Deterioration', 217, 226.

76 Plesters, 'Ultramarine', 44-45; Bergeon, *"Science et Patience"*, 154; van Eikema Hommes, *Changing Pictures*, 28; van Loon, *Color Changes*, 19, 81-84, 122, 169; Klaas, *"Ultramarinkrankheit"*, passim.

77 De Burtin, *Traité*, I, 391, 392, 408-10; Secco-Suardo, *Restauratore*, 408-20; Wyld et al., 'Blanching'; Koller and Burmester, 'Blanching of Poliakoff'; Van Loon, *Color Changes*, 119-204; Spring and Keith, 'Aelbert Cuyp'.

78 Althöfer, 'Pettenkofer'; Voets, 'Pettenkofersche Regenerierverfahren'; Schmitt, 'Pettenkofer's Process'; Klaas, *"Ultramarinkrankheit"*, 45-46;

Favre-Félix, 'Pettenkofer'; Schmitt, 'Pettenkofer method'.

79 Van der Werf et al., 'Copaiba Balsam'.

80 Wyld, Mills and Plesters, 'Blanching'; Berger, 'Use of Water', 68; Pfister, 'Traitement', Waldeis and Feucht, 'Traitement'.

81 Information from the archives of Dulwich Picture Gallery.

82 De Burtin, *Traité*, I, 396, 410.

83 Plesters, 'Ultramarine', 37, 41; Harley, *Artists' Pigments*, 43; Klaas, *"Ultramarinkrankheit"*, 9; cf. Wehlte, *Materials and Techniques*, 137; Mayer, *Artist's Handbook*, 71.

84 Plesters, 'Ultramarine', 55-57.

85 Plesters, 'Ultramarine', 40-41.

86 Church, *Chemistry of Painting*, 223-24; Gettens and Stout, *Painting Materials*, 157-59; Harley, *Artists' Pigments*, 53-56; Mühlethaler and Thissen, 'Smalt'.

87 Plesters, 'Preliminary Note … Smalt'; Bergeon, *"Science et Patience"*, 156; Giovanoli and Mühlethaler, 'Discoloured Smalt'; Spring, Higgitt and Saunders, 'Investigation … Smalt'; van Eikema Hommes, *Changing Pictures*, 20, 28; van Loon, *Color Changes*, 53-56, 81-83, 84, 156-57; van Loon et al., 'Ageing and Deterioration', 218, 231-33.

88 Campbell, *Sixteenth Century Netherlandish Paintings*, 180.

89 Mühlethaler and Thissen, 'Smalt', 113-15.

90 Van Mander, *Schilder-boeck*, 50r.

91 Van Loon et al., 'Ageing and Deterioration', 231-33.

92 Hofenk de Graaff, *Colourful Past*, 240-61.

93 Cennini, *Craftsman's Handbook*, 52; Church, *Chemistry of Painting*, 217-23; Thompson, *Materials of Medieval Painting*, 135-41; Gettens and Stout, *Painting Materials*, 120-21; Wehlte, *Materials and Techniques*, 152-53; Harley, *Artists' Pigments*, 67-70; Schweppe, 'Indigo and Woad'; van Eikema Hommes, *Changing Pictures*, 91-169.

94 Van Loon et al., 'Ageing and Deterioration', 237, 240. It is sometimes claimed that by combining the dye with a clay known as palygorskite, the Maya were able to turn indigo into a colourfast paint. However, examples of Mayan indigo have been unearthed too recently for us to be sure of its longterm colourfastness. Cf. Sánchez del Río et al., 'Maya Blue'. I thank Emilie Carreón for discussing this matter with me.

95 Clark, *100 Views*, 39.

96 Egerton, *British Paintings*, 432-33.

97 Gettens and Stout, *Painting Materials*, 149-51; Harley, *Artists' Pigments*, 70-71; Berrie, 'Prussian Blue', 193.

98 Church, *Chemistry of Painting*, 216.

99 Kirby and Saunders, 'Fading … Prussian Blue', 76-77.

100 Wehlte, *Materials and Techniques*, 152; Kirby, 'Prussian Blue', 66; Berrie, 'Prussian Blue', 202.

101 Gettens and Stout, *Painting Materials*, 150.

102 Berrie, 'Prussian Blue', 213.

103 Berrie, 'Prussian Blue', 199; Kirby and Saunders, 'Fading … Prussian Blue', 87-88; Van Loon et al., 'Ageing and Deterioration', 219.

104 Egerton, *British Paintings*, 80.

105 Kirby and Saunders, 'Fading … Prussian Blue', 87-89.

106 Kirby, 'Fading and Colour Change of Prussian Blue', 64-65.

107 Thompson, *Materials of Medieval Painting*, 190; Bergeon, *"Science et Patience"*, 160.

108 Wyld and Plesters, 'Some Panels from Sassetta', 11-12; Gordon, *Fifteenth Century Italian Paintings*, 330-31.

109 Gordon, *Italian Paintings Before 1400*, 45, 432.

110 Cassar et al., 'Air Pollution'; Bergeon, *"Science et Patience"*, 160.

111 Cennini, *Craftsman's Handbook*, 60.

5.
DARKENING

As we saw in the introduction (p. 14, fig. 9), Giorgio Vasari had already noticed darkening in Raphael's *Transfiguration* fifty years after it was painted. A century later, the idea that pictures darken with time was widely accepted by painters. Charles Lebrun, the Director of the French Royal Academy of Painting and Sculpture, claimed in 1667 that "in discussing the paintings of Raphael or the artists of his period, everyone gives for the most part his own conjectures and imparts his own sentiments, because, since the colours they used have kept neither their initial brilliance nor their true tints, one cannot easily discern all that these great men represented, and one can no longer judge all of the beauty which they put into their works".[1]

Lebrun made these remarks at a meeting of the Academy where he was expected to talk about one of the paintings in the Royal Collection, and he used this statement as an explanation of why he did not intend to talk about a work from the preceding century. Instead he wanted to discuss a painting made during his own lifetime, by an artist from whom he had learned much – Nicolas Poussin: "Since [Lebrun] had the advantage of conversing with this great man of whom he meant to speak, and since [Poussin's] paintings have still the same lustre, and the same vivacity of colours that they had when he gave them their last touches, he will be able to give his feelings about it with more knowledge and certainty than about other works".[2]

Unfortunately Poussin's works no longer have the same "lustre and vivacity of colours". We saw in the introduction an example of the way his paintings can darken with time (figs. 10, 11). Seventeenth-century French artists like Poussin and Claude are

'A MASS OF DARKNESS'

161

particularly susceptible to darkening of this sort. Henry Mogford, the eloquent nineteenth-century restorer whose opinions we have already encountered (pp. 113 and 121), singled out works by Poussin's brother-in-law Gaspard Dughet when decrying the general tendency of old landscapes to darken:

> In their oil pictures, the most fugitive colours, the greens for example, have lost the freshness of nature; the verdant hues have become sickly-grey, or brownish-dark. Scarcely a single landscape painted by the great masters retains the original tints in which the vegetation was painted. The two large landscapes by Gaspar Poussin, in the National Gallery [fig. 33], prove to what an extent changes have taken place. It were absurd to imagine that such a mass of darkness, scarcely making any details discoverable, was ever originally so produced by this great painter, living in the bright sunny land of Italy. The skies in ancient landscapes are lowered in tone, and the foregrounds, where it is earth or rock, are in the same condition; the colours of the figures have become blackened in the shades, and water, if tranquil water, has changed into pools of ink where it has received shadows; or if it be a falling torrent, excepting where the foam retains its whitish hue, it resembles rather a cascade of brown stout. In such a state do we find a great number of the finest pictures of Ruysdael [fig. 102]; the forms are there, the composition is there, but the truth and freshness of nature have departed.[3]

VARNISH

What causes the extreme darkening of which Mogford is complaining? Helmut Ruhemann, restorer at the National Gallery in London in the middle decades of the past century, wrote that darkening of this kind could almost always be ascribed to the same cause:

> It is exceptional to find a painting where a striking overall darkening is in the paint itself and not in a discoloured varnish. Such a painting will usually turn out to be a later copy or a fake. This is easily explained: firstly, copies are often made from originals covered with darkened varnish and dirt. Second, the copyist's technique is usually inferior, so that his work suffers more obviously from the effects of time, of which darkening is one.[4]

Ruhemann was certainly right that the Dughet in fig. 33 would look a lot brighter if it were cleaned. It has the same varnish that it had when it entered the National Gallery's collection in 1824, and it was already a dark painting then.[5] However, the same cannot be

102
Jacob van Ruisdael, *Landscape with waterfall*, c. 1665–70, oil on canvas, 100 × 86.5 cm, Fitzwilliam Museum, Cambridge

103
Raphael, *The Marriage of the Virgin*, 1504, oil on poplar, 173.5 × 120.7 cm, Pinacoteca della Brera, Milan

said of the Ruisdael in fig. 102; this photograph was taken recently, shortly after the picture's varnish had been removed and replaced.

We will return to the Ruisdael in a moment, but first more needs to be said about the darkening effects of varnish. The Dughet has not been cleaned for over two centuries, and parts of it may never have been cleaned at all. It is obscured by a varnish that has darkened profoundly. However, not all varnishes darken to this extent. In general, they are not very predictable: as we observed in Chapter One, the sixty-year-old synthetic varnish on Poussin's *Landscape with man killed by a snake* (fig. 10) has darkened more than the five-hundred-year-old pine resin varnish on Crivelli's *Dead Christ* (fig. 35).

Nevertheless, darkened varnishes can have noticeable effects on the appearance of paintings, even after they have been cleaned. Different museums have different attitudes towards cleaning, and paintings are therefore cleaned to different degrees. In the post-war period when Helmut Ruhemann was an influential figure at

104
Raphael, The Ansidei
Madonna, 1505, oil on poplar,
216.8 × 147.6 cm, National
Gallery, London

the National Gallery in London, it was considered good practice to remove all the varnish from a painting before revarnishing. At other museums, especially in Italy, Spain and Germany, it was and still is thought better to thin the varnish, leaving a layer of the original varnish so that the paint would be protected from the solvents used during cleaning.[6] The result of these differing approaches is that anyone used to pictures in the National Gallery in London who visits (say) the Brera in Milan may find the paintings rather dark, while Milanese visitors to London may find the paintings in the National Gallery rather bright. The Milanese paintings are seen through (very thin) layers of darkened old varnish, which on most paintings in the National Gallery have been removed. It is hard to show the difference using illustrations, because when paintings are lit for photography they generally look brighter than under ordinary museum lighting conditions. But perhaps some of the contrast can be seen by comparing Raphael's *Marriage of the Virgin* in Milan with his Ansidei Madonna in London (figs. 103, 104). The painting

105
Detail from Vincent van
Gogh, *A wheatfield with
cypresses*, 1889, oil on canvas,
72.1 × 90.9 cm, National
Gallery, London

in Milan was last cleaned in 2008, that in London in 1956, but one
could be forgiven for thinking that those dates should be the other
way round. The *Marriage of the Virgin* has an overall coherence of
tone, while in the Ansidei Madonna each zone of colour has its own
independent character.[7] The comparison may seem subtle, but there
has been some angry controversy over which of the two methods
of cleaning is to be preferred. We will discuss this matter further in
Chapter Six. The difference is not just an academic squabble: when
fully cleaned paintings are hung next to partially cleaned paintings
in loan exhibitions, considerable ingenuities of lighting can be
needed to hide the disparities in appearance.

DIRT AND SMOKE

Old layers of varnish will make paintings look dark, but often an
overall lowering of tone is caused by simple dirt. Even if a picture
is kept in clean surroundings it will attract dust, much of which is
made up of human skin debris.[8] At many modern galleries dirt is

106
Keisai Eisen, *Carp swimming up a waterfall*, 1830s, woodblock print, British Museum, London (discoloured by fire)

107
Keisai Eisen, *Carp swimming up a waterfall*, 1830s, woodblock print, British Museum, London (intact)

monitored and tested, since it is known to damage paintings: for instance, chlorides from skin grease have been implicated in the blackening of vermilion.⁹ Even paintings behind glass suffer from dust, which can find its way through cracks and crevices and which also lies thick on the backs of paintings, providing fertile ground for microbes. The visual effect of ordinary dirt can be seen in fig. 105. It is easy to suppose that this is a photograph of a painting in the midst of varnish removal, but it is not: this Van Gogh (fig. 111) has never been varnished. What is being removed is just a century's accumulation of sticky dust.¹⁰

Another cause of overall darkening is smoke. In private houses, smokers can quickly yellow and brown their own paintings, and in churches candles can have a not dissimilar result; but if an actual fire breaks out, the combination of smoke and heat will have much more dramatic effects.¹¹ The print by Keisai Eisen in fig. 106 has survived a fire, but only just; if we compare an unscorched version of the same print (fig. 107) we can see how all the colours have been

transformed. This is what proximity to flames can do to a work of art; it is clear from this comparison that the fire damage suffered by the Claude we encountered in the introduction (fig. 12) was far from extensive. *The Sermon on the Mount* has dimmed selectively; the sky is still blue and white. In this it is like Ruisdael's *Waterfall*.

SUPPORTS
AND GROUNDS

Sometimes a painting can become murkier if its support or ground darkens. We have already seen examples of this in Dirk Bouts's *Entombment* and Xu Xi's *Snowy bamboo* (figs. 29, 30). One of the reasons that many Chinese paintings are so sombre is that they allow the support of silk or paper to play a large part in the final appearance of the image, and when the support darkens the work darkens with it. The same often happens to drawings and prints. The effects of such shifts in hue and tint are often subtle, but not negligible. Figs. 108 and 109 show the same engraving, but in the second of the two prints the paper has discoloured. It is surprising

how much difference is caused by this small change: the second print seems flatter, and the different materials depicted – flesh, hair, cloth, metal – lose some of their particular character.

Supports are clearly visible in most drawings and prints, as well as in some paintings. It is therefore a cause of concern if restoration techniques bring about a change of colour in the support or the ground. When drawings or prints have been mounted on acidic board or card, discolourations can result. Not dissimilar problems can afflict paintings. As we saw in Chapter Three (p. 116), certain types of lining, especially lining using wax or wax-resin, are thought to cause darkening of the support and ground. One painting on which the canvas has darkened due to a wax-resin lining is *Van Gogh's chair* (fig. 110). Here the support is allowed to show through the paint at many points in the painting, and it is easy to see that the canvas has turned a hazelnut brown.[12] On another painting by Van Gogh, the *Wheatfield with cypresses* (fig. 111) – which has never been lined – the canvas also shows through the paint, and it is much lighter than the canvas in the *Chair*.[13]

It is not only that the canvas is darker in the one painting than in the other. When one stands back from the two pictures – and this effect is very powerful in the gallery itself – the *Wheatfield with cypresses* looks much lighter than *Van Gogh's chair*. But is this a result of the darkening of the latter's canvas? It is not entirely clear that it is. The importance of support and ground to the appearance of a painting should not be overstated. If the paint layer is thick and opaque, then both support and ground will be indiscernible.

Take Sebastiano del Piombo's *Holy Family* for example (fig. 112). When Sebastiano began this painting he covered a panel with a white chalk gesso, which is still there, in a good state of preservation, under the priming and the upper layers. However, he decided at some point during the work on the picture that he wanted to make an addition at right, and so he added a plank to the original panel. This plank begins just to the right of the sleeping Joseph's ear. For some reason Sebastiano chose not to cover this plank with white gesso. He covered it with a thick layer of the same brownish-grey priming he had used on the rest of the painting, but under that priming there is nothing but wood. So most of the painting has a white gesso; a strip down the right does not, and while the difference between the two is perfectly plain in infrared, to anyone looking at the painting's surface, it is quite invisible. The colour of the support and of the ground layer does not have any perceptible effect on the final image.[14]

We should bear this example in mind when looking at the two paintings by Van Gogh. The gaps in the paint where the canvas shows through have indeed darkened in the painting of the artist's

108
Pieter van Gunst, *John, second Viscount Chaworth*, after Anthony Van Dyck, c. 1715, engraving on paper, 50.8 × 30.9 cm, British Museum, London

109
Pieter van Gunst, *John, second Viscount Chaworth*, after Anthony Van Dyck, c. 1715, engraving on paper, 50.8 × 30.9 cm, British Museum, London

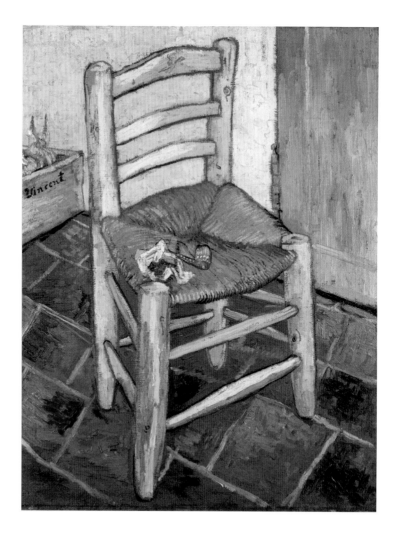

chair, but the relative brightness of the landscape is perhaps not so much a result of its lighter ground as an effect of the brighter pigments in its upper layers.

TONE AND SPACE

As we have already observed, the Dughet in fig. 33 and the Ruisdael in fig. 102 are both dark paintings, but they are dark in different ways. The Dughet, under its varnish, suffers from an overall darkening, while the Ruisdael's obscurity is selective. In the Ruisdael there are areas of lighter paint, in the foam of falling water, as well as in the sky and in various highlights of wood and stone throughout the picture. The dark areas of the painting are not effects of varnish, or dirt, or a discoloured ground; the darkness is 'in the paint itself'.[15]

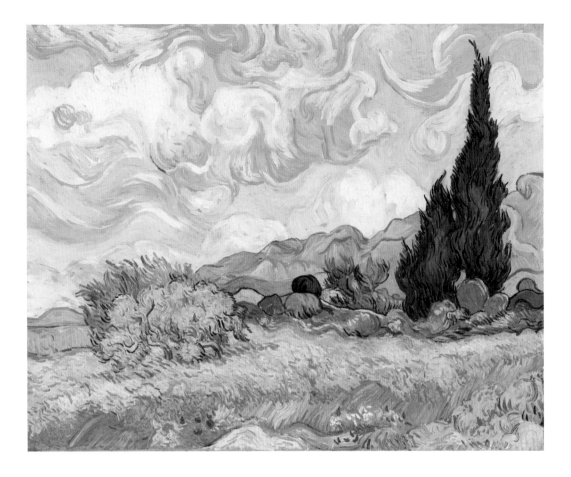

But is it the result of changes over time, or was it intended by the artist? This is a matter which it is hard to decide using the kinds of instruments available at present to conservation scientists. If an area of a painting has browned owing to copper resinate discoloration, then this fact can be established by ascertaining the chemical constituents of the paint. If an area has darkened, however, there is no such obvious test, because darkening is not normally due to chemical change in the pigments. It is usually due to change in the medium, and at present media are less studied and less well understood.[16]

What can be done is to measure the levels of light and darkness in the painting using various kinds of colorimetric apparatus. Forty years ago 'spectrophotometers' were introduced, and now the same work is done by electronic imaging. These devices measure changes in colour and tonality over long periods of time.[17] However, since they are recent inventions, they cannot reveal what took place in past centuries. We may be able to establish that a painting has darkened since 1970, but we do not know what happened between (say) 1570 and 1970.

111
Vincent van Gogh, *A wheat-field with cypresses*, 1889, oil on canvas, 72.1 × 90.9 cm, National Gallery, London

112
Sebastiano del Piombo,
*The Holy Family with John
the Baptist and a donor*, 1517,
oil on wood, 97.8 × 106.7 cm,
National Gallery, London

In order to understand how the tonal balance of a painting may have looked when it was first made, we have to fall back on art historical methods. It is sometimes possible to compare darkened works with contemporary copies which have fared better than the originals. It was by using this method that Margriet van Eikema Hommes was able to establish that the central region of Raphael's *Transfiguration* blackened significantly during the sixteenth century (p. 14, fig. 9). Unfortunately only a small number of very famous paintings are copied by contemporary artists, and, when they are, the copies themselves may have aged in a similar way to the originals.

Another source of evidence comes from reproductive prints. We used this method very briefly when examining the Poussin in the introduction (pp. 16–17, figs. 10, 11). As with painted copies, contemporary engravings were made only after relatively few paintings, and they have of course the disadvantage of being

composed of black lines on white paper rather than of coloured paints on canvas. However, they have the advantage of being exceptionally durable. Engravings can alter owing to the yellowing or foxing of the paper on which they are printed, and they can also be scorched or abraded, but engraver's ink is of exceptional permanence, and therefore not subject to the kinds of darkening and blanching that paintings undergo. This means that an engraving can preserve much of its balance of light and dark, and since in the Western post-Renaissance tradition light and dark have been used to suggest three-dimensional form and space, then the spatial illusion of the print can remain more or less as it was when it was made. If the paper yellows severely this affects the relationship of the highlights to the shadows, as in fig. 109, but, as the print in fig. 11 shows, paper can retain its creaminess over many centuries.

An engraving cannot reproduce the colour balance of a painting, but it can try to reconstruct its illusion of space.[18] Étienne Baudet's engraving after Poussin (fig. 11) achieves a remarkably successful evocation of depth. The location of each element of the composition is expressed lucidly, to the point where we can almost sense the air around the corpse and the man fleeing in horror; every rock and plant around the dead body is depicted clearly and intelligibly in the illusory space. The path on the opposite side of the lake is easy to follow with the eye, while the distance over the lake to the town on the opposite shore is mapped out in a convincing way.

Compare these details with the indeterminate masses of darkness in the Poussin (fig. 10), where the foreground is impenetrable and the left-hand shore of the lake is lost in obscurity. Baudet's print makes perfect three-dimensional sense; Poussin's painting, as it is today, does not.

There are two possibilities here. Either Baudet took Poussin's deliberately obscure painting and made it into a lucid exposition of three dimensions, against the artist's intentions and wishes. Or Poussin's painting was once as clearly legible as Baudet's print, but the alterations of paint over time have destroyed the original clarity of its expression of depth. Since all of the reproductive engravings after Poussin's paintings, made not only by Baudet but by other engravers, have the same perfectly rendered spatial development, it seems likely that this was originally a defining feature of Poussin's art, which his contemporaries were copying but which time has severely damaged.

Returning to the Ruisdael, there is a similarly illegible spatial construction. Areas of darkness abut regions of light in a murky way.[19] Was this what Ruisdael intended? Probably not. A contemporary sketch by the artist (fig. 113) shows a not dissimilar

scene, with the difference that the space is laid out in such a way that the eye can, so to speak, walk through it.[20]

We know from contemporary writings on art that painters and their public expected pictures to provide readable transcriptions of space. Around the time that Ruisdael's drawing and painting were being made, in the late 1660s, one of his fellow countrymen, Willem Goeree, published a book about art in which he said that the artist should make everything in a drawing or painting "stand in its own position, without seeming nearer or further, lighter or darker, than its distance or closeness permits; placing each thing, without confusion, separate and well apart from the objects which are next to and around it ... as if it were accessible with one's feet". This was in his view "one of the most essential things to be observed in a Drawing or Painting; since it gives the same sensation to the eye, that we enjoy in the contemplation of natural objects". And any painting that failed to achieve it was, he claimed, "senseless, and more than half dead".[21]

Ruisdael's painting in its present state would probably have been found "senseless, and more than half dead" by Willem Goeree. But the drawing, on the other hand, does indeed seem like a landscape which is "accessible with one's feet". If Ruisdael's painting was made in accordance with the artistic ideals of his time as expressed

in contemporary writings about art, then it too once "gave the same sensation to the eye, that we enjoy in the contemplation of natural objects".

An interest in space and relief is a universal feature of European art from the fourteenth to the nineteenth centuries. An important aspect of this interest was given a strong impulse by Leonardo da Vinci (fig. 26) when – as Vasari put it – "he added to the manner of colouring in oils a certain obscurity, which has allowed the moderns to give great force and relief to their figures".[22] Leonardo increased the tonal range of his paintings, using dark browns and blacks so that the lights could stand out against them and seem to be placed before the background. At the same time, rather than just depicting lightly shaded figures against dark backgrounds, as in fig. 26, he made figures emerge gradually from those backgrounds by painting much darker shadows on the figures themselves.

114
Leonardo da Vinci, *Saint Jerome*, c. 1480, oil on panel, 130 × 75 cm, Pinacoteca Vaticana, Rome

115
Georges Seurat, *The Channel of Gravelines, Grand Fort-Philippe*, 1890, oil on canvas, 65 × 81 cm, National Gallery, London

Another development in Leonardo's art was in the use of 'dead-colouring' (figs. 32, 114), where a tonal underlayer blocked out the masses of light and darkness and underlay the chiaroscuro of the upper layers.

From Leonardo to Courbet, European art is often very dark in tone. When brown and black fell from favour after the Impressionist revolution the difference was profound – compare fig. 115 with any of the pre-Impressionist landscapes in this book. And besides being very dark, European painting also had a tendency to darken further. The selective darkening which we will be examining for the rest of this chapter is largely a feature of Western art from 1470 to 1870.[23]

ABSORBING OILS

What are the causes of this selective darkening? There are a number of theories, and one of them goes back at least as far as the Renaissance. As we saw in the introduction, Vasari blamed the darkening of Raphael's *Transfiguration* (fig. 9) on lamp black,

claiming that it "becomes ever darker with time and harms the other colours with which it is mixed" (p. 16). In a different passage he denounces not only lamp black but a number of other blacks, and gives a suggestion of what may be the cause of their darkening. Writing of an altarpiece by Giulio Romano (fig. 116) he claims that "if this altarpiece had not been so tinted with black, from which it has become very dark, it would certainly have been much better; but this black makes the greater part of the work put into the picture seem lost or mislaid, since black, whether it be of carbon or burnt ivory or lamp black or burnt paper, even if it is mixed with varnish, destroys what is good, since it is always somewhat dry".[24]

What does Vasari mean by "dry" (*alido*)? It is a word he hardly ever uses; but, when he does, it refers to the capacity of a mineral to soak up oil.[25] It would seem then that Vasari is telling us that blacks darken because they are too absorbent.

If this is what he was saying, then he was right. Blacks do drink in a lot of oil. Every pigment needs a different amount of medium in order to make a paint. Some turn into a smooth spreadable

paste with the addition of a mere thimbleful of oil, whereas others need half a cup. This power of pigments to sop up oil is sometimes measured, and books on pigments often give numerical 'oil absorption values', which are supposed to be the number of grams of oil needed in order to turn 100 grams of pigment into a pliable paint. Unfortunately measuring the amount of oil that a pigment needs is far from easy. For one thing, the amount that a pigment will absorb depends on how finely it has been ground, as well as on its purity. An even bigger problem is that it is hard to decide when a pigment has soaked up the right amount of oil. So, for example, Ralph Mayer's *Artist's Handbook of Materials and Techniques* asserts that burnt sienna has oil absorption values between 18 and 38; Kurt Wehlte's *Materials and Techniques of Painting* proposes values between 45 and 210; Winsor & Newton, the paint manufacturer, said that the burnt sienna they were selling at the beginning of the last century had a value of 150.[26]

These disagreements are disturbingly large – it is clear that we are still some way from a science of oil absorption. Nevertheless, it is the case that different pigments need different amounts of oil, and if one collates the figures that have been assembled, a few tentative conclusions can be drawn. Lamp black is one of the most absorbent pigments, and it can soak up over ten times as much oil as lead white, which is one of the least absorbent. Blacks and browns in general are highly absorbent; next come the blues and red lakes. The mineral yellows and reds can, like lead white, be made with relatively little oil.[27]

So when Vasari says that blacks are "dry", and therefore thirsty, he is quite right. But what is the connection between oil absorption and darkening?

Oils, like varnishes, turn yellow and darken with time. So if a paint contains a great deal of oil it will be more susceptible to darkening, and vice versa. Lighter areas of a painting will normally be mixed with, or consist of, lead white, and lead white has a very low absorption value. Darker areas of a painting will normally be mixed with, or consist of, browns and blacks, which have a very high absorption value. The darks will therefore grow darker more quickly, owing to the larger amounts of oil they contain.[28]

If we turn back to Ruisdael's *Waterfall* (fig. 102), we can see how this idea applies in practice. Areas of the painting which were white, yellow or red from the start have kept their tone much more successfully than areas which contain a great deal of black and brown. The blue of the sky has also held up fairly well, although this is largely because it has been mixed with lead white.

Some artists were aware of the importance of lead white. Guido Reni, according to his biographer Carlo Cesare Malvasia, painted

his later pictures with as much lead white as he could, so that they
would not darken like the works of his contemporaries.[29] Not all of
his late paintings are as conspicuously full of white as this *Rape of
Europa* (fig. 117), but there is no doubt that an absence of brown and
black has done much to preserve its balance of tone.

Linseed oil yellows more than walnut oil or poppy oil, a fact
of which artists were aware. Linseed oil also dries more quickly
than its competitors, and so painters were reluctant to abandon
it. Nevertheless, research on paintings in the National Gallery in
London has shown that walnut oil was sometimes used specially
to bind whites and blues, which were thought to look particularly
displeasing if shrouded in a yellowing medium.[30]

Another possible factor in the process of darkening is the use of
siccatives (see p. 46). Pigments which use a great deal of oil also
tend to be slow dryers (although speed of drying is not a simple
matter of amount of oil: chemical reactions with the pigments also

118
Corrado Giaquinto, *An Allegory of Peace and Justice*, 1753–54, oil on canvas, 41 × 69.2 cm, Indianapolis Museum of Art

play a part in the process). As we noted in Chapter One, various processes were used to speed up the drying times of oil. The oil was often left to stand in the sun for a long period, and sometimes it was boiled with lead oxide (litharge). Certain pigments, including verdigris, lead white, copper sulphate and smalt, or a particular kind of glass, rich in manganese, might be mixed in with the paint, and varnish could be added for the same purpose. Of all these various methods, oil boiled with litharge was probably the most widespread, and it has been suggested that the lead oxide may have accelerated the natural darkening of the oil. Since the litharge oil had a reddish colour it was not normally used with lighter paints such as white and yellow. These paints were mostly fast driers in any case. It was the blacks and browns that most benefitted from the help of siccatives.[31]

DARKENING
AND LINING

Differing oil absorption rates seem to have an effect on darkening, but the simple volume of oil feeds into another element in the process. Paints that contain a great deal of medium are also more susceptible to heat. This tendency is aggravated by the fact that dark pigments reflect heat less and become warmer more quickly than light pigments.[32] And dark areas of pictures are often painted thinly, making them still more vulnerable. In a fire, this can be catastrophic; but it may also become important in the milder stress of lining.

119
Corrado Giaquinto, *The Brazen Serpent*, 1743–44, oil on canvas, 136.5 × 95 cm, National Gallery, London

As we saw in Chapter Three, paintings have been lined for several centuries, and it has not always been possible to regulate with great accuracy the amount of heat applied in the operation. One might suspect that passages of fragile medium-rich paint have suffered as a result. It is in fact arguable that the effects of lining can be seen in a painting even when the painting appears to have been lined well.[33]

Take for example the *Allegory of Peace and Justice* by Corrado Giaquinto in fig. 118. This painting is in good condition, and certainly does not display any of the symptoms of harsh lining we saw in fig. 75. Nevertheless, if we compare it to another painting by the same artist, the *Brazen Serpent* in fig. 119, we can see some significant differences. The dark areas in the *Allegory* are black, flat and impenetrable to the gaze. This is particularly evident in the bottom corners of the painting, where it is hard to see precisely what is going on. Compare this to the dark areas in the *Brazen*

120

Canaletto, *Piazza San Marco*,
c. 1723–24, oil on canvas,
141.5 × 204.5 cm, Museo
Thyssen-Bornemisza, Madrid

Serpent. Although much of the foreground is decidedly gloomy, there are no areas of the paint that are not legible, as a limb, a cloak, armour or rock. Even in deep shadow – for example the chest of the ill man being supported in the foreground – we can read the forms clearly as they round. The painting has almost certainly darkened to some extent, and the browns and blacks have darkened more than the areas blended with white, leading to slight distortions in the pictorial space. But every inch of the paint surface is readable. That is quite unusual for an eighteenth-century canvas; most have sombre regions which are hard to interpret.

In *The Brazen Serpent* there is a great variety of tone, from the lightest lights to the darkest darks, and this variety is used to map out the spatial relations of the various forms. In the *Allegory*, lights and darks adjoin one another in a much more abrupt way – the transitions are less clearly portrayed. It is the shades in between light and dark, the 'half-tints', which have gone missing.[34] It is precisely these half-tints which we can see in a wonderfully well-preserved state in fig. 119.

The Brazen Serpent is unlined, while the *Allegory of Peace and Justice* is lined.[35] Is this a coincidence? It is hard to say for sure, since there are so few unlined canvasses from the period before 1800. But the unlined canvasses that have come down to us do seem, for the most part, to have exceptionally well-preserved half-tints.[36] We

can pick one more example to illustrate this. The two Canalettos in figs. 120 and 121 depict the same place from the same angle in similar weather at more or less the same time of day, and yet the differences between the two are stark and obvious. In fig. 120 the shadows are much deeper, the contrasts much greater. One might think that in fig. 120 the sun is shining more brightly, since the shadows are darker. Perhaps Canaletto did want to convey a more strongly lit effect; but it seems very likely that any effect he intended has been increased by time. That this depth of tone was not planned by the artist is suggested by the appearance of the figures standing in the shadow at right. Once again, the lighter colours, especially the whites, have preserved more of their original tints. As a result they appear to be lit by a light source which is different from that of the darkened pavement around them. In fig. 121, on the other hand, the figures standing in the shadow seem to belong there; the light forms a unified, coherent whole which makes the figures and the piazza blend together.

Whenever one sees an area of a painting in which the lighter parts do not seem to form a unified whole with the darker parts, one can reasonably suspect that some darkening has occurred. Whenever one sees large illegible areas of shadow, one can suspect the same. To what extent lining can be accused of contributing to these darkenings is harder to judge. In this comparison of the two

121
Canaletto, *Piazza San Marco*, c. 1728–29, oil on canvas, 68.6 × 112.4 cm, Metropolitan Museum of Art, New York

Canalettos the painting in fig. 121, as the reader will have realised, is the unlined painting.[37] In the coherence of its half-tints it is in many ways comparable to the unlined Giaquinto. We will leave open the idea that lining has helped cause the destruction of half-tints in fig. 120; but the theory seems worth researching further.

If lining does flatten half-tints, then what of the many paintings made on wood – are their shadows in a better state of preservation? Two answers can be given to this question. The first is that, yes, on balance, panel paintings do seem to preserve rather more of their original half-tints. There are many panel paintings which are in a very darkened condition, of course, but the percentage which have suffered in this way is lower than the percentage of similarly troubled canvasses. And since unlined canvasses seem in general better preserved than lined canvasses, it is tempting to suspect that lining has done some of the damage.

The second answer to the question is to point out that, as we observed above (p. 117), panel paintings are also subjected to heat treatments of various kinds, and the heat may well be the cause of the problem.

So far we have proposed two (related) suggestions to explain selective darkening, oil absorption rates and lining.[38] They are not incompatible with one another, nor with other explanations of the same phenomenon; and a chemical event as complex as the darkening of a painting may well have more than one cause. In the recent conservational and curatorial literature there are two other widely promoted theories. These have a rather technical cast, with the concepts of 'refractive index' and 'lead saponification' being central to their arguments. Both, however, have something in common: they stress the effects brought about by increased translucency in paint layers.

TRANSLUCENCY

In the early years of the past century Professor A.P. Laurie, whose prescriptions for lasting technique we have already encountered (p. 33 and fig. 25), developed a theory of darkening based on the idea that the upper layers of a painting must, in time, become translucent.[39]

Laurie based his theory on a fundamental concept in optics, the 'refractive index' of materials. We do not need to get entangled in the physics of this; the concepts were explained with great lucidity by Laurie himself, and anyone who wants to pursue the subject will find references to his work, and to the work of others, in the footnotes.[40] For our purposes, we need to know only three things:

1. Substances which are translucent in some liquids are opaque in others. For example, powdered chalk is opaque in water or egg or glue but translucent in linseed oil.
2. The reason for chalk's translucency in oil is that both chalk and oil bend incoming light rays to the same degree.
3. The degree to which a substance bends light can be measured and given a numerical value. This numerical value is known as the 'refractive index' of the substance.

The refractive index of chalk is 1.51, and the refractive indices of water, egg and glue are 1.33, 1.346 and 1.348. But the refractive index of linseed oil is 1.48. This is so close to the refractive index of chalk that chalk in linseed oil appears translucent.[41]

When the difference in refractive index between a substance and its medium is 0.03 or less, that is considered very close, and a high degree of translucency will be the result. Anything from 0.04 to 0.12 is considered a moderate convergence, resulting in some degree of translucency; while anything over 0.12 displays divergence, and the substance will appear opaque.[42]

Laurie's great contribution to the study of paint was to notice that, over time, the refractive index of linseed oil rises. Fresh linseed oil has a refractive index of 1.48, but Laurie discovered that linseed oil which has dried for ten years has a refractive index of 1.512. Over a period of around five hundred years, he calculated, the refractive index would rise to around 1.57.

The refractive indices of pigments are all higher than the refractive index of fresh linseed oil. But, as the oil ages, the difference between the refractive indices of the oil and the refractive indices of the pigments decreases. As a result, pigments become less opaque with time. This, Laurie argued, was the reason for the darkening of European oil paintings. Dead-colouring and dark grounds, which had been hidden from view beneath opaque upper layers, were increasingly visible, since those upper layers were slowly becoming translucent.

Laurie's theory has had great success, and, seventy-five years after it was first put forward, restorers and curators still adduce the rise in the refractive index of oil as a cause of darkening.[43] Nevertheless recently this consensus has started to attract some scepticism, and questions have begun to be raised about the application of the theory to all kinds of pigment.

The rise in the refractive index of the oil medium makes paints less opaque, but it does not follow that it makes them translucent. Something can be less opaque, but nevertheless still be opaque; there are degrees of opacity, just as there are degrees of translucence. Opacity can be lowered for some time before the

point of translucence is reached. If the difference between the refractive indices of linseed oil and of a particular pigment was very large to begin with, then the oil, even over centuries, would be unable to narrow the gap sufficiently to make the mixture of the two see-through.

How many pigments, then, have refractive indices which are so high that linseed oil could not render them translucent, even after five centuries? We noted earlier that a difference of refractive index between pigment and medium in excess of 0.12 is enough to make the resultant paint opaque. So how many pigments have a refractive index in excess of 1.57 + 0.12 = 1.69?

The answer is that many do: blue verditer, azurite, burnt sienna, raw sienna, raw umber, lead white, yellow ochre, Naples yellow, burnt umber, orpiment, brown ochre, red lead, massicot, vermilion, charcoal black and lamp black. In fact charcoal black and lamp black do not have refractive indices at all, since they are permanently opaque; no medium will make them transparent.[44]

It is clear from this list that many of the brown and black pigments used by artists are opaque even in aged linseed oil. And yet we have already noticed that it is precisely the black and brown areas of paintings that tend to darken most. Since this darkening appears not to be a result of the rise in the refractive index of oil, Laurie's theory is not providing us with the explanation we are looking for.

As stated here, Laurie's theory is too simple. Many pigments that have refractive indices very close to that of linseed oil are not always translucent. Ultramarine, for example, has a refractive index of 1.5, which should make it almost transparent in fresh linseed oil. It is indeed a very translucent pigment when used pure in a glaze. But if it is applied thickly enough, as in the shadows of the blue garments in Titian's *Bacchus and Ariadne* (fig. 59), it is opaque. Thickness affects translucency. Another factor in the opacity of pigments with low refractive indices is particle size; if the pigment is ground coarsely it will be less translucent. Smalt, which has a refractive index between 1.49 and 1.52, is – as we noted above (p. 151) – deliberately ground coarsely, since when it is ground fine it is transparent in oil.

Other pigments with refractive indices very close to that of linseed oil include indigo, verdigris and Prussian blue. All are problematic pigments with a tendency to discolour (though the same can be said of a number of pigments with very high refractive indices, such as orpiment, red lead, realgar and vermilion). But when one is looking for areas of a painting which have darkened, it is not usually the blues and greens which are worst affected. It is, as we keep insisting, the browns and the blacks.

Another problem with Laurie's theory is that it requires us to believe that darkening is invariably the fault of a sombre underlayer. In reaching this conclusion, Laurie was struck by the fact that fifteenth-century paintings with chalk or gesso underlayers had survived well, while paintings following the Leonardesque dead-colour-on-a-dark-ground model (fig. 114) had tended to darken.[45] However, it is easy to overestimate the effect of ground layers on the appearance of surface pigments, as we saw when discussing Sebastiano del Piombo's *Holy Family* (fig. 112). Early Netherlandish paintings may look light and be painted on light grounds, but this is not necessarily effect and cause.

Leonardo made so many technical innovations that it is not always easy to separate out the various elements of the style he introduced. Besides using dark underlayers, he also favoured dark upper layers (fig. 26). It is possible therefore that the darkness which was introduced into Western art in the wake of his work was an effect of the increased use of darker, oil-rich pigments in the upper layers, rather than the grounds and the dead-colouring showing through.

Translucency, in any case, cannot always be the cause of darkening. The blacks and browns in Leonardo's *Saint Jerome* (fig. 114) have obviously darkened: the saint's chest no longer connects with his shoulders, and the background has all the illegible murkiness we have come to associate with darkened paint. And yet this can hardly be the result of the dead-colouring showing through, for the simple reason that this painting *is* the dead-colouring of an unfinished picture. We cannot blame the darkening of dead-colouring on the underlying primer, either, since the primer itself is much lighter in tone than the darkened pigments above it.

This point is also of importance when considering Poussin's *Man killed by a snake* (fig. 10). The National Gallery's catalogue says of this painting that, "in common with many paintings by Poussin … [its] visual appeal has suffered mainly because the increased transparency of the paint with age reveals more of the ground colour beneath".[46] Poussin's red-brown ground is indeed revealed in various places, especially in the bottom left-hand corner of the painting. However, the earth colours in this region of the painting will have high refractive indices, so the effect of the ground shining through is not likely to be the result of translucency from increased age of the medium: the effect is more likely caused by abrasion, or damage during a harsh lining. In any case, it is hard to blame the red-brown ground for the darkened appearance of the picture, since the ground is notably lighter than the paint above it. And besides, Poussin's red-brown grounds are revealed in other paintings by the artist which have not significantly darkened, for example in

122
Nicolas Poussin, *The Nurture of Jupiter*, 1636–37, oil on canvas, 96.2 × 119.6 cm, Dulwich Picture Gallery, London

fig. 122. Here the ground can also be seen through the upper layers, especially in the rather worn sky; but it has not darkened those upper layers to anything like the depth of obscurity visible in the *Man killed by a snake*. The darkness in the latter painting, then, is more likely an effect of oil-rich umbers and siennas in the upper layers, which have blackened with time. The preservation of the tints in the *Nurture of Jupiter* would then be due to the abundance of oil-sparse lead white mixed into its surface colours. Only in the darker passages do we see evidence of a lowering of tone, and the underlayer is not the only factor in this darkening.[47]

One often sees paintings which have very translucent passages. An example is the *Allegory of Love* by Pieter Pourbus (fig. 63), which has numerous pentimenti (passages where lower layers can be seen through upper layers which have become translucent).[48] So, for example, the head of the stick held by the reclining man at right has become almost entirely transparent, and so too has the upper part of the same man's head. Much underdrawing can be seen through the faded lake skirt of the woman sitting next to him. And at the left of the painting various underlayers can be seen through the

bared breasts of the seated woman and the Cupid leaning against her thigh.

But all this translucency does not lead to darkening. The only area of the painting which does seem to have darkened significantly is the (brown) shadow under the table, where there are no pentimenti. And the translucency in the flesh tones is not likely to be the result of the rise in the refractive index of linseed oil. The flesh which has gone translucent is largely painted in lead white, which has a refractive index between 1.94 and 2.09 – well above the 1.69 level.

It has recently been claimed that "most pentimenti involve the use of lead white".[49] Since lead white is the most commonly used pigment in Western art, that may be a coincidence. Nevertheless, there has been much interesting work carried out over the past decade on the role of lead white in a number of pictorial deteriorations, and it is argued that the translucency from which the pigment can suffer is not best explained by Laurie's refractive index theory.

We have already observed (p. 136) that lead pigments sometimes react with the fatty acids in linseed oil to form 'lead soaps'.[50] Sometimes these lead soaps are white, as in the example of the orange cloak of St John in Sebastiano del Piombo's *Raising of Lazarus* (fig. 44), and they can form noticeable white lumps on the surface.[51] But sometimes they are translucent, to the point of transparency.

Since lead soaps are brought about by a reaction with linseed oil, they are more likely to form if they are bound with a great deal of oil. When used in its pure state, as we have already noted, lead white has one of the lowest oil absorption values of any pigment (the only traditional pigment that outdoes it in this regard is red lead). But when it is mixed with a pigment with a high oil absorption value, a brown or a black for example, it has more oil with which to react. Particles of white lead which are mixed into a brown or a black paint in order to make it lighter, therefore, can form lead soaps more easily. When these soaps become transparent, the whiteness of the pigment is lost, and the light brown or grey mixture darkens as a result.[52]

An example of this darkening can be seen in fig. 123. Analysis of pigment samples has shown that saponification of lead whites has taken place in the dark foreground, with the result that regions which were meant to be lightened with a touch of white are now entirely sombre.

In recent writings on lead saponification the reaction with fatty acids is said to bring about darkening in two ways. One is the process we have just described: whites go transparent and the

123
Roelandt Savery, *Orpheus
enchanting the Animals with his
Music*, 1627, oil on oak panel,
62 × 131.5 cm, Mauritshuis,
The Hague

paints in which they are mixed lose their light tints. The other
process returns to the concept of translucency; transparent lead
whites are thought to make it more likely that underlayers will show
through, and if those layers are dark, darkening will be the result.
Some of the criticisms of Laurie's theory presented above will also
apply to this second strand of the lead soaps theory. We cannot
blame the darkening of Leonardo's *St Jerome* or Poussin's *Man killed
by a snake* on translucency, even if transparent lead soaps should
prove to be present in the darkened paint.

It is still early days in the study of saponification in art, and
many aspects of recent theory will be revised and expanded as more
evidence comes in. At present a relatively small number of pigment
samples are being used to support an ambitious set of conclusions.
But that the formation of lead soaps is at least a contributing factor
in the darkening of some paintings has already been shown. There
is no reason at present to think that saponification alone is the
cause of darkening, and the yellowing of abundant oil, the heat of
restorers' irons and the rise in the refractive index of linseed oil
may all form part of this complex process, as well as other causes
which remain to be discovered by research in future.

Finally, we should note that a rise in translucency in paint
layers is often due neither to refraction nor to saponification,
but to abrasion. If a paint layer has been thinned by scrubbing or
solvents then it will reveal more of the paint layers beneath it, even
if the pigments themselves remain opaque. But this leads us into
controversial territory, and a subject which requires a new chapter.

1 Félibien, *Conferences*, 401 (Sixth Conference): *"Que quand l'on a examiné les Peintures de Raphaël & des Peintres de son siecle, chacun a donné beaucoup à ses conjectures & deferé à ses propres sentimens, parce que les couleurs dont ils se sont servis, n'ayant pas conservé leur premier éclat ni leurs véritables teintes, l'on ne voit pas bien tout ce que ces grands hommes ont representée, & l'on ne peut plus juger de tout ce qu'ils ont mis de beau dans leurs Ouvrages"*.

2 Félibien, *Conferences*, 401 (Sixth Conference): *"Mais comme il a eu l'avantage de converser avec ce grand homme dont il entreprend de parler & que ses Tableaux ont encore le même lustre, & la même vivacité de couleurs qu'ils avoient lorsqu'il y donnoit les derniers traits, il en pourra dire son sentiment avec plus de connoissance & de certitude que les autres"*. I thank Helen Glanville for drawing this passage to my attention.

3 Mogford, *Hand-Book*, 6-7.

4 Ruhemann, *Cleaning of Paintings*, 182-83.

5 Wine, *French Paintings*, 147; Crookham, 'Turner Bequest', 59, fig. 41.

6 Brachert, *Patina*, 40; Hedley, 'Long Lost Relations'.

7 The cleaning of the *Marriage of the Virgin* is discussed at the website of the Brera Gallery ('Il restauro di Raffaello'): http://www.brera. beniculturali.it/Page/t02/view_ html?idp=330. The conservation history of the Ansidei Madonna is online at the National Gallery's Raphael Project: http://cima. ng-london.org.uk/documentation/ index.php. There is probably another reason for the relative darkness of paintings in Italian collections: when British and American collectors were buying Italian art in the 18th, 19th and 20th centuries they tended to select pictures which had not irredeemably darkened, leaving the darkest in Italy.

8 Saunders, 'Pollution'.

9 Spring and Grout, 'Blackening of Vermilion'.

10 Bomford with Dunkerton and Wyld, *Conservation*, 70-73.

11 Boissonnas, 'Fire-Blistered Oil Paintings'; Cornelius, 'Further Developments'; Nicolaus, *Restoration*, 200-03.

12 Bomford with Dunkerton and Wyld, *Conservation*, 39-40; on the darkening of grounds see too van de Wetering, 'Aged painting', 264.

13 Bomford with Dunkerton and Wyld, *Conservation*, 70-73.

14 Dunkerton and Howard, 'Sebastiano', 34.

15 But cf. note 38 below.

16 Ruisdael's greens have darkened too. Their darkness was taken to contribute to the melancholy appeal of Ruisdael's art by one early nineteenth-century critic: Taillasson, *Observations*, p. 49: *"[ses tableaux] inspirent une douce mélancolie: cela vient, sans doute, de la sensibilité de son âme, de son choix dans les objets qu'il imitoit, et peut-être de la couleur sombre de presque tous ses verts"*. I do not know of a study of the part condition has played in the development of the image of the 'melancholy' Ruisdael.

17 Saunders, 'Detecting … Colour Change'; Saunders, Chahine and Cupitt, 'Long-Term Colour Change Measurement'.

18 On this see the remarks of Roger de Piles in du Fresnoy, *Art of Painting*, 163-65.

19 The painting is also very worn, which does not help the coherence of the image.

20 Slive, *Ruisdael*, nos. 90, 218-19. For a similar contrast between Rembrandt paintings and Rembrandt drawings, see van de Wetering, 'Aged painting'.

21 Goeree, *Inleydinge*, 62-63. For other contemporary expressions of similar views see Taylor, 'Concept of *Houding*'.

22 Vasari, *Vite*, II, 10: *"Nell'arte della pittura aggiunse costui alla maniera del colorire ad olio una certa oscurità, donde hanno dato i moderni gran forza e rilievo alle loro figure"*. The word *'forza'*, like the words 'force' and *'kracht'* as used in the art theory of other European languages, has connotations of space and depth: Taylor, 'Concept of *Houding*', 217-18.

23 Keim, *Ueber Mal-Technik*, 13-14, suggests that darkening began in the late 16th century.

24 Vasari, *Vite*, II, 329: *"E se anco questa tavola non fusse stata tanto tinta di*

nero, onde è diventata scurissima, certo sarebbe stata molto migliore; ma questo nero fa perdere o smarrire la maggior parte delle fatiche che vi sono dentro, con ciò sia che il nero, ancora che sia vernicato, fa perdere il buono, avendo in sé sempre dell'alido, o sia carbone o avorio abruciato o nero di fumo o carta arsa". Cf. Vasari, *Vite*, II, 38, the life of Fra Bartolommeo: "*E nel vero si valse assai d'immitare in questo colorito le cose di Lionardo, e massime negli scuri, dove adoprò fumo da stampatori e nero di avorio abruciato. È oggi questa tavola da' detti neri molto riscurata più che quando la fece, che sempre sono diventati più tinti e scuri.*" For a discussion of both passages with different conclusions see van Eikema Hommes, *Changing Pictures*, 202-03.

25 Vasari, *Vite*, I, 19: "*Aviene questo medesimo de la pietra detta piperno, da molti detta preperigno, pietra nericcia e spugnosa come il trevertino la quale si cava per la campagna di Roma, e se ne fanno stipiti di finestre e porte in diversi luoghi, come a Napoli et in Roma, e serve ella ancora a' pittori a lavorarvi su a olio, come al suo luogo racconteremo; è questa pietra alidissima, et ha anzi dell'arsiccio che no*". From this passage it is still not clear what "*alidissima*" means, but in another passage Vasari discusses *piperno* again. This time Vasari uses not the dialectal form '*alido*', but the more common form '*arido*' (though this is still a word he very rarely uses, and only once in this sense), I, 54: "*Hanno provato poi le pietre più fine, come mischî di marmo, serpentini e porfidi et altre simili, che, sendo lisce e brunite, vi si attacca sopra il colore. Ma nel vero, quando la pietra sia ruvida et arida molto meglio inzuppa e piglia l'olio bollito et il colore dentro, come alcuni piperni overo piperigni gentili.*" Piperno, then, is "*una pietra alidissima*", a very dry stone, and "*quando la pietra sia ruvida et arida*", when a stone is coarse and dry, "*molto meglio inzuppa e piglia l'olio bollito*", it soaks up and absorbs boiled oil much better. See Vasari, *On Technique*, 55, 238.

26 Wicks et al., *Organic Coatings*, 444-45; Mayer, *Artist's Handbook*, 76; Wehlte, *Materials and Techniques*, 101;

Church, *Chemistry of Painting*, 53.

27 These conclusions are based on averages of the oil absorption values given in Church, *Chemistry of Painting*; Doerner, *Materials of the Artist*; Mayer, *Artist's Handbook*; Wehlte, *Materials and Techniques*; Gettens and Stout, *Painting Materials*; Feller, *Artists' Pigments*; Roy, *Artists' Pigments*; FitzHugh, *Artists' Pigments*; and Berrie, *Artists' Pigments*. At the risk of giving bogus precision to imprecise findings, here are the average numerical values I obtained: red lead, 11; white lead, 13; Naples yellow, 19; lead tin yellow, 20; vermilion, 20; massicot, 25; ultramarine, 36; bone black, 52; yellow ochre, 59; Prussian blue, 60; green earth, 70; burnt umber, 72; raw umber, 73; carmine, 73; madder lake, 77; indigo, 95; burnt sienna, 111; raw sienna, 128; vine black, 162; bitumen, 162; Vandyke brown, 200; lamp black, 203. I have not been able to find numerical values for smalt or azurite, but van Eikema Hommes, *Changing Pictures*, 18, writes that they have high oil absorption.

28 Pernety, *Dictionnaire portatif*, lxxxvi; Paillot de Montabert, *Traité*, VIII, 505-25, and 9, 20-32, 694; Déon, *Conservation*, 32; Marijnissen, *Dégradation*, I, 141-42; Wehlte, *Materials and Techniques*, 101; van Eikema Hommes, *Changing Pictures*, 18-26, 204; van de Wetering, 'Aged painting', 264. I thank Margriet van Eikema Hommes for discussing this issue with me. On oil absorption in general, see too Mayer, *Artist's Handbook*, 65-66, 114; Gettens and Stout, *Painting Materials*, 149; Wehlte, *Materials and Techniques*, 71, 160-68; Gettens, Kühn and Chase, 'Lead White', 70; Winter and FitzHugh, 'Pigments based on Carbon', 14-15.

29 Malvasia, *Felsina Pittrice*, 2, 81: "*Egli alla per fine ha voluto far così, ed al contrario de' buoni Maestri passati s'è arrischiato oprar smoderatamente la biacca, a porre giù una sola pennellata della quale, soleva avvisar Lodovico suo Maestro, bisognare pensarvi un'anno intero; e certo che si osserva ogni dì più anverarsi il suo presagio, che dove le pitture de gli altri perdono tanto col tempo, le sue acquistariano, ingiallendosi quella biacca, e pigliando*

une certa patena, che riduce il colore ad un vero, e buon naturale; ove l'altre annerendosi troppo, ed in quella affumicata oscurità uguagliandosi, non lasciano conoscere e distinguere il più e 'l meno, le mezze tente, e i lumi principali"; Conti, *History of Restoration*, 110-11; Conti, 'Restauro', 110; van Eikema Hommes, *Changing Pictures*, 25; Glanville, 'Veracity, Verisimilitude'. The passage, which seems to contain more than one line of reasoning, was interpreted in a different way by Kurz, 'Varnishes', 58, writing in defence of the idea that artists and writers in the past valued 'patina' (see pp. 216-20 below). Kurz believed that Malvasia was telling us that Reni painted with an excess of white in the knowledge that time would tone down his colours. Mahon, 'Miscellanea', 466-67, disagreed with Kurz's reading of Malvasia; Kurz, 'Time the Painter', 95, rejected the criticism. I think that the reading of the passage given here can co-exist with Kurz's: Reni painted in lead white so his paintings would not darken; at the same time he used an excess of the pigment since he knew it would yellow slightly over time.

30 Vergnaud, *Manuel*, 84; Mills and White, 'Paint Media'; White and Pilc, 'Analyses of Paint Media'; Carlyle, 'Artist's anticipation of change', 62; van Eikema Hommes, *Changing Pictures*, 21-22; Bol, *Oil and the Translucent*, 126.

31 Pernety, *Dictionnaire portatif*, lxxxvii-viii; Tingry, *Traité … vernis*, I, 94-123; Vergnaud, *Manuel*, 120-22; Déon, *Conservation*, 32, 119-20; Eastlake, *Materials and Methods*, I, 78; Plesters, 'Preliminary Note … Smalt', 69-71; Nicolaus, *Restoration*, 163; van Eikema Hommes, *Changing Pictures*, 204; Roy, Spring and Plazzotta, 'Raphael's Early Work'; Higgitt and White, 'Paint Media'; Ward (ed.), *Materials and Techniques*, 427. For varnish as a drier, see Hundertpfund, *Painting Restored*, 110.

32 Nicolaus, *Restoration*, 200-03. On the effects of heat on paints, see Erhardt et al., 'Long-Term Processes'.

33 Van de Wetering, 'Aged painting', 264.

34 Anyone who wants to argue that this effect was intentional will find supporting evidence in Taylor, 'Flatness'.

35 Bomford with Dunkerton and Wyld, *Conservation*, 40; Kirsh and Levenson, *Seeing Through Paintings*, 262.

36 But there are exceptions. If lining can flatten half-tints, other factors can have the same effect, such as lead white saponification (of which more on ppp. 189-90). There are some unlined paintings in which half-tints may have darkened for this reason. On Velázquez's portrait of Juan de Pareja in the Metropolitan Museum, New York, the shadows are unusually flat and murky and there are also small raised spots, a symptom of saponified lead whites.

37 Kirsh and Levenson, *Seeing Through Paintings*, 262.

38 Another explanation for selective darkening which is sometimes given is that lights tend to be cleaned more thoroughly, since they are more resistant to solvents: Delacroix, *Journal*, II, 399 (29 July 1854); Carlyle, 'Artist's anticipation of change', 63; Phenix and Townsend, 'Historical varnishes', 260-61; van de Wetering, 'Aged painting', 261. This can only be a partial explanation of the phenomenon, since the darkening of dark areas occurs also on paintings which have been cleaned thoroughly.

39 That paints go translucent with time had been noted before: see Lairesse, *Groot Schilderboek*, I, 331; van Eikema Hommes, *Changing Pictures*, 38-39; van Loon, *Color Changes*, 206.

40 Laurie, 'Refractive Index'; Laurie, *Painter's Methods and Materials*, 102-55; Eibner, *Entwicklung und Werkstoffe*, 66-72; Rees Jones, 'Changed Appearance'; Horie, *Materials for Conservation*, 32-33; Townsend, 'Turner', 57; Nicolaus, *Restoration*, 162-63; Van Eikema Hommes, *Changing Pictures*, 204; Wicks et al., *Organic Coatings*, 385-93; Van Loon, *Colour Changes*, 206-07; Glanville, 'Verisimilitude, Veracity'.

41 Taft and Mayer, *Science of Paintings*, 107-10.

42 Feller and Bayard, 'Terminology and Procedures', 290, citing Stoiber and Morse, *Identification of Crystals*, 118.

43 Skaug, 'Music, Painting and

Restoration', 244; Wine, *French Paintings*, 296, as quoted above on p. 187; van Loon, *Color Changes*, 206-07.

44 All the figures for refractive indices of pigments are from Gettens and Stout, *Painting Materials*, 147-48.

45 Laurie's theory had earlier been proposed by Eastlake. See Merrifield, *Original Treatises*, cclxxxvii.

46 Wine, *French Paintings*, 296.

47 The idea that the darkening of underlayers is the main cause of the darkening of mid-tones and shadows was argued by Goethe, *Farbenlehre*, 518-19 (§§ 908-09). He believed that it was the thickness of the highlights and the thinness of the mid-tones and shadows that led to the darkened underlayers having more effect on the shaded areas of the painting: see Brachert, *Patina*, 34.

48 The original meaning of '*pentimento*' is 'repentance', and in Italian art history it is used to refer to an artist's revisions or second thoughts. In English-language art history it has acquired a broader meaning, and refers to transparent passages, whether or not they are in fact second thoughts.

49 Van Loon, *Color Changes*, 206.

50 Church, *Chemistry of Painting*, 131-32, argued that this saponification gives lead white its unusual toughness as a pigment.

51 Déon, *Conservation*, 190-91; Higgitt, Spring and Saunders, 'Pigment-Medium Interactions'.

52 Eibner, *Malmaterialenkunde*, 121; Noble et al., 'Chemical Changes'; Keune, *Binding Medium*; van Loon, *Color Changes*, esp. 206-39; Keune and Boon, 'Analytical imaging'; Spring and Keith, 'Aelbert Cuyp', 82; van Eikema Hommes and Froment, 'Decoration Programme', 41.

6.

CLEANING

The cleaning of art works raises the temperature of artistic debate more than any other subject. Accusations that masterpieces have been 'scoured', 'flayed', 'skinned', 'ruined' or 'destroyed' by 'inept' picture cleaners are strewn through the literature of art, and form the central theme of numerous articles, books, letters to the press and submissions to government committees. Given the angry tone often adopted by those who believe that the works they love have been wrecked for ever, it is hardly surprising that picture restorers sometimes defend themselves in an equally forthright way, accusing their accusers of lacking the knowledge, experience or technical expertise to judge the matter.[1]

It is not simply a matter of restorers in one camp, with artists, historians and critics in the other. Sometimes restorers publish misgivings about cleaning, and sometimes historians and critics side strongly with the cleaners. 'Cleaning controversies', in which different parties publish accusations and replies, have erupted on numerous occasions in recent decades. While I was writing this book, the cleaning of Leonardo's *Virgin and Child with St Anne* in the Louvre was the subject of much debate,[2] and twenty-five years ago the cleaning of the Sistine Chapel ceiling attracted large amounts of both criticism and praise.[3] In the years after the Second World War the National Gallery's policy of 'total cleaning', in which old varnish layers were removed and replaced by clear varnishes, was denounced by some restorers and art historians,[4] and defended by others.[5]

The public cleaning controversy, carried out in newspapers and journals, has a history extending back to the middle of the nineteenth century, but complaints about the effects of cleaning

go back further than that. Pliny writes of a painting by Aristides "of which the beauty has perished owing to the lack of skill of a painter commissioned by Marcus Junius as praetor to clean it".[6] When Karel van Mander retold this story in his *Schilder-Boeck* of 1604 he added in the margin: "An idiot of this sort cleaned the foot of Jan van Eyck's altarpiece in Ghent".[7] In the middle of the sixteenth century the Van Eyck brothers' *Adoration of the Lamb* altarpiece was cleaned by a painter who, in Van Mander's words, "erased and ruined" a painting of Hell which used to be placed at the foot of the altar.[8]

Quite what happened in this disaster is not clear. Van Mander stated that the picture was painted in glue or egg tempera, so implied that the cleaning fluid used safely on the parts of the altarpiece painted in (waterproof) oils dissolved the aqueous medium. That is perfectly possible; it could indeed have happened if the cleaner was using simple water. Another possibility entirely is that the *Hell* was in fact painted in oil, but the cleaning agent found its way through the craquelure and dissolved the ground,[9] or possibly caused the canvas to shrink.[10] Early sources recount similar disasters. Filippo Baldinucci, in a dictionary of artistic terms published in 1681, tells the following tale:

> When this portrait was entrusted to an experienced gilder, probably to have it framed, he also wanted to wash it in the same way as he had done in his time with many other paintings. Having washed it, the priming and the colour immediately became detached and whatever was on the canvas crumbled and fell to the ground in minute fragments, nothing remaining of the fine picture but the canvas and the stretcher.[11]

Complete destruction of the work was one danger of cleaning, but more often the problem was that, as in the painting by Aristides mentioned by Pliny, the work survived, but its beauty 'perished', owing to the restorer's lack of skill. One way that this could come about was by harsh scrubbing of the paint surface. An anonymous author who published a treatise in London in 1668 wrote:

> Divers there be which have pretended to be well skill'd or knowing in the Cleansing of Pictures, and skill in Painting, and have undertaken the spoyling of things they have been unworthy to understand; as with Sope, or Ashes, and a Brush, and divers other inventions, by their ignorance to deface and spoyl those things which might otherwise have been worth great value.[12]

This reproach is rather hypocritical, given that the author recommends wood-ash as a scouring agent himself. Nevertheless, contemporaries were aware of the damage that could be caused

by soaping and scouring a picture. It was felt in particular that overcleaning might destroy the delicate final glazes and scumbles which were the highpoint of the painter's art.[13] As Baldinucci put it,

> By the term *rifiorire* the ignorant also mean the washing of old paintings, which they sometimes do with such lack of caution as if they were scouring a rough block of marble And so they run the risk of removing from these paintings during the process of cleaning the veilings, the middle tones and also the retouchings, which are the last brushstrokes in which the greater part of their perfection consists.[14]

This idea that it is, in particular, the last fragile touches of the artist that are erased in the process of cleaning has a long history. In the *Encyclopédie Méthodique*, the enlarged successor of the *Encyclopédie* of Diderot and D'Alembert, we read as follows, in the article on glazes by the painter Claude Robin:

> It is useful to observe that people ignorant of the practice of painting and who involve themselves in the cleaning of pictures almost never know how to distinguish *glazed* parts from those which are not; with the result that, wishing to remove everything that seems to them to be grime and dirt from certain parts of the painting, they also succeed in removing absolutely everything all the way down to the first layer, which then seems to them to be the true tone of the picture.[15]

Opponents of picture cleaning in more recent times have often repeated this criticism, without always being aware of the damage to glazes that had been wrought well before the twentieth century. So for example one post-war critic of the National Gallery's cleaning policy, the painter Pietro Annigoni, lamented:

> What is interesting in these masterpieces, now in mortal danger, is the surface as the master left it, aged, alas! as all things age, but with the magic of the glazes preserved, and with all those final accents which confer unity, balance, atmosphere, expression – in fact, all the most important and moving qualities in a work of art. But after these terrible cleanings little of all this remains.[16]

Annigoni's reverence for the glazes of the Old Masters may not always have been based on original paintwork. In eighteenth-century France, Denis Diderot and Claude Robin argued that glazes, rich as they were in binding oil, soon darkened;[17] and, precisely because they darkened, they looked like "grime and dirt" and were often cleaned away.[18] If these Enlightenment authors were right, then "surfaces as the master left them" cannot have been very common in Annigoni's day.

The idea that works of art should be restored, rather than repainted, or thrown away and replaced, is an unusual one. From Pliny's remark about the ruined work by Aristides it seems that pictures were sometimes cleaned in antiquity, but in the middle ages old paintings were treated with less reverence. Images that were showing their age were either removed and substituted with a new image, or they were given to a competent artist to repaint. No one was concerned that the particular style and character of the original should be preserved. It was the function of the original – as an altarpiece, a votive image, a holy narrative or an allegory – that was important.[19]

Most peoples around the world have had a similar attitude. The manufacture is of less importance than the meaning. Only in regions where artistry in itself is highly prized – for example in China, the Islamic world and Europe – does the restoration of paintings, rather than their replacement or renovation, make cultural sense.[20]

In Europe it was in the sixteenth century that a new concern for the individuality of the specific work began to emerge. It is no surprise that this change took place when it did; the achievements of Leonardo, Michelangelo, Raphael and Titian had revolutionized the concept of art. The masterpieces of these artists, and of artists of less renown, were thought so unique and so precious that they deserved to be maintained exactly as they were. When at the end of the sixteenth century Carlo Saraceni restored the *Holy Family* by Raphael's pupil Giulio Romano (fig. 116), and had the temerity to overpaint some of the master's work, the new attitude could be heard loud and clear in the complaints from his contemporaries: 'wherever he had intervened, Giulio's hand was no longer apparent, and all the masters were very unhappy that Saraceni should have dared to lay a hand with so little restraint, on so precious a work.'[21] The age of image replacement was ending, and the age of conservation had begun.

The history of picture cleaning can be divided into two main phases.[22] Before the eighteenth century, the stated aim of cleaning was to remove various kinds of dirt. These varieties of dirt were summarised in a book published in 1676 as 'dust, smoak, fly-shits, humid vapours and the like'.[23] There are very few texts from this early period which impart methods for removing varnish, and when they do, it is hard to tell if they mean aqueous varnishes – egg white, isinglass, gum arabic – or resin varnishes.[24]

It is only after about 1720 that our sources increasingly focus on the problem of how to remove a resin varnish. Part of the reason for this lack of concern about varnish removal in the early period may have been that many paintings did not have a resin varnish

to remove. As we saw in Chapter One (p. 46), François-Xavier de Burtin, in a treatise published in 1808, claimed that he came across paintings which either did not have a varnish at all or had the discoloured remnants of an aqueous varnish.

Another reason may have been that the resin varnishes which were present on paintings had not darkened sufficiently to be visually disruptive. In the seventeenth and eighteenth centuries, art from before 1500 was little collected or cleaned, and so any resin varnishes that a seventeenth-century picture-cleaner might have encountered could not have been more than a hundred to two hundred years old.[25] There are varnishes of that age which are not dark, but mildly and pleasantly yellow; as we noted in Chapter One, Turner's *Fighting Temeraire* has a varnish which is over 150 years old (fig. 34).[26] But give that varnish another 150 years, and it may tend more to the obscurity of the varnish in fig. 33.

It is perhaps telling that in an early set of instructions on how to remove a varnish, from Antonio Palomino's *Museo pictorico* (1723), it is suggested that the reader may want to carry out this operation if the varnish has become misty due to a scouring with powdered varnish or contact with water, or has been put on too thickly and glaringly in the first place. There is no mention of the varnish having yellowed.[27]

Although early cleaning instructions are largely concerned with what we would call surface cleaning, it should not be supposed that this was just a simple matter of light dusting. We have already seen (p. 167 and fig. 105) that dirt can make a considerable difference to a painting's appearance. Compacted grime, especially if combined with carbon from smoke or incense, can be extremely difficult to remove. This description of the cleaning of a Russian icon in a Soviet restoration studio in the 1920s makes the difficulty clear:

ALKALIS AND ABRASIVES

> The grime was primarily composed of hardened soot. First they used turpentine, then alcohol. Since the grime did not come off quickly enough, [the head of the restoration studio] had some ammonia poured on the painting. I pointed out that this liquid was quite corrosive and could attack the consistency of certain pigments. No one paid any attention to my remark. The grime still resisted, and the two assistants then resorted to scraping with a scalpel.[28]

Given the resistance that grime can present, it is not surprising that early cleaning instructions contain some strong substances and processes.

Detail from Workshop of Dirk
Bouts, *The Virgin and Child*,
c. 1465, oil with egg tempera
on oak, 20.2 × 14.3 cm,
National Gallery, London

The most common cleaning fluid found in early texts is a
combination of ash (either of wood or vine) and water.[29] This
seems to have been found effective in part because the ashes
were mildly abrasive, and could bite into the grime. But there
was also a chemical component to the recipe: ash is rich in
potassium carbonate (potash). When soaked in water, ash
produces lye, an alkaline solution which long formed the basis of
soap manufacture.[30] Soap is also recommended in seventeenth-
century treatises; at that time this was normally lye mixed with
lard.[31] Another by-product from ash is sodium carbonate, washing
soda, which is also recommended in some early cleaning texts.[32]

Cleaning agents based on ash would certainly be effective against
many forms of dirt. They would also, unfortunately, clean away not
only aqueous varnishes but also resin varnishes and paint if used
too enthusiastically, and, since many early recipes recommend the
use of a scrubbing brush to help get the filth off, it is easy to imagine
that paint surfaces were sometimes seriously abraded by these
methods.[33]

A milder cleaning fluid, recommended several times in early
texts, was urine. Stale urine – known at the time as chamber-lye
or lant – was a common cleaning agent in early modern Europe.
It contains a form of ammonia, which is still an ingredient of
cleaning fluids today. Pure ammonia is dangerous to pigments,
but in urine it is in highly dilute form. Some nineteenth-century
writers on the arts condemned urine as a cleaning fluid, but some
of their contemporaries continued to recommend it. Conservation
scientists do not seem to have researched the properties of
cleaning-lye; until they do, we should perhaps reserve judgement
on its efficacy.[34]

Another cleaning agent mentioned on occasion, and probably
used more often than that, was saliva. In fact saliva is still used by
restorers with the blessing of modern science, which has analysed
its chemical make-up and pronounced it both effective and benign.[35]

Lye, soap, urine and saliva can all dissolve grime, but for tough
layers of smoke and other hardened filth an abrasive of some kind
was found necessary. The abrasive most often recommended in
early recipes was smalt,[36] although pumice stone and 'filings' also
had their advocates.[37] The dangers of such abrasives were clear
to people at the time, and one author wrote of them that "this
scowring ought not to be practised but very seldom (as when
your Picture is very much soyled) because often and too frequent
operations of this kind must needs wear off a little of the Colours;
therefore strive what you can to preserve their first beauty, by
keeping them free from smoak, and by often striking off the dust
with a Fox tail; as likewise preserving them from Flies, by dressing

up your Rooms with green boughes, to which the flies will gather themselves, and so not hurt your Pictures."[38]

Lye, soap and urine, applied with a brush or sponge, are the most frequently endorsed cleaners, but there are other suggestions too: mustard,[39] beer,[40] sorrel leaves,[41] apples,[42] egg yolk,[43] 'aqua fortis' (nitric acid),[44] and solutions of hydrochloric and sulphuric acid[45] all make occasional appearances.

Early cleaning methods are often dismissed as 'barbaric' in the conservation literature, but the alkaline substances which underlay the main methods of cleaning all survived into the past century. Thomas Beaufort's *Pictures and How to Clean Them* of 1926 recommends ammonia, potash and soda.[46] Ammonia and sodium hydroxide – which has taken over the name of 'lye', owing to its chemical similarities with caustic potash – long kept a place on the shelves of twentieth-century restorers, for the last-resort removal of particularly recalcitrant residues of varnish and overpaint.[47]

There are many paintings which have come down to us through the centuries in a worn or abraded state, and, while it is rarely possible to be sure what has caused the damage a picture has suffered, it is nevertheless tempting to think that one can see the scourings of smalt and lye on some of these painted surfaces. Take an extreme example, a detail from a Netherlandish *Virgin and Child* (fig. 124). Here half the face of the Christ Child has been rubbed off, and timidly restored. The parts of the surface that are original are severely pitted. It is possible, though not provable, that an attempt to clean away smoke darkening with soap, smalt and a scrubbing brush has caused this damage.

A subtler form of abrasion can be seen in fig. 125, which is a detail of fig. 94. All the paint here is original, but it is nevertheless abraded. This is most evident in the goldfinch in the Christ Child's hand; it has become translucent. The face of the child is still opaque, but the brushstrokes of the tempera look blurred and worn, something that becomes clear when it is compared to the perfectly preserved paintwork in fig. 27. Again, we cannot be sure what has caused this, but an energetic use of ash and water is one possibility.

In the first half of the eighteenth century there are few texts which discuss picture cleaning, and it is only after 1750 that we can pick up the historical thread again. It is clear that something had changed in the interim; restorers were now focussed on the task of varnish removal, and different substances were mentioned as necessary aids for the picture cleaner. Foremost amongst these were alcohol and turpentine, which were widely used in cleaning well into the

FRICTION AND SOLVENTS

twentieth century. At the same time, the old seventeenth-century recipes were still being employed. An advertisement published in 1773 by the Parisian colourman Jean-Félix Watin, who wrote a treatise on art as a way of drumming up business, gives a list of the four cleaning agents that were available at his shop: they were lye (by which he may have meant chamber-lye), potash, ashes and black soap.[48] Even de Burtin, whose instructions on cleaning are state-of-the-art and exceptionally detailed, admitted that he was willing to fall back on old procedures if necessary: "one should not suppose, as happens all too often, that one single method will suffice for the cleaning of all paintings. The nature of the matter and a wealth of experience have taught me the error of this opinion, and have convinced me, that simple rubbing with the fingers, spirits, alkalis both moderate and caustic, spirit of turpentine, mastic varnish, oils, cold water, hot water, saliva, even knives, sand and ash have to be employed, each in turn, either separately, or many together at one time, according to the nature of the case and the kind of dirt which has to be removed."[49]

Two main methods have been used for the removal of varnish since the late eighteenth century, the dry process and the wet process. In the former, the varnish is gently rubbed with the fingers. If it is a spirit varnish made of a soft resin it will turn to powder, and can be brushed away. This method will not, however, work for hard resins, nor for oil varnishes. The advantage of the process is that solvents are not allowed near the paint surface, which may contain soluble paints. A disadvantage is that, on uneven surfaces like coarse canvasses or paintings with impasto, it is impossible to get the varnish out of dips and furrows. Another disadvantage is that, with slightly too much pressure, the powdered varnish can act as an abrasive on the paint layer below. Soft resinous paints are particularly vulnerable to scouring of this sort. The dry method requires a very delicate touch and much patience, and this makes it hard to apply to very large paintings.[50]

The friction method is often described in the cleaning literature, but it has always been more common for varnishes to be removed using the wet process, with solvents. It was already known in the 1630s that alcohol could dissolve varnish, but this knowledge does not seem to have been put to use before the eighteenth century.[51] In part this may have been because varnish removal was not a priority for early picture cleaners, but it also seems that alcohol was considered by some to be dangerous. In 1758, Robert Dossie published the longest text written up to that time on the art of picture cleaning. It is evident from what he says that alcohol was already being used to dissolve varnishes, but he was clearly worried about its effects:

Spirit of wine, as it will dissolve all the gums and gum resins, except gum Arabic, is very necessary for the taking off from pictures varnishes composed of such substances: but it corrodes also the oils of the paintings; and softens them in such a manner, as makes all rubbing dangerous while they are under its influence.[52]

Dossie also used spirit of turpentine, "very sparingly, and with great caution; as it will soon act even on the dry oil of the painting". Dossie's cautious approach is admirable, but it seems that he was wrong about turpentine dissolving dry oil; conservation scientists are convinced that turpentine can dissolve neither dry oil nor dry varnish. Indeed turpentine has often been used as a 'restrainer', together with alcohol, in cleaning. The idea was that turpentine would immediately stop the solvent action of the alcohol.[53] Restorers sometimes worked with an alcohol-soaked swab in one hand and a turpentine-soaked swab in the other. If the alcohol was biting into the varnish too swiftly, turpentine would be dabbed over the area. Another way of combining the effects of alcohol and turpentine was to mix them. A cleaner would begin with a weak mixture, 15:1 turpentine to alcohol for example, and then if it was having no effect on the varnish, gradually increase the dosage of alcohol.[54]

These methods of cleaning with a combination of alcohol and turpentine seem to have been invented in the late eighteenth century, and are described in numerous texts from then on.[55] They are still used by some restorers today, although over the past century a raft of new solvents have been introduced – ketones, esters, ethers, enzyme gels, resin soaps and more.[56]

The aim of all these solvents is to dissolve the varnish or dirt which covers a painting without harming the paint beneath the varnish. Everyone agrees, however, that in some cases it will not be possible to avoid damage.

One situation in which dissolving the varnish must harm the pigments is when the pigments have actually merged with the varnish. This can come about in a number of ways. One is when the varnish is put on to a painting too soon, while the paint is still wet. We saw in Chapter One that the final varnishing of a picture was supposed to take place a year or more after the paint had dried. If this did not happen, then the pigment could drift up into the varnish. In Degas's painting, *Miss La La at the Cirque Fernando* (fig. 126), orange paint has found its way into the varnish on the surface,

CHALKING
AND LEACHING

126
Edgar Degas, *Mademoiselle La La au cirque Fernando*, 1879, oil on canvas, 117.2 × 77.5 cm, National Gallery, London

and a too early varnishing has been suggested as the cause. As a result of the merging of paint and varnish, this canvas can never be cleaned.[57]

There are other mechanisms which bring about the same effect. One is if the paint exhibits a phenomenon known as 'chalking'. 'Chalking' refers to the situation when pigment particles are mixed with a binder which is too sparse, and which is therefore unable to fix the particles securely to the surface. When a varnish is drawn across a chalked surface, particles can detach from the binder and float up into the varnish.[58]

Chalking can take place from the day a paint was applied. Artists who use too much turpentine to lay down their glazes will often create a chalked surface.[59] So too will artists who simply misjudge the oil absorption of their pigments.

But chalking can also be an effect of time. Some pigments – vermilion is particularly noticeable in this regard, and to a lesser extent so is verdigris – appear to speed up the oxidation of linseed oil, resulting in a deteriorated, friable medium from which particles can easily be dislodged.[60] And the same effect can also be brought about if the medium is abraded. A paint surface which has been attacked by lye or nitric acid or too strong an alcohol may well suffer a depletion of its binding medium.

There has been a certain amount of research in recent years on the effects of modern solvents on binding media; it has been found that, when applied to new paint, solvents can extract (the technical term is 'leach') certain chemicals from the binding medium, leading to a drop in the weight of the binder. When solvents are applied to old media the effect is less pronounced, but still sometimes measurable. Those who believe that cleaning is a dangerous activity have made much of this phenomenon;[61] those involved in the research have said that it is too soon to draw conclusions from preliminary and ambiguous data.[62] Nevertheless the findings have quietly contributed to a change in cleaning practices, which now err on the side of caution. Whereas fifty years ago some museums favoured a policy of thorough cleaning, in which all the old varnish was removed,[63] now a more restrained policy, in which a thin layer of the old varnish is left on the painting, has found new favour. The aim is to protect the paint surface as much as possible from any harmful effects of solvents.[64]

In chalking, pigment has found its way into the varnish unintentionally, owing to the degradation of the oil medium. But sometimes pigment can find its way into a varnish because an artist has deliberately mixed it in. This can occur either because a tinted varnish has been applied as a toning layer – we will discuss cases of this sort in the next section – or it can occur because varnish was used as a medium in the paint layers of the picture.

Ever since the seventeenth century, critics of cleaning have argued that delicate final glazes may be removed by the restorer's swab, and it has been claimed as part of this argument that glazes are delicate not only because they are thin and on the surface, but also because they were often painted in a soft resinous medium, which will liquefy in solvents designed to remove a final coating varnish.[65]

It is well known that, in eighteenth- and nineteenth-century paintings, waxes and resins were often mixed into the media in the upper layers,[66] and that pictures from this period have to be cleaned with the utmost care – indeed sometimes cannot be cleaned at all. Sir Joshua Reynolds, for example, would on occasion paint glazes and scumbles in soft resinous paints, and then coat the painting with a hard oil varnish. Any solvent strong enough to clear the painting of the oil varnish would destroy the resinous binder, should it find its way through the whole of the coating layer.[67]

Reynolds, and other English painters such as Stubbs, have long been notorious among picture cleaners for their use of media. But the widespread use of solvents in order to clean paintings was only beginning to get under way in the second half of the eighteenth century, when both Stubbs and Reynolds were in mid career. In their youth there was little need to worry about solvents attacking resinous glazes. To be sure, lye and soap would destroy a glaze of this sort, but then they would destroy a pure oil medium as well. There was no reason to avoid certain media rather than others.

It has been claimed in the past by advocates of thorough cleaning methods that painters in the centuries before Reynolds would not have been so foolish as to use resinous glazes when they must have known they would be removed by solvents.[68] However this line of argument forgets that solvent cleaning is a relatively recent practice. In any case, painters do not seem to have worried greatly about the longevity of their paintings. From the comments collected by Margriet van Eikema Hommes on what counted as 'permanence' for pigments, most artists seem to have thought that their pictures would last decades rather than centuries.[69] We noted above (p. 179) that Guido Reni was said to have mixed lead white into his paints in order to make his paintings darken less over time. For this he was condemned in Francesco Scannelli's *Microcosmo della Pittura* of 1651, since in Scannelli's view the artist's duty was to paint for his contemporaries, not to second guess the unpredictable changes which would take place in the future.[70]

Given this lack of concern for posterity and obliviousness of the coming solvent era, did painters in the centuries before Reynolds and Stubbs also use varnish as a medium? Recent research, especially by the Scientific Department of the National Gallery in London, has shown that a certain amount of resin can be found in some paint media even in fifteenth-century Italian paintings, though the majority of media tested hitherto seem not to contain resin. Media which do include resin invariably also include oil.[71] Had this not been the case, their chances of surviving into the 1970s, when scientific techniques for detecting resins in media were first developed, would not have been good. Most of the paintings

in the National Gallery had been cleaned more than once before they entered the collection, and had therefore been subjected to lye, soap, washing soda, smalt, alcohol or some other cleaning medium at some point in the past. If there ever were spirit varnish glazes on these paintings, they are not likely to have lasted intact for centuries.[72]

Despite the lack of physical evidence of glazes of this kind, there is literary evidence that spirit varnish was sometimes the main constituent of media in the Low Countries in the century before Reynolds. A painter called Gérard de Lairesse, who was one of the most successful artists in the Netherlands in the 1670s and 1680s, went blind in 1690, and spent the rest of his life lecturing on art; his lectures then appeared as a treatise, the *Groot Schilderboek*, or Large Book on Painting, in 1707. This is much our most informative source on late seventeenth-century Dutch and Flemish painting technique. Lairesse tells us in his treatise to paint final glazes in varnish, and while sometimes he tells us to mix oil into this varnish,[73] at other times he simply suggests spreading "thin varnish mixed with a little light ochre" over flesh, and then brushing highlights into this varnish scumble.[74]

Modern conservators who have recently cleaned some of Lairesse's own paintings report that they have been unable to find the varnish glazes he describes,[75] but it is of course possible that such soft paints have been cleaned away at some point during the three hundred years since his death.[76]

De Burtin tells us that a number of Dutch painters, among them Gerrit Dou, Pieter van Slingelandt and Frans van Mieris, also painted in varnish.[77] Certainly there are many paintings by all three artists which look as if they may have lost glazes and scumbles (fig. 127), and the same can be said for works by other Dutch painters, such as Johannes Vermeer (fig. 128). The flesh in Vermeer's last works has a peculiar greenish hue,[78] and the reason for this may be a change in his technique towards the fragile resinous layers recommended by Lairesse for flesh paint.[79] Surface scumbles may have have dissolved too easily in cleaning agents, leaving the painter's underlayers bare.[80]

Painters in the Netherlands may have used spirit varnish as a binder on occasion, as Lairesse recommended, but in European art treatises it was more common to recommend a glazing medium which either blended oil with varnish or used varnishes that had been made with oil in the first place.[81] There is no doubt that varnishes of this kind would have been tougher and so more resilient than spirit varnishes. In fact we are told in early sources that painters who used oil varnish glazes felt it unnecessary to add a final coating of varnish to their pictures.[82] Nevertheless, there

would be a great variety of toughness depending on the resin, the ratio of resin to oil, and the method by which the varnish was made.

If a painting with oil varnish glazes was later coated with a soft spirit varnish, then its glazes should be safe against the mild cleaning solvents needed to remove the spirit coating. The greater danger would come if the painting were coated with an oil varnish or pure oil, because then the more aggressive solvents needed to dissolve the tougher varnish could also bite into any oleo-resinous glazes.

127
Detail from Gerrit Dou, *A woman playing at a clavichord*, c. 1665, oil on panel, 29.9 × 37.7 cm, Dulwich Picture Gallery, London

VEILING

'*Velatura*', veiling, is an Italian artistic term which cannot quite be translated into English. On the one hand it means the same as the English 'glaze'. But whereas, in current art terminology, 'glaze' usually means a translucent layer of paint applied to a fairly small area,[83] the Italian '*velatura*' can also mean a more general toning layer, applied over large expanses of a painting in order to subdue colours which are too bright, and to bring the whole picture into harmony.[84]

We have already encountered the term in the quotation from Filippo Baldinucci at the beginning of this chapter. He defined its associated verb, 'velare', as follows: "To veil. To cover with a veil. According to our artists, to veil means to paint with a little pigment and much tempera (or as it is commonly called, watery or long) the colouring on a canvas or panel, in such a way that it does not disappear from sight, but remains somewhat subdued and pleasantly obscured, as if it were covered by a most subtle veil."[85]

The French word 'glacis' had a similar range of meaning. In the article on glazes by Claude Robin in the *Encyclopédie Méthodique*, the word is defined as follows:

GLAZE is so named from the word 'glass', the transparency of which it imitates. It is used principally in oil painting. It is a layer of colour so light that it allows one to see the tint which is beneath it.There are painters who paint by *glazing* even *with the first stroke*; like Rubens and his school…. Glazes placed in this way on well-dried *underlayers* are durable, light and bring out the tint.

But the more general meaning of *glaze* is to give, after the first layer, tints at will to different parts of the work, to increase their vigour, lightness and harmony, and to ensure the accuracy of the light effects. So the *glaze* is an effective means to achieve artistic perfection, and a remedy for the faults which have appeared in the first layer. The old Venetian school, and many French painters, have used *glazes* with this aim.[86]

128

Detail from Johannes
Vermeer, *A young woman
standing at a virginal,*
c. 1670–72, oil on canvas,
51.7 × 45.2 cm, National
Gallery, London

Despite his claim that glazes of this kind were "a means to achieve
artistic perfection", they had according to Robin one serious
drawback:

> However good the effect of a glaze on a painting already painted
> – in giving power to certain colours and adding, as we say, the
> harmonies [*accords*] – it is physically a lethal method in a painting.
> The artist uses it soon after he has finished his work in impasto;
> the oils of the first layer have not yet evaporated. In glazing one
> spreads a kind of varnish or glaze; but the oil of the first layer still
> tries to evaporate out, it finds itself trapped under the glazing, and
> forms there a yellowish-brown crust which gives its tint to the
> glazed parts.
>
> It is mainly to the use of glazes that many excellent works owe
> the black tint which spoils them.[87]

Robin was not the only person in eighteenth-century France to
complain about the effects of glazing/veiling. In his review of the
Salon of 1763, Denis Diderot wrote: "I am also extremely angry that
pieces of painting which have the freshness and force of flowers
should be condemned to wither no less quickly. This problem is
the result of a technique which makes the painting look twice as
effective in the short term. When the painter has almost finished his
work, he glazes. To glaze, is to pass across the whole painting a thin
layer of a colour and a tint which suits each part. This layer which
has little colour and a great deal of oil serves the function and has
the failing of a varnish; the oil dries and yellows in drying, and the
painting becomes more or less blackened, depending on how thickly
the glaze has been applied."[88]

Robin and Diderot were surely right that these glazings
darkened quickly, due to their excessive use of medium and the
discolouration of the pigments – often lakes – which were mixed
into them.[89] If as a result they looked like no more than dirt they
might well have been removed as such by picture cleaners, just as
Robin said (p. 197 above).

This problem must have been worsened if the veilings were
mixed with resin, and it appears that sometimes they were.
Giovanni Battista Armenini, in his *De' veri precetti della pittura* of
1587, asserted that all glazes used for veiling should use varnish
in their medium.[90] Quite what proportion of varnish he thought
should be used he does not say, but since the varnishes he
recommends were mostly soft and spirituous,[91] the resultant veiling
may have been quick to discolour and fragile.[92]

Robin, in the passage quoted above (p. 197), wrote that ignorant
amateur restorers "succeed in removing absolutely everything all
the way down to the first layer, which then seems to them to be

129
Agnolo Bronzino, *Venus,
Cupid, Time and Oblivion*,
c. 1540–45, oil on wood,
146.1 × 116.2 cm, National
Gallery, London

the true tone of the painting".[93] Given the difficulties of cleaning pictures with discoloured and fragile glazes, it seems very likely that many paintings which have been cleaned repeatedly over the centuries have lost their veilings.[94] But when we are looking at a picture, how can we distinguish "the first layer" from the "true tone of the painting"?

It is not an easy thing to do. We can hardly expect many of these veilings to have survived, and, if they have survived, they may be so discoloured as to give us little idea of their original appearance. There is too the further problem that some of them will have been replaced by earlier restorers.[95]

In order to get some idea of what a painting covered in original veiling glazes might have looked like, literary descriptions can again be of help. Armenini writes of the process of veiling as follows:

But when all the first layers are finally finished and dried, one begins again to scrape the work lightly with a knife, with which

130
Agnolo Bronzino, *Venus, Cupid and Envy*, c. 1548–50, oil on poplar, 192 × 142 cm, Szépmûvészeti Múzeum, Budapest

one lifts away the roughness and the excess of colours that have remained on top of it, and when it has been cleaned one begins again to paint with more judgement, working over everything with the finest colours, and nevertheless making mixtures while one works little by little, since this time one is more nearly veiling, rather than covering, those things which have already been sketched out well, especially the flesh, which is covered in a most delicate and lively manner, improving all the parts in unity and in tints, with that dexterity and judgment which can best be employed by a diligent and accurate arteficer, in such a way that the flesh appears in its proper tones, effortlessly, with its blues and pinks as they are in life, pleasantly soft and unified.[96]

With this description in mind, we can compare two paintings by Bronzino (figs. 129, 130). The National Gallery's *Venus, Cupid, Time and Oblivion* (fig. 129) is now so iconic that we take the stony

flesh of its figures for granted; it has become an integral part of the icy, unnerving appearance of this famous image. And yet a comparison with a similar allegory by Bronzino, in a different state of preservation (fig. 130), suggests that the skin in the National Gallery's painting may look so strangely cold because it has lost its veilings, which once gave it "blues and pinks as they are in life, pleasantly soft and unified". Certainly the skin in the Budapest painting looks more full-blooded than the alabaster flesh of the London picture. And it is not only the skin that is different. The London painting has an overall piercing clarity of hue which has probably contributed to its popularity in an era accustomed to the brightness of machine-made images. The Budapest picture has darkened, but even in the areas where the colour is well preserved it has a mellowness of tone which is very different from the electric colour harmonies we see in fig. 129. Were those strong contrasts actually intended by Bronzino, or did he originally veil the shrill blues and greens so that, as Armenini put it, "the rest would be soft and correspond to those flesh tones"?[97] This question leads us into questions of what Renaissance painting was meant to look like, and to a concept which provoked strident disagreement in twentieth-century cleaning controversies.

PATINA

'Patina' is a vague term, and its use in the literature of conservation has often resulted in talk at cross purposes.[98] Even its etymology is unclear. In Latin, '*patina*' meant a copper bowl, and as a result it has often been assumed that the modern meaning of the term, as a surface layer transformed by the effects of time, must have been inspired by the green oxidized outer crust of copper objects. However, it seems that the etymology of 'patina' may not be so straightforward. In Latin the word never had the meaning of an aged surface; this is an Italian invention, dating to the seventeenth century. And the first recorded uses of the word '*patina*' in Italian in its newly coined sense do not refer to statues: they refer to paintings. In 1657 the artist, merchant and dealer Paolo del Sera wrote in a letter to Cardinal Leopoldo de' Medici about a picture that seems to have displeased its recipient: "I imagine that the too great freshness of the painting perturbed you, because in truth that patina which time bestows is a most attractive thing, and gives a certain unity which pleases".[99]

A generation later Filippo Baldinucci provided a definition of the word, as follows: "Patina. Term used by Painters, and they call it alternatively skin, and it is that universal darkness that time makes appear on paintings, which sometimes also benefits them."[100]

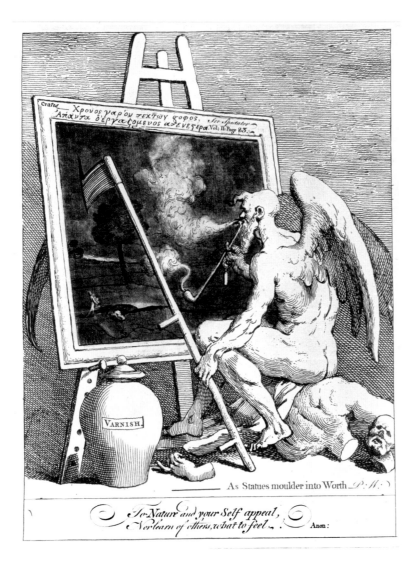

From these quotations it would seem that 'patina' was imprecise
from the start; it could refer to the effects of dirt, yellowed varnish,
darkened media, craquelure or even changing pigments – in fact
most of the phenomena we discussed in Chapters Three to Five.

It is clear from Del Sera and Baldinucci that this "universal
darkness" was not always considered damaging to a work. It
could increase a painting's unity and harmony. Nevertheless,
from Baldinucci's use of the word 'sometimes' we can see that
'patina' was not always thought beneficial. The effects of age were
sometimes found pleasing, sometimes not. And, at the same time,
aged paintings which pleased some people did not please others. In
England, fine pieces of writing by John Dryden and Joseph Addison
were devoted to the praise of 'time the painter' (see fig. 131), and

131
William Hogarth, *Time
smoking a picture*, 1761,
etching, engraving and
mezzotint, 26.2 × 18.4 cm,
British Museum, London

yet Dryden's lines were quoted by William Hogarth in a passage in which he forcefully argued for the view that time damaged paintings:

I own it would be a pity that Mr. Addison's beautiful description of time at work in the gallery of pictures, and the following lines of Mr. Dryden, should want a sufficient foundation;

> For time shall with his ready pencil stand;
> Retouch your fingers with his ripening hand;
> Mellow your colours, and embrown the tint;
> Add every grace, which time alone can grant;
> To future ages shall your fame convey,
> And give more beauties than he takes away.

were it not that the error they are built upon, hath been a continual blight to the growth of the art, by misguiding both the proficient, and the encourager; and often compelling the former, contrary to his judgment, to imitate the damaged hue of decayed pictures.[101]

We have the beginnings of an argument at cross purposes. Del Sera, Addison and Dryden seem to have been claiming that the initial, overall darkening of a painting, due to the browning of the varnish and the medium and the muting effects of dust and dirt, could harmonize colours which had been too bright and garish. Hogarth observes that, over longer periods, time can alter the pigments and throw the balance of light, shade and colour off-key:

When colours change at all it must be somewhat in the manner following, for as they are made some of metal, some of stone, and others of more perishable materials, time cannot operate on them otherwise than as by daily experience we find it doth, which is, that one changes darker, another lighter, one quite to a different colour, while another, such as ultramarine, will keep its natural brightness even in the fire. Therefore how is it possible that such different materials, ever variously changing (visibly after a certain time) should accidentally coincide with the artist's intention, and bring about the greater harmony of the piece, when it is manifestly contrary to their nature; for do we not see in most collections that time disunites, untunes, blackens, and by degrees destroys even the best preserved pictures.[102]

Hogarth is of course right about this, but a distinction might be made between a little time and a lot of time; a little time could make an improvement, when a lot of time will ruin a painting.

It is possible that even Hogarth would have agreed with this, just as Dryden might have acknowledged that the ageing of, for example, Jacob van Ruisdael's *Waterfall* (fig. 102) has gone too far.

Artists' opinions are rarely written down, and so we do not have much idea of what painters thought on the subject of patina. There certainly have been artists who believed that time improved the appearance of paintings. Louis Lagrenée,[103] Joseph Vernet,[104] Charles Eastlake[105] and Auguste Renoir[106] are among the painters whose admiration for the effects of time has been recorded, and to their names might be added those of some distinguished writers about art from the seventeenth to the nineteenth centuries – Marco Boschini,[107] André Félibien,[108] Francesco Algarotti[109] and Denis Diderot.[110] In the opposite camp were the painters Sebastiano Mazzoni, William Hogarth, Jean-Étienne Liotard and John Constable.[111] Quite what these small samples tell us about the balance of opinion among artists at large is very hard to say; and it would also be good to know what more influential artists thought – Titian or Rembrandt or Velázquez.

Whatever their opinion about the aesthetics of patina, there is some evidence that certain artists deliberately attempted to forestall its effects. It has been claimed that Paolo Veronese, Guido Reni, Donato Creti, Joseph Vernet and Caspar David Friedrich painted in brighter colours knowing that time would soften their tone.[112] Another artist who did something similar was Vincent van Gogh, who thought time would mute the excesses of his colouring, but knew as well that it would go too far and eventually ruin his paintings: "all the colours that Impressionism has made fashionable are unstable, all the more reason boldly to use them too raw, time will only soften them too much".[113]

Van Gogh knew that time does not bring pictures into a harmonious state and then conveniently stop. The problem with patina is that it continues to accrue, and, once it has brought the colours into harmony, it carries on and, in Hogarth's words, "disunites, untunes, blackens, and by degrees destroys". For the restorer, then, deciding whether or not to preserve 'the' patina is an impossibility: patina is a process, not a state. An excess of patina needs treatment. At the same time, stripping away every last speck of dirt and varnish so the bare paint is revealed may leave the painting in a state which might also betray an artist's intentions.

There are two separate dangers here. If, by removing old dirt and varnishes, it were possible to restore the painting to its appearance when it left the artist's studio, that might not produce the result that the artist intended. He or she might well have painted the picture in too high a key in the hope that the yellowing of varnish and the accrual of dirt would bring the whole into a harmony. Just

as artists had to imagine what verdigris would look like when it had turned green (see p. 141 above), so too they had to imagine what the overall appearance of their painting would be when the varnish had started to yellow, and painters may have factored this in from the outset.[114]

However, as we have seen, the yellowing of the varnish is not the only alteration that a painting will undergo. Paints discolour, and they also darken unevenly. As a result, the overall harmony of the original painting will in any case be untuned, and colours and tones which before were in accord will now clash. A layer of yellowed varnish will not be able to stop this process, but it may be able to soften its effects and rekindle some of the lost harmonies the paintings once had.[115]

The matter is made more complex by the possibility that restorers in past centuries, faced with original but darkened glazes, decided not only to clean them off but also to replace them. This, certainly, is what one German restorer who published a book in the late 1820s, Christian Philipp Koester, openly recommended:

> Patina is something which deserves great reverence; the restorer, who must of course be an artist, will certainly accord it special respect. But in cases where the patina, together with the topmost layer of paint, is chemically fused with dark, hard grime, it cannot alas be treated with deference; both must be sacrificed for the public good. Given furthermore that the restorer must also at the same time be a painter, it will not be too difficult for him to use glazes to put those areas that have lost their patina back in tune with those parts which still preserve their patina.[116]

If this practice was widespread, then it might mean that nineteenth-century overpaint, which is generally removed by modern picture-cleaners,[117] gives at least some information about the original appearance of the painting. And, whether or not that information is accurate, to remove old overpaints without replacing them may leave the viewer looking at the painting's underlayers. Which is not to suggest that the repainting of glazes should form part of the modern restorer's repertoire; only that the art historian needs to be aware of the possibility that a painting had long lost glazes in the past.

In practice, even when its application is not over-imaginative and anachronistic,[118] later overpaint has often discoloured, and needs to be removed, together with any discoloured varnish which covers it. The main concern of the conservator is not with these later additions, but with the original paint surface. The principal fear of the picture cleaner is of course that her or his solvent will harm the paint layers underneath the varnish and overpaint. The standard way of ensuring this does not happen is to try out solvents of different strengths on inconspicuous parts of the picture. Four examples of such test areas can be seen around the edges of the painting in fig. 33.

The problem with keeping to the edges is that paintings are far from uniform, and marginal parts of paintings are not necessarily representative of the whole.[119] Research into media has shown that painters would often vary their medium in different parts of a painting, depending on which pigment they were using, or which effect they wanted to achieve.[120] A solvent which is safe on an indistinct patch at the edge of the picture may well be dangerous when used on the flesh of the principal subject.

Conservators today are well aware of this issue, and try to carry out small tests on a large variety of paints.[121] In the past, however, testing methods sometimes lulled picture cleaners into a false sense of security, with deleterious effects for the condition of paintings. An example of this state of mind can be seen in a passage from the memoirs of Helmut Ruhemann, where he describes the cleaning of a landscape by Ruisdael:

> It is often difficult to prove by visual means alone that an entire passage has been overpainted, particularly when the original cracks have broken through the repaint. This had occurred in an area of extensive overpainting, differing little in style from the original, on Ruisdael's 'Pool surrounded by trees' [fig. 132]. That it did not belong to Ruisdael's paint became evident only during the cleaning, when the solvent which had been proved not to attack any original paint, began to dissolve the passage in question.[122]

What happened can be seen in fig. 133, which shows what the painting looks like now, after the removal of the overpaint. A reflection in the pool, some of the light bark on the fallen silver birch and a plant at left, together with various other light touches, have all been removed.

That this was overpaint, in a soft medium, is clear, but the claim that it cannot have been put there by Ruisdael can be queried. The only evidence we are given that this was overpaint applied by a later hand is that it came away in the solvent. However, the solvent had

132
Jacob van Ruisdael, *Forest pool with hunters* (fig. 133), photograph taken in 1954, showing state before cleaning

not been proved not to attack any original paint. It had only been proved not to attack the paint in the test area on which it was first applied.

If it had been shown that the white scumble which was removed had been painted in zinc or titanium white, then clearly Ruisdael could not have painted it. If too the crackle pattern in the scumble had been inconsistent with the crackle pattern of the paint beneath it, then that would have been a strong argument in favour of a later hand. Neither criterion appears in this case to have been met. We are also told that the overpaint "differed little in style from the original". In fact this was an understatement; the painting as it is now, stripped of its white reflection, differs in style from all of Ruisdael's other paintings of ponds. He always added a reflection of the sort that was removed.

One of the problems with cases of this kind is that it is more or less impossible to prove that the paint dissolved was not later overpaint. One can prove that it *was* overpaint, if it included anachronistic pigments or media. But to prove that it was *not* overpaint is much harder. Even if the swabs that removed the paint were kept and analysed, and it was shown that all the materials used were available to Ruisdael, that would not demonstrate with

133
Jacob van Ruisdael, *Forest pool with hunters*, c. 1665, oil on canvas, 107.5 × 143 cm, National Gallery, London

certainty that he applied them. Lead white and linseed oil are still available today.

One way to decide the matter would be to compare the picture with an early copy, a painting or an engraving in which all the details removed by the solvent could plainly be seen. Unfortunately, we do not have many early copies of works of art, so the original state of a painting is nearly always impossible to ascertain.

It is only the most famous works which are copied immediately, and for which we can use copies in arguments about cleaning and the removal of overpaint. One example of a controversy in which early visual documents can be used is the debate over the cleaning of the Sistine Chapel ceiling.

Michelangelo's figure of the prophet Zacharias provides a telling example (fig. 134). When the ceiling was cleaned thirty years ago, a large area of *secco* was removed from the Prophet's draperies (fig. 135). The restorers at the time were sure that this was all later overpaint, added in the eighteenth century by a man called Mazzuoli, who is said to have cleaned the ceiling – precisely what he did is not known – between 1710 and 1713.[123]

The *secco* can be made out quite clearly in the photograph of the fresco before it was cleaned (fig. 135). It covered the back of

 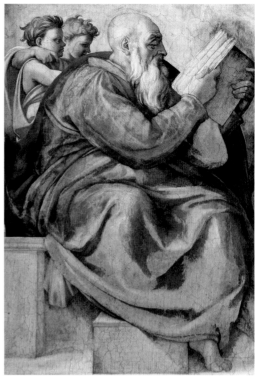

134
Michelangelo, *Zacharias*,
c. 1508, fresco, Sistine Chapel,
Vatican City, Rome, after
cleaning

135
Michelangelo, *Zacharias*, c.
1508, fresco and secco, Sistine
Chapel, Vatican City, Rome,
before cleaning

the Prophet's garment, where there used to be a noticeable double fold, and extended under his sleeve. His cape used to reach down to touch the seat on which he is sitting, and the folds on his green cloak were more simply depicted.

These details were retouched by a later restorer, but he was clearly attempting to conserve Michelangelo's original *secco*. This is shown by two early copies, an engraving made after the figure of Zacharias in the middle of the sixteenth century by Adamo Scultori (fig. 136),[124] and a drawing made shortly after 1600 by Peter Paul Rubens (fig. 137).[125] It is clear that both artists were copying the garment folds of the Prophet with the *secco*, not the Prophet without. The noticeable double fold across the back is there in both copies, as are the thicker sleeve and the way in which the cloak touches the seat. The draperies removed by the restorers in the 1980s were certainly on the ceiling in the sixteenth century.[126]

The Sistine Chapel ceiling was cleaned with an alkaline solvent, chemically close to the 'barbaric' soda, potash and ammonia used in the seventeenth century.[127] This solvent removed layers of glue that had been found all over the frescoes, and which, the conservation team argued, had been added by later restorers to consolidate the plaster.[128] They may have been right that glue was added for this purpose,[129] but given that it was normal, as we saw in Chapter One,

for artists to make *secco* additions using glue as a medium, then any solvent designed to destroy glue would inevitably destroy any *secco* additions that Michelangelo might have made. Indeed texts on how to clean fresco warn against the use of simple water, since it will dissolve *secco* in tempera or size.[130]

The conservators were aware of the danger, but they felt that for the most part there was no need for concern, since in their opinion Michelangelo painted almost entirely in *buon fresco* and rarely made *secco* additions.[131] However, a close comparison of photographs of the ceiling before and after cleaning raises doubts about this claim.[132] In the case of the Zacharias, Michelangelo repainted the Prophet's beard and flesh and eyes. He erased a shadow on the back wall which he thought obtrusive. He muted the colours of the garments with half-tones to make them puff out and suggest the body within. He even took the trouble to paint extra shadows on the book and the hand that held it, to add to the impression that the Prophet was thumbing through the pages. But the restorers apparently believed that these final touches of the artist were later overpaint, and removed them.

136
Adamo Scultori after Michelangelo, *Zacharias*, c. 1550, engraving, 14.2 × 10.1 cm, Rijksprentenkabinet, Amsterdam

137
Peter Paul Rubens after Michelangelo, *Zacharias*, c. 1601–02, black and red chalk, 45 × 33 cm, Musée du Louvre, Paris

The conservation scientist Gerry Hedley once made a distinction
between three different kinds of cleaning – total cleaning, partial
cleaning, and selective cleaning. In total cleaning, all the old
discoloured varnish is removed, and the painting is then covered
with a clear, synthetic varnish which theoretically will not darken
again. In partial cleaning, a very thin, even layer of the old varnish
is left across the whole painting, and the painting is then covered
either with a synthetic varnish or with an organic resin varnish.
In selective cleaning, the restorer thins the varnish at will, leaving
it thick in some places, thin in others, in an attempt to bring the
whole painting into harmony. The selective restorer is trying to
compensate for the darkening of the medium and the alteration
in the pigments, and uses the remnants of the varnish as a kind
of tonal palette, to impose a kind of aesthetic unity on the picture
which has become "disunited and untuned", as Hogarth put it.[133]

Partial cleaning faces a number of objections, which can be
summarized as follows:

1. When cleaning a picture with solvents, the varnish does not
 always come away smoothly; it tends to lift off in patches.
 It is therefore very difficult to leave an even layer of varnish
 behind, and even more difficult to remove the varnish at will,
 as selective cleaning requires.
2. When cleaning a painting with an uneven surface, patches
 of discoloured varnish tend to get stuck in the depressions,
 leading to a blotchy appearance across the surface.
3. In order to remove and replace old, discoloured retouchings,
 the varnish above them must be cleaned away. If the painting is
 being partially cleaned, then the retouchings have to be made to
 match the discoloured varnish, not the original paint.
4. The varnish that is being left on the painting is hardly ever
 original varnish; it is almost always nineteenth- or twentieth-
 century, so it is not as if anything of the artist's original work is
 being preserved.[134]

These are useful objections to partial cleaning, but this does
not make them good arguments in favour of total cleaning. The
complete removal of old varnishes, if the arguments in the earlier
section on patina have any merit, may leave the painting looking
very unlike its original appearance. And the fact that partial removal
is very difficult does not entail that one should not try to achieve it.

At the same time, it must be said that overcleaning is not the
only danger the restorer has to avoid. Another is undercleaning.
There are many paintings which are covered with freckles of
darkened varnish, lurking in the hollows of the paint surface, and

producing a mottled effect that the artist cannot have intended (figs. 65, 75).[135] And even when partial cleaning produces an effect which is smoother and more even, as in fig. 103, we may still reasonably doubt that this is what the artist envisaged. We simply do not know as much as we would like about the look of pictures in the past.

As Hedley put it, "there can be no going back to the originals". Whatever method of cleaning is used, it will have to be some kind of negotiation between what we know about the past, how we respond to paintings today, and what we can achieve with works that have altered, and been altered, over time.

1 On cleaning controversies in general, see Merritt, *Pictures and Dirt*; Galichon, 'Restoration'; Thayer, 'Restoration'; Keck, 'Some Picture Cleaning Controversies'; Walden, *Ravished Image*; Beck and Daley, *Art Restoration*; Starn, 'Patina'; Bomford, 'Picture cleaning'.

2 Curie and Pasquali, 'Restoration', give the restorers' point of view. On 28 December 2011 *The Guardian* announced that Ségolène Bergeon had resigned from the scientific committee overseeing the restoration. She gave her reasons for resigning in an interview to *Le Journal des Arts* on 17 April 2012. *The Guardian* summarized her remarks on 27 April 2012 as follows: "The Virgin's face is less modelled now. The cleaning should never have gone so far The whitened layer on the Christ Child's body has been mistakenly understood as a late varnish gone mouldy."

3 Beck and Daley, *Art Restoration*, 63-122, with further literature. For an overview of the debate which sides with the restorers' point of view, see Caple, *Conservation Skills*, 100-05, and further on pp. 223-25 below.

4 Brandi, 'Cleaning of Pictures'; Brandi, 'Some Factual Observations'; Brandi, 'Letter: Cleaning of Pictures'; Gombrich, 'Dark Varnishes'; Kurz, 'Varnishes'; Rees Jones, 'Science and Picture Cleaning'; Gombrich, 'Controversial Methods'; Kurz, 'Time the Painter'; Muraro, 'Traditional Methods'; Rees Jones, 'Further Comments'.

5 Hendy (ed.), *Cleaned Pictures*; MacLaren and Werner, 'Some Factual Observations'; Plesters, 'Dark Varnishes'; Mahon, 'Miscellanea'; Thomson, 'Notes'; Ruhemann, *Cleaning of Paintings*, 170-239. For recent surveys of the debate, see Daley, 'Oil, Tempera'; Gilsa, 'Cleaning Controversy'; Hope, 'Cleaning Controversy'.

6 Pliny, *Natural History*, xxxv, 36; Conti, *History of Restoration*, 55.

7 Van Mander, *Schilder-Boeck*, 72v: "*De weergade van desen plompaert maecte den voet van I. van Eycken tafel te Ghent schoon*".

8 Van Mander, *Schilder-Boeck*, 200v: "*De principael Tafel hadde eenen voet, daer sy op stondt, desen was gheschildert van lijm, oft Ey-verwe, en daer in was een Helle ghemaeckt, daer de helsche knien, oft die onder d'aerde zijn, hun knien buyghen voor den naem Iesu, oft het Lam: maer alsoo men dat liet suyveren oft wasschen, is het door onverstandighe Schilders uytgewischt en verdorven gheworden*" (The main altar had a foot, on which it stood, this was painted in glue, or egg-colour, and in it there was a Hell, where the residents of Hell, or those under the earth, are kneeling, bending their knees before the name of Jesus, or the Lamb: but when someone had it cleaned or washed, it was erased and ruined by ignorant painters). Van Mander may have relied on Vaernewyck, *Historie van Belgis*, 208: "*Den voet van dit tafereel plagt te wezen eene helle, door den voornoemden Jan van Eyck*

geschildert in water-verwe, maer eenige slegte schilders, zoo men zegt, hebbende ondernomen dit konstig en wonderbaer werk te kuysschen of te zuyveren, hebben het zelve met hunne onkundige handen uytgevaegt" (The foot of this painting used to be a Hell, painted by the aforementioned Jan van Eyck in water-colour, but some bad painters, so they say, having undertaken to wash or clean this artful and wonderful work, wiped it away with their ignorant hands). The whole painting, according to Vaernewyck (203-04), was restored in 1550 by Lancelot Blondeel and Jan van Scorel, and modern restorers believe that the incompetent restorer(s) who destroyed the *Hell* also did more damage to the rest of the altar, which Blondeel and Scorel had to put right: Coremans, 'Agneau Mystique'. Van der Velden, 'Reply to Herzner', 140, has recently suggested that the scene depicted was more likely to have been Purgatory than Hell. I think it was probably a scene of the Patriarchs in Limbo, the first circle of hell. On Limbo in art, see Franceschini, *Limbo*; Taylor, 'Julius II and Stanza della Segnatura', esp. 123-24.

9 Mérimée, *Peinture à l'huile*, 263; Doerner, *Materials of the Artist*, 389-91.

10 On canvas shrinkage, see above, p. 107. I thank Erma Hermens for pointing out this possible cause of destruction.

11 Baldinucci, *Vocabolario*, 135 (as translated in Gombrich, 'Dark Varnishes', 53).

12 Anon., *Excellency of the pen and pencil*, 107.

13 This is the first time we have needed to use the word 'scumble'. The Oxford English Dictionary defines 'glaze' as "a thin coat of a different transparent colour", and 'scumble' as "a thin coat of opaque or semi-opaque colour". Bol, *Oil and the Translucent*, 15-16, provides a clear distinction between 'glaze' and 'scumble' by amplifying the definition in the OED with reference to concepts of transparency as a function of refractive index, as discussed on pp. 185-86 above. My impression is that writers on art before the nineteenth century did not make a sharp distinction between 'glaze' and 'scumble' (see e.g. Lairesse, *Groot Schilderboek*, I, 39, where he talks of scumbling smalt and ultramarine), and the latter concept is in any case extremely rare before 1800. For the uses of the two words in the 19th century see Carlyle, *Artist's Assistant*, 218-20. The words 'glaze' and 'scumble' are sometimes used in the modern literature in a different sense: a glaze is said to be a thin layer of darker paint applied over a lighter ground, while a scumble is said to be a thin layer of lighter paint applied over a darker ground (for these meanings, see e.g. Thompson, *Practice of Tempera Painting*, 101; Brandi, 'Cleaning of Pictures', 184; MacLaren and Werner, 'Factual Observations', 190). Since tempera has a refractive index of 1.35 (Taft and Mayer, *Science of Paintings*, 110), it is impossible to paint glazes in the first sense when working in tempera; but it is of course possible to produce glazes in the second sense (Thompson, *Practice of Tempera Painting*, 106). In this book I use the words in the senses outlined in the OED.

14 Baldinucci, *Vocabolario*, 135: '*Sotto questo termine rifiorire, intendono anche gl'ignoranti, il lavare l'antiche pitture; il che fanno alcuna volta con tanta indiscretezza, che più non farebbono nel dirozzare un marmo; e non considerano, che non sapendosi bene spesso qual sia il composto delle mestiche, o imprimature, e quali siano i colori adoprati dagli Artefici (perchè più assai sopportano il ranno, o altra materia men forte le terre naturali, che i colori artificiali) non solo mettono esse pitture in pericolo di mandar dietro alla lavatura, i velamenti, le mezze tinte, e ancora i ritocchi, che sono gli ultimi colpi, ove consiste gran parte di lor perfezzione; ma anche di scrostarsi tutte a un tratto*" (as translated in Gombrich, 'Dark Varnishes', 53).

15 Watelet and Lévesque (eds.), *Encyclopédie Méthodique*, I, 337: "*A ce propos, il n'est pas inutile d'observer que les gens ignorans dans la pratique de peindre & qui se mêlent de nétoyer les tableaux ne savent presque jamais distinguer les parties glacées de celles qui ne sont pas: d'où*

il arrive que, voulant enlever tout ce qui leur paroît crasse et saleté dans certains endroits, ils parviennent aussi à tout ôter jusqu'à la première couche exclusivement, qui alors leur paroît être le vrai ton du tableau"; quoted by Brandi, 'Some Factual Observations', 113. Cf. Carlyle, *Artist's Assistant*, 264; Bouvier, *Manuel*, 613.

16 From a letter to *The Times* quoted in Beck and Daley, *Art Restoration*, 145.

17 See p. 212 above.

18 As quoted above on p. 197.

19 Conti, *History of Restoration*, 1-30; Thomas, 'Restoration or Renovation'.

20 I do not mean to suggest that non-European cultures are unconcerned about the visual appearance of their imagery. For aesthetic attitudes outside Europe, see Van Damme, *Beauty in Context*.

21 Conti, *History of Restoration*, 77. Dolce, *Aretino*, 10-11, tells a similar story about attempts by Sebastiano del Piombo to restore some heads by Raphael in the Papal Stanze: "*Trovandosi adunque Titiano in Roma; & andando un giorno per quelle camere in compagnia di Bastiano, fisò col pensiero e con gli occhi in riguardar le Pitture di Rafaello, che da lui non erano state più vedute, giunto a quella parte, dove havea rifatte le teste Bastiano, gli dimandò, chi era stato quel presontuoso & ignorante che aveva imbrattati quei volti, non sapendo però, che Bastiano gli avesse riformati, ma veggendo solamente la sconcia differenza che era dall'altre teste a quelle*".

22 Conti, *History of Restoration*; Caley, 'Aspects of Varnishes'; Massing, *Picture Restoration*, 137, 203-08, 218, 279, 282.

23 Smith, *Art of Painting*, 73. Fly shits are a serious problem for picture cleaners; they usually have to be removed with a scalpel. See Watelet and Lévesque (eds.), *Encyclopédie Méthodique*, II, 775; Nicolaus, *Restoration*, 335, 353. As a way of deterring flies, De Piles, *Élémens*, 175, and following him Watelet and Lévesque (eds.), *Encyclopédie Méthodique*, II, 775, recommend washing paintings with water in which leeks have been soaked.

24 Richard Symonds, *Secrete intorno la pittura*, BM Egerton 1636, as cited in Caley, 'Aspects of Varnishes', 71, writes that Nicholas Lanier had discovered aqua vitae (distilled alcohol spirit) "took off all the spotts and blackness and he says 'twill take off old Varnishes". However Symonds does not say that Lanier intentionally used aqua vitae to take off old varnishes. The only recipe before 1700 known to me in which instructions are given on how to remove a varnish is in de Mayerne, *Pictoria Sculptoria*, 110v: "*Pour oster le vernis de dessus un Tableau. De la cendre passée avec de l'eau & le frotter avec une brouësse bien rude & puis l'essuyer*" (To remove the varnish from a Painting. Ash mixed with water and rub it with a very coarse brush and then rinse). This may be meant as a method for removing aqueous varnishes. The same method is recommended for cleaning a painting before the application of varnish: de Mayerne, *Pictoria Sculptoria*, 15r; Volpato, *Modo da tener nel dipinger*, 751; Smith, *Art of Painting*, 73-74; Salmon, *Polygraphice*, I, 192.

25 Seventeenth-century picture-cleaners were not professionals, but painters doing work on the side: Talley, 'Miscreants and Hotentots', 33-34; Massing, *Painting Restoration*, 22-23; Bomford, 'Picture cleaning', 482-87.

26 Egerton, *British Paintings*, 306.

27 Palomino, *Museo pictorico*, II, 333: "*Concluido ya lo que toca á barnices, no será fuera de proposito decir como se puede quitar el barniz á una pintura, quando la ha barnizado quien no lo entiende; y mas si el dicho barniz se ha anieblado, como lo hace el de grasilla, ó si le lava con agua, que suele quedar todo el lienzo del color de ceniza; ó si está muy cargado, y relumbrante que no se dexa gozar bien la pintura, que á los que poco saben, les parece que en eso consiste su mayor perfeccion, sieno así que debe ser á el contrario, que tenga xugo, y no relumbre*". I thank Karin Hellwig for discussing this passage with me.

28 Puyvelde, 'Cleaning of Old Paintings', 75.

29 De Mayerne, *Pictoria Sculptoria*, 15r, 57r, 110v; Anon., *Excellency of*

the pen and pencil, 106; Volpato, *Modo da tener nel dipinger*, 751; Lemery, *Recueil des curiositez*, 287; Smith, *Art of Painting*, 73; la Fontaine, *Académie de la peinture*, II, 19; Salmon, *Polygraphice*, 192; de Piles, *Élémens*, 171, 174, 177-78, 179; Watelet and Lévesque (eds.), *Encyclopédie Méthodique*, II, 773. Doerner, *Materials of the Artist*, 393, warns that potash etc. "can never be entirely removed from the painting. Therefore their use as cleansing media is prohibited."

30 Anon., *Ricette*, 673; Watelet and Lévesque (eds.), *Encyclopédie Méthodique*, II, 773.

31 Anon., *Ricette*, 673; de Mayerne, *Pictoria Sculptoria*, 57r, 110v; La Fontaine, *Académie de la peinture*, II, 18. De Piles, *Élémens*, 171, and Watelet and Lévesque (eds.), *Encyclopédie Méthodique*, II, 774-75, warn that this can take away the glazes.

32 Lemery, *Recueil des curiositez*, 286; De Piles, *Élémens*, 173; Watelet and Lévesque (eds.), *Encyclopédie Méthodique*, II, 773.

33 Contemporaries were aware that lye and soap could remove varnish and paint: de Mayerne, *Pictoria Sculptoria*, 14v; Volpato, *Modo da tener nel dipinger*, 751; la Fontaine, *Académie de la peinture*, II, 19; Salmon, *Polygraphice*, 192.

34 De Mayerne, *Pictoria Sculptoria*, 15r, 57r, 110v, 145v; Lemery, *Recueil des curiositez*, 287; la Fontaine, *Académie de la peinture*, II, 19; De Piles, *Élémens*, 171, 174, 177-78, 179; Forni, *Manuale*, 41; Brommelle, '1850 and 1853 Reports', 178; Massing, *Painting Restoration*, 203. Plesters, 'Bibliography', 378, writes that Jean Félix Watin in his *L'art du peintre, doreur et vernisseur* "warns against the use of potash, abrasives, urine etc. for cleaning". This is not quite accurate: he claims (Watin, *Art du peintre*, 123-24) that his method of cleaning paintings with black soap and water is "*préférable sûrement aux lessives de potasse, de cendres gravelées, d'eau seconde composée d'urine, qui peuvent servir à la vérité, mais doivent être bien ménagées et bien affoiblies*", but he was selling "*eau seconde*", potash, and ashes as cleaning agents for painters in his shop in Paris (see below, note 48).

A similar attitude towards the use of these alkaline fluids can be found in Watelet and Lévesque (eds.), *Encyclopédie Méthodique*, II, 773. Urine was still recommended as a cleaning agent in Ris Paquot's *Guide pratique du restaurateur-amateur de tableaux* of 1890 (Plesters, 'Bibliography', 394). A blend of female urine, salt and grated raw potato is recommended for the cleaning of oil paintings in Lush and Hayes, *Stainless*, 296. Shannon Lush writes in the introduction to this book that she is "an artist and a fine arts restorer in 27 different mediums".

35 Secco-Suardo, *Restauratore*, 464; Caley, 'Aspects of Varnishes', 71; Massing, *Painting Restoration*, 203-04; Wolbers, *Cleaning Painted Surfaces*, 6-7. Wolbers observes, however, that in saliva the principal solvent is water.

36 Anon., *Excellency of the pen and pencil*, 106; Smith, *Art of Painting*, 74; la Fontaine, *Académie de la peinture*, II, 17 (*l'azure en poudre*); Salmon, *Polygraphice*, 192. Sanderson, *Graphice*, 86, condemns the use of "blue starch", by which he may mean smalt: "If you use blew starch, or glare of eggs, or other such trash, as is very common, it will take off the heightning, and spoil the grace of the work".

37 La Fontaine, *Académie de la peinture*, II, 19 (with a note of caution: "*non pas si rude, parce que la pierre ponce emporteroit toutes vos couleurs*"). Pumice stones were also used for smoothing canvasses and grounds: e.g. Félibien, *Principes*, 407-08, 417; Watin, *L'art du peintre*, 81.

38 Smith, *Art of Painting*, 75. See too la Fontaine in the previous note.

39 De Mayerne, *Pictoria Sculptoria*, 15r.

40 Sanderson, *Graphice*, 86.

41 De Piles, *Élémens*, 175-76; Watelet and Lévesque (eds.), *Encyclopédie Méthodique*, II, 774.

42 De Piles, *Élémens*, 174; Watelet and Lévesque (eds.), *Encyclopédie Méthodique*, II, 773.

43 De Mayerne, *Pictoria Sculptoria*, 14v.

44 De Mayerne, *Pictoria Sculptoria*, 14v; Watelet and Lévesque (eds.), *Encyclopédie Méthodique*, II, 774.

45 "*Esprits de Sel de Vitriol, ou de Sulphre*": de Mayerne, *Pictoria Sculptoria*, 14v.

46 Beaufort, *Pictures and How to Clean Them*, 82-89.

47 Ruheman, *Cleaning of Paintings*, 196; Burnstock and Learner, 'Alkaline Reagents', 166.

48 Watin, *L'art du peintre*, 362: "*Pour lessiver ou nettoyer les couleurs & les vernis. Eau seconde, la pinte, 12 sols. –Ditto, double, 18 sols. Potasse la livre en pierre, 12 sols. Cendre gravelée en pierre, 12 sols. Savon noir, 12 sols.*" '*Eau seconde*' has various meanings. The '*eau seconde des peintres*', according to Fosset, *Encyclopédie domestique*, 194-95, was a lye formed of water, ash and potash; see too Massing, *Picture Restoration*, 205. Watin, however, in note 34 above, writes of "*l'eau seconde composée d'urine*".

49 De Burtin, *Traité*, I, 385. See too Mérimée, *Peinture à l'huile*, 264-5; Vergnaud, *Manuel*, 229-30; Déon, *Conservation*, 87.

50 De Burtin, *Traité*, I, 386-8; Vergnaud, *Manuel*, 227-28; Mérimée, *Peinture à l'huile*, 253; Bouvier, *Manuel*, 613-15; Paillot de Montabert, *Traité*, IX, 709-10; Déon, *Conservation*, 61-62; Forni, *Manuale*, 120-21; Secco-Suardo, *Restauratore*, 420-25; Frimmel, *Gemäldekunde*, 138; Ruhemann, *Cleaning of Paintings*, 202-03; Nicolaus, *Restoration*, 367-68; Massing, *Picture Restoration*, 206-07, 221 n. 71.

51 See Symonds in note 24 above.

52 Dossie, *Handmaid*, I, 221-22.

53 Stolow, 'Solvent Action', 48-49; Nicolaus, *Restoration*, 343.

54 De Burtin, *Traité*, I, 389-91; Vergnaud, *Manuel*, 228-9; Koester, *Ueber Restauration*, I, 18-19; Mérimée, *Peinture à l'huile*, 253-54; Field, *Chromatography*, 218; Bedotti, *Restauration*, 42; Déon, *Conservation*, 163; Forni, *Manuale*, 122-23; Secco-Suardo, *Restauratore*, 425; Frimmel, *Gemäldekunde*, 127; Hendy (ed.), *Cleaned Pictures*, xv; Ruhemann, *Cleaning of Paintings*, 192; Nicolaus, *Restoration*, 343.

55 Palomino, writing in the 1720s, recommended hot vinegar or nitric acid for removing varnish: *Museo pictorico*, II, 333-34.

56 Ruhemann, *Cleaning of Paintings*, 196; Feller, 'Solvents'; Nicolaus, *Restoration*, 339-44.

57 Bomford with Dunkerton and Wyld, *Conservation*, 68-69. As noted on p. 50 above, Impressionist paintings were not normally varnished, and Impressionist painters often aimed for a matt surface. One way to achieve a matt surface is to use a sparse medium, and the Impressionists often soaked oil out of their paints with blotting paper. It is possible therefore that the varnish was added many years after the painting was completed, but that pigment drifted up into the varnish owing to too little binder – an example of chalking, as discussed in the next paragraph. I thank Erma Hermens for this observation.

58 Stout, *Care of Pictures*, 31-36; von der Goltz, Birkenbeul et al., 'Consolidation', 377-78. 'Chalking' is also now sometimes (rather confusingly) used to refer to the disintegration of the medium in 'blanching': van Loon et al., 'Ageing and Deterioration', 226, 236.

59 De Piles, *Élémens*, 112-13; Watelet and Lévesque (eds.), *Encyclopédie Méthodique*, II, 454 (this article is based on de Piles); Bouvier, *Manuel*, 202, 553, 570.

60 Rasti and Scott, 'Effect of Pigments on Linseed Oil'; Spring and Grout, 'Blackening of Vermilion', 57-58.

61 Daley, 'Oil, Tempera', 132-33.

62 Stolow, 'Solvent Action'; Sutherland, 'Solvent Cleaning Effects'; Phenix and Wolbers, 'Removal of Varnish', 533-37.

63 Ruhemann, *Cleaning of Paintings*, 208-39.

64 Keith et al., 'Leonardo', 36. I thank Ashok Roy for discussing this topic with me.

65 Brandi, 'Cleaning of Pictures', 187-88; Kurz, 'Varnishes', 57.

66 Mérimée, *Peinture à l'huile*, 92-94; Paillot de Montabert, *Traité*, IX, 395-412; Field, *Chromatography*, 202-03; Gage, 'Magilphs and mysteries'; Carlyle, 'Artist's anticipation of change', 63-64; Carlyle and Southall, 'No short mechanic road'; Carlyle, *Artist's Assistant*, 101-33; Morrison, 'Mastic and Megilp'; Hermens and Townsend, 'Binding media', 212.

67 Ruhemann, *Cleaning of Paintings*, 185; Bomford with Dunkerton and Wyld, *Conservation*, 68-69; Hermens and Townsend, 'Binding media', 211-12. Cf. Secco-Suardo, *Restauratore*, 349-50.

68 Merritt, *Pictures and Dirt*, 29; MacLaren and Werner, 'Factual Observations', 191; Ruhemann, *Cleaning of Paintings*, 220.

69 Van Eikema Hommes, *Changing Pictures*, 41-42; cf. remarks by Italian art theorists on the permanence of mosaic, which had survived from antiquity: Vasari, *Vite*, I, 57; Borghini, *Riposo*, 36.

70 Scannelli, *Microcosmo*, 114: "*Mà lasciamo una tal ragione per insufficiente, perche deve chi opera dopo la debita preparatione sodisfare con ogni potere in ordine alla presente prima veduta, e poi tralasciare alla prima causa del tutto gl'incerti effetti del futuro*". For discussion, see Mahon, 'Miscellanea', 466-67.

71 Mills and White, 'Paint Media'; White and Pilc, 'Analyses of Paint Media'.

72 Brandi, 'Cleaning of Pictures', 188. Amber varnishes may of course have lasted longer, and, as noted on p. 62 above, may not be detectable using current scientific methods.

73 Lairesse, *Groot Schilderboek*, I, 14-15: "*Om dit wel te doen, zo haal u stuk met een goede en dunne Vernis, waar onder eenige taaje witten olie gemengd word, uit, het zy geheel of half, zo als gy oordeeld bekwamelijk te zullen konnen bewerken, eer het droog word: zet dan uw lichten op de hoogste partyen, zagjens en dunnetjens in het nat verdryvende, benevens de teêrheden van naakt en kleeding, ider na zyn eis, gelijk ook de geelachtigheid of gloeyendheid in de reflectien of weerkaatzingen des lichts. Indien nu, hier of daar, het naakt te licht mogt zyn, zo mengd een weinig Ligten ooker, Vermilioen, Bruyn rood, Lak of Aspalt, na de koleur teder of robust is, onder de Vernis, en lakseerd het dunnetjes over.*"

74 Lairesse, *Groot Schilderboek*, I, 39: "*Op deze wyze opgemaakt zynde, geschied de retokeering in dezer voegen. Het beeld, dat gy gezind zyt te voltooijen, haald het zelve dunnetjes uit met vernis, door welke gy een weinig lichten ooker getemperd zuld hebben: zet dan uwe uyterste hoogzels daar op, en verdryfd dezelve heel zagjens in het nat, zo verre als gy begeerd; maar indien het een kind zy, zo temperd onder de vernis een weinig veermilioen: wat lichten ooker voor een mansbeeld, en noch wat minder*

lichten ooker voor dat van een vrouw". In Taylor, 'Colouring Nakedness', 68, I suggested that Lairesse here meant by '*vernis*' an oil varnish; I now think this was wrong. Since he tells us that we can mix this varnish with oil, he must mean to suggest that it is of a distinct nature. See too Eastlake, *Methods and Materials*, I, 473, quoting the Norgate MS: "Sir Nathaniel Bacon's vernish for oyl pictures. Allsoe it was the vernish of Sir Anthony Vandike, which he used when he did work over a face again the second time all over, otherwise it will hardly dry. Take two parts of oyle of turpentine and one part of Venice turpentine; put it in a pipkin and set it over the coles, on a still fire, untill it begin to buble up: or let them boyl very easily, and stop it close with a wett woollen cloth untill it be cold. Then keep it for your use; and when you will use it, lay it but warm, and it will dry". Eastlake, *Methods and Materials*, I, 476, interprets this as a thin layer of varnish acting as a surface for the second layer, but the passage is surely ambiguous, and may refer to a spirit varnish being added to (or used as) a medium to paint flesh. Van Dyck may have passed this method down to Lairesse, through Lairesse's teacher Bertholet Flémal and Flémal's teacher Gérard Douffet, who studied in Antwerp. See too Phenix and Townsend, 'Historical varnishes', 257: "In the context of these authors [de Mayerne, Rubens], 'varnish' could mean an additive to paint as well as the final coating applied over paint".

75 De Vries, *De Lairesse*, 63, n. 74.

76 It is also of course possible that there was a discrepancy between Lairesse's theory and his practice. For an example of this phenomenon, see Talley and Groen, 'Described and Actual Painting Technique'.

77 De Burtin, *Traité*, I, 388.

78 In particular *Allegory of Faith* (Metropolitan Museum, New York), *Guitar player* (Kenwood House, London), *Lady seated at a virginal* (National Gallery, London) and the example shown here, *Lady standing at a virginal*. All are thought to date from the last five

years of Vermeer's life. Costaras, 'Vermeer', 159-60, and Sheldon and Costaras, 'Vermeer', 94-95, discuss the use of green earth in Vermeer's late flesh-painting technique but do not suggest the loss of glazes. In the second of these articles it is acknowledged that "sometimes these green shadows seem excessive, overpowering the pale pinks of the lighter parts". As observed in an article on Vermeer's palette at the National Gallery website (http://www.nationalgallery. org.uk/paintings/research/meaning- of-making/vermeer-and-technique/ vermeers-palette, accessed 10 July 2013), the green earths Vermeer was using in these pictures have been painted on top of pink flesh tints. Clearly his technique was more complex than that of the early Italian painters, but the possibility that upper layers have been lost remains. It is also possible that Vermeer was relying on tinted varnish to produce his final effect. I thank Jonathan Janson for discussion and information on this issue.

79 Although his book was published over thirty years after Vermeer's death, Lairesse was a near contemporary of Vermeer: Taylor, *Vermeer*, 24.

80 Mason, 'Vermeer', argued on the basis of 1930s photographs that the green flesh visible in fig. 128 was the result of twentieth-century restorations. He may have been right, but one cannot tell from a photograph if the paint removed was original or added by an eighteenth- or nineteenth-century restorer.

81 De Mayerne, *Pictoria Sculptoria*, 151r; Mérimée, *Peinture à l'huile*, 92-4; Merrifield, *Original Treatises*, cclxiii-iv; Eastlake, *Methods and Materials*, I, 269-319; Forni, *Manuale*, 147-49; Secco-Suardo, *Restauratore*, 293-97; Laurie, *Pigments and Mediums*, 158-63; Kurz, 'Varnishes', 57-58; Plesters, 'Bibliography', 381, 387; Percival-Prescott, 'Eastlake Revisited'.

82 Vasari, *Vite*, I, 52-53; Borghini, *Riposo*, 137.

83 However, it has sometimes been given a broader meaning close to the Italian *velatura*: Carlyle, *Artist's Assistant*, 218-9.

84 Luigi Crespi, letter to Francesco Algarotti, quoted by Conti, *Restoration*, pp. 111-12; Brandi, 'Cleaning of Pictures', 184. For the saying attributed to Titian, *'Svelature, trenta o quaranta!'*, see Doerner, *Materials of the Artist*, 345; Brachert, *Patina*, 42. Cf. Félibien, 'Reines de Perse', 61-62: "*Il en est de mesme dans la Peinture, où la trop grande vivacité offense la veûe. C'est pourquoy Appelles, cet excellent Peintre, se servoit d'un vernis dont il couvroit ses ouvrages pour diminuer la force des couleurs. Et l'on peut considerer dans ce Tableau* [Charles Le Brun's *The Queens of Persia at the feet of Alexander*] *de quelle manière le Peintre les a éteintes, & leur a osté de leur éclat & de leur vivacité naturelle, afin de les affoiblir, & d'empescher qu'elles n'offensent la veûë par une trop vive lumière.*" On Apelles's varnish, see Gombrich, 'Dark Varnishes'. On the connotations of 'toning layer' in nineteenth-century England, see Carlyle, *Artist's Assistant*, 248-49. Von der Goltz et al., 'Varnishing', 636, give a number of examples of artists who used toning layers; all are British or American, eighteenth century or later. The Anglo-American toning layer is not quite the same as the *velatura* of Armenini and Baldinucci.

85 Baldinucci, *Vocabolario*, 174: "*Velare. Coprire con velo. Appresso i nostri artefici, velare val tignere con poco colore e molta tempera (o come volgarmente si dice acquidoso o lungo) il colorito in una tela o tavola, in modo che questo non si perda di veduta, ma rimanga alquanto mortificato e piacevolmente oscurato, quasi che avesse sopra di sè un sottilissimo velo*".

86 Robin in Watelet and Lévesque (eds.), *Encyclopédie Méthodique*, I, 336: "*Le GLACIS est ainsi nommé du mot glace dont il imite la transparence. Il s'emploie principalement dans la peinture à l'huile. C'est une couche de couleur tellement légère qu'elle doit laisser appercevoir la teinte qui est dessous. Il y a des peintres qui peignent en glaçant même au premier coup; comme Rubens & son école. ... Les glacis placés ainsi sur des fonds bien secs, sont durables, légers et puissans de teinte.Mais l'usage le plus géneral*

des glacis est de donner, d'après la première couche, les teintes à volonté sur diverses parties de l'ouvrage, d'en augmenter la vigueur, la légereté, l'harmonie, & d'assurer la justesse des effets de lumière. Alors le glacis est un moyen efficace de perfection pour l'art, & un remède aux défauts échappés dans la première couche. L'ancienne Ecole Vénitienne, & beaucoup de peintres françois ont usé de glacis dans cette intention." The passage is translated without acknowledgement in Milizia, *Dizionario*, II, 277, quoted by Brandi, 'Cleaning of Pictures', 184. For a discussion of the relationship between *velatura* and *glacis*, and an analysis of what appears to be a surviving *velatura* on a painting by Matteo Preti, see Pfister, 'Mattia Preti ... velatura'.

87 Robin in Watelet and Lévesque (eds.), *Encyclopédie Méthodique*, I, 336-37: "Quelque soit le bon effet du glacis sur un tableau déjà peint pour donner de la puissance à certaines couleurs & pour mettre, comme nous disons, les accords, c'est physiquement un moyen funeste au tableau. L'auteur l'emploie peu de tems après avoir fini son ouvrage dans la pâte; les huiles du première couche ne sont pas encore evaporées. On repand par le glacis un espèce de vernis ou de glace; mais l'huile de la première couche n'en tend pas moins à pousser au dehors, elle se trouve arrêtée sous le glacis, & y forme une croute d'un jaune noir qui donne cette teinte aux parties glacées. C'est principalement à l'usage fréquent des glacis que beaucoup d'excellens ouvrages doivent la teinte noire qui les gâte."

88 Diderot, *Oeuvres*, X, 169 (Salon of 1763, Louis-Michel van Loo): "Je suis aussi bien fâché que ces morceaux de peinture qui ont la fraîcheur et l'éclat des fleurs soient condamnés à se faner aussi vite qu'elles. Cet inconvénient tient à une manière de faire qui double l'effet du tableau pour le moment. Lorsque le peintre a presque achevé son ouvrage, il glace. Glacer, c'est passer sur le tout une couche légère de la couleur et de la teinte qui convient à chaque partie. Cette couche peu chargée de couleur et très-chargée d'huile fait la fonction et a le défaut d'un vernis; l'huile se sèche et jaunit en se séchant, et le tableau s'enfume plus

ou moins, selon qu'il a été peint plus ou moins franchement."

89 For English sources making similar complaints, see Carlyle, 'Artist's anticipation of change', 63.

90 Armenini, *Veri precetti*, 126: "... vernice commune, la qual si suol mettere in tutti i colori quando si velano gli altri che vi e sotto". Armenini, *True Precepts*, 193. For later sources who assert that varnish was used in glazing, see Watelet and Lévesque (eds.), *Encyclopédie Méthodique*, I, 336; Mérimée, *Peinture à l'huile*, 98; Forni, *Manuale*, 151 (this is taken without acknowledgement from Mérimée).

91 He recommends a very soft varnish, apparently used by Correggio and Parmigianino, of conifer balsam (*olio di abezzo*) mixed with naphtha (Phenix and Townsend, 'Historical varnishes', 256). For this and other varnish recipes see Armenini, *Veri precetti*, 128-30; see too Merrifield, *Original Treatises*, cclxx-cclxxi.

92 Huyghe, 'Dévernissage', 12.

93 See p. 197 above.

94 Luigi Crespi, letter to Francesco Algarotti quoted in Conti, *Restoration*, 112, wrote that it was possible to clean a painting without removing the veilings that gave it "accord, harmony and union", but added pessimistically: "do not expect it with the materials used by picture-cleaners, nor hope for it considering the quality of people who become picture-cleaners". At least one early sixteenth-century *velatura* has survived intact, on a painting of *Christ carrying the Cross* by Giampietrino in the National Gallery: Keith and Roy, 'Giampietrino and Boltraffio', 10. The authors write that this toning layer is most unusual, but that may of course be because most layers of the kind have been removed by restorers in the past. Cf. Favre-Félix, 'Gombrich', esp. 8-9.

95 Koester, *Ueber Restauration*, I, 22; Secco-Suardo, *Restauratore*, 528-31.

96 Armenini, *Veri precetti*, 126-7: "Ma finite finalmente che sono tutte le bozze, & quelle raciutte, si vien di novo razzando tutto quel lavoro col coltello legiermente, con il quale si lieva il ruvido, e il soverchio de i colori che gli erani rimasi sopraposti, si che

fatto pulito si incomincia di novo poi con far più da senno con finissimi colori lavorando ogni cosa, e tuttavia di quelli facendo le mestiche mentre si lavora à poco à poco, perciochè questa volte quasi più presto si vela che si coprano le cose, le quali son già condotte bene al segno, et specialmente le carni, il che si scuopre con modi delicatissimi, & vivaci migliorando di unione, & di tinte tutte le parti, con quella destrezza, & giuditio che si può usar maggiore da un diligente, & accurato Artefice, di maniera che senza fiento mostrino le proprie carni con li lor lividi, & rosetti che sono dal vivo, dolci morbidi, & uniti": Armenini, *True Precepts*, 193-94. I have translated the word '*bozze*' as 'first layers', rather than 'sketches', although 'sketches' is often the correct translation of '*bozze*'. Baldinucci, *Vocabolario*, 23, defines '*bozza*' as "*alcuni piccoli modelli, o quadri, che conducono gli Artefici, per poi farli maggiori nell'opera*"; the Accademici della Crusca, *Vocabolario*, 129, suggest "*prima forma non ripulita, né condotta a perfezione, propriamente di scultura, e pittura*", which seems to make more sense in this context. For other uses of the word '*velare*' in Italian art theory, see Luigi Crespi, letter to Francesco Algarotti, quoted by Conti, *Restoration*, pp. 111-12; Boschini, *Carta del navegar*, 340.

97 Cf. Koester, *Ueber Restauration*, I, 30: "*Hier ist der natürliche Fleischton dahin, und ließ eine kalte Kreidefarbe zurück*". I am not claiming that original veilings have survived on the Budapest painting; this comparison is only intended to suggest the possibility that veilings have been removed from the London painting. I am also not suggesting that Bronzino's veilings were removed by the National Gallery's restorers.

98 Koester, *Ueber Restauration*, I, 22-23, III, 7-9; Brandi, 'Cleaning of Pictures'; Kurz, 'Varnishes'; Plesters, 'Dark Varnishes', 459-60; Mahon, 'Miscellanea', 465-69; Muraro, 'Traditional Methods'; Kurz, 'Time the Painter'; Philippot, 'Idea of Patina'; Ruhemann, *Cleaning of Paintings*, 234; Brachert, *Patina*, 9-13; Conti, *History of Restoration*, 107-13; Weil, 'Review'; Lowenthal, *The Past*,

155-63; Starn, 'Three Ages of Patina'; Bomford, 'Picture cleaning', 486-87.

99 Quoted in Muraro, 'Traditional Methods', 477, and Conti, *History of Restoration*, 107: "... *mi immagino che la troppa freschezza del quadro habbia dato fastidio, perché in effetto quella pattina che dà il tempo è una cosa che alletta assai, e da una certa unione che piace*". Conti relates that the painting in question was an *Adoration of the Shepherds* by Veronese. Since it was not a very new painting, its 'freshness' may have been the result of a recent cleaning.

100 Baldinucci, *Vocabolario*, 119: "*Patena. Voce usata da'Pittori, e diconla altrimenti pelle, ed è quella universale scurità che il tempo fa apparire sopra le pitture, che anche talvolta le favorisce*".

101 Hogarth, *Analysis of Beauty*, 120. Hogarth is quoting from Dryden's poem 'To Sir Godfrey Kneller, Principal Painter to his Majesty'. See too Addison, 'Mellowing Effects of Time'.

102 Hogarth, *Analysis of Beauty*, 118-19.

103 Kurz, 'Time the Painter', 97.

104 Diderot, *Oeuvres*, XI, 142-43 (Salon of 1767, Vernet); Diderot, *Oeuvres*, XI, 417 (Salon of 1769, Vernet); Kurz, 'Varnishes', 59; Kurz, 'Time the Painter', 95.

105 Eastlake, *Methods and Materials*, I, 409-10.

106 Kurz, 'Time the Painter', 96. Kurz, 'Varnishes', 59, also tried to enlist Goya as an admirer of time's painterly skills, but the letter by Goya which Kurz cited, although it is scornful of picture cleaners, is neutral about the effects of time: Goya, *Life in Letters*, 263.

107 Boschini, *Carta del navegar*, 6-8, Boschini, *Ricche minere*, c2v.

108 Félibien, *Entretiens*, III, 460-61 (Entretien VII, Rembrandt).

109 Algarotti, *Saggio*, 77.

110 Diderot, *Oeuvres*, XI, 97 (Salon of 1767, Chardin); Diderot, *Oeuvres*, XI, 142-43 (Salon of 1767, Vernet); Diderot, *Oeuvres*, XI, 417 (Salon of 1769, Vernet).

111 Hendy (ed.), *Cleaned Pictures*, xx-xxiii; Kurz, 'Varnishes', 58; Conti, *History of Restoration*, 107-13.

112 Diderot, *Oeuvres*, XI, 142-43 (Salon of 1767, Vernet); Kurz, 'Varnishes', 58; Mahon, 'Miscellanea', 466-67;

Muraro, 'Traditional Methods', 476; Kurz, 'Time the Painter', 95; Brachert, *Patina*, 39-40, 48; Carlyle, 'Artist's anticipation of change'; Conti, *History of Restoration*, 110. Cf. de Piles, *Dialogue sur le coloris*, 9; Mérimée, *Peinture à l'huile*, 98.

113 Vincent van Gogh, letter to Theo van Gogh, Arles, on or about Wednesday, 11 April 1888: "... *toutes les couleurs que l'impressionisme a mises à la mode sont changeantes, raison de plus de les employer hardiment trop crues, le temps les adoucira que trop*": Amsterdam, Van Gogh Museum, inv. no. b516 V/1962; http://vangoghletters.org/vg/letters/let595/letter.html. See too Vellekoop et al., *Van Gogh at Work*, 264.

114 Kurz, 'Varnishes', 59; Kurz, 'Time the Painter', 97; but cf. Carlyle, *Artist's Assistant*, 264-65.

115 Huyghe, 'Dévernissage', 11; Favre-Félix and Pfister, 'Entrevues au Louvre'.

116 Koester, *Ueber Restauration*, I, 22: "*Die Patina ist eine feine verehrungswürdige Sache; der Restaurator, welcher ja ohnedem Künstler seyn muß, wird ihr gewiß eine besondere Hochachtung widmen. Aber im Fällen, wo die Patina nicht allein, sondern auch der letzte Farbenton mit einem dunklen, harten Schmuz chemisch verbunden ist, kann darauf leider keine Rücksicht genommen werden; beide müssen sich dem allgemeinen Besten aufopfern. Da ferner der Restaurator auch zugleich Maler seyn muß, so wird ihm nicht schwer fallen, diejenigen Stellen, welche ihre Patina verloren haben, wider durch Lasurtöne denen Theilen gleich zu stimmen, welche ihre Patina behalten haben.*" Instructions on how to repaint *velature* are given by Secco-Suardo, *Restauratore*, 528-31.

117 Ruhemann, *Cleaning of Paintings*, 53-54; Nicolaus, *Restoration*, 359. Sometimes retouchings which are nearly contemporary to the original are preserved: Bergeon, "*Science et Patience*", 178-79. See too for ethical discussion von der Goltz and Stoner, 'Overpainted additions'.

118 Bergeon, "*Science et Patience*", 172-73.

119 Ruhemann, *Cleaning of Paintings*, 190; Phenix and Wolbers, 'Removal of Varnish', 537-41, 544-45.

120 Mills and White, 'Paint media'; White and Pilc, 'Analyses of Paint Media'.

121 Phenix and Wolbers, 'Removal of varnish', 537-38.

122 Ruhemann, *Cleaning of Paintings*, 183.

123 De Vecchi, *Cappella Sistina*, 98; Mancinelli, 'Michelangelo', 236; Hartt et al., *Sistine Chapel*, 48; Beck and Daley, *Art Restoration*, 73-75. These authors give his first name variously as Alessandro or Annibale.

124 Bellini, *L'opera incisa*, 79-80, no. 47; Moltedo (ed.), *Sistina riprodotta*, 88, no. 19/27. Neither book mentions the ceiling's cleaning. Bellini notes that since Scultori depicted Prophets destroyed by Michelangelo to make way for the *Last Judgment* he was probably working from drawings that predated 1535. Scultori's engraving was published in a book that was published some years before 1585, according to Bellini; Moltedo suggests a date of execution for the prints in the late 1540s or early 1550s.

125 Wood, *Rubens Copies*, 140-42, no. 175. Wood illustrates the drawing next to a photograph of the Prophet after cleaning, without commenting on the differences. The relationship of Rubens's drawing to Michelangelo's *Zacharias* is discussed in Toubeau, 'Rubens copiste'.

126 On Michelangelo's use of *secco* in general, the discussion by Wilson, *Michelangelo*, 175-76, is still of exceptional value. Wilson was a painter as well as a Michelangelo scholar, inspected the ceiling close up, and actually touched the paint surface with a wet finger to test if it was painted in size (it was). See Beck and Daley, *Art Restoration*, 93-99.

127 The constituents were ammonium bicarbonate and sodium bicarbonate, together with a fungicide called Desogen and a thickener, carboxymethyl cellulose. See Colalucci, 'Tecniche di restauro', 265; Colalucci, 'Lo stato di conservazione', 199; Beck and Daley, *Art Restoration*, 110-18; Caple, *Conservation Skills*, 102. It has been argued (Beck and Daley, *Art Restoration*, 114) that the brightness of the frescoes today may have been

increased by the solvent acting on the plaster. It seems to me that the brightness of the original colours is visible in the photographs of the ceiling taken before the cleaning (Chastel and Okamura, *Vatican Frescoes*), but that they are subdued by Michelangelo's *velature*. It seems likely that Michelangelo made his underpaint deliberately bright, knowing it was easier to tone down brightness than to brighten darkness. Cf. Shearman, 'Function of Michelangelo's Colour'.

128 Colalucci, 'Tecniche di restauro', 264.

129 For counter-arguments see Beck and Daley, *Art Restoration*, 93-99. Wilson, *Michelangelo*, 175, writes that "portions of the fresco are passed over with size, without any admixture of colour, precisely as the force of water colour drawings is increased with washes of gum". Photographs of Michelangelo's frescoes taken before the cleaning (Chastel and Okamura, *Vatican Frescoes*) give numerous instances of the phenomenon Wilson is describing; one of the most striking is on the face of Eve in the *Temptation*. The restorers clearly felt this was not intentional size wash but later restorers' glue, and removed it.

130 Secco-Suardo, *Restauratore*, 481; Reille-Taillefert, *Peintures murales*, 63.

131 Colalucci, 'Tecniche di restauro', 261, 264; Colalucci, 'Lo stato di Conservazione', 195; Caple, *Conservation Skills*, 102. An argument found important by the restorers was that there was a thin layer of dirt between the fresco surface and the layers of glue which covered it. However, in the confined space between the ceiling and the scaffolding it would not have taken long for the surface of the fresco to become dirty from candle smoke, dust and Michelangelo's skin debris (see p. 166 above), and we do not know how long he delayed between completing the *buon fresco* and starting the *secco*. For further discussion, see Beck and Daley, *Art Restoration*, 101.

132 A comparison of the superb photographs by Takashi Okamura in Chastel and Okamura, *Vatican Frescoes*, and Hartt et al., *Sistine Chapel*, show that the *Zacharias* was by no means an isolated instance.

133 Hedley, 'Long Lost Relations'; Bomford, 'Picture Cleaning'. Hedley was not the first to analyse different styles of picture-cleaning: see Huyghe, 'Dévernissage', 11; Brachert, *Patina*, 40.

134 Huyghe, 'Dévernissage', 12; Ruhemann, *Cleaning of Paintings*, 214-17.

135 But against this see Huyghe, 'Dévernissage', 13: "*La critique fondée sur l'inégalité du dévernissage ne nous a pas paru peser d'un poids comparable aux dangers encourus par la thèse qu'elle défend : cette inégalité n'apparaît guère qu'à un oeil inhabituellement rapproché du tableau. De plus, et c'est là l'essentiel, elle constitue un moindre mal: car il sera toujours possible, et plus aisément avec les progrès futurs, d'enlever ce que nous aurons laissé en trop sur le tableau; il sera impossible d'y remettre ce qu'on en aura ôté. Entre le mal remédiable et le mal irrémédiable, une conscience nette des responsabilités ne peut hésiter.*"

CONCLUSION

One of the great preoccupations of our painter in his last years
was the judgement of posterity and the uncertain durability of his
works. At one moment his sensitive imagination would be fired by
the prospect of eternal glory, at another he was talking bitterly of
the fragility of canvasses and colours This frailty of the painted
work, as against the durability of the printed word, was one of the
constant themes of his conversation.[1]
Charles Baudelaire, *The work and life of Eugène Delacroix*

A famous claim of classical and Renaissance art theory was that
painting and poetry are sisters.[2] If they are, then they age in very
different ways. We can still read Homer and Hesiod and other
Greek poets, but we can no longer view works by the most famous
Greek painters, Zeuxis and Apelles. We can read Renaissance
poets like Ariosto and Tasso in the original editions which they
themselves delivered to the press, but works by the painters of their
time, for example Michelangelo (fig. 135) or Titian (fig. 91), although
they still exist, have altered significantly. And if Baudelaire's
poetry has survived intact, Delacroix's paintings, as he feared, have
suffered with the centuries: most have darkened and faded, and
their shadows were already being damaged by varnish removal in
his own lifetime (fig. 138).[3]

The art historian and the literary historian find themselves
therefore in very different positions. The literary historian can
theorize about a text which in itself is largely taken for granted;
but the art historian who wants to theorize about the object of his
or her research must first attempt to reconstruct what that object
once looked like. Literary historians are occasionally faced with
'corrupt' texts; art historians face 'corrupt' paintings every day of
their working lives.

138
Detail from Eugène Delacroix,
The Massacre at Skios, 1824,
oil on canvas, 419 × 354 cm,
Musée du Louvre, Paris

239

As a result, the art historian is forced to take an active interest in questions of condition; and this interest is hard to separate from concepts of artistic quality. In the current academic environment, notions of quality are thought intellectually and politically suspect,[4] but in art history they are unavoidable. If we are to reimagine the original appearances of paintings which have deteriorated over time, we have to try to understand the artistic aims and priorities of the people who made them.

This act of understanding is far from easy. We need to develop a knowledge of the physical and chemical processes which have brought paintings to their current state, in the hope that we can imagine their reversal. We also need to engage in a long and detailed study of old treatises, in an attempt to reconstruct the conceptual worlds of the artists of the past. And we have to look as much as we can, at a wide variety of paintings, so we can learn to distinguish those in a worse or better state of preservation; we have to try to understand what it is about a picture that differentiates good and bad condition.

When we have done all of this, there is still wide room for disagreement. Paintings which to some art historians and conservators seem immaculately preserved look offensively overcleaned to others, while pictures that to some eyes have a rich, mellow harmony seem just dirty to viewers with a different vision of the past.

It is this vision of the past, this odd mixture of history, science, imagination and feeling, that we have to develop. No one expects consensus in these matters any time soon. But if more art historians contribute to the discussion about how pictures once looked, and how they should be preserved, then the debate over conservation will surely benefit from their experience and thought.

NOTES

1 Baudelaire, *Art romantique*, 40: "*Une des grandes préoccupations de notre peintre* [Eugène Delacroix] *dans ses dernières années était le jugement de la postérité et la solidité incertaine de ses oeuvres. Tantôt son imagination si sensible s'enflammait à l'idée d'une gloire immortelle, tantôt il parlait amèrement de la fragilité des toiles et des couleurs. D'autres fois il citait avec envie les anciens maîtres, qui ont eu presque tous le bonheur d'être traduits par des graveurs habiles, dont la pointe ou le burin a su s'adapter à la nature de leur talent, et il regrettait ardemment ne n'avoir pas trouvé son traducteur. Cette friabilité de l'oeuvre peinte, comparée avec la solidité de l'oeuvre imprimée, était un de ses thèmes habituels de conversation.*"

2 Lee, *Ut pictura poesis.*

3 Delacroix, *Journal*, II, 381 (27 June 1854): "*Arnoux venu dans la journée. Il dit que le* Massacre *n'a pas gagné au dévernissage, et je suis presque de son avis, sans avoir vu. Le tableau aura perdu la transparence des ombres comme ils ont fait avec le Véronèse et comme il est presque immanquable que cela arrive toujours.*"

4 Bourdieu, *Distinction*.

REFERENCES

Accademici della Crusca, *Vocabolario*, 2nd edition, Venice: Bastiano de'Rossi, 1623

Paul Ackroyd, 'Retouching Media used at the National Gallery, London, since the Nineteenth Century', in Ellison et al. (eds.), *Mixing and Matching*, 51–60

Paul Ackroyd, 'The Structural Conservation of Canvas Paintings: Changes in Attitude and Practice since the Early 1970s', *Reviews in Conservation*, 3, 2003, 3–14

Paul Ackroyd, 'The structural conservation of paintings on wooden panel supports', in Stoner and Rushfield (eds.), *Conservation*, 543–78

Joseph Addison, 'The Mellowing Effects of Time', in Bomford and Leonard (eds.), *Readings II*, 441–53 (originally in *The Spectator*, 83, 5 June 1711)

Francesco Algarotti, *Saggio sull'architettura e sulla pittura*, Milan: Società Tipografica de' Classici Italiani, 1756

Heinz Althöfer, 'Max von Pettenkofer', in Althöfer (ed.), *19. Jahrhundert*, 305–07

Heinz Althöfer (ed.), *Das 19. Jahrhundert und die Restaurierung: Beiträge zur Malerei, Maltechnik und Konservierung*, Munich: Callwey, 1987

Manolis Andronicos, *Vergina: The Royal Tombs*, Athens: Ekdotike Athenon S.A., 1987

Anonymous, *Ricette per fare ogni sorte di colore* ('The Paduan Manuscript', late 16th century), in Merrifield, *Original Treatises*, 641–717

Anonymous, *The excellency of the pen and pencil, exemplifying the uses of them in the most exquisite and mysterious arts of drawing, etching, engraving, limning. Painting in oyl, washing of maps & pictures. Also the way to cleanse any old painting, and preserve the colours. Collected from the writings of the ablest masters, both antient and modern, as Albert Durer, P. Lomantius, and divers others*, London: Newman and Jones, 1668

Giovanni Battista Armenini, *De' veri precetti della pittura*, Ravenna: Francesco Tebaldini, 1587

Giovanni Battista Armenini, *On the True Precepts of the Art of Painting*, ed. and trans. Edward J. Olszewski, New York: Burt Franklin, 1977

Umberto Baldini, *Teoria del restauro e unità di metodologia*, 2 vols., Florence: Nardini, 2003

Umberto Baldini and Sergio Taiti, 'Italian Lining Techniques: Lining with Pasta Adhesive (and Other Methods) at the Fortezza da Basso, Florence', in Villers (ed.), *Lining Paintings*, 115–20

Filippo Baldinucci, *Vocabolario Toscano dell'Arte del Disegno*, Florence: Santi Franchi, 1681

Sandro Baroni, *Restauro e conservazione dei dipinti*, 2nd edn, Milan: Fabbri, 2003

Adam Bartsch, *Le peintre graveur*, Leipzig: Barth, 1854–1876

Charles Baudelaire, *L'art romantique*, Paris: Louis Conard, 1925

Michael Baxandall, *Painting and Experience in Fifteenth Century Italy: A Primer in the Social History of Pictorial Style*, Oxford: Clarendon Press, 1972

Thomas Beaufort, *Pictures and How to Clean Them*, London: John Lane, The Bodley Head, 1926

James Beck and Michael Daley, *Art Restoration: The Culture, the Business and the Scandal*, London: John Murray, 1993

Jean [Giovanni] Bedotti, *De la restauration des tableaux*, Paris: Chez l'Auteur, 1837; reprinted with introduction and commentary as Giovanni Bedotti, *Il restauro dei dipinti*, ed. Valentina Parodi, Florence: Edifir-Edizioni, 2010

H.C.A. van Beek and P.M. Heertjes, 'Fading by Light of Organic Dyes on Textiles and Other Materials', *Studies in Conservation*, 11, 1966, 123–32

Paolo Bellini, *L'opera incisa di Adamo e Diana Scultori*, Vicenza: Neri Pozza, 1991

Roberto Bellucci, Cecilia Frosinini and Luca Pezzati, 'Caravaggio's Underdrawing: a "Quest for the Grail"?', in Spring (ed.), *Studying Old Master Paintings*, 118–24

Ségolène Bergeon, *"Science et patience" ou la restauration des peintures*, Paris: Editions de la Réunion des musées nationaux, 1990

Ségolène Bergeon, Gilberte Émile-Mâle, Claude Huot and Odile Baÿ, 'The Restoration of Wooden Painting Supports: Two Hundred Years of History in France', in Dardes and Rothe, *Conservation of Panel Paintings*, 264–88

Ernst Berger, *Beiträge zur Entwickelungsgeschichte der Maltechnik*, Munich: Callwey, 1901

Gustav A. Berger, 'Inpainting using PVA', in Mills and Smith (eds.), *Cleaning, Retouching and Coatings*, 150–55

Gustav A. Berger, 'Lining and Mounting with BEVA', in Berger with Russell, *Conservation of Paintings*, 85–108

Gustav A. Berger, 'Lining of a Torn Painting with BEVA 371', in Villers (ed.), *Lining Paintings*, 49–62

Gustav A. Berger, 'Some Effects of Impregnating Adhesives on Paint Films', in Villers (ed.), *Lining Paintings*, 125–35

Gustav A. Berger, 'The Use of Water in the Conservation of Canvas Paintings', in Berger with Russell, *Conservation of Paintings*, 63–79

Gustav A. Berger, 'A Vacuum Envelope for Treating Panel Paintings', *Studies in Conservation*, 10, 1965, 18–23

Gustav A. Berger, 'Weave Accentuation and Weave Interference in Vacuum Lining of Paintings', in Berger with Russell, *Conservation of Paintings*, 109–16

Gustav A. Berger and William H. Russell, 'Interaction between Canvas and Paint Film in Response to Environmental Changes', *Studies in Conservation*, 39, 1994, 73–86

Gustav A. Berger with William H. Russell, *Conservation of Paintings: Research and Innovation*, London: Archetype Publications, 2000

Gustav A. Berger and Harold I. Zeliger, 'Wax Impregnation of Cellulose: an Irreversible Process', in Villers (ed.), *Lining Paintings*, 25–27

Marianne Bernhard, *Verlorene Werke der Malerei. In Deutschland in der Zeit von 1939 bis 1945 zerstörte und verschollene Gemälde aus Museen und Galerien*, Berlin: Henschelverlag and Munich: Friedrich Adolf Ackermans Kunstverlag, 1965

Marin Berovič, 'Biodeterioration Studies on Pastels and Oil-Based Paintings', in Koestler et al. (eds.) *Art, Biology, and Conservation*, 50–59

Barbara H. Berrie (ed.), *Artists' Pigments: A Handbook of their History and Characteristics*, vol. 4, Washington, D.C.: National Gallery of Art, 2007

Barbara H. Berrie, 'Prussian Blue', in FitzHugh (ed.), *Artists' Pigments*, 191–217

S.K. Bhowmik, 'A Note on the Use and Deterioration of Verdigris in Indian Watercolour Painting', *Studies in Conservation*, 15, 1970, 154–56

Rachel Billinge, Lorne Campbell, Jill Dunkerton, Susan Foister, Jo Kirby, Jennie Pilc, Ashok Roy, Marika Spring and Raymond White, 'The Materials and Techniques of Five Paintings by Rogier van der Weyden and his Workshop', *National Gallery Technical Bulletin*, 18, 1997, 68–86

Rachel Billinge, Lorne Campbell, Jill Dunkerton, Susan Foister, Jo Kirby, Jennie Pilc, Ashok Roy, Marika Spring and Raymond White, 'Methods and Materials of Northern European Painting in the National Gallery, 1400–1550', *National Gallery Technical Bulletin*, 18, 1997, 6–55

Anthony Blunt, 'Mantegna's "Triumph of Caesar" at Hampton Court: Report on Work in Progress', *The Burlington Magazine*, 104, 1962, 322

Anthony Blunt, 'A Project for Restoring Mantegna's "Triumph of Caesar"', *The Burlington Magazine*, 106, 1964, 126–27

Simon Bobak, 'A Flexible Unattached Auxiliary Support', in Dardes and Rothe (eds.), *Conservation of Panel Paintings*, 371–81

Achille Bocchi, *Symbolicarum quæstionum de uniuerso genere quas serio ludebat libri quinque*, Bologna: Apud Societatem Typographiæ Bononiensis, 1574

Alain G. Boissonnas, 'The Treatment of Fire-Blistered Oil Paintings', *Studies in Conservation*, 8, 1963, 55–66

Marten Jan Bok, 'Pricing the Unpriced. How Dutch 17th-century Painters Determined the Selling Price of their Work', in *Markets for Art*, ed. Clara Eugenia Nuñez, Seville: Universidad de Sevilla, 1998, 101–10

Marjolijn Bol, *Oil and the Translucent. Varnishing and Glazing in Practice, Recipes and Historiography, 1100–1600*, Ph.D. dissertation, University of Utrecht, 2011

David Bomford (ed.), *Art in the Making: Underdrawings in Renaissance Paintings*, London: National Gallery, 2002

David Bomford, 'The Conservator as Narrator: Changed Perspectives in the Conservation of Paintings', in Leonard (ed.), *Personal Viewpoints*, 1–12

David Bomford, 'Introduction: Keynote Address', in Dardes and Rothe, *Conservation of Panel Paintings*, xiii–xxii

David Bomford, 'Moroni's "Canon Ludovico di Terzi": An Unlined Sixteenth-Century Painting', *National Gallery Technical Bulletin*, 3, 1979, 34–42

David Bomford, 'Picture Cleaning: Positivism and Metaphysics', in Stoner and Rushfield (eds.), *Conservation*, 481–91

David Bomford, Christopher Brown and Ashok Roy, *Art in the Making: Rembrandt*, London: National Gallery, 1988 (1st edn)

David Bomford, Jill Dunkerton, Dillian Gordon and Ashok Roy, *Art in the Making: Italian Art before 1400*, London: National Gallery, 1989

David Bomford, Jo Kirby, Ashok Roy, Axel Rüger and Raymond White, *Art in the Making: Rembrandt*, 2nd edn, London and New Haven: Yale University Press, 2006

David Bomford with Jill Dunkerton and Martin Wyld, *Conservation of Paintings*, London: National Gallery, 2009

David Bomford and Mark Leonard (eds.), *Readings in Conservation II: Issues in the Conservation of Paintings*, Los Angeles: The Getty Conservation Institute, 2004

David Bomford and Ashok Roy, 'Hogarth's *Marriage à la Mode*', *National Gallery Technical Bulletin*, 6, 1982, 44–67

David Bomford, Ashok Roy and Alistair Smith, 'The Techniques of Dieric Bouts: Two Paintings Contrasted', *National Gallery Technical Bulletin*, 10, 1986, 39–57

David Bomford and Sarah Staniforth, 'Wax-Resin Lining and Colour Change: an Evaluation', *National Gallery Technical Bulletin*, 5, 1981, 58–65

Raffaello Borghini, *Il Riposo*, Florence: Nestenus & Moücke, 1730 (1st edn 1584)

Marco Boschini, *La carta del navegar pitoresco*, Venice: Li Baba, 1660

Marco Boschini, *Le ricche minere della pittura veneziana*, Venice: Francesco Nicolini, 1674

Abraham Bosse, *Le peintre converty aux precises et universelles regles de son art*, Paris: A. Bosse, 1667

Catharina I. Bothe, 'Asphalt', in Berrie (ed.), *Artists' Pigments*, 110–49

Roger Boulay, *La Maison Kanak*, Marseilles: Editions Parenthèses, 1990

Pierre Bourdieu, *Distinction. A Social Critique of the Judgment of Taste*, trans. Richard Nice, London: Routledge, 1984 (1st edn, in French, 1979)

Pierre-Louis Bouvier, *Manuel des jeunes artistes et amateurs en peinture*, Strasbourg: Levrault, 1827

S. Bracci, E. Cantisani, L. Fenelli, R. Olmi, R. Manganelli Del Fà, D. Magrini, S. Penoni, M. Picollo, S. Priori, C. Riminesi, B. Sacchi and C. Todaro, *Applicazione di tecniche diagnostiche non invasive e micro-invasive su dipinti murali: il caso studio della cappella di S. Antonio abate della ex Chiesa di S. Maria a Le Campora*, Florence: Istituto per la Conservazione e Valorizzazione dei Beni Culturali, Consiglio Nazionale delle Ricerche, 2011

Thomas Brachert, *Patina. Von Nutzen und Nachteil der Restaurierung*, Munich: Callwey, 1985

Robert Brain, *Art and Society in Africa*, London: Longman, 1980

Cesare Brandi, 'The Cleaning of Pictures in Relation to Patina, Varnish, and Glazes', *The Burlington Magazine*, 91, 1949, 183–88 (reprinted in Brandi, *Theory of Restoration*, 101–08)

Cesare Brandi, 'Letter: The Cleaning of Pictures in Relation to Patina, Varnish and Glazes', *The Burlington Magazine*, 92, 1950, 297–98

Cesare Brandi, 'Some Factual Observations on Varnishes and Glazes', in Brandi, *Theory of Restoration*, 109–22 (originally in *Bolletino dell'Istituto Centrale del Restauro*, 3–4, 1950, 9–29)

Cesare Brandi, *Theory of Restoration*, trans. Cynthia Rockwell, Florence: Nardini, 2005

Al Brewer, 'Practical Aspects of the Structural Conservation of Large Panel Paintings', in Dardes and Rothe (eds.), *Conservation of Panel Paintings*, 448–78

Carmen F. Bria, 'The History of the Use of Synthetic Consolidants and Lining Adhesives', *WAAC Newsletter*, 8, 1, Jan. 1986, 7–11

Janet Bridgland and Jessica Brown (eds.), *Preprints of the 12th Triennial Meeting, Lyon, 29 August – 3 September 1999, ICOM Committee for Conservation*, London: James and James, 1999

Norman Brommelle, 'Material for a History of Conservation. The 1850 and 1853 Reports on the National Gallery', *Studies in Conservation*, 2, 1956, 176–188

Richard D. Buck, 'Is Cradling the Answer?', *Studies in Conservation*, 7, 1962, 71–74

Spike Bucklow, 'The Classification of Craquelure Patterns', in Stoner and Rushfield (eds.), *Conservation*, 285–90

Spike Bucklow, 'The Description and Classification of Craquelure', *Studies in Conservation*, 44, 1999, 233–44

Spike Bucklow, 'The Description of Craquelure Patterns', *Studies in Conservation*, 42, 1997, 129–40

Andreas Burmester and Florian Bayerer, 'Towards Improved Infrared Reflectograms', *Studies in Conservation*, 38, 1993, 145–54

Aviva Burnstock and Tom Learner, 'Changes in the Surface Characteristics of Artificially Aged Mastic Varnishes after Cleaning Using Alkaline Reagents', *Studies in Conservation*, 37, 1992, 165–84

François-Xavier de Burtin, *Traité théorique et pratique des connoissances qui sont nécessaires à tout Amateur de Tableaux, et à tous ceux qui veulent apprendre à juger, apprécier et conserver les productions de la Peinture*, Brussels: Weissenbruch, 1808

Tom Caley, 'Aspects of Varnishes and the Cleaning of Oil Paintings before 1700', in Mills and Smith (eds.), *Cleaning, Retouching and Coatings*, 70–2

Lorne Campbell, *National Gallery Catalogues: The Fifteenth Century Netherlandish Paintings*, London: National Gallery, 1998

Lorne Campbell, *National Gallery Catalogues: The Sixteenth Century Netherlandish Paintings, with French Paintings before 1600*, London: National Gallery, 2014

Sheila Canby, *Persian Painting*, London: British Museum Press, 1993

Chris Caple, *Conservation Skills, Judgement, Method and Decision Making*, Abingdon: Routledge, 2000.

Marco Cardinali, Maria Beatrice de Ruggieri and Claudio Falcucci, *Diagnostica artistica: tracce materiali per la storia dell'arte e per la conservazione*, Rome: Palombi, 2002

Leslie Carlyle, 'The artist's anticipation of change as discussed in British nineteenth-century instruction books on oil painting', in Todd (ed.), *Appearance, Opinion, Change*, 62–67

Leslie Carlyle, *The Artist's Assistant: Oil Painting Instruction Manuals and Handbooks in Britain 1800–1900, With Reference to Selected Eighteenth-century Sources*, London: Archetype, 2001

Leslie Carlyle, 'Reproducing traditional varnishes: problems in representing authentic surfaces for oil paintings', in Carlyle and Bourdeau, *Varnishes*

Leslie Carlyle and James Bourdeau (eds.), *Varnishes: Authenticity and permanence. A workshop handbook*, Ottawa: Canadian Conservation Institute, 1994

Leslie Carlyle and Anna Southall, 'No short mechanic road to fame: the implications of certain artists' materials for the durability of British painting, 1770–1840', in Hamlyn (ed.), *Vernon's Gift*, 21–26

Roberto Casanelli, Alessandro Conti, Giuliano Ercoli, Michael Ann Holly and Adalgisa Lugli, *L'Arte (Critica e Conservazione)*, Milan: Jaca, 1993

May Cassar, Nigel Blades and Tadj Oreszczyn, 'Air Pollution Levels in Air-Conditioned and Naturally Ventilated Museums: a Pilot Study', in Bridgland and Brown (eds.), *12th Triennial Meeting*, 31–37 (available at http://eprints.ucl.ac.uk/2274/1/2274.pdf)

Cennino Cennini, *Il Libro dell'Arte*, ed. Daniel V. Thompson, New Haven: Yale University Press, 1932–33

Cennino Cennini, *The Craftsman's Handbook: "Il Libro dell'Arte"*, trans. Daniel V. Thompson, New York: Dover Publications, 1960 (reprint of New Haven: Yale University Press, 1932–33)

André Chastel and Takashi Okamura, *The Vatican Frescoes of Michelangelo*, New York: Abbeville Press, 1980

André Chastel, John Shearman, John O'Malley, Pierluigi de Vecchi, Michael Hirst, Fabrizio Mancinelli and Gianluigi Colalucci, *La Cappella Sistina: I primi restauri: la scoperta del colore*, Novara: Istituto geografico de Agostini, 1986

Arthur H. Church, *The Chemistry of Paints and Painting*, London: Seeley & Co. Ltd, 1901

Marco Ciatti, 'Il laboratorio di restauro della Fortezza da Basso a Firenze e gli sviluppi della metodologia del restauro di Umberto Baldini', in Schädler-Saub (ed.), *Kunst der Restaurierung*, 53–66

Orio Ciferri, 'Microbial Degradation of Paintings', *Applied and Environmental Microbiology*, 65, 1999, 879–85

Orio Ciferri, Piero Tiano and Giorgio Mastromei (eds.), *Of Microbes and Art: the Role of Microbial Communities in the Degradation and Protection of Cultural Heritage*, New York: Kluwer Academic/Plenum Publishers, 2000

Timothy Clark, *100 Views of Mount Fuji*, London: British Museum Press, 2001

T.J. Clark, *The Sight of Death. An Experiment in Art Writing*, New Haven and London: Yale University Press, 2006

Karolien De Clippel, Katharina Van Cauteren and Katlijne Van der Stighelen, *The Nude and the Norm in the Early Modern Low Countries*, Turnhout: Brepols, 2011

Marjorie B. Cohn (ed.), *Mark Rothko's Harvard Murals*, Cambridge (Mass.): Harvard University Art Museums, Center for Conservation and Technical Studies, 1988

Gianluigi Colalucci, 'Lo stato di conservazione e l'intervento di restauro', in Mancinelli (ed.), *Cappella Sistina*, 195–201

Gianluigi Colalucci, 'Tecniche di restauro', in Chastel et al., *Cappella Sistina*, 260–65

Alessandro Conti, *A History of the Restoration and Conservation of Works of Art*, trans. Helen Glanville, Oxford: Butterworth-Heinemann, 2007

Alessandro Conti, 'La patina della pittura a vent'anni dalle controversie "storiche". Teoria e pratica della conservazione', *Ricerche di storia dell'arte*, 16, 1982, 22–35

Alessandro Conti, 'Restauro', in Casanelli et al., *L'Arte*, 101–57

Alessandro Conti, *Storia del restauro e della conservazione delle opere d'arte*, Milan: Electa, 2002 (1st edn 1988)

Paul Coremans, 'La technique des "Primitifs flamands": Etude scientifique des matériaux, de la structure et de la technique picturale. III. Van Eyck: l'Adoration de l'Agneau Mystique (Gand: Cathedrale Saint-Bavon)', *Studies in Conservation*, 1, 1954, 145–61

F. duPont Cornelius, 'Further Developments in the Treatment of Fire-Blistered Oil Paintings', *Studies in Conservation*, 11, 1966, 31–36

Nicola Costaras, 'A Study of the Materials and Techniques of Johannes Vermeer', in Gaskell and Jonker (eds.), *Vermeer Studies*, 145–67

Patricia Cox Crews, 'The Fading Rates of Some Natural Dyes', *Studies in Conservation*, 32, 1987, 65–72

Alan Crookham, 'The Turner Bequest at the National Gallery', in Warrell, *Turner Inspired*, 51–65

Alan Cummings and Gerry Hedley, 'Surface Texture Changes in Vacuum Lining: Experiments with Raw Canvas', in Villers (ed.), *Lining Paintings*, 87–95

Pierre Curie and Cinzia Pasquali, 'Restoration of the *Saint Anne*', in Delieuvin (ed.), *Leonardo's Saint Anne*, 381–408

Michael Daley, 'Oil, Tempera and the National Gallery', in Beck and Daley, *Art Restoration*, 123–51

Kathleen Dardes and Andrea Rothe, *The Structural Conservation of Panel Paintings. Proceedings of a Symposium at the J. Paul Getty Museum, 24–28 April 1995*, Los Angeles: The Getty Conservation Institute, 1998

Bernice Davidson, *The Frick Collection, An Illustrated Catalogue. II: Paintings. French, Italian and Spanish*, New York: The Frick Collection, 1968

Luigi Dei, Andreas Ahle, Piero Baglioni, Daniela Dini and Enzo Ferroni, 'Green Degradation Products of Azurite in Wall Paintings: Identification and Conservation Treatment', *Studies in Conservation*, 43, 1998, 80–88

Eugène Delacroix, *Journal*, 3 vols., edn Paris: Librairie Plon, 1926

Horsin Déon, *De la Conservation et de la Restauration des Tableaux*, Paris: Hector Bossange, 1851

Vincent Delieuvin (ed.) *Saint Anne: Leonardo da Vinci's Ultimate Masterpiece*, exh. cat., Paris: Musée du Louvre, 2012

Denis Diderot, *Oeuvres complètes*, 20 vols., ed. Jules Assézat, Paris: Garnier Frères, 1875–77

William J. Diebold, 'The Politics of Derestoration. The Aegina Pediments and the German Confrontation with the Past', *Art Journal*, 54, 1995, 60–66

Shawn Digney-Peer, Karen Thomas, Roy Perry, Joyce Townsend and Stephen Gritt, 'The imitative retouching of easel paintings', in Stoner and Rushfield (eds.), *Conservation*, 607–34

Joris Dik, 'Jan van Huysum's Painting Technique', in Segal et al., *Jan van Huysum*, 69–74

Max Doerner, *The Materials of the Artist and Their Use in Painting*, San Diego, New York and London: Harcourt Inc., 1985 (translation by Eugen Neuhaus of *Malmaterial und seine Verwendung im Bilde*, Stuttgart: Enke, 1933)

Lodovico Dolce, *Dialogo della pittura, intitolato l'Aretino*, Venice: Gabriel Giolito, 1557

Robert Dossie, *The Handmaid to the Arts*, London: J. Nourse, 1758

Henry T. Dover, 'The Restoration of Paintings', *The Burlington Magazine*, 39, 1921, 184–88, 221–23

Jim Druzik and Stefan Michalski, 'The lighting of easel paintings', in Stoner and Rushfield (eds.), *Conservation*, 678–92

Jill Dunkerton and Helen Howard, 'Sebastiano del Piombo's *Raising of Lazarus*: A History of Change', *National Gallery Technical Bulletin*, 30, 2009, 26–51

Jill Dunkerton, Nicholas Penny and Marika Spring, 'The Technique of Garofalo's Paintings at the National Gallery', *National Gallery Technical Bulletin*, 23, 2002, 20–41

Jill Dunkerton and Ashok Roy, 'The Materials of a Group of Late Fifteenth-Century Florentine Panel Paintings', *National Gallery Technical Bulletin*, 17, 1996, 20–31

Jill Dunkerton and Raymond White, 'The Discovery and Identification of an Original Varnish on a Panel by Carlo Crivelli', *National Gallery Technical Bulletin*, 21, 2000, 70–76

Albrecht Dürer, *Schriftlicher Nachlass*, ed. Hans Rupprich, 3 vols., Berlin: Deutscher Verein für Kunstwissenschaft, 1956–69

Noel Dyrenforth, *Batik: Modern Concepts and Techniques*, London: B.T. Batsford, 2003

Charles Lock Eastlake, *Methods and Materials of Painting of the Great Schools and Masters*, New York: Dover Publications, 1960 (reprint of *Materials for a History of Oil Painting*, London: Longmans, 1847)

Judy Egerton, *National Gallery Catalogues: The British Paintings*, London: National Gallery, 1998

Alexander Eibner, *Entwicklung und Werkstoffe der Tafelmalerei*, Munich: Heller, 1928

Alexander Eibner, *Malmaterialenkunde als Grundlage der Maltechnik*, Berlin: Springer, 1909

Margriet van Eikema Hommes, *Changing Pictures. Discoloration in 15th – 17th-Century Oil Paintings*, London: Archetype Publications, 2004

Margriet van Eikema Hommes and Emilie Froment, 'Het decoratieprogramma in de galerijen van het Koninklijk Paleis Amsterdam: een harmonieuze interactie tussen schilderkunst, architectuur en licht? / The decoration programme in the galleries of the Royal Palace Amsterdam: a harmonious interaction between painting, architecture and light?', in van der Zwaag and Tervaert (eds.), *Batavian Commissions*, 34–53

Margriet van Eikema Hommes and Emilie Froment, '"Een doek van geene beteekenis": de nachtelijke samenzwering van Claudius Civilis in het Schakerbos van Govert Flinck en Jürgen Ovens technisch onderzocht', *Oud Holland*, 124, 2011, 141–70

Rebecca Ellison, Patricia Smithen and Rachel Turnbull (eds.), *Mixing and Matching: Approaches to Retouching Paintings*, London: Archetype Publications, 2010

Gilberte Émile-Mâle, 'The First Transfer at the Louvre in 1750: Andrea del Sarto's *La Charité*', in Bomford and Leonard (eds.), *Readings II*, 275–89 (originally 'La première transposition au Louvre en 1750: *La charité* d'Andrea del Sarto', *Revue du Louvre*, 3, 1982, 223–30, reprinted in Émile-Mâle, *Histoire de la Restauration*, 230–45)

Gilberte Émile-Mâle, *Pour une Histoire de la Restauration des Peintures en France*, Paris: Institut National du Patrimoine/Somogy Editions d'Art, 2008

Gilberte Émile-Mâle, *Restauration des Peintures de Chevalet*, 2nd edn, Fribourg: Office du Livre, 1981

David Erhardt, Charles S. Tumosa and Marion F. Mecklenburg, 'Long-Term Chemical and Physical Processes in Oil Paint Films', *Studies in Conservation*, 50, 2005, 143–50

Michel Favre-Félix, 'Delacroix: sur la restauration', *Nuances*, 27, 2001, 11–16

Michel Favre-Félix, 'Gombrich, les vernis, et la science', *Nuances*, 29, 2002, 4–9

Michel Favre-Félix and Paul Pfister, 'Entrevues au Louvre. À la recherche de la peinture ancienne', *Nuances*, 38/39, 2007, 23–31 (English translation by Alison Clarke, 'The pictorial role of old varnishes and the principle of their preservation' is available at www.aripa-revue-nuances.org)

Michel Favre-Félix, 'Les deux systèmes du Professeur Pettenkofer', *Nuances*, 42/43, 2010–11, 42–47

André Félibien, *Conférences de l'Académie Royale de Peinture et de Sculpture*, in Félibien, *Entretiens*, vol. 5

André Félibien, *Entretiens sur les vies et sur les ouvrages des plus excellens peintres anciens et modernes, avec la vie des architectes …*, Trevoux: De l'Imprimerie de S.A.S., 1725

André Félibien, *Des principes de l'architecture, de la sculpture, de la peinture, et des autres arts qui en dépendent: avec un dictionnaire des termes propres à chacun de ces arts*, Paris: Jean-Baptiste Coignard, 1676

André Félibien, 'Les Reines de Perse aux pieds d'Alexandre. Peinture du Cabinet du Roy', in Félibien, *Recueil*, 25–67

André Félibien, *Recueil de descriptions de peintures et d'autres ouvrages faits pour le Roy*, Paris: Veuve de Sebastien Mabre-Cramoisy, 1689

Robert L. Feller (ed.), *Artists' Pigments: a Handbook of their History and Characteristics*, vol. 1, Washington, D. C.: National Gallery of Art, 1986

Robert L. Feller, 'Solvents', in Feller et al., *On Picture Varnishes and their Solvents*, 7–23

Robert L. Feller and Michael Bayard, 'Terminology and Procedures Used in the Systematic Examination of Pigment Particles with the Polarizing Microscope', in Feller (ed.), *Artists' Pigments*, 285–98

Robert L. Feller, Nathan Stolow and Elizabeth H. Jones, *On Picture Varnishes and their Solvents*, Washington, D.C.: National Gallery of Art, 1985

Astrid Fendt, 'Restoration or De-Restoration? Two Different Concepts of Presenting Authentic Conditions of Ancient Sculptures in the Collection of Classical Antiquities in 19th-century Berlin', in Hermens and Fiske (eds.), *Authenticities*, 41–49

George Field, *Chromatography, or a Treatise on Colours and Pigments, and of their Powers in Painting, & c.*, London: Charles Tilt, 1835

Robert E. Fieux, 'Consolidation and Lining Adhesives Compared', in Villers (ed.), *Lining Paintings*, 35–7

Elisabeth West FitzHugh (ed.), *Artists' Pigments: A Handbook of their History and Characteristics*, vol. 3, Washington, D.C.: National Gallery of Art, 1997

Elisabeth West FitzHugh, 'Orpiment and Realgar', in FitzHugh (ed.), *Artists' Pigments*, 47–79

Elisabeth West FitzHugh, 'Red Lead and Minium', in Feller (ed.), *Artists' Pigments*, 109–39

Gert-Rudolf Flick, *Missing Masterpieces: Lost Works of Art, 1450–1900*, London: Merrell, 2003

Jean-Henry de la Fontaine, *L'Académie de la peinture*, Paris: I. Baptiste Loyson, 1679

Ulisse Forni, *Manuale del pittore restauratore*, Florence: Successori Le Monnier, 1866

Ulisse Forni, 'The Transfer of an Oil Painting from a Panel onto Canvas', in Bomford and Leonard (eds.), *Readings II*, 245–48 (originally Forni, *Manuale*, 108–11)

Adolphe Fosset, *Encyclopédie domestique, recueil de procédés et de recettes, concernant les arts et métiers, & c.*, Paris: Salmon, 1830

Chiara Franceschini, *Il limbo. Storia, teologia, immagini*, Bologna: Il Mulino (forthcoming)

Thomas Frangenberg (ed.), *Poetry on Art: Renaissance to Romanticism*, Donington: Shaun Tyas, 2003

Thomas Frangenberg and Rodney Palmer (eds.), *Lives of Leonardo*, London: Warburg Institute, 2013

David Freedberg and Jan de Vries (eds.), *Art in History/History in Art. Studies in 17th-century Dutch Culture*, Santa Monica: Getty Center, 1991

Charles Alphonse du Fresnoy, *The Art of Painting*, with a commentary by Roger de Piles, trans. John Dryden, London: W. Rogers, 1695

Max J. Friedländer, *Die altniederländische Malerei, II: Rogier van der Weyden und der Meister von Flémalle*, Berlin: P. Cassirer, 1924

Max J. Friedländer, *On Art and Connoisseurship*, trans. Tancred Borenius, Boston, MA: Beacon Press, 1960

Theodor von Frimmel, *Handbuch der Gemäldekunde*, 2nd edn, Leipzig: J.J. Weber, 1904

Roger Fry, 'The Authenticity of the Renders Collection', *The Burlington Magazine*, 50, 1927, 261–63

Antonella Fuga, *Artists' Techniques and Materials*, trans. Rosanna M. Giammanco Frongia, Los Angeles: J. Paul Getty Museum, 2006

John Gage, 'Magilphs and mysteries', *Apollo*, 80, 1964, 38–41

Emilio Galan and Arieh Singer (eds.), *Developments in Palygorskite-Sepiolite Research: a New Outlook on these Nanomaterials*, Amsterdam and Oxford: Elsevier, 2011

Émile Galichon, 'Restoration of the Paintings of the Louvre: Response to an Article by Mr. Frédéric Villot', in Bomford and Leonard (eds.), *Readings II*, 473–82 (originally *Restauration des tableaux de Louvre: réponse à une article de M. Frédéric Villot*, Paris: Chez Tous Les Libraires, 1860)

Ivan Gaskell and Michiel Jonker (eds.), *Vermeer Studies*, Washington: National Gallery of Art, 1998

Martin Gayford, *A Bigger Message: Conversations with David Hockney*, London: Thames and Hudson, 2011

Rutherford J. Gettens, Robert L. Feller and W.T. Chase, 'Vermilion and Cinnabar', in Roy (ed.), *Artists' Pigments*, 159–82

Rutherford J. Gettens and Elisabeth West FitzHugh, 'Azurite and Blue Verditer', in Roy (ed.), *Artists' Pigments*, 23–35

Rutherford J. Gettens and Elisabeth West FitzHugh, 'Malachite and Green Verditer', in Roy (ed.), *Artists' Pigments*, 183–202

Rutherford J. Gettens, Hermann Kühn and W.T. Chase, 'Lead White', in Roy (ed.), *Artists' Pigments*, 67–81

Rutherford J. Gettens and George L. Stout, *Painting Materials: A Short Encyclopaedia*, New York: Dover Publications, 1966

Cristina Giannini (ed.), *Dizionario del restauro: tecniche diagnostica conservazione*, Florence: Nardini, 2010

Bettina von Gilsa, 'The Cleaning Controversy – Zur Diskussion der Gemäldereinigung in England von 1946–1963', in Harmssen, *Firnis*, 193–200

Rudolf Giovanoli and Bruno Mühlethaler, 'Investigation of Discoloured Smalt', *Studies in Conservation*, 15, 1970, 37–44

Helen Glanville, 'Veracity, verisimilitude and optics in painting in Italy at the turn of the 17th century', *Kermes: la revista del restauro*, 84, 2011, 59–74

Jean-Albert Glatigny, 'Backings of Painted Panels: Reinforcement and Constraint', in Dardes and Rothe, *Conservation of Panel Paintings*, 364–70

Willem Goeree, *Inleydinge tot de Al-ghemeene Teycken-Kons*, ed. Michael Kwakkelstein, Leiden: Primavera Pers, 1998 (1st edn 1668)

Johann Wolfgang von Goethe, *Zur Farbenslehre*, ed. Rike Wankmüller, in *Goethes Werke*, XIII, Hamburg: Christian Wegner Verlag, 1955, 314–642

Michael von der Goltz, Ina Birkenbeul, Isabel Horovitz, Morwenna Blewett and Irina Dolgikh, 'Consolidation of flaking paint and ground', in Stoner and Rushfield (eds.), *Conservation*, 369–83

Michael von der Goltz, Robert G. Proctor, Jr, Jill Whitten, Lance Mayer and Gay Myers, with Anne Hoenigswald and Michael Swicklik, 'Varnishing as Part of the Conservation Treatment of Easel Paintings', in Stoner and Rushfield (eds.), *Conservation*, 635–57

Michael von der Goltz and Joyce Hill Stoner, 'Considerations on removing or retaining overpainted additions and alterations', in Stoner and Rushfield (eds.), *Conservation*, 497–9

E.H. Gombrich, 'Controversial Methods and Methods of Controversy', *The Burlington Magazine*, 105, 1963, 90–3

E.H. Gombrich, 'Dark Varnishes: Variations on a Theme from Pliny', *The Burlington Magazine*, 104, 1962, 51–55 (reprinted in Bomford and Leonard (eds.), *Readings II*, 507–18)

Dillian Gordon, *National Gallery Catalogues: The Fifteenth Century Italian Paintings, Volume I*, London: National Gallery, 2003

Dillian Gordon, *National Gallery Catalogues: The Italian Paintings before 1400*, London: National Gallery, 2011

Francisco de Goya, *A Life in Letters*, ed. Sarah Symmons, trans. Philip Troutman, London: Pimlico, 2004

J.A. van de Graaf, 'The Interpretation of Old Painting Recipes', *The Burlington Magazine*, 104, 1962, 471–5

Michael Greenhalgh, *The Survival of Roman Antiquities in the Middle Ages*, London: Duckworth, 1989

Michèle Gunn, Geneviève Chottard, Eric Rivière, Jean-Jacques Girerd and Jean-Claude Chottard, 'Chemical Reactions between Copper Pigments and Oleoresinous Media', *Studies in Conservation*, 47, 2002, 12–23

Daniel Gutscher, Bruno Mühlethaler, Armin Portmann and Armin Reller, 'Conversion of Azurite into Tenorite', *Studies in Conservation*, 34, 1989, 117–122

Rosalind Hackett, *Art and Religion in Africa*, London: Cassell, 1996

Stephen Hackney, 'Texture and Application: Preserving the Evidence in Oil Paintings', in Todd (ed.), *Appearance, Opinion, Change*, 22–5

Stephen Hackney, Joan Reifsnyder, Mireille te Marvelde and Mikkel Scharf, 'Lining easel paintings', in Stoner and Rushfield (eds.), *Conservation*, 415–52

Robin Hamlyn (ed.), *Robert Vernon's Gift: British Art for the Nation, 1847*, London: Tate Gallery, 1993

R.D. Harley, *Artists' Pigments c. 1600–1835: A Study in English Documentary Sources*, London: Archetype Publications, 2001

Anne Harmssen (ed.), *Firnis: Material, Ästhetik, Geschichte. Internationales Kolloquium, Braunschweig, 15–17 Juni 1998*, Braunschweig: Herzog Anton-Ulrich-Museum, 1999

Frederick Hartt, Fabrizio Mancinelli, Gianluigi Colalucci and Takashi Okamura, *The Sistine Chapel*, London: Barrie & Jenkins, 1991

Gerry Hedley, 'Long Lost Relations and New Found Relativities: Issues in the Cleaning of Paintings', in Bomford and Leonard (eds.), *Readings II*, 407–23 (originally in Todd [ed.], *Appearance, Opinion, Change*, 8–13)

Kate Helwig, 'Iron Oxide Pigments, Natural and Synthetic', in Berrie (ed.), *Artists' Pigments*, 39–109

Kenneth Hempel, 'Note on the Conservation of Sculpture, Stone, Marble and Terracotta', *Studies in Conservation*, 13, 1968, 34–44

Philip Hendy (ed.), *An Exhibition of Cleaned Pictures (1936–1947)*, London: The National Gallery, 1947

Erma Hermens (ed.), *Looking through Paintings. The Study of Painting Techniques and Materials in Support of Art Historical Research, Leids Kunsthistorisch Jaarboek*, XI, Baarn: De Prom, 1998

Erma Hermens and Tina Fiske (eds.), *Art: Conservation and Authenticities. Material, Concept, Context*, London: Archetype Publications, 2009

Erma Hermens and Joyce Townsend, 'Binding media', in Stoner and Rushfield (eds.), *Conservation*, 207–13

Erma Hermens and Arie Wallert, 'The Pekstok Papers, Lake Pigments, Prisons and Paint-Mills', in Hermens (ed.), *Looking through Paintings*, 269–91

Catherine Higgitt, Marika Spring and David Saunders, 'Pigment-Medium Interactions in Oil Paint Films containing Red Lead or Lead-Tin Yellow', *National Gallery Technical Bulletin*, 24, 2003, 75–95

Catherine Higgitt and Raymond White, 'Analyses of Paint Media: New Studies of Italian Paintings of the Fifteenth and Sixteenth Centuries', *National Gallery Technical Bulletin*, 26, 2005, 88–97

Judith Hofenk de Graaff, *The Colourful Past: Origins, Chemistry and Identification of Natural Dyestuffs*, Riggisberg and London: Abegg-Stiftung and Archetype Publications, 2004

William Hogarth, *The Analysis of Beauty*, London: J. Reeves, 1753

Charles Holmes, 'Some Elements of Picture Cleaning', *The Burlington Magazine*, 40, 1922, 132–34

Charles Hope, 'The National Gallery Cleaning Controversy', *Artwatch UK Journal*, 28, 2012, 4–15

Charles Hope, 'Vasari's *Vite* as a Collaborative Project', in *The Ashgate Research Companion to Giorgio Vasari*, ed. David J. Cast, Farnham: Ashgate, 2014, 11–22

Velson Horie, *Materials for Conservation: Organic Consolidants, Adhesives and Coatings*, Kidlington: Butterworth-Heinemann, 2010

Isabel Horovitz and Joan Reifsnyder, 'The use of slate or stone as a painting support', in Stoner and Rushfield (eds.), *Conservation*, 97–99

Giles Hudson, 'The Vanity of the Sciences', *Annals of Science*, 60, no. 2, April 2003, 201–05

Georges Hulin de Loo, 'Diptychs by Rogier van der Weyden – II', *The Burlington Magazine*, 44, 1924, 185–89

Hundertpfund, Liberat, *The Art of Painting Restored to its Simplest and Purest Principles*, London: David Bogue, 1849 (originally *Die Malerei auf ihre einfachsten und sichersten Grundsätze zurückgeführt*, Augsburg: Verlag von J. Walch'schen Kunst- und Landkartenhandlung, 1847)

René Huyghe, 'Le problème du dévernissage des peintures anciennes et le Musée du Louvre', *Nuances*, 29, 2002, 11–17 (originally in *Museum*, 3, 1950)

Julius Caesar Ibbetson, *An Accidence, or Gamut, of Painting in Oil*, London: Harvey & Darton, 1828

John Ingamells, *The Wallace Collection: Catalogue of Pictures*, 4 vols., London: The Wallace Collection, 1985–92

Jonathan Janson, *How to Paint Your Own Vermeer: Materials and Methods of a Seventeenth-Century Master*, Raleigh, NC: Lulu, 2008

Paul Joannides, *Titian to 1518: The Assumption of Genius*, New Haven and London: Yale University Press, 2001

P.L. Jones, 'Scientism and the Art of Picture Cleaning', *The Burlington Magazine*, 105, 1963, 98–103

Joanna Karbowska-Berent, 'Microbiodeterioration of Mural Paintings: a Review', in Koestler et al. (eds.), *Art, Biology, and Conservation*, 267–301

Adam Karpowicz, 'A Study on Development of Cracks on Paintings', *Journal of the American Institute for Conservation*, 29, 1990, 169–80

T. Katsaros, I. Liritzis and N. Laskaris, 'Is White Pigment on Apelles' Palette a TiO_2-Rich Kaolin? New Analytical Results on the Case of Melian-Earth', *Mediterranean Archaeology and Archaeometry*, 9, no. 1, 2009, 29–35

Caroline Keck, 'Lining Adhesives: their History, Uses and Abuses', *Journal of the American Institute for Conservation*, 17, 1977, 45–52

Caroline Keck, Herbert Lank, Steven Miller, John Golding, Angelica Zander Rudenstine, Robert Rosenblum and John Richardson, '"Crimes against the Cubists": an Exchange', in Bomford and Leonard (eds.), *Readings II*, 539–47 (originally in *New York Review of Books*, 30, no. 15, October 1983, 41–43)

Sheldon Keck, 'Mechanical Alteration of the Paint Film', *Studies in Conservation*, 14, 1969, 9–30

Sheldon Keck, 'Some Picture Cleaning Controversies: Past and Present', in Bomford and Leonard (eds.), *Readings II*, 426–40 (originally *Journal of the American Institute for Conservation*, 23, 1984, 73–87)

Adolf Wilhelm Keim, *Ueber Mal-Technik: Ein Beitrag zur Beförderung rationeller Malverfahren*, Leipzig: A. Foerster, 1903

Larry Keith and Ashok Roy, 'Giampietrino, Boltraffio and the Influence of Leonardo', *National Gallery Technical Bulletin*, 17, 1996, 4–19

Larry Keith, Ashok Roy, Rachel Morrison and Peter Schade, 'Leonardo da Vinci's *Virgin of the Rocks*: Treatment, Technique and Display', *National Gallery Technical Bulletin*, 32, 2011, 32–56

Francis Kelly, *Art Restoration*, Newton Abbot: David & Charles, 1971

Martin Kemp, *Leonardo da Vinci: The Marvellous Works of Nature and Man*, Oxford: Oxford University Press, 2006

Katrien Keune, *Binding Medium, Pigments and Metal Soaps Characterised and Localised in Paint Cross-Sections*, PhD dissertation, University of Amsterdam, 2005 (available online at http://aigaion.amolf.nl/index.php/publications/show/661)

Katrien Keune and Jaap Boon, 'Analytical imaging studies of cross-sections of paintings affected by lead soap aggregate formation', *Studies in Conservation*, 52, 2007, 161–76

Jo Kirby, 'Fading and Colour Change of Prussian Blue: Occurrences and Early Reports', *National Gallery Technical Bulletin*, 14, 1993, 62–71

Jo Kirby and David Saunders, 'Fading and Colour Change of Prussian Blue: Methods of Manufacture and the Influence of Extenders', *National Gallery Technical Bulletin*, 25, 2004, 73–99

Jo Kirby and David Saunders, 'Sixteenth- to eighteenth-century green colours in landscape and flower paintings: composition and deterioration', in Roy and Smith (eds.), *Painting Techniques*, 155–9

Jo Kirby, Marika Spring and Catherine Higgitt, 'The Technology of Red Lake Pigment Manufacture: Study of the Dyestuff Substrate', *National Gallery Technical Bulletin*, 26, 2005, 71–87

Jo Kirby and Raymond White, 'The Identification of Red Lake Pigment Dyestuffs and a Discussion of their Use', *National Gallery Technical Bulletin*, 17, 1996, 56–80

Andrea Kirsh and Rustin S. Levenson, *Seeing Through Paintings: Physical Examination in Art Historical Studies*, New Haven: Yale University Press, 2002

Jörg Klaas, *Die "Ultramarinkrankheit". Studien zu Veränderungen in ultramarin-haltigen Farbschichten an Gemälden*, doctoral dissertation, Technische Universität, Munich, 2011

Heiner Knell and Hanno-Walter Kruft, 'Re-Opening of the Munich Glyptothek', *The Burlington Magazine*, 114, 1972, 431–36

L. Kockaert, 'Note on the Green and Brown Glazes of Old Paintings', *Studies in Conservation*, 24, 1979, 69–74

Christian Koester, *Ueber Restauration alter Oelgemälde. Nachdruck der Originalausgabe von 1827 bis 1830*, ed. and intro. by Thomas Rudi, Leipzig: E.A. Seemann, 2001

Robert J. Koestler, Victoria H. Koestler, A. Elena Charola and Fernando E. Nieto-Fernandez (eds.), *Art, Biology, and Conservation: Biodeterioration of Works of Art*, New York: The Metropolitan Museum of Art, 2003

Johann Koller and Andreas Burmester, 'Blanching of Unvarnished Modern Paintings: a Case Study on a Painting by Serge Poliakoff', in Mills and Smith (eds.), *Cleaning, Retouching and Coatings*, 138–43

Hermann Kühn, 'Verdigris and Copper Resinate', in Roy, *Artists' Pigments*, 131–58

Otto Kurz, 'Varnishes, Tinted Varnishes, and Patina', *The Burlington Magazine*, 104, 1962, 56–59

Otto Kurz, 'Time the Painter', *The Burlington Magazine*, 105, 1963, 94–97

Suzanne Laemers, '"A matter of character". Max J. Friedländer et ses relations avec Emile Renders et Jef Van der Veken', in Vanwijsberghe (ed.), *Autour de la Madeleine Renders*, 147–76

Gérard de Lairesse, *Groot Schilderboek*, 2nd edn, Amsterdam: Henri Desbordes, 1712 (http://www.dbnl.org/tekst/lair001groo01_01/colofon.htm)

Leonilla Laiz, Delfina Recio, Bernardo Hermosin and Cesareo Saiz-Jimenez, 'Microbial Communities in Salt Efflorescences', in Ciferri et al., *Microbes and Art*, 77–88

Herbert Lank, 'Egg Tempera as a Retouching Medium', in Mills and Smith (eds.), *Cleaning, Retouching and Coatings*, 156–57

A.P. Laurie, *The Painter's Methods and Materials*, New York: Dover Publications, 1988 (1st edn 1960)

A.P. Laurie, *The Pigments and Mediums of the Old Masters*, London, Macmillan & Co., 1914

A.P. Laurie, 'The Refractive Index of a Solid Film of Linseed Oil. Rise in Refractive Index with Age', *Proceedings of the Royal Society of London, Series A. Mathematical and Physical Sciences*, 159, 1937, 123–33

Rensselaer W. Lee, *Ut pictura poesis: The humanistic theory of painting*, New York: W.W. Norton, 1967

Jirina Lehmann, 'Öl-, Harzöl- und Harzfirnisse in den Quellenschriften zur Maltechnik von der Spätantike bis zum Beginn der Neuzeit. Ein Beitrag zur Interpretation der Anweisungen', in Harmssen (ed.), *Firnis*, 63–79

Nicolas Lemery (Le Sieur d'Emery), *Recueil des curiositez rares & nouvelles des plus admirables effets de la nature & de l'art*, Paris: Pierre Vander Aa, 1684

Mark Leonard (ed.), *Personal Viewpoints: Thoughts about Painting Conservation*, Los Angeles: Getty Conservation Institute, 2003

Mark Leonard, Narayan Khandekar and Dawson Carr, '"Amber varnish" and Orazio Gentileschi's "Lot and his daughters"', *The Burlington Magazine*, 143, 2001, 4–10

Rustin Levenson, 'Emergency preparedness and recovery', in Stoner and Rushfield (eds.), *Conservation*, 717–26

Haida Liang, Marta Gomez Cid, Radu Cucu, George Dobre, Boris Kudimov, Justin Pedro, David Saunders, John Cupitt and Adrian Podoleanu, 'Optical Coherence Tomography: a Non-Invasive Technique Applied to Conservation of Paintings', in Salimbeni and Pezzati (eds.), *Optical Methods*, 261–69

Jean-Étienne Liotard, *Traité des Principes et des Règles de la Peinture*, Geneva: Cailler, 1945 (1st edn 1781)

Annelies van Loon, *Color Changes and Chemical Reactivity in Seventeenth-Century Oil Paintings*, London: Archetype Publications, 2008

Annelies van Loon, Petria Noble and Aviva Burnstock, 'Ageing and deterioration of traditional oil and tempera paints', in Stoner and Rushfield (eds.), *Conservation*, 214–41

David Lowenthal, *The Past is a Foreign Country*, Cambridge: Cambridge University Press, 1985

Arthur Lucas, 'Lining and Relining Methods and Rules Evolved at the National Gallery Conservation Department', in Villers (ed.), *Lining Paintings*, 107–111

Arthur Lucas and Joyce Plesters, 'Titian's *Bacchus and Ariadne*', *National Gallery Technical Bulletin*, 2, 1978, 25–47

Shannon Lush and Trent Hayes, *Stainless*, Sydney: Harper Collins, 2010

Rhona MacBeth, 'The technical examination and documentation of easel paintings', in Stoner and Rushfield (eds.), *Conservation*, 291–305

Ian McClure, 'History of Structural Conservation of Panel Paintings in Great Britain', in Dardes and Rothe (eds.), *Conservation of Panel Paintings*, 237–51

Sabine MacCormack, *Religion in the Andes: Vision and Imagination in Early Colonial Peru*, Princeton: Princeton University Press, 1993

Neil MacLaren and Christopher Brown, *National Gallery Catalogues: The Dutch School, 1600–1900*, London: National Gallery, 1991

Neil MacLaren and Anthony Werner, 'Some Factual Observations about Varnishes and Glazes' *The Burlington Magazine*, 92, 1950, 189–92

Denis Mahon, 'Miscellanea for the Cleaning Controversy', *The Burlington Magazine*, 104, 1962, 460–70

Carlo Cesare Malvasia, *Felsina Pittrice: Vite de' Pittori Bolognesi*, Bologna: Per l'Erede di Domenico Barbieri, 1678

Fabrizio Mancinelli, 'Michelangelo all'opera: tecnica e colore', in Chastel et al., *Cappella Sistina*, 218–59

Fabrizio Mancinelli (ed.), *Michelangelo: La Cappella Sistina. Rapporto sul restauro degli affreschi della volta*, Novara: Istituto Geografico de Agostini, 1994

Karel van Mander, *Het Schilder-Boeck*, Haarlem: Paschier van Wesbuch, 1604

Bohdan L. Marconi, 'Unusual Examples of Lining on Wax-Resin', in Villers (ed.), *Lining Paintings*, 77–82

Roger-Henri Marijnissen, *Dégradation, Conservation et Restauration de l'Oeuvre d'Art*, Brussels: Éditions Arcade, 1967

Roger-Henri Marijnissen, *The Masters' and the Forger's Secrets, X-ray Authentication of Paintings*, Brussels: Mercatorfonds, 2010

Jane Martineau (ed.), *Andrea Mantegna*, New York and London: Metropolitan Museum of Art and Royal Academy of Arts, 1992

Ann Massing, 'French Painting Technique in the Seventeenth and Early Eighteenth Centuries and De la Fontaine's *Académie de la peinture* (Paris 1679)', in Hermens (ed.), *Looking through Paintings*, 319–90

Ann Massing, *Painting Restoration Before La Restauration: The Origins of the Profession in France*, London: Harvey Miller Publishers, 2012

Ann Massing, 'Restoration Policy in France in the Eighteenth Century', in Sitwell and Staniforth (eds.), *History of Restoration*, 63–84

Ann Massing and Karin Groen, 'A self-portrait by Godfried Schalcken', *The Hamilton Kerr Institute Bulletin*, 1, 1988, 105–8

Lance Mayer, 'Traditional Artists' Varnishes', www.conservation-wiki.com, American Institute for Conservation, 1995

Ralph Mayer, *The Artist's Handbook of Materials and Techniques*, 5th edn, London: Faber & Faber, 1991

Theodore Turquet de Mayerne, *Pictoria Sculptoria & quae subalternarum artium 1620*, in Berger, *Maltechnik*, 98–365

Vishwa Raj Mehra, 'A Low-Pressure Cold-Relining Table', in Villers (ed.), *Lining Paintings*, 121–4

Vishwa Raj Mehra, 'The Cold Lining of Paintings', *The Conservator*, 5, 1981, 12–14

Vishwa Raj Mehra, *Foderatura a freddo: I testi fondamentali per la metodologia e pratica*, Florence: Nardini, 1990

Jean François Léonor Mérimée, *De la Peinture à l'huile: ou, Des procédés matériels employés dans ce genre de peinture, depuis Hubert et Jean Van-Eyck jusqu'à nos jours*, Paris: Huzard, 1830

Mary Merrifield, *The Art of Fresco Painting, as practised by the old Italian and Spanish masters, with a preliminary inquiry into the nature of the colours used in fresco painting*, London: published for the author by Charles Gilpin, 1846

Mary Merrifield, *Original Treatises, Dating from the XIIth to the XVIIIth Centuries, on the Arts of Painting*, London: John Murray, 1849

Henry Merritt, *Pictures and Dirt Separated, in the Works of the Old Masters*, London: Holyoake & Co., 1854

Georges Messens, 'Hand Lining with Wax-Resin Using an Iron', in Villers (ed.), *Lining Paintings*, 70–76

A.J.P. Meyer, *Oceanic Art*, Cologne: Könemann, 1995

Francesco Milizia, *Dizionario delle belle arti del disegno estratto in gran parte dall'enciclopedia metodica*, Bassano: Remondini, 1797 (for the 'enciclopedia metodica', see Watelet and Lévesque (eds.), *Encyclopédie Méthodique*)

John Mills and Perry Smith (eds.), *Cleaning, Retouching and Coatings: Technology and Practice for Easel Paintings and Polychrome Sculpture*, Preprints of the Contributions to the Brussels Congress, 3–7 September 1990, London: International Institute for Conservation of Historic and Artistic Works, 1990

John Mills and Raymond White, 'Analyses of Paint Media', *National Gallery Technical Bulletin*, 1, 1977, 57–59; 3, 1979, 66–67; 4, 1980, 65–67; 5, 1981, 66–67; 7, 1983, 65–67; 9, 1985, 70–71; 11, 1987, 92–95; 12, 1988, 78–79; 13, 1989, 69–71

John Mills and Raymond White, 'The Mediums used by George Stubbs: Some Further Studies', *National Gallery Technical Bulletin*, 9, 1985, 60–64

John Mills and Raymond White, 'Natural Resins of Art and Archaeology, their Sources, Chemistry and Identification', *Studies in Conservation*, 22, 1977, 12–31

John Mills and Raymond White, *The Organic Chemistry of Museum Objects*, Abingdon: Routledge, 2011 (1st edn 1987)

Henry Mogford, *Hand-Book for the Preservation of Pictures, containing Practical Instructions for Cleaning, Lining, Repairing and Restoring Oil Paintings, with Remarks on the Distribution of Works of Art in Houses and Galleries, their Care and Preservation*, London: Winsor and Newton, 1851

Alida Moltedo (ed.), *La Sistina riprodotta: gli affreschi di Michelangelo dalle stampi del cinquecento alle campagne fotografiche Anderson,* Rome: Fratelli Palombi, 1991

Rachel Morrison, 'Mastic and Megilp in Reynolds's Lord Heathfield of Gibraltar: a Challenge for Conservation', *National Gallery Technical Bulletin*, 31, 2010, 112–28

Bruno Mühlethaler and Jean Thissen, 'Smalt', in Roy (ed.), *Artists' Pigments*, 113–30

Michelangelo Muraro, 'Notes on Traditional Methods of Cleaning Pictures in Venice and Florence', *The Burlington Magazine*, 104, 1962, 475–77

Jilleen Nadolny, 'History of visual compensation for paintings', in Stoner and Rushfield (eds.), *Conservation*, 573–585

Arnold Nesselrath, *Raphael's School of Athens*, Vatican City: Musei Vaticani, 1996

Peter Newman, 'A Method for Lining Canvas with Glue Composition', in Villers (ed.) *Lining Paintings*, 30–31

Knut Nicolaus, *Handbuch der Gemälderestaurierung*, Cologne: Könemann, 1998

Knut Nicolaus, *The Restoration of Paintings*, trans. Judith Hayward, Cologne: Könemann, 1999

Petria Noble, Annelies van Loon and Jaap J. Boon, 'Chemical Changes in Old Master Paintings II: Darkening due to Increased Transparency as a Result of Metal Soap Formation Processes', *ICOM Committee for Conservation preprints, 14th triennial meeting The Hague, 12–16 September 2005*, London: James & James, 2005, 496–503 (www.viks.sk/chk/14tmh_43.doc)

Edward Norgate, *Miniatura or the Art of Limning*, ed. Jeffrey M. Muller and Jim Murrell, New Haven and London: Yale University Press, 1997

Christopher Norris, 'The Disaster at Flakturm Friedrichshain; A Chronicle and List of Paintings', *The Burlington Magazine*, 94, 1952, 337–47

Joseph Padfield, David Saunders, John Cupitt and Robert Atkinson, 'Improvements in the Acquisition and Processing of X-ray Images of Paintings', *National Gallery Technical Bulletin*, 23, 2002, 62–75

Jacques-Nicolas Paillot de Montabert, *Traité complet de la peinture*, 10 vols., Paris: J.-F. Delion, 1829–51

Antonio Palomino de Castro y Velasco, *El Museo pictorico y escala óptica*, Madrid: Imprenta de Sancha, 1795–97 (1st edn 1715–24)

Erwin Panofsky, *Studies in Iconology. Humanistic Themes in the Art of the Renaissance*, New York: Oxford University Press, 1939

Nicholas Penny, *National Gallery Catalogues: The Sixteenth Century Italian Paintings, Volume I, Bergamo, Brescia and Cremona*, London: National Gallery, 2004

Nicholas Penny, *National Gallery Catalogues: The Sixteenth Century Italian Paintings, Volume II, Venice 1540–1600*, London: National Gallery, 2008

Westby Percival-Prescott, 'Eastlake Revisited: Some Milestones on the Road to Ruin', in Mills and Smith (eds.), *Cleaning, Retouching and Coatings*, 73–75

Westby Percival-Prescott, 'The Lining Cycle. Causes of Physical Deterioration in Oil Paintings on Canvas: Lining from the 17th Century to the Present Day', in Villers (ed.), *Lining Paintings*, 1–15 (reprinted in Bomford and Leonard (eds.), *Readings II*, 249–66)

Antoine-Joseph Pernety, *Dictionnaire portatif de peinture, sculpture et gravure; avec un traité pratique des differentes manieres de peindre*, Paris: Bauche, 1756

Karin Petersen and Jens Klocke, 'Understanding the deterioration of paintings by microorganisms and insects', in Stoner and Rushfield (eds.), *Conservation*, 693–708

Paul Pfister, 'Mattia Preti: un exemple de velatura au XVIIe siècle', *Nuances*, 36/37, 2006, 34–37

Paul Pfister, 'Le traitement d'un chanci de vernis: régénération par les vapeurs d'alcool', *Nuances*, 42–43, 2010–2011, 24–26

Alan Phenix and Joyce Townsend, 'A brief survey of historical varnishes', in Stoner and Rushfield (eds.), *Conservation*, 254–63

Alan Phenix and Richard Wolbers, 'Removal of varnish: organic solvents as cleaning agents', in Stoner and Rushfield (eds.), *Conservation*, 524–54

Paul Philippot, 'The Idea of Patina and the Cleaning of Paintings', in Price et al. (eds.), *Readings I*, 372–76 (originally 'La notion de patine et le nettoyage des peintures', *Bulletin de l'Institute Royal du Patrimoine Artistique,* 9, 1966, 138–43)

Roger de Piles, *Dialogue sur le coloris*, Paris: Nicolas Langlois, 1673

Roger de Piles, *Cours de peinture par principes*, Paris: Jacques Estienne, 1708

Roger de Piles, *Élémens de peinture pratique*, in *Oeuvres diverses de M. de Piles, tome troisième,* Paris: Charles-Antoine Jombert, 1767 (the section on picture cleaning in this edition of de Piles's book is thought to have been written by Jombert: Plesters, 'Bibliography', 380)

Matthew Pilkington, *The Gentleman's and Connoisseur's Dictionary of Painters*, London: T. Cadell, 1770

Daniela Pinna, Monica Galeotti and Rocco Mazzeo (eds.), *Scientific Examination for the Investigation of Paintings. A Handbook for Conservator-Restorers*, Florence: Centro Di, 2009

Joyce Plesters, 'Bibliography', in Ruhemann, *Cleaning of Paintings*, 361–481

Joyce Plesters, 'Cross-Sections and Chemical Analysis of Paint Samples', *Studies in Conservation*, 2, 1956, 110–57

Joyce Plesters, 'Dark Varnishes – Some Further Comments', *The Burlington Magazine*, 104, 1962, 452–60 (reprinted in Bomford and Leonard [eds.], *Readings II*, 519–30)

Joyce Plesters, 'A Preliminary Note on the Incidence of Discolouration of Smalt in Oil Media', *Studies in Conservation*, 14, 1969, 62–74

Joyce Plesters, 'The Preparation and Study of Paint Cross-Sections', in Bomford and Leonard (eds.), *Readings II*, 185–93 (originally in *The Museums Journal*, 54, 1954, 97–101)

Joyce Plesters, 'Ultramarine Blue, Natural and Artificial', in Roy (ed.), *Artists' Pigments*, 37–65

Pliny the Elder, *Natural History*, vol. 10, ed. and trans. D.E. Eichholz, Loeb Classical Library, London: Heinemann, 1963

J.J. Pollitt, *Art in the Hellenistic Age*, Cambridge: Cambridge University Press, 1986

Nicholas Stanley Price, M. Kirby Talley Jr and Alessandra Melucco Vaccaro (eds.), *Readings in Conservation I: Historical and Philosophical Issues in the Conservation of Cultural Heritage*, Los Angeles: The Getty Conservation Institute, 1996

Léo van Puyvelde, 'The Cleaning of Old Paintings', in Bomford and Leonard (eds.), *Readings II*, 73–81 (originally 'Le nettoyage des tableaux anciens', *Annuaire général des Beaux-Arts*, 3, 1932–33, 19–30)

Nancy H. Ramage, 'Restorer and Collector: Notes on Eighteenth-Century Recreations of Roman Statues', *Memoirs of the American Academy in Rome. Supplementary Volumes, Vol. 1, The Ancient Art of Emulation: Studies in Artistic Originality and Tradition from the Present to Classical Antiquity*, Ann Arbor: University of Michigan Press, 2002, 61–77

Faramarz Rasti and Gerald Scott, 'The Effects of Some Common Pigments on the Photo-Oxidation of Linseed Oil-Based Paint Media', *Studies in Conservation*, 25, 1980, 145–56

Richard and Samuel Redgrave, A Century of Painters of the English School, 2nd edn, London: Sampson Low, Marston, Searle & Rivington, 1890

Stephen Rees Jones, 'The Changed Appearance of Oil Paintings Due to Increased Transparency', *Studies in Conservation*, 36, 1991, 151–54

Stephen Rees Jones, 'The Cleaning Controversy: Further Comments', *The Burlington Magazine*, 105, 1963, 97–98

Stephen Rees Jones, 'Science and the Art of Picture Cleaning', *The Burlington Magazine*, 104, 1962, 60–62

Anthony Reeve, 'Structural Conservation of Panel Paintings at the National Gallery, London', in Dardes and Rothe (eds.), *Conservation of Panel Paintings*, 403–17

Anthony Reeve, Paul Ackroyd and Ann Stephenson-Wright, 'The Multi-Purpose Low Pressure Conservation Table', *National Gallery Technical Bulletin*, 12, 1988, 4–15

Geneviève Reille-Taillefert, *Conservation-restauration des peintures murales de l'Antiquité à nos jours*, Paris: Eyrolles, 2010

John Richardson, 'Crimes against the Cubists', in Bomford and Leonard (eds.), *Readings II*, 531–38 (originally in *New York Review of Books*, 30, no. 10, June 1983, 32–34, and also reprinted in Price et al. [eds.], *Readings I*, 185–92)

E. René de la Rie, 'The Influence of Varnishes on the Appearance of Paintings', *Studies in Conservation*, 32, 1987, 1–13

David Rosen, 'Notes on the Preservation of Panel Pictures', *Journal of the Walters Art Gallery*, 4, 1941, 123–27

David Rosen, 'The Preservation of Wood Sculpture: The Wax Immersion Method', *Journal of the Walters Art Gallery*, 13/14, 1950/51, 44–71

Andrea Rothe, 'Croce e Delizia', in Leonard (ed.), *Personal Viewpoints*, 13–25

Andrea Rothe, 'Mantegna's Paintings in Distemper', in Martineau (ed.), *Mantegna*, 80–88

Andrea Rothe and Giovanni Marussich, 'Florentine Structural Stabilization Techniques', in Dardes and Rothe (eds.), *Conservation of Panel Paintings*, 306–15

Ashok Roy (ed.), *Artists' Pigments: A Handbook of their History and Characteristics*, vol. 2, Washington, D.C.: National Gallery of Art, 1993

Ashok Roy, 'Comments: Response to papers of David Bomford and Andrea Rothe', in Leonard (ed.) *Personal Viewpoints*, 30

Ashok Roy and Georgia Mancini, '"The Virgin and Child with an Angel", after Francia: A History of Error', *National Gallery Technical Bulletin*, 31, 2010, 64–77

Ashok Roy and Perry Smith (eds.), *Painting Techniques: History, Materials and Studio Practice. Contributions to the Dublin Congress 7–11 1998*, London: International Institute for Conservation
of Historic and Artistic Works, 1998

Ashok Roy, Marika Spring and Carol Plazzotta, 'Raphael's Early Work in the National Gallery: Paintings before Rome', *National Gallery Technical Bulletin*, 25, 2004, 4–35

Helmut Ruhemann, *The Cleaning of Paintings: Problems and Potentialities*, London: Faber & Faber, 1968

Helmut Ruhemann, 'Criteria for Distinguishing Additions from Original Paint', *Studies in Conservation*, 3, 1958, 145–61

Helmut Ruhemann, 'The Impregnation and Lining of Paintings on a Hot Table', *Studies in Conservation*, 1, 1953, 73–76

Helmut Ruhemann, Alain Boissonnas, Christian Wolters, Elisabeth Packard and Peter Michaels, 'Some Notes on Vacuum Hot Tables', *Studies in Conservation*, 5, 1960, 17–24

Helmut Ruhemann and Joyce Plesters, 'The Technique of Painting in a "Madonna" attributed to Michelangelo', *The Burlington Magazine*, 106, 1964, 546–554

John Ruskin, *The Elements of Drawing*, New York: John Wiley, 1864

Renzo Salimbeni and Luca Pessati, *Optical Methods for Arts and Archaeology*, Bellingham: SPIE (Society of Photo-Optical Engineers), 2005

William Salmon, *Polygraphice, or The Arts of Drawing, Limning and Painting &c.*, London: Passenger and Sawbridge, 1685

Manuel Sánchez del Río, Antonio Doménech, María Teresa Doménech-Carbo, María Luisa Vázquez de Agredos Pascual, Mercedes Suárez and Emila García-Romero, 'The Maya Blue Pigment', in Galan and Singer (eds.), *Palygorskite-Sepiolite Research*, 453–81

William Sanderson, *Graphice. The use of the Pen and Pensil. Or, the most excellent art of Painting*, London: Robert Crofts, 1658

Joachim von Sandrart, *L'academia todesca della architectura, scultura & pittura, oder, Teutsche Academie der Bau-, Bild- und Mahlerey-Künste*, Nuremberg: Joachim von Sandrart, 1675–79

Anna Santoni (ed.), *L'autore multiplo*, Pisa: Scuola Normale Superiore, 2005

Paul Sarasin, *Der Verkündigungsengel des Leonardo da Vinci*, Basle: Frobenius A.G., 1917

David Saunders, 'Detecting and Measuring Colour Changes in Paintings at the National Gallery', in Todd (ed.), *Appearance, Opinion, Change*, 68–71

David Saunders, 'Pollution and the National Gallery', *National Gallery Technical Bulletin*, 21, 2000, 77–94

David Saunders, Helene Chahine and John Cupitt, 'Long-Term Colour Change Measurement: Some Results after Twenty Years', *National Gallery Technical Bulletin*, 17, 1996, 81–90

David Saunders and John Cupitt, 'Elucidating Reflectograms by superimposing Infra-red and Colour Images', *National Gallery Technical Bulletin*, 16, 1995, 61–65

David Saunders and Jo Kirby, 'Light-Induced Colour Changes in Red and Yellow Lake Pigments', *National Gallery Technical Bulletin*, 15, 1994, 79–97

Francesco Scannelli, *Il Microcosmo della Pittura*, Cesena: Per il Neri, 1657

Ursula Schädler-Saub, 'Italia und Germania: die italienischen Restaurierungstheorien und Retuschiermethoden und ihre Rezeption in Deutschland', in Schädler-Saub (ed.), *Kunst der Restaurierung*, 105–21

Ursula Schädler-Saub (ed.), *Die Kunst der Restaurierung. Entwicklungen und Tendenzen der Restaurierungsästhetik in Europa*, Munich: ICOMOS, Nationalkomitee der Bundesrepublik Deutschland, 2005

Mikkel Scharf, 'Structural treatment of canvas paintings, especially using low-pressure suction tables', in Stoner and Rushfield (eds.), *Conservation*, 00–00

Ulrich Schiessl, 'History of Structural Panel Painting Conservation in Austria, Germany and Switzerland', in Dardes and Rothe (eds.), *Conservation of Panel Paintings*, 200–36

Sibylle Schmitt, 'Examination of Paintings Treated by Pettenkofer's Process', in Mills and Smith (eds.), *Cleaning, Retouching and Coatings*, 81–84

Sibylle Schmitt, 'Research on the Pettenkofer method and the historical understanding of paint film swelling and interaction', in Stoner and Rushfield (eds.), *Conservation*, 492–96

Arno P. Schniewind, 'Consolidation of Wooden Panels', in Dardes and Rothe (eds.), *Conservation of Panel Paintings*, 87–107

Helmut Schweppe, 'Indigo and Woad', in FitzHugh (ed.), *Artists' Pigments*, 80–107

Helmut Schweppe and Heinz Roosen-Runge, 'Carmine – Cochineal Carmine and Kermes Carmine', in Feller (ed.), *Artists' Pigments*, 255–83

Helmut Schweppe and John Winter, 'Madder and Alizarin', in FitzHugh (ed.), *Artists' Pigments*, 109–42

Giovanni Secco-Suardo, *Il restauratore dei dipinti*, Milan: Ulrico Hoepli, 1927 (1st edn 1866)

Sam Segal, with Mariël Ellens and Joris Dik, *The Temptations of Flora. Jan van Huysum 1682–1749*, exh. cat., Delft: Museum Het Prinsenhof, and Houston: Museum of Fine Arts; Zwolle: Waanders, 2007

Anna Maria Seves, Maria Romanò, Tullia Maifreni, Alberto Seves, Giovanna Scicolone, Silvio Sora and Orio Cifferi, 'A Laboratory Investigation of the Microbial Degradation of Cultural Heritage', in Ciferri et al. (eds.), *Of Microbes and Art*, 121–34

John Shearman, 'The Function of Michelangelo's Colour', in De Vecchi (ed.), *Sistine Chapel*, 80–89

Libby Sheldon and Nicola Costaras, 'Johannes Vermeer's "Young woman seated at a virginal"', *The Burlington Magazine*, 148, 2006, 89–97

Christine Sitwell and Sarah Staniforth (eds.), *Studies in the History of Painting Restoration*, London: Archetype Publications, 1998

Erling Skaug (ed.), *Conservare necesse est: festskrift til Leif Einar Plahter på hans 70-årsdag*, Oslo: Nordisk Konservatorforbund, Den norske seksjon (IIC Nordic Group), 1999

Erling Skaug, 'Music, Painting and Restoration', in Skaug (ed.), *Conservare necesse est*, 242–50

Basil Skinner, 'Philip Tideman and the Allegorical Decorations at Hopetoun House', *The Burlington Magazine*, 106, 1964, 368–71

Stefan Slabczynski, 'The Large Vacuum Hot-Table for Wax Relining of Paintings in the Conservation Department of the Tate Gallery', *Studies in Conservation*, 5, 1960, 1–16

Seymour Slive, *Jacob van Ruisdael: Master of Landscape*, London: Royal Academy of Arts, 2005

John Smith, *The Art of Painting, wherein is included The whole Art of Vulgar Painting, according to the best and most approved Rules for preparing, and laying on of Oyl Colours*, London: Samuel Crouch, 1676

Frances Spalding, *Roger Fry, Art and Life*, London: Granada Publishing, 1980

Marika Spring (ed.), *Studying Old Master Paintings: Technology and Practice*, London: Archetype Publications, 2011

Marika Spring and Rachel Grout, 'The Blackening of Vermilion: an Analytical Study of the Process in Paintings', *National Gallery Technical Bulletin*, 23, 2002, 50–61

Marika Spring, Catherine Higgitt and David Saunders, 'Investigation of Pigment-Medium Interaction Processes in Oil Paint Containing Degraded Smalt', *National Gallery Technical Bulletin*, 26, 2005, 56–70

Marika Spring and Larry Keith, 'Aelbert Cuyp's "Large Dort": Colour Change and Conservation', *National Gallery Technical Bulletin*, 30, 2009, 71–85

Marika Spring, Nicholas Penny, Raymond White and Martin Wyld, 'Colour Change in *The Conversion of the Magdalen* attributed to Pedro Campaña', *National Gallery Technical Bulletin*, 22, 2001, 54–63

Harriet Standeven, 'The History and Manufacture of Lithol Red, a Pigment Used by Mark Rothko in his Seagram and Harvard Murals of the 1950s and 1960s', *Tate Papers*, 10, 2008 (http://www.tate.org.uk/download/file/fid/7323)

Joan Stanley-Baker, 'The Problem of Retouching in Ancient Chinese Paintings, or Trying to See Through Centuries', *Artibus Asiae*, 51, 1991, 257–74

Randolph Starn, 'Three Ages of "Patina" in Painting', *Representations*, 78, 2002, 86–115

Richard E. Stoiber and Stearns A. Morse, *Microscopic Identification of Crystals*, New York: Ronald Press, 1972

Nathan Stolow, 'Solvent Action', in Feller et al., *Varnishes and their Solvents*, 47–116

Maartje Stols-Witlox, 'Grounds, 1400–1900', in Stoner and Rushfield (eds.), *Conservation*, 161–85

Joyce Hill Stoner and Rebecca Rushfield (eds.), *The Conservation of Easel Paintings*, Abingdon: Routledge, 2012

Joyce Storey, *The Thames and Hudson Manual of Dyes and Fabrics*, London: Thames and Hudson, 1992

George L. Stout, *The Care of Pictures*, New York: Columbia University Press, 1948

George L. Stout and Murray Pease, 'A case of paint cleavage', *Technical Studies in the Field of the Fine Arts*, 7, 1938, 33–45

Rolf E. Straub and Stephen Rees-Jones, 'Marouflage, Relining and the Treatment of Cupping with Atmospheric Pressure', *Studies in Conservation*, 2, 1955, 55–63

Ken Sutherland, 'Measurements of Solvent Cleaning Effects on Oil Paintings', *Journal of the American Institute for Conservation*, 45, 2006, 211–26

W. Stanley Taft and James W. Mayer, *The Science of Paintings*, New York: Springer-Verlag, 2000

Jean-Joseph Taillasson, *Observations sur quelques grands peintres, dans lesquelles on cherche à fixer les caractères distinctifs de leur talent, avec un précis de leur vie*, Paris: Imprimerie de Duminil-Lesueur, 1807

M. Kirby Talley, 'Miscreants and Hotentots: Restorers and Restoration Attitudes and Practices in Seventeenth- and Eighteenth-Century England', in Sitwell and Staniforth (eds.), *History of Restoration*, 27–42

M. Kirby Talley and Karin Groen, 'Thomas Bardwell and his Practice of Painting: A Comparative Investigation between Described and Actual Painting Technique', *Studies in Conservation*, 20, 1975, 44–108

Piotr Targowski, Magdalena Iwanicka, Ludmiła Tymińska-Widmer, Marcin Sylwestrzak, Ewa A. Kwiatkowska, 'Structural Examination of Easel Paintings with Optical Coherence Tomography', *Accounts of Chemical Research*, 43/6, 2009, 826–36

David Tavárez, *The Invisible War: Indigenous Devotions, Discipline and Dissent in Colonial Mexico*, Stanford: Stanford University Press, 2011

Paul Taylor, 'Colouring Nakedness in Flanders and Holland', in De Clippel et al., *The Nude and the Norm*, 65–79

Paul Taylor, 'The Concept of *Houding* in Dutch Art Theory', *Journal of the Warburg and Courtauld Institutes*, 55, 1992, 210–232

Paul Taylor, 'Flatness in Dutch Art: Theory and Practice', *Oud Holland*, 121, 2008, 153–84

Paul Taylor, 'Julius II and the Stanza della Segnatura', *Journal of the Warburg and Courtauld Institutes*, 72, 2009, 103–41

Paul Taylor, 'Leonardo and the Low Countries', in Frangenberg and Palmer (eds.), *Lives of Leonardo*, 29–60

Paul Taylor, *Vermeer, Lairesse and Composition*, Zwolle: Waanders, 2010

Paul Taylor, '*Zwierich van sprong*: Samuel van Hoogstraten's *Night Watch*', in Weststeijn, *Hoogstraten*

Abbott H. Thayer, '"Restoration": The Doom of Pictures and Sculpture', in Bomford and Leonard (eds.), *Readings II*, 483–91 (originally in *International Studio*, March 1920, 13–17)

Anabel Thomas, 'Restoration or Renovation: Remuneration and Expectation in Renaissance *acconciatura*', in Sitwell and Staniforth (eds.), *History of Restoration*, 1–14

Daniel V. Thompson, 'Artificial Vermilion in the Middle Ages', *Technical Studies*, 2, 1933, 62–70

Daniel V. Thompson, *The Materials and Techniques of Medieval Painting*, New York: Dover Publications, 1956 (1st edn 1936)

Daniel V. Thompson, *The Practice of Tempera Painting. Materials and Methods*, New York: Dover Publications, 1962 (1st edn 1936)

Garry Thomson, 'Notes on "Science and the Art of Picture Cleaning"', *The Burlington Magazine*, 104, 1962, 499–500

Jonathan Thornton, Nick Umney, Gregory Landrey, Sherry Doyal, Kathryn Gill, Roger Griffith and Shayne Rivers, 'Deterioration of other materials and structures', in Umney and Rivers, *Conservation of Furniture*, 315–59

Pierre François Tingry, *Traité théorique et pratique sur l'art de faire et d'appliquer les vernis*, Geneva: G.J. Manget, 1803

Gary Tinterow and Philip Conisbee (eds.), *Portraits by Ingres: Image of an Epoch*, exh. cat., London: National Gallery, and New York: Metropolitan Museum of Art, 1999

Victoria Todd (ed.), *Appearance, Opinion, Change: Evaluating the Look of Paintings*, London: United Kingdom Institute for Conservation, 1990

Carolyn Tomkiewicz, Mikkel Scharf and Rustin Levenson, 'Tear mending and other structural treatments of canvas paintings, before or instead of lining', in Stoner and Rushfield (eds.), *Conservation*, 384–96

Jean-Max Toubeau, 'Rubens copiste à la Capelle Sistine', *Nuances*, 26, 2001, 14–18

Joyce Townsend, 'Turner's Oil Paintings: Changes in Appearance', in Todd (ed.), *Appearance, Opinion, Change*, 26–31

Joyce Townsend and Jaap Boon, 'Research and instrumental analysis in the materials of easel paintings', in Stoner and Rushfield (eds.), *Conservation*, 341–365

Nick Umney and Shayne Rivers, *Conservation of Furniture*, Ocford: Butterworth-Heinemann, 2003

Marcus van Vaernewyck, *De historie van Belgis*, Ghent: D.J. Vanderhaeghen, 1829 (1st edn 1568)

Wilfried Van Damme, *Beauty in Context: Towards an Anthropological Approach to Aesthetics*, Leiden, 1996

Nico Van Hout, 'Meaning and Development of the Ground Layer in Seventeenth-Century Painting', in Hermens (ed.), *Looking through Paintings*, 199–225

Dominique Vanwijsberghe (ed.), *Autour de la Madeleine Renders. Un aspect de l'histoire des collections, de la restauration et de la contrefaçon en Belgique dans la première moitié du XXe siècle*, Brussels: Koninklijk Instituut voor het Kunstpatrimonium, 2008

Giorgio Vasari, *Lives of the Painters, Sculptors and Architects*, trans. Gaston de Vere, ed. David Ekserdjian, London: Everyman's Library, 1996

Giorgio Vasari, *On Technique*, trans. Louisa Maclehose, ed. G. Baldwin Brown, New York: Dover Publications, 1960 (1st edn 1907)

Giorgio Vasari, *Le vite de' più eccellenti pittori, scultori ed architettori*, Florence: I Giunti, 1568

Pierluigi de Vecchi (ed.), *The Sistine Chapel: A Glorious Restoration*, New York and London: Abradale, 1994

Pierluigi de Vecchi, *La Cappella Sistina: il restauro degli affreschi di Michelangelo*, Milan: Rizzoli, 1996

Hugo van der Velden, 'The Quatrain of *The Ghent Altarpiece*', *Simiolus*, 35, 2011, 5–39

Hugo van der Velden, 'A reply to Volker Herzner and a note on the putative author of the Ghent quatrain', *Simiolus*, 35, 2011, 131–41

Marije Vellekoop, Nienke Bakker, Maite van Dijk, Muriel Geldof, Ella Hendriks and Birgit Reissland, *Van Gogh at Work*, Amsterdam: Van Gogh Museum, 2013

Armand-Denis Vergnaud, *Manuel du peintre en bâtimens*, 5th edn, Paris: Roret, 1831

Hélène Verougstraete, Roger Van Schoute and Till-Holger Borchert (eds.), *Restaurateurs ou Faussaires des Primitifs Flamands*, Ghent and Amsterdam: Ludion, 2004

Georges Vigne, 'Ingres and Co.: A Master and his Collaborators', in Tinterow and Conisbee (eds.), *Portraits by Ingres*, 523–42

Caroline Villers, 'Introduction', in Villers (ed.), *Lining Paintings*, xi–xvi

Caroline Villers (ed.), *Lining Paintings. Papers from the Greenwich Conference on Comparative Lining Techniques*, London: Archetype Publications, 2003

Vitruvius, *On Architecture*, ed. and trans. Frank Granger, Loeb Classical Library, London: Heinemann, 1931–34

Michael Voets, 'Das Pettenkofersche Regenerierverfahren', in Althöfer (ed.), *19. Jahrhundert*, 308–10

Giovanni Batista Volpato, *Modo da tener nel dipinger* (late 17th century), in Merrifield, *Original Treatises*, 727–55

Lyckle de Vries, *How to Create Beauty. De Lairesse on the Theory and Practice of Making Art*, Leiden: Primavera Press, 2011

Peter Waldeis and Gerd Feucht, 'Traitement d'un blanchiment de l'outremer au Städel Museum de Francfort', *Nuances*, 42/43, 2010–11, 38–41

Sarah Walden, *The Ravished Image, or, How to Ruin Masterpieces by Restoration*, New York: St Martin's Press, 1985

Horace Walpole, *Anecdotes of Painting in England*, London: Alexander Murray, 1871 (1st edn 1786)

Gerald R. Ward (ed.), *The Grove Encyclopedia of Materials and Techniques in Art*, Oxford: Oxford University Press, 2008

Ian Warrell, *Turner Inspired: In the Light of Claude*, London: National Gallery, 2012

Jack Wasserman, *Leonardo*, London: Book Club Associates, 1980

Claude-Henri Watelet and Pierre-Charles Lévesque (eds.), *Encyclopédie Méthodique. Beaux-Arts*, Paris: Pancoucke, 1788–91

Jean Félix Watin, *L'art du peintre, doreur et vernisseur*, 2nd edn, Paris: Grangé, 1773

Karl Wehlte, *The Materials and Techniques of Painting. With a Supplement on Colour Theory*, New York and Wokingham: Van Nostrand Reinhold Company, 1967

Phoebe Dent Weil, 'A Review of the History and Practice of Patination', in Price et al. (eds.), *Readings I*, 394–414 (originally in *National Bureau of Standards Special Publication*, 479, 1977, 77–92)

Roberto Weiss, *The Renaissance Discovery of Classical Antiquity*, Oxford: Basil Blackwell, 1988

Inez van der Werf, Klaas Jan van den Berg, Sibylle Schmitt and Jaap Boon, 'Molecular Characterization of Copaiba Balsam used in Painting Techniques and Restoration Procedures', *Studies in Conservation*, 45, 2000, 1–18

Thijs Weststeijn (ed.), *The Universal Art of Samuel van Hoogstraten (1627–1678), painter, writer and courtier*, Amsterdam: Amsterdam University Press, 2013

Ernst van de Wetering, 'The aged painting and the necessities and possibilities to know its original appearance', in Skaug (ed.), *Conservare necesse est*, 259–64

Ernst van de Wetering, 'The Autonomy of Restoration: Ethical Considerations in Relation to Artistic Concepts', in Price et al. (eds.), *Readings I*, 193–99

Ernst van de Wetering, *Rembrandt: The Painter at Work*, Amsterdam: Amsterdam University Press, 1997

Raymond White, 'Brown and Black Organic Glazes, Pigments and Paints', *National Gallery Technical Bulletin*, 10, 1986, 58–71

Raymond White, 'Van Dyck's Paint Medium', *National Gallery Technical Bulletin*, 20, 1999, 84–88

Raymond White and Catherine Higgitt, 'Rembrandt's paint medium', in Bomford, Kirby, Roy, Rüger and White, *Art in the Making: Rembrandt* (2nd edn), 2006, 48–51

Raymond White and Jo Kirby, 'Rembrandt and his Circle: Seventeenth-Century Dutch Paint Media Re-examined', *National Gallery Technical Bulletin*, 15, 1994, 64–78

Raymond White and Jo Kirby, 'A Survey of Nineteenth- and Early Twentieth-Century Varnish Compositions Found on a Selection of Paintings in the National Gallery Collection', *National Gallery Technical Bulletin*, 22, 2001, 64–84

Raymond White and Jennifer Pilc, 'Analyses of Paint Media', *National Gallery Technical Bulletin*, 14, 1993, 86–94; 16, 1995, 85–95; 17, 1996, 91–103

Zeno Wicks, Frank Jones, Peter Pappas and Douglas Wicks (eds.), *Organic Coatings: Science and Technology*, 3rd edn, Hoboken: John Wiley & Sons, 2007

Rolf Wihr, *Restaurierung von Steindenkmälern*, Munich: Callwey, 1980

Robert Wilmot, 'Examining "authenticity" in two contemporary conservation projects in Scotland: Charles Rennie Mackintosh's Dysart Kirk murals and Daniel Cottier's painted decorative scheme at Cottier's Theatre, Glasgow', in Hermens and Fiske, *Authenticities*, 96–105

Charles Heath Wilson, *Life and Works of Michelangelo*, London: John Murray, 1876

Humphrey Wine, *National Gallery Catalogues: The Seventeenth Century French Paintings*, London: National Gallery, 2001

John Winter, *East Asian Paintings. Materials, Structures and Deterioration Mechanisms*, London: Archetype Publications, 2008

John Winter and Elisabeth West FitzHugh, 'Pigments Based on Carbon', in Berrie (ed.), *Artists' Pigments*, 1–37

Richard Wolbers, *Cleaning Painted Surfaces: Aqueous Methods*, London: Archetype Publications, 2000

Richard Wolbers, Susan Buck and Peggy Olley, 'Cross-section microscopy and fluorescent staining', in Stoner and Rushfield (eds.), *Conservation*, 326–35

Diane Wolfthal, *The Beginnings of Netherlandish Canvas Painting, 1400–1530*, Cambridge: Cambridge University Press, 1989

Jeremy Wood, *Rubens, Copies and Adaptations from Renaissance and Later Artists III. Artists working in Central Italy and France*, London and Turnhout: Harvey Miller Publishers, 2011

Ad van der Woude, 'The Volume and Value of Paintings in Holland at the Time of the Dutch Republic', in Freedberg and De Vries (eds.), *Art in History*, 285–389

Renate and Paul Woudhuysen-Keller, 'The history of eggwhite varnishes', *Bulletin of the Hamilton Kerr Institute*, 2, 1994, 90–141

Renate and Paul Woudhuysen-Keller, 'A short history of eggwhite varnishes', in Harmsen (ed.), *Firnis*, 81–85

Renate and Paul Woudhuysen-Keller, 'Thoughts on the Use of the Green Glaze called "Copper Resinate" and its Colour Changes', in Hermens (ed.), *Looking through Paintings*, 133–46

Martin Wyld, 'The Restoration History of Holbein's Ambassadors', *National Gallery Technical Bulletin*, 19, 1998, 4–25

Martin Wyld, John Mills and Joyce Plesters, 'Some Observations on Blanching (with special Reference to the Paintings of Claude)', *National Gallery Technical Bulletin*, 4, 1980, 48–63

Martin Wyld and Joyce Plesters, 'Some Panels from Sassetta's Sansepolcro Altarpiece', *National Gallery Technical Bulletin*, 1, 1977, 3–17

Larisa Ivanovna Yashkina, 'Relining of an Easel Oil Painting with Sturgeon Glue', in Villers (ed.), *Lining Paintings*, 101–04 (reprinted in Bomford and Leonard [eds.], *Readings II*, 267–74)

Larisa Ivanovna Yashkina, 'Adhesive Method of Consolidating Oil Paintings with Cuppings and Hard Craquelure', in Villers (ed.), *Lining Paintings*, 105–06

Christina Young and Paul Ackroyd, 'The Mechanical Behaviour and Environmental Response of Paintings to Three Types of Lining Treatment', *National Gallery Technical Bulletin*, 22, 2001, 85–104

Christina Young, 'History of Fabric Supports', in Stoner and Rushfield (eds.), *Conservation*, 116–47

Frank Zöllner, *Leonardo da Vinci, 1452–1519, The Complete Paintings*, Cologne: Taschen, 2003

Marianna van der Zwaag and Renske Cohen Tervaert (eds.), *Opstand in opdracht: Flinck, Ovens, Lievens, Jordaens, De Groot, Bol en Rembrandt in het paleis / The Batavian commissions: Flinck, Lievens, Ovens, Jordaens, Bol and Rembrandt in the Palace*, exh. cat., Amsterdam: Koninklijk Paleis, 2011

INDEX

PHOTOGRAPHIC CREDITS

Figs. 1, 16: © The Estate of Nicola Lochoff, Photo: courtesy of the University of Pittsburgh; fig. 2: Google Art Project, licensed under public domain via Wikimedia Commons; figs. 3, 55: Warburg Institute; figs. 4, 6: © Philadelphia Museum of Art; figs. 5, 51, 53, 103, 114, 116, 135: © SCALA Florence/ (5: Art Resource NY 2014; 53, 103: courtesy of the Ministero per i Beni e le Attività Culturali 2014; 116: Andrea Jemolo; 135: Heritage Images 2014); fig. 7: Bequest of Fritz Sarasin 1942. Photo: © Kunstmuseum Basel; fig. 8: Bequest of Fritz Sarasin 1942. Photo: Martin B. Bühler, © Kunstmuseum Basel; figs. 9, 28: Wikimedia Commons; figs. 10, 22, 24, 27, 29, 31, 33–44, 56–62, 64–66, 69, 71, 74–82, 85, 88–90, 92, 94–97, 100–01, 104–05, 110–12, 115, 119, 124–126, 128–29, 132–33: © The National Gallery, London; fig. 11: www.rijksmuseum.nl; fig. 12: © The Frick Collection; fig. 13: Courtesy The David Hockney No. 1 U.S. Trust; fig. 14, 81, 86, 93, 99, 106–09: © Trustees of the British Museum; fig. 15: © DeA Picture Library / Art Resource, NY; figs. 17, 18: © The Tokugawa Art Museum; fig. 19: Olaf Wipperfürth © and courtesy Anthony JP Meyer, Paris; figs. 20, 21, 23: © Victoria and Albert Museum, London; fig. 25: University of Aberdeen; fig. 26: © Musée du Louvre, © Direction des Musées de France, 1999; photo: © Réunion des musées nationaux © Franck Raux; fig. 30: The Shanghai Museum; fig. 32: Collection the artist © Jonathan Janson; figs. 45, 47: Glyptothek Munich; fig. 46: © Vanni Archive/ Art Resource, NY; fig. 48: AERIA; figs. 49, 136: www.rijksmuseum.nl; fig. 50:

www.rijksmuseum.nl, The National Gallery, London; fig. 52: © bpk / Gemäldegalerie, SMB / Jörg P. Anders; fig. 54: Gianni Dagli Orti / The Art Archive at Art Resource, NY; fig. 63: © by kind permission of the Trustees of the Wallace Collection, London; fig. 67: © Nationalgalerie der Staatlichen Museen zu Berlin - Preußischer Kulturbesitz; Photographer: Jörg P. Anders; fig. 68, 137: © RMN-Grand Palais (musée du Louvre) / 68: Christian Jean; fig. 70, 131: Warburg Institute; fig. 72: © Christie's Images / Bridgeman Images; fig. 73: Courtauld Institute of Art; fig. 83: George Tatge for Alinari Archives, Florence, reproduced with the permission of Ministero per i Beni e le Attività Culturali; fig. 84: © Kunsthistorisches Institut in Florenz – Max-Planck-Institut 601369; Nr. fld0003556z_p, credit: Rabatti - Domingie Photography; figs. 87, 98: © 2014 Museum of Fine Arts, Boston; fig. 91: Alinari Archives, Florence; fig. 102: © The Fitzwilliam Museum, Cambridge; fig. 113: The Pierpont Morgan Library, New York ; fig. 117: © National Gallery of Canada; figs. 118, 120: Google Art Project, licensed under public domain via Wikimedia Commons; fig. 121: www.metmuseum.org; fig. 122: by permission of the Trustees of Dulwich Picture Gallery, London; fig. 123: Mauritshuis; fig. 127: Ian Jones. By permission of the Trustees of Dulwich Picture Gallery, London; fig. 130: © Museum of Fine Arts, Budapest 2014; fig. 134 © Erich Lessing; fig. 138: © Direction des musées de France, 1986; photo: © H. Lewandowski; © Réunion des musées nationaux